From Supplication to Revolution

FROM SUPPLICATION TO REVOLUTION

A Documentary Social History of Imperial Russia

GREGORY L. FREEZE

Brandeis University

New York Oxford
OXFORD UNIVERSITY PRESS
1988

Oxford University Press

Oxford New York Toronto
Delhi Bombay Calcutta Madras Karachi
Petaling Jaya Singapore Hong Kong Tokyo
Nairobi Dar es Salaam Cape Town
Melbourne Auckland

and associated companies in
Beirut Berlin Ibadan Nicosia

Library of Congress Cataloging-in-Publication Data
Freeze, Gregory L., 1945–
From supplication to revolution.
Bibliography: p. Includes index.
1. Soviet Union—Social conditions—1801–1917—Sources.
2. Soviet Union—History—Catherine II, 1762–1796—Sources.
3. Soviet Union—History—Revolution of 1905—Sources. I. Title.
HN526.F74 1988 306′.0947 87–12246
ISBN 978-0-19-504359-4 (pbk.)

68975

Printed in the United States of America

For T. M. R.

PREFACE

"Let the people speak"—such is the spirit that inspired the present volume, a collection and translation of original sources in Russian social history. As such it seeks to satisfy the acute need for materials on the prerevolutionary social order, which has generally received little attention in the specialized or, especially, general literature on Imperial Russia. To be sure, the existing source volumes and general histories do not wholly neglect social history; it is nonetheless true that documentary collections and secondary accounts have tended to concentrate almost exclusively upon the political chronology of the old regime. As a result, we have neither a good documentary collection nor secondary syntheses to address the basic issues of social structure and change in prerevolutionary Russia—and one need not be a Marxist to appreciate how fundamental these problems are to a proper understanding of the ancien régime as it drifted toward the shoals of revolution.

"Let the people speak." And then listen to what is said—by the nobility, civil and military service groups, clergy, professions and educated elites, townsmen and commercial-industrial elites, peasantry, industrial labor, and minorities and women. It is my hope that this material will bring to life the ancien société and enable the reader, student as well as specialist, to come face-to-face with the various groups in society. By seeing what these groups decried and demanded, how they defined themselves and formulated their demands, and to whom they turned for redress of grievances, one can obtain rich insights into the life and problems of various strata in prerevolutionary society. Moreover, the structure of this collection—three cross-sections of the social order at discrete intervals (1760s, 1860s and 1905–6)— serves to cast in sharp relief the dynamics and patterns of change in Imperial Russia. More important for the social historian, it was precisely at these junctures that society obtained—or usurped—the right to assert its grievances and aspirations; the documents left behind provide an extraordinary opportunity not only to hear the voice of a particular group at a particular time, but to observe how that voice

changed over time and how it harmonized—or clashed discordantly—with that of others.

On technical matters. Transliteration follows the practice used in American Slavic scholarship; archival notation corresponds to the forms and abbreviations customarily used in Soviet research. The substance of each item should be clear from the title of the document; where available and appropriate, the formal title of a particular archival document or published entry is given in the source reference. Dates are given in the "Old Style" (Julian calendar), which lagged behind the Western (Gregorian) calendar by eleven days in the eighteenth century, twelve in the nineteenth and thirteen in the twentieth. Most documents are presented in their entirety; most excisions (especially for collective documents) include only minor detail, formal greetings and closings; deletions by the editor are indicated by ellipses (and to be distinguished from those in the original, signalled by the conventional [sic]). Because of the incessant geographical-administrative reorganization, terms like province can be highly confusing, especially before the 1775 provincial reforms; to put locales on the larger map, reference is here made to the essentially stable set of names and boundaries in use in the nineteenth century. Dates given reflect the known date of composition or, failing that, the date of contemporary publication; if the document contained no exact date, the approximate date is given in brackets.

The material presented here is drawn from Soviet archives and libraries, and I wish to thank both the host institutions (especially the Central State Historical Archive in Leningrad) and the International Research and Exchanges Board, which made possible repeated and lengthy research trips to the USSR. The Alexander von Humboldt-Stiftung has generously supported my parallel research in Russian religious and social history that underlies the present volume.

Tübingen G.L.F.
June 1987

CONTENTS

G. INDUSTRIAL WORKERS 87

H. MINORITIES AND WOMEN 93

Part Two
The Era of Great Reforms: Society in the 1860s 101

A. NOBILITY 103

B. BUREAUCRACY AND ARMY 114

From Supplication to Revolution

INTRODUCTION

Despite the populist spirit of the prerevolutionary Russian intelligentsia and the modern interest in social history, the available corpus of translated sources has little to offer for Russian social history. As a result, peasants and priests, workers and industrialists, nobles and minorities loom as vague apparitions or twisted reflections of Western stereotypes. With some noteworthy exceptions,[1] the primary sources available in English emanate from outsiders—travellers like Baron von Haxthausen or Sir Donald McKenzie Wallace, or the members of the intelligentsia (memoirs, belles-lettres, and theoretical tracts).[2] Valuable as they are, such materials are heresay testimony and reveal more about the mentality of the rapporteur than his subjects. Indeed, compared with the sources on Russian political history (the state and various political parties), the quantity of material on social history is distressingly thin. Nor is this lack of materials on social history simply an idiosyncracy of translation: such published collections are also wanting in Russian. To be sure, Soviet historians have produced numerous specialized documentary collections (especially, on the revolutionary movement among peasants and workers), but these publications—quite apart from problems of calculated bias in selectivity and excisions—in fact do not mainly present documents from the groups themselves, but reports by government authorities or exhortations by the Social-Democratic party. A good example is the eighteen-volume collection of documents published in the immediate post-Stalin era to commemorate the 1905 Revolution (*Revoliutsiia 1905–1907 gg. v Rossii. Dokumenty i materialy*): of the 2,101 documents pertaining to the peasantry, only 150 emanate from peasants themselves—the overwhelming majority come from landowners and government authorities (1,631), Social Democrats (180), and miscellaneous other sources.[3]

To a significant degree, this paucity of published sources reflects not the lack of materials (the archives, indeed, contain countless tons of unpublished, often untouched materials), but the appalling backwardness of Russian historiography both in the West and in the

USSR. For a variety of reasons, scholarship in this field has lagged considerably behind parallel work in European and American social history; only recently have Western and Soviet historians begun to assemble the most elementary data and address the most elementary questions. Although that research has produced some valuable studies of particular groups, it has so far failed to find its way into a new synthesis or to inform the traditional political narrative of general histories and survey accounts.

In a modest way this volume—a structured documentary introduction to Russian social history—seeks to help fill this gap in the published literature. It presents the first systematic collection of documents (in translation or in Russian) from the major social groups—not all, certainly, but at least the more important ones. So far as possible, I have attempted to present "collective statements"—petitions, instructions, resolutions, declarations and proclamations from local or national groups that express the particular problems and demands of a given group. Specialists too should find this collection of interest, for it is drawn chiefly from sources—archives and contemporary periodicals—not easily accessible to Western scholars.[4] Most documents are given in full, with minor deletions; only in a few cases, where the document was inordinately long or repetitious, did I decide to abbreviate the text, rather than reproduce a shorter, but less articulate alternative document.[5]

The materials assembled and translated here should, I hope, provide new insight into the collective mentality of major social groups—their grievances and aspirations, their fears and expectations. What a particular group (e.g., the clergy and nobility) wanted, for instance, is shrilly exclaimed in their petitions, declarations, resolutions and proclamations; a close reading should reveal what these groups represented and how they changed between the mid-eighteenth and the early twentieth centuries. The *type* of document is important too—whether it is an individual or group statement, an ad hoc declaration or formal resolution, a legal brief or public proclamation, for that too reveals much about the group's legal status, its right of remonstrance and the cultural capability to articulate its needs and wants. Attention should be given also to *tone;* surely one of the most striking changes to be observed here is the transition from the servile supplication in 1767 to the assertive demands in 1906.

Although a documentary collection might simply include a pot-

pourri of seemingly important or revealing materials, the approach employed here is to present documents from three discrete chronological junctures—essentially, from the late 1760s, early 1860s and 1905–6. While all three dates are in themselves important milestones in Russian history (1767 for the opening of Catherine's Legislative Commission, 1861 for peasant emancipation and onset of the Great Reforms, and 1905–6 for revolution and convocation of the first Duma), they are no less noteworthy in social history: each elicited an extraordinary volume of direct statements—petitions, declarations and resolutions—from a wide variety of social groups. To be sure, supplication and petition was an endemic feature of Russian political culture, providing a partial substitute for popular representation and a vital bond between Tsar and people from medieval times.[6] What was quite extraordinary about the three junctures chosen here is the broad range of groups that suddenly spoke up, all across the land, virtually in all strata of the population. And for precisely that reason they constitute exceptional periods in modern Russian history, when autocracy was driven to invite or was unable to repress the relatively free articulation of group interest. To be sure, not all groups could speak out, especially in 1767; yet most did, thereby providing the historian a unique cross-section of Russian society—both its structural composition and the aspirations of particular social groups.

The principle virtue of this triadic structure is the kind of comparative analysis it makes possible. Thus, within a given period, one can compare various groups—their concrete demands and grievances, modes of articulation (type of document, style, tone), and degree of formal organization (as latent, informal or corporate group). That kind of analysis can reveal much about the cultural level, status and mentality of each and place it within a meaningful comparative context. More interesting still are the diachronic comparisons that this structure affords, for individual groups (or clusters of groups) can be compared over a significant span of time, from the mid-eighteenth to the early twentieth century. This kind of longitudinal analysis can shed valuable light on each group's evolution—most obviously in its concrete demands, but more broadly in its internal structure, consciousness and organization. How a group defined itself, mobilized its latent membership, and articulated its demands are central problems in refining our picture of social change and structure in Imperial Russia.

Furthermore, a systematic collection of documents makes possible a comparison of the social structure at these three junctures. In particular, the cross-sections offered here provide a graphic illustration of the structural development of prerevolutionary Russian society, which was more complex than the traditional "estates" or "classes" paradigms would allow.[7] Diachronic comparisons show, moreover, the differential rates of development and, especially, the formation of cohesive new strata like the professions that would play so important a role in the political history of late imperial Russia. But most important, comparison of the three junctures shows the conversion of latent, inert groups into highly conscious—and highly politicized—collectivities. In that sense the documents give a graphic sense of why the ancien régime had ever greater difficulty governing in its final decades: compared to prereform times, the social order of 1906 was infinitely more unruly (compare the obsequious instructions of 1767 with the irreverent resolutions of 1906) and far more complex (with entirely new groups and entirely new demands). In other words, the revolutionary situation derived not only from the failure of the old regime but from the emergence of the new society that *any* regime would have found difficult to manipulate, pacify and govern.

These documents also shed light on basic dynamics in the development and transformation of the social order. While the emergence of new groups (like white-collar professions and workers) and politicization of virtually all groups is obvious enough, it is equally important to emphasize the particular patterns of group organization. Much coalescence and aggregation occurred chiefly and most effectively at the grass-roots, local level; it proved incomparably more difficult—even for elites—to establish social organization and cohesion at the regional and especially national level. To be sure, many endeavored to do so, especially in the latter decades of the nineteenth century, and in 1905 virtually all established some kind of national organization. But for the most part these could claim only the nominal allegiance of their purported constituency and suffered from enormous internal tensions and contradictions—regional, confessional, economic and ethnic. In that sense it would not be far amiss to recast the traditional thesis of Russia's "underdevelopment" to mean not "backwardness," but to refer to the disparity between rapid micro-aggregation and retarded macro-aggregation at the regional and national level.

A structured, thematic documentary collection like this—in which

documents serve as representative voices for various social groups—raises several problems. Doubtless most important is whether particular documents are truly representative—especially, whether specific documents are truly representative of a given group. Although the objection would be somewhat alleviated by a larger array of documents (which, alas, the economic realities of publication preclude), the problem would nevertheless remain—it would still be a sampling of documents, no one of which could claim to embrace the manifold dimensions of any given group or stratum. It is indeed a primary thesis of this book that regional differences played a major role in impeding the development and integration of various social groups. But, so far as possible, I have attempted to include multiple documents on major groups to give some sense of the role that regionalism played in an empire so vast and diverse as that in Russia. Nevertheless, one must still select from a plenitude of documents and choose those which appear most characteristic and most revealing. To make such selections, I have relied upon my own comparison with other documents from that group,[8] or followed the guidance of specialized analyses of the collective statements,[9] or chosen documents that illustrate patterns attested in recent research.[10] In some instances, documents were chosen not because they were typical, but because they were unusually articulate, revealing more about the group than do most collective statements from that particular group. For example, in 1906 *most* peasant resolutions contained a monomaniacal demand for land and paid little heed to other issues; although long resolutions with complex lists of grievances and desiderata were less common, they do show what the more articulate peasants—and perhaps most peasants, in the long run—desired. In such cases, editorial introductions to each section note this distinction between typicality and articulateness. Finally, I have deliberately preferred documents—especially from 1861 and 1906—that obtained broader publicity through the press; although archival materials are also readily available, the documents that appeared in the contemporary press hold greater historical importance, for they not only expressed but also molded group consciousness and public opinion.

A somewhat different question is the "social authenticity" of a given document—not so much whether it is apocryphal, but whether it really constituted a collective statement. Whenever possible, preference was given to collective statements, at the local or national level,

as directly expressing the opinion of a given group. To be sure, it is possible or even likely that many—even those who signed such documents—neither understood nor endorsed all the provisions of a particular document. And, whether it be a peasant or noble statement, it is fair to assume that only one hand held the pen, even for the educated groups; matters no doubt were more complex for lower status groups, given the low literacy rates. Still, even if the immediate writer put his personal stamp on the document, the fact remains that the group (often unanimously) endorsed the document—and doubtless determined its tone and content. That holds true, too, for the 1906 period, when various political parties—from right to left—tried to mobilize society and enlist particular groups, drafting addresses to them and helping less educated groups to articulate their needs. While there is no point in producing party manifestoes to a particular group, evidence of external influence is not ipso facto grounds for exclusion—not only because that intrusion is itself an important historical datum, but also because the group gave its legal assent (e.g., peasant signatures). Finally, while preference is given to group statements, in some instances I have had to draw upon individual documents—either because the group had no opportunity to express collective demands (e.g., army officers and teachers in the 1860s) or because the group (such as women in 1767) was still only a latent collectivity, with neither the corporate organization nor self-consciousness to issue group statements. At the same time, the inclusion of these explicitly individual statements underscores the developmental process of that group—from latent to active collectivity—and sustains the symmetry of the volume's triadic structure.

Translation is always a process of endless choices and frustrations, but it is especially difficult when the texts are so different in style and sophistication. There was, after all, a world of difference between the elegant prose in a noble supplication and the awkward text from a semiliterate village clerk, hastily drafted at the behest of rebellious peasants and filled with transgressions against orthography, grammar and syntax. While stylistic replication would have something in its favor, here I have tried to present the documents in idiomatic English.[11] Nevertheless, even if through the prism of translation, these documents should bring us face-to-face with life under the ancien régime and—hopefully—will "let the people speak."

NOTES

1. See, for instance, Daniel Field's analysis of peasant documents from Bezdna and Chigirin (*Rebels in the Name of the Tsar* [Boston, 1976]), Victoria Bonnell's collection of worker memoirs (*The Russian Worker: Life and Labor under the Tsarist Regime* [Berkeley, 1983]), or my edition of I. S. Belliustin's memoir (*Description of the Clergy in Rural Russia* [Ithaca, 1985]).

2. Apart from the enormously rich travel literature (of which the works by Haxthausen and Wallace are particularly well-known and accessible, but represent only the peak of the iceberg), a good sense of *byt* (material culture) is to be gleaned from H. Troyat, *Daily Life under the Tsars* (New York, 1961).

3. L. G. Senchakova, "Opublikovannye dokumenty po istorii krest'ianskogo dvizheniia 1905–7 gg.," *Istoriia SSSR*, 1979, no. 2: 68–86.

4. For the 1760s, a valuable set of materials was published by a prerevolutionary historical society (in *Sbornik Imperatorskogo russkogo istoricheskogo obshchestva* [hereafter *SIRIO*]), which provides most of the documents for part one of this volume. For the remaining sections, I have relied chiefly upon Soviet archives and the contemporary press; in a few, relatively rare instances, suitable materials were found in Soviet source publications, chiefly from the relatively open era of the 1920s.

5. The bibliographical reference is provided in the list of sources at the end of this volume. Any deletions are indicated by ellipses and bracketed editorial note; ellipses in the original are noted by the customary *sic*.

6. For a general discussion, see Margarita Mommsen, "Vom Untertanen zum Bürger: Bittschriften und Eingaben im alten und neuen Rußland" (Habilitationsschrift, Universität Bochum, 1984). For more specialized discussions and materials, see: M. M. Bogoslovskii, "Zemskie chelobitnye v drevnei Rusi," *Bogoslovskii vestnik*, 1911, no. 1: 133–50; no. 2: 215–41; no. 3: 403–19; no. 4: 685–96; V. Latkin, *Materialy dlia istorii zemskikh soborov XVII stoletiia* (St. Petersburg, 1884); A. Plavil'shchikov, *Rassuzhdenie o prosheniiakh i zhalobakh* (St. Petersburg, 1811); S. N. Pisarev, *Uchrezhdeniia po priniatiiu i napravleniiu proshenii i zhalob, prinosimykh na Vysochaishee imia 1810–1910 gg.* (St. Petersburg, 1909); N. Karyshev, *Zemskie khodataistva. 1865–1884 gg.* (Moscow, 1900).

7. For a review of the literature and critical analysis of these traditional conceptions of the prerevolutionary social structure, see G. L. Freeze, "The *Soslovie* (Estate) Paradigm and Russian Social History," *American Historical Review*, 91 (Feb. 1986): 11–36.

8. When possible, I assembled a complex of potential sources for any given group at each period and then chose those which seemed most articulate and representative. In some cases, that meant an embarrassment of riches—for example, the clerical cahiers of 1863 or the reports by city commissions

for the same period—and required an examination of vast quantities of archival or printed materials. Although such collections merit a separate study on their own, the documents presented here offer a good sense of what one finds in these materials.

9. Soviet historians and, to a lesser extent, Western scholars have undertaken serious exercises in *istochnikovedenie*—critical, structural analyses of particular source types. For representative Soviet literature on the general problem of collective petitions, see M. E. Sorokin, "O krest'ianskikh prosheniiakh kak istoricheskii istochnik," *Iz istorii Sibiri,* 13 (Tomsk, 1974): 179–84; V. A. Il'inikh, "Krest'ianskie chelobitnye XVIII-pervoi poloviny XIX v. (na materialakh Zapadnoi Sibiri)," *Sibirskoe istochnikovednie i arkheografiia* (Novosibirsk, 1980), pp. 81–92; and E. S. Paina, "Zhaloba pomeshchich'ikh krest'ian v pervoi polovine XIX v. kak istoricheskii istochnik," *Istoriia SSSR,* 1964, no. 6: 110–17.

10. A selective "Bibliography" at the end of this volume provides references to the newest literature, which can serve as a further guide to the basic sources and secondary research on particular groups.

11. Apart from style, specific terminology creates considerable difficulty—because of multiple meanings in English (e.g., "estate" as social estate [*soslovie*] and landed estate [*pomest'e*]), because of misleading equivalents (e.g., *kollegiia* meant, in the eighteenth-century cameralist terminology, administrative bodies, not educational institutions), and because of more recent corruption (e.g., *tovarishch* since the Cold War has a communist ring, even though usage was entirely different in prerevolutionary Russia, finding routine application in official terminology, e.g., *tovarishch ministra* as assistant or deputy minister). However, some terms (e.g., Duma) are given in transliteration if they have already acquired general currency in the field.

Part One

The Catherinean Era

On 14 December 1766, Catherine the Great issued a manifesto summoning her subjects to participate in the preparation of a new Law Code—a step fully consonant with the spirit of enlightened despotism. Although much emphasis is traditionally laid upon the Western principles in her famous "Great Instruction," it is important to note the empress's pragmatic approach—an updating of the outdated law code [*Ulozhenie*] of 1649 through instructions and consultations with various groups and institutions. Thus Catherine directed major institutions (such as the Senate and administrative colleges) and various segments of the population to draft "instructions" [*nakazy*] and to send deputies to a "commission for the preparation of a new draft of the *Ulozhenie,*" conventionally known as the Legislative Commission. Although there were some instances of bureaucratic meddling in the composition of instructions, for the most part the exercise constituted an open-ended poll of opinion on needs and wants. Only "individual" needs, deemed irrelevant to the law-making tasks of the Commission, were specifically excluded from the purview of an instruction. For the historian, this enterprise has bequeathed a rich complex of documents which, largely published before the revolution, have long constituted a major and well-worked historical source on various social groups in the Catherinean era.

But not *all* social groups. For it was only selected strata in society—chiefly those deemed "free" or independent—that received the right to draft instructions and elect deputies. Specifically, that included the nobility, townsmen, certain service groups (such as Cossacks), and those categories of the non-seigniorial peasantry directly subordinate to the government (crown, tributary and sundry groups of state peasants). Other social elements, in theory, were to be represented through an institution (for example, the Synod for clergy or the Military College for officers and soldiers) or, in the case of serfs, through their noble seigniors. Nevertheless, many groups—petty civil servants, factory serfs, "economic" (former church) peasants, parish clergy and some others—had no charge to write instructions yet in some areas did so, as local authorities misunderstood or exploited ambiguities in Catherine's manifesto. Doubtless the greatest exception remained the serfs, who comprised approximately one-half of the rural populace. It was not an accidental oversight: Catherine had no intention of including a group that seemed so uneducated and unreliable in this august assemblage.

The sources presented below are drawn primarily from the collective "instructions" from various social groups to the Commission. It should be obvious that, in an empire as sprawling and diverse as Russia, no single instruction is archetypical; in detail, style and substance they differed greatly within regions and within groups. Nor can one safely assume that a single instruction perfectly mirrors the will of a given group in a given district; the high rate of absenteeism and non-participation, the occasional intrusion of government officials to ensure that the "right" instruction was adopted, the limited but recurrent tendency to plagiarize from neighboring districts—all that casts a shadow upon the "representativity" of these documents. Nevertheless, the instructions do generally reflect local groups and constitute our best source on conditions and attitudes in early modern Russia.

Apart from the information yielded on various groups, the following documents also reveal significant bonds of common interest. Particularly striking is the universal dissatisfaction with administration and justice: nobles, townsmen and peasants all complained bitterly about arbitrariness, procrastination and corruption. Moreover, many groups demanded greater local control and autonomy, primarily to expedite administration and justice, but perhaps also to subvert and temper the demands of central authorities. In particular, the non-

nobles—virtually all of whom bore tax, recruit and service obligations—complained that these were excessive or inequitable, and pleaded that they be reduced or altogether commuted. Their appeal partly reflected real need, but it derived still more from the desire to exploit Catherine's evident insecurity, to take advantage of her self-advertised "maternal" magnanimity, and to satisfy appetites whetted by the emancipation of the nobility from obligatory service in 1762. It is, however, typical of the era that most supplicants rationalized their pleas either by traditional allusions to their total poverty, or by more modern references to the happy coincidence of their request and "state interest." Both the demands and mode of articulation reveal much about the status, culture and expectations of various strata in early Catherinean Russia.

A. NOBILITY

Although many nobles failed to participate in preparing instructions or electing deputies, those who did took full advantage of the opportunity to voice their concerns and aspirations. The instructions varied considerably in length and detail, but for so diverse a group they nonetheless had much in common. Most notably, they rigorously eschewed any hint of political demands; indeed, they sugar-coated all their special requests with obsequious syntax (use of the interrogative conditional: "could it not be"), a diction of abject servility ("most humble slave"), and fatuous praise of the empress. To be sure, the nobles' instructions did urge reform in provincial administration (including corporate noble election of local officials), but carefully limited the request to *local* administration and justified the proposal by referring to the incontrovertible need for improvements in local government and justice. If slow in advancing political claims, the nobles had no such inhibition in other issues and requested a host of special concessions—in particular, restrictions on the ennoblement of commoners, guarantee of the nobles' monopoly on serf ownership, recognition of their commercial and economic interests, and privileges in the production and sale of spirits. Some also urged the government to broaden public services in such areas as roadways and education, but these demands took a distinctly lower priority in their agenda.

The instruction from Moscow (doc. 1), as sycophantic and florid as any, was particularly noteworthy for its enlightened tone, reflected not only in its references to European models but also in its professed—if disingenuous—desire to protect serfs from the hardships of estate division. The Moscow nobles also made a formal distinction between the corporate interests common to the entire rank and those specific to their district, thereby revealing a higher corporate consciousness transcending region and internal stratification. It is also significant that the Moscow nobles—like their provincial brethren—were unabashed to request commercial rights not only for their serfs but also for themselves, with no apparent concern for the derogation that troubled their European peers.

The instruction of Mikhailov District in Riazan province (doc. 2),

less prolix but no less obsequious than that from Moscow, is a fairly representative statement from the provincial nobility. Shorn of references to Europe, concise but comprehensive, it bluntly sought to protect noble privilege—the monopoly in serf ownership, the unrestricted authority to sell and relocate serfs, and the right to market all that their estates produced. Their request for land surveys makes for rather tedious reading, but the issue was obviously one of intense concern for provincial noblemen, provoking endless feuds, litigation and occasional land wars. Like peers in other parts of the empire, the nobles in Mikhailov urged a thorough-going reform in local administration and the election of noble marshals.

The laconic instruction from Kozel'sk District in Kaluga Province (doc. 3) contains not only the customary medley of requests but also an unusually vigorous assertion of corporate rights—above all, the proposal that the nobles elect the district governor [*voevoda*]. Nor were these nobles in Kozel'sk shy in other matters, as they requested the elimination of state duties on their serfs and the return of military recruits to their former squires. But it is important to emphasize how they draped this avarice in a clever appeal to *raison d'état:* approval of their requests would serve "the general welfare" and cause no harm to the state treasury. This line of argument, which recurs frequently in the instructions, was partly a rhetorical device (to dispel any hint of demand), but also constituted a realistic recognition that no private demand was likely to prevail if overtly contrary to state interest. The Kozel'sk instruction also contained an interesting critique of contemporary industrialists and factory-owners, who, though few in number, enjoyed the special protection of the state. Disgruntled over the privilege and influence of these entrepreneurs, the nobles of Kozel'sk sought to have local courts handle disputes involving factory-owners and nobles—doubtlessly because of their confidence that local judges would be more amenable to noble influence.

1. Instruction from the Nobility of Moscow
[1767]

. . . The nobility of Moscow shares, in the same high degree as all true sons of Russia, the ubiquitous and most reverent gratitude to our

most merciful empress for her work and achievements, which arise and grow stronger with each passing day. But it is now Her Majesty's intention to give [our] fatherland a new set of fundamental laws—based upon natural justice, fully consonant with the changes in the circumstances of government and the mores of the different ranks of citizens. [This new deed] will stand as a solid and permanent monument to the wisdom, humanitarianism, and the incomparable glory of Her Imperial Majesty, not only among us and our heirs, but also in the very annals of the entire world. Therefore, with feelings of ecstatic jubilation, the nobility of Moscow deem it their first and sacred duty to fall to Her Majesty's feet and proclaim their unanimous and most reverent gratitude as well as their solemn belief that the entire nobility—from the smallest to greatest—regard the completion of this great enterprise as a blessing for themselves and for future generations. This [undertaking] was obviously inspired in the great soul of Catherine II by divine providence. Thus the nobility of Moscow joins all Her Imperial Majesty's happy and loyal subjects in due praise of Her virtuous, good deeds, and further expresses their most fervent wish and prayer to the Lord that Her Majesty live to a grand old age. Her life will remain forever the period of rejuvenation and enlightenment in our beloved fatherland.

From the foregoing, our deputy can conclude for himself what his first task is to be when he approaches the throne. But as for the presentation of the nobility's needs to the future commission that will draft a new law code, these may be divided into two natural components: those common to the entire Russian nobility and those specific to the district of Moscow. With regard to the latter category, we propose to explain certain disorders and difficulties that we have collectively reviewed and acknowledged. Nevertheless, we have complete confidence in our deputy's well-known zeal and concern for the benefit and welfare of his fellow nobles; inspired by our instructions in these matters and by his own perspicacity, he will not fail at the proper moment to petition the Commission and, as general laws are adopted for the entire state, he will strive in cooperation and collaboration with others toward all which could serve the special benefit of the district of Moscow without harm to others.

With respect to the general needs of the whole Russian nobility, it is to be remembered that the nobility dates back to the earliest times. On the one hand, it is a corps that forms the power, defense and in-

dependence of the state (and hence the firmness of its sovereigns' rule); on the other hand, it entrusts its own privileges and security in the inviolability and steadfastness of the autocrats' power. Hence, in accordance with this natural mutual relationship, the nobility has always left the establishment and preservation of these [prerogatives] to the full discretion and good will of its autocrats. It seems that, finding ourselves now under the good rule of the Great Catherine, we should follow this praiseworthy example of our forefathers and, with full and unbounded confidence, leave all the new statutes and decrees that pertain to the nobility to the wise, perceptive and motherly discretion and judgment of Her Imperial Majesty. Each day her governance is distinguished by new blessings for her subjects and all mankind, and she has undertaken to crown these glorious deeds with the world's greatest deed—the establishment of our own prosperity on firm, solid foundations through laws that are appropriate to new times and mores.

Of course her great spirit, with respect to the essential matters of popular welfare, embraces everything that is necessary, proper and useful for the nobility in the general framework of the state system. Indeed, her spirit by itself is inclined not only to satisfy, but even to surpass the legitimate desires of the nobility. But Her Imperial Majesty, from a surfeit of mercy, designed to issue a published manifesto that each rank of her subjects present their needs for the drafting of a new law code. Hence [we shall comply with this order] for the sake of proper and exact fulfillment of Her Majesty's will, and still more for the sake of our future heirs' everlasting memory of that great, unlimited trust and the sincere loyalty of our forefathers. [These feelings] have been inspired by the monarch's indescribable generosity [as she] instructed them to submit to the throne of their true mother and sovereign all those needs, which they—through agreement among themselves—could only recognize as truly general and essential. [This instruction] does not in the least deal with general state institutions and statutes, which require the collective agreement of various parts of the state administration and the various peoples subordinate to it; nor has it dealt with government finances, which are always to be treated and managed by superior state authorities as the times, circumstances and needs warrant. We empower our deputy to transmit and represent at the time and proper place the following articles which pertain directly to the condition of the nobility, and in a

seemly fashion to petition that these be incorporated into the state laws in harmonious and unified agreement with the general statutes on all the inhabitants of various ranks in our fatherland. [We request:]

1. That the content of the rights and privileges inherent in and proper to the nobility be precisely explained; and that a fundamental law be issued once and for all to determine who may enjoy these rights and privileges and in what manner one may henceforth enter the noble rank through an exercise of the autocrat's authority.

2. That ownership rights to personal, family and acquired properties be precisely defined, and that the law clarify the owners' degree of discretion and authority in bequeathing this property to kinsmen and others by will and testament.

3. That a clear and precise statute regulate the inheritance of the nobility's moveable and immoveable properties that were acquired through inheritance, marriage and contractual purchase; and that it be issued without any supplementary explanatory codicils in order to preclude any misunderstandings, superfluous litigation and perverse interpretation by the courts.

4. That a decree be issued to protect [seigniorial] peasants and to avoid the disputes that so frequently occur among landowners when a populated estate is divided up at inheritance. If it is really impossible to prevent the subdivision of an individual hamlet into separate parts, then at least the divisions of a village by households should not be left to the caprice of the heirs. Rather, the division of households should start on one side of the village and run in orderly rows, while the apportionment of land to heirs should be made according to its worth. But division of individual households should be categorically prohibited.

5. That, in the event a husband and wife are legally separated, a statute should determine the division of personally owned land and also the rearing of any children produced by the marriage. At the same time, a law should also determine guardianship both for minors (up to a specified age) and for anyone else who may require this.

6. That, bearing in mind other well-ordered Christian parts of Europe, each landowner be given the rightful authority to bequeath, at his own discretion, some of his personal real estate and moveable property as indivisible inheritance; that one be empowered to give, to whomever and whatever one wishes and to prescribe the order for

the transmission of this property from one generation to the next. Our earlier law on entailed estates (known as "the articles of 1714") borrowed something from similar models in certain European countries. But that decree did not survive, of course, because it restricted the landowner's will in the narrowest terms, requiring that he give all the immoveable property (the most important property of the Russian nobility) to a single person, to be chosen, admittedly, at the testator's discretion. The present order recognizes three different types of landed property: (a) clan property, acquired by blood lineage from one's parents; (b) property acquired fortuitously from another family branch through marriage or kinship (from childless relatives); and (c) personal property acquired by the landowner himself. It seems both possible and fair (according to natural reason) to establish the special legal right of the owner to dispose of these types of property, as noted above, more or less as he wishes. In that way the true aim and benefits to the state, sought by the decree of 1714, will be attained.

7. That a precise government statute be promulgated once and for all as to who may buy and sell villages and in what manner. The aim is to eliminate and avoid in the future the sales now transacted under various forms and pretexts, without clear rights and legal basis. In addition, the deputy is to make a particular effort (and to petition Her Imperial Majesty for an act of the monarch's generosity and justness) to have the current ten-percent tax on the sale of immoveable property abolished. This has hitherto been a great burden on the property of each citizen and has impeded the circulation of landed estates that is so necessary in a state—especially at the present, joyous time when nobles are moving from their home areas to other regions. May it please Her Imperial Majesty to set aside no more than a tenth of these [new lands to the state] for the benefit of the empire?

8. That, with respect to serfs and other people, it be ordered that these not be dealt with according to current kinship, but be returned to serfowners in accordance with the 1719 poll-tax census (as the law now requires). This will settle the matter once and for all, especially if it is deemed appropriate to destroy the old cadastres to eliminate altogether the basis for any new changes.

9. That a statute of limitations be established in landholding matters. Otherwise, these will forever come up for re-adjudication in the

future, causing confusion in justice and in the property rights of everyone.

10. That the nobility be allowed to sell, wherever they wish, the agricultural products from their estates, to erect and operate factories and manufactories, to engage in domestic and foreign trade (both wholesale and retail), and to undertake every kind of commercial venture, with the stipulation, however, that they bear all the rights and obligations pertaining to the establishment and operation of commercial activity of townspeople's enterprises in the empire. With respect to these needs (which pertain equally to the entire Russian nobility), the true benefit of the fatherland and the establishment of a permanent order make it desirable that new decrees and laws—on each citizen's property rights and inheritance, but also on. the nobility's rights and privileges—be solemnly confirmed by the sovereign's mercy and the sanctity of the imperial word for undeviating, permanent implementation in the future.

It remains here to cite the particular needs of Moscow district, which consists chiefly in the following requests to Her Imperial Majesty:

11. That the district nobility be permitted to elect from their number one or more commissars, who will assume this duty voluntarily, be replaced every year or two, and receive their support from the community. This office would attend to the following: (a) resolve minor disputes between nobles and other inhabitants of the district—e.g., cultivation of land outside one's property boundary, taking trees from someone else's woods, harvesting the grain of others, and taking other people's grass and hay; (2) make an orderly judicial investigation when an act of violence, offense or murder has occurred (together with the nearest inhabitants, and immediately after some incident has occurred or as soon as someone demands it), and to report the findings to appropriate government authorities. This is the most convenient way to reduce the slowness of litigation and to protect the injured party from unnecessary red-tape; (3) accompany troops passing through the district and assign them to quarters. Moreover, he is to see that military people not inflict needless burdens and injury on local inhabitants; if such occurs, he is to report it immediately to the chief commander for corrective action.

12. That the present shortcomings in Moscow district with regard to prosecution and punishment of those squires who reside on their

estates rather than in the towns be eliminated and be corrected in the future. While those residing in towns fall under the authority of the judicial office, the others do not; hence there is nowhere to petition and obtain justice against squires living in rural areas.

13. That, to increase the livestock and fertilization required for agriculture, nobles be permitted to distill spirits and brew beer for personal consumption in any quantity they wish; and that they be able to sell the excess for a set price at a place designated by the state.

14. That the governor be directed, with respect to the maintenance of roads, to expend funds not only on villages along primary roads, but proportionately for the entire district. However, due attention should always be given to the amount of benefit accruing to settlements on the primary roads.

15. That the nobility in Moscow and contiguous central provinces be granted, through imperial mercy, the establishment of two institutions in this capital [Moscow] for the education of noble girls (one for young, another for older girls) and also a cadet corps for young boys. Such an institution has already been established in St. Petersburg and has begun to show its true benefits. As for the capital endowment required to establish and maintain these institutions, the nobility will gladly agree to levy an assessment on themselves (based upon their fixed assets) and, in addition, each year will pay a specific sum for the children enrolled in these institutions.

16. That the Moscow River be dredged to permit the unhindered transit of ships from Kolomna; and, especially, that a canal be built in the area of Marchuga. The requisite capital for this can be raised from an assessment on passing ships and will not constitute a burden.

17. That the regular petty levies still assessed on gentry estates (these will upon occasion be noted during the deliberations of the Commission) no longer be collected, but be completely abolished and annulled; and that the sums so raised be made part of the general state revenues (so that the state treasury, for its part, not suffer a loss) and incorporated in the poll tax—the simplest, purest assessment upon the nobility [through their serfs]. This will avert and eliminate superfluous bureaucratic red-tape and be of particular benefit to rural inhabitants. . . . [A proposal to erect a monument in honor of the empress is deleted—ed.]

2. Instruction from the Nobility of Mikhailov District (Riazan Province) [1767]

Her Imperial Majesty, our magnanimous mother and sovereign, through her wisdom and work has opened the path and unlocked the door to the chapel of true prosperity in life. As the means to raise all her subjects [to this condition] and keep them there forever, she had a manifesto published on the preparation of a draft law code, with the intention that, once confirmed, it will remain permanent and inviolate for all future generations. As loyal subjects with pure hearts, we will construct an altar for her; here will burn an eternal flame of loyalty, zeal and love that will forever inspire our future progeny.

We firmly believe that because of Her Imperial Majesty's amazing perspicacity in human affairs and love for the fatherland (and to her own immortal glory), she will give sacred orders for the drafting of the new law code. According to these rules, a clear and immutable law will be compiled that, for all times and circumstances, will preserve, defend and protect the honor, life and property of sons of the fatherland; extirpate all false denunciations and injustice; protect the weak from oppression by the strong, and the poor from the rich; not suffer the innocent to be condemned as guilty or give legal protection to the guilty. Each will enjoy in reality what is appropriate to his station in society, without infringement. As a result, all the numerous peoples of this vast empire will live in prosperity and tranquillity, just as children live in peace in the home of a good father. Beyond this, so far as our feeble minds can discern, there is nothing further to be desired—save the most humble request that this newly established law be more expeditiously confirmed and reaffirm the hereditary rights of us Russian sons of Her Imperial Majesty (our protectress and mother). We have not the slightest doubt that the new law code being drafted will bring order to justice and punishment and thereby be beneficial to the entire state. But so that, in this memorable moment given by the Lord, particular shortcomings in our own internal order pertaining to the nobility and our peasants

be corrected, with Her Imperial Majesty's permission we make bold to state these and to request most humbly of Her Imperial Majesty the following:

1. [We request] that the nobility permanently have a marshal (with four assistants), to be replaced through biennial elections, on the same basis established as in the imperial manifesto for the election of a marshal and deputies to draft this instruction.

2. This marshal and his assistants should hold court and set penalties for disputes and lawsuits involving nobles, their people and their peasants in all matters (save criminal offenses), in accordance with the new law code, for all petty matters (less than ten rubles) and through oral procedures (recorded, however, in a journal). In significant cases, the judicial process is to be in written documents and subject to appeals as determined by Her Imperial Majesty. The plaintiff must explain everything in his claim; the court is to accept no supplementary depositions; correspondingly, the defendant is not to write more than one statement in reply.

3. When this noble court issues a summons, at the plaintiff's request, for a defendant to appear (or send a legal representative) in a fixed period of time, he will be found guilty if he fails to appear. The only exception is for defendants in state service, who may respond in the original court of venue; the same applies to nobles not in state service. In the event that they do not want the noble court to judge these matters, then either the plaintiff or the defendant may request that the case be decided in the same place as before. If, however, someone does not respond [to a court summons] within the prescribed period, he forfeits the right to a change of venue for his reply to the accusation.

4. If a noble, his servant, or [his] peasant has a dispute with a landowner from a neighboring district, in this case the courts from both districts are to investigate and adjudicate the matter jointly. For this purpose, set aside several days each year for the heads of both districts to meet in one city to resolve such cases.

5. The court is to be in session in the city from 1 November to 1 May. Petitions may be received until 1 February; thereafter absolutely no new petitions for any dispute are to be accepted in order that all petitions be resolved in the same year they are filed. If this [rule] is violated, the marshal and his assistants not only will never be reelected, but also will be held in contempt by their peers. When

new elections are held, the previous officials are to give an account-
ing to local nobles and, if they perform their duties well, will receive
the approbation of the entire community. In addition, [these officials]
are to act as guardians for [orphaned] minors in the district.

6. Since many nobles own villages in several different districts,
as a consequence, not only is no one available to hold office, but
there are also very few nobles to make the selection (to judge from
the number of landowners assembled at the present election). So
that each district henceforth know how many landowners are avail-
able to hold office and participate in elections, could it not most
mercifully be ordered that each noble declare the district in which
he wishes to hold franchise and be eligible for office? Such a regis-
tration of nobles in one district deprives no one of the right to own
villages in other districts and to enjoy privileges equal to others.
This arrangement will enable the nobility, who are dispersed through-
out the state, to constitute a noble community in each district.

7. These district lists of nobles are to be compiled by the marshals
and submitted by their deputies to the Legislative Commission. The
lists are to include the names of those landowners who send written
notification or file in person. For those men whose noble status is
suspect and cannot be clearly demonstrated, the procedure (to avoid
further investigations) is to include in the noble lists all current
landowners whose grandfathers held an officer's rank. If the grand-
father did not hold this rank, put the landowner on separate lists so
that no one not born to noble status may receive this rank without
a patent from the monarch.

8. Hereafter, if a landowner comes to a district by inheriting or
purchasing villages, and if he was not previously registered in an-
other district, and if he did not receive a patent of nobility from
the monarch, then—even if he was a person of high rank—do not
enter his name into the lists of nobility for the district without a
personal decree from Her Imperial Majesty.

9. [We request] that nobles and peasants be permitted to bring
grain (as well as all that grown and produced in the villages) to the
cities and markets to sell wholesale and retail from carts during an
entire trading day. But they are not to have their own shops in
the cities for such sales; nor are they to engage in commerce and be
admitted to ports. The trade in shops and foreign commerce is to
be reserved for merchants.

10. We request that, except for the poll tax, landowners and their serfs henceforth be exempt from the miscellaneous petty levies assessed by government chancelleries in towns—i.e., that they not pay the state assessments on mills, bathhouses, fisheries, and leases on lands and woods. This will free them from bureaucratic red-tape in the towns, and from chancellery messengers in obtaining written receipts for payment. At the same time, so that the treasury suffer no loss in revenues, but always receive the money still more efficiently and fully, set the sum for each tax item so that a landowner who so wishes can pay it all at once. For example, in lieu of the annual one-ruble tax on bathhouses, permit the landowner to pay 17 rubles once and for all. That will form a capital [fund], which the treasury can deposit in a bank and receive 2 kopecks [interest] per ruble. Employ this method to designate sums for other petty assessments so that those who so wish can make a single payment and thereby free their villages from [annual] assessments and the red-tape and inconvenience of dealing each year with government chancelleries. Those who do not wish to make a single payment under this law must follow the old order and make annual payments to the city chancelleries.

11. Nothing is more ruinous in rural life and more pernicious for the development of agriculture and conservation of forests than the intermingling of several squires' land in a single village. To be sure, the general survey is now reducing many of the disputes and lawsuits over land. But the survey will not eliminate the intertwining of strips, for it does not partition villages into their separate units. Consequently, the same difficulties shall persist in the future. To eliminate this evil, we request that when the land in each village or hamlet is surveyed and deeded separately for each landowner, these units (as well whole villages and hamlets) remain forever indivisible. Consequently, after this survey each unit will be transferred—in sales, mortgages, dowry and inheritance—as an entire village. But rectification of this evil may make it difficult to give equal shares of inheritance. For example, someone may have two villages, one with 100 male souls and another with 70, but there are three sons—what then is the third son to receive? Even if there were only two sons, one would receive a third more than the other. We think that this difficulty could be overcome in the following manner: (1) Require each of the present owners, at his own discretion, to designate all

the villages that he wishes to remain indivisible. Each hamlet or village should have not less than four, nor more than one thousand souls (according the most recent census), but be between these two limits. Each [settlement], together with the accompanying land and resources, should be surveyed for future transfer as indivisible property. (2) Each owner should designate a special value for each of the villages that have been so surveyed and measured (according to its resources); (3) If the landowner has two villages, as noted above, one with 100 souls and another with 70 souls, the former is worth 5,000 rubles and the other 4,000 rubles. Hence the capital in these villages equals 9,000 rubles. If there are three sons, each will receive 3,000 rubles. The first son, who receives the village with 100 serfs that his father valued at 5,000 rubles, will pay the third son 2,000 rubles; the second son, receiving the estate with 70 souls and appraised at 4,000 rubles, is to pay the third son 1,000 rubles. Consequently, the heirs will receive equal shares. (4) This will give rise to a further difficulty: where are the first and second sons, without selling or mortgaging their estates, to obtain the money to pay the third son? Solve this by having the first two pay the third brother interest on the 3,000 rubles; the brother who receives this income is to be in state service and to find his happiness there. The noble court is to ensure that the interest is paid punctually.

12. It is quite essential to encourage peasants engaged in agriculture so that they are better able to reside permanently in their villages. Then, without sparing their means or labor, they could fertilize their land more zealously and diligently, develop and conserve their forests, and expand all their home construction on a secure basis. To do this, the landowner of a surveyed, indivisible hamlet or village should not sell peasants without land. If the peasants in a certain village or hamlet increase such that those bearing dues lack sufficient land, then the owner may transfer them to another district—to a hereditary village or to land that he has purchased. He may even sell them to another estate, but only in the same district (so that the peasants involved be near to their kinsmen). But the owner does have the authority to transfer peasants from one village to another within the same district. As for peasants who neglect agriculture or indulge in other vices, the landowner should retain the right to send them into exile with credit [toward his recruit obligation], as fixed in current law.

13. If the noble court is most mercifully established, could it not be empowered to deal with people who are not legally permitted to own villages and serfs? These illegal owners ruin many villages that are presently under their control, for—as temporary owners— they are aware that their ownership of serfs is just transitory and make no attempt to take care of them. But when these have been deprived of their servants and peasants, they will be forced to hire free people, for they cannot live without servants. But freely hired labor is unavailable; the only exception is state peasants, many of whom have abandoned agriculture and support themselves in the towns by engaging in various trades and hiring themselves out. When these people of various non-noble ranks [*raznochintsy*] have lost their servants and are forced to induce such peasants to abandon agriculture and work for them, there will be a decline of many agricultural producers and an increase in consumers. Agriculture, as a result, will decline. So that these non-nobles have no need to lure people away from agriculture to work for them, they should be provided with labor in the following manner: people of every rank should be allowed to purchase abroad people of every foreign confession, except Christians. This is limited by the following: if the purchased foreigner is more than 15 years old, he is bonded to his master for no more than twenty years from date of purchase; if younger than 15, his indenture is 30 years from date of purchase. After this term has elapsed, he may serve as a free man wherever and for whomever he wishes. It seems that in this way the non-nobles, having been provided with labor, will not need to reduce the number of agriculturalists through the enticement of large payments.

14. If the request in point 11 is most mercifully approved, then we most humbly request that, in order to obtain the desired survey more quickly, a surveyor be commissioned at our expense.

15. If our nobility encounters any general need in the future, we most humbly request that we be mercifully permitted to submit a representation wherever deemed appropriate.

3. Instruction from the Nobility of Kozel'sk District (Kaluga Province) [1767]

. . . 1. From past times up to the present, the Governing Senate has appointed district governors [*voevody*] to [serve in] towns. Given the large number of people appointed as district governors, however, the Governing Senate cannot possibly know the personal traits that are necessary for this office. So could not the nobility of that town [and district] be permitted to select the district governor from their own ranks? The election could follow the same procedure prescribed in Her Imperial Majesty's manifesto of 14 December 1766 for the selection of a marshal and a deputy to the Legislative Commission. . . .

2. State forests, administered by the Tula Armaments Chancellery and scattered amidst private woods, are put in the care of seignioral peasants, who endure great ruin and intolerable corporal punishment in judicial offices for accidentally taking timber. There are also many reprimands from state foresters (especially from those who are constantly drunk), as if they were the serfs' commanders: they declare every stump a felled tree and deem it a case of illegal timbering. But it is hardly possible for the serf to guard an area so vast that a musket shot is not audible from one end to the other; how then can the sound of an axe be heard? Besides, the peasant has to cultivate and harvest grain, pay state taxes, and provide labor and goods for the squire. To spare the squires such trouble when their serfs are taken away to be prosecuted by the government, could it not be ordered that the serfs be exempted from this guard duty? . . .

3. With respect to the form of judicial procedure (which is presently an oral proceeding before an official desk), could it not be ordered that this court proceeding be in writing and conducted thus: once the defendant has received the plaintiff's petition, he has eight days in which to respond? A copy of his reply is sent to the plaintiff, who also has eight days in which to respond and to supply evidence; and so on until the case is finished. As for legal notes and other devices used in judicial matters, reaffirm that these be sent promptly, without delays and within a specified period of time. The virtue of this [proposal] derives from the fact that the state does not have as

many lawyers as are needed; those available are in exceedingly short supply, and not all of them are men of integrity. Under the circumstances, [if the court procedure] is written, each can handle judicial matters himself.

4. In minor towns of a province, no legal contracts of any variety may exceed a value of 100 rubles; those exceeding that value must be drawn up [and notarized] in a provincial capital. But, for a variety of reasons (in particular, infirmity of health), some people cannot travel to the provincial capital. Could not such documents be made in district towns as well as provincial capitals? This will not harm the treasury and will make things easier for society. In addition, illiterate people sometimes wish to transact sales; in this case such sellers should be questioned either at the Estates College [Bureau] or [elsewhere] according to a decree from that office. In this event could not matters be alleviated for poor people by conducting this formal inquiry in the cities at the time of the sale and without any delay (when the documents are signed in the Estates College)? This will be a significant amelioration for poor people.

5. All complaints of injury and damage against owners of ironworks and various factories are adjudicated by the state colleges [bureaux] for mining and manufacturing. Some have been granted special privileges and are not liable to adjudication in those colleges. They sometimes cause damages to nobles who reside in the same districts and near their plants and factories; however, because of the distance from the above colleges [in St. Petersburg] or lack of means, the injured parties cannot bring legal action. Hence, with respect to our petitions on damages by factory and plant owners, could not the adjudication be held in those cities where the factories and plants are located?

6. Some retired soldiers (i.e., those permanently released from active service) suffer want of support, while others have adequate support but are a source of disorder and burden to society because of their bad morals. Could not these soldiers, instead of retirement, be returned to their former domicile, where they can live with their family, wives and children, or with their mothers and fathers? Their children (both those born before the father's induction and those born after his return home) should be regular seignioral serfs. The benefit here is a reduction in the number of idle vagrants in the state. Moreover, because they will be included in the poll-tax registry, they

will bring benefit as peasants, from whom poll taxes, recruits and all kinds of state levies can be collected.

7. The establishment of an appeals system is most useful for securing one's rights. When an honest person is wrongly accused at a court of the first instance, he can sometimes suffer ruin from a false denunciation. When the accuser sees that he will be found in the wrong by the law, he dreams up all kinds of delays and files an appeal to ruin his adversary. When that does not succeed, he appeals somewhere else, even going as far as the Senate; by shifting the case about, he seeks every chance (even illegally) to evade his guilt. Could not an extremely heavy fine be imposed upon such false accusers? To wit: when such people are found guilty [of false denunciations] at the province level, assess double the fine; at the higher regional [*guberniia*] level, triple the fine; at the Judicial College, one half of his estate; at the Senate, confiscate the entire estate and deprive the false accuser of noble status (or, for a non-noble, his honorable occupation). Such expulsions will rid society of a great burden, and this craft [of making false accusations] will gradually lose its teachers and completely disappear.

8. With respect to public health, we who live in rural districts have no protection whatsoever. Therefore could not an adequate apothecary and a physician [*lekar'*] be established in each district town? Because Kozel'sk District encompasses an extensive territory and has a large number of inhabitants, it is necessary to appoint two physicians here. One should be responsible for the apothecary and be given a state salary; the other would receive a salary from the nobility. The two will manage the medical practice jointly: the one in charge of the apothecary will visit the sick close to town, the other attending to remote areas. Establishment of the apothecary and appointment of physicians will not harm the state treasury, for the medicine will be sold for money, thereby yielding a profit. This profit will pay the salary of the physician responsible for the apothecary, while the salary of the other will be paid by nobles residing in the district. [A final paragraph, proposing to erect a monument in honor of the Empress, is omitted here.]

B. BUREAUCRACY
 AND ARMY

The civil and military service underwent enormous changes in the eighteenth century—in structure, size, composition and function—to keep pace with the development of state's expanding role, at home and abroad. The civil service, a chaotic conglomeration of offices and scribes in seventeenth-century Muscovy, gradually became a formalized hierarchy with a steadily expanding body of central and provincial officials. It was an extraordinarily diverse population, especially at the lower echelon, which recruited heavily from various non-noble strata of the population; that many such *parvenus* eventually rose in the Table of Ranks and achieved noble status was an issue of acute concern to established noble families, as the instruction from Mikhailov (doc. 2 above) indicates. Although the Senate's instruction nominally spoke on behalf of the civil service, and most civil servants had no chance to compile their own instructions, in a few towns petty officials did add their own sections to the collective instruction from the city. As that from Veneva (doc. 4) shows, they complained primarily about their inadequate material support, aspired to quasi-noble privileges (including the right to purchase serfs), and solicited pensions for their retirement. It is a relatively short list of wants, but plainly identifies the reference group—nobility—to which they looked.

The army had very uneven opportunities to express its grievances and wants. In general, the Military College—like other central institutions—filed the main instruction and bluntly directed its deputy to defend its special interests. But the rank-and-file officer corps, not to say regular soldiers, had no opportunity to draft instructions; unlike urban scribes and urban priests, they plainly did not belong to the city's community and hence could not tack on their "instructions" to the general statement from the city. But there were exceptions. The most important were the various paramilitary communities like Cossacks, who still enjoyed special rights and stood distinctly apart

from the regular army; as the statement from the Cossacks of Novorossiia (doc. 5) makes abundantly clear, these communities were under mounting pressure for integration into the regular army and suffering a steady erosion of their traditional rights and privileges. Little wonder that a few years hence the Cossacks would be a main driving force in the Pugachev Rebellion of 1773–75. Another group which drafted instructions were retired military personnel, who had left active service and provided a prime source of the flotsam drifting about in eighteenth-century Russia. As the statement from former military servitors (doc. 6) shows, they had no clear function or status and requested a pension for their support. Although the government gradually introduced pensions over the next century and a half, it did this so slowly and niggardly that post-service support would remain one of the major weaknesses and grievances for civil and military servitors alike.

4. Instruction from Civil Servants in Veneva (Moscow Province) [1767]

1. The budget for district chancelleries allots the clerical staff the following annual salaries: 60 rubles for chancellerists, 40 rubles for assistant chancellerists, and 30 rubles for copyists. But such a salary does not suffice for the most elementary needs of the man himself (let alone a wife, children and household) and leaves him in dire straits, especially as he is constantly being detained at the office day and night to perform his duties, resulting in total exhaustion. Some clerks do not have their own homes, but live in rented apartments, which are legally exempt from billeting [and cannot be assigned to civil servants gratis]. Under the circumstances, we most humbly ask Her Imperial Majesty that, out of her maternal compassion, she increase our salaries so that the chancellery clerks be able to support themselves in all decency and cleanliness.

2. Her Imperial Majesty's laws prohibit chancellery clerks who do not have noble status and attendant rights to purchase and keep either house serfs or populated estates. As a result, these employees suffer great want because of the following circumstance: constantly

at work in their chancelleries (as explained above), and sometimes sent to other places on official business, they have no one in their homes to attend to various domestic needs and to look after their residences. The salary, as set in the budget, does not suffice to hire servants. We most humbly request that Her Imperial Majesty authorize us to purchase house-serfs, in whatever number [deemed] allowable.

3. Chancellery clerks in Veneva receive a salary and support so long as they are still in service. But once they retire from service because of old age or infirmity, they have no support (for they have neither serfs nor land) and are obliged to go about in their old age and beg for charity. They share the plight of retired soldiers, who live in the towns but have no source of support. Therefore we most humbly request Her Imperial Majesty to set a monetary salary for them after their retirement from service (in whatever amount Her Imperial Majesty, out of compassion, deigns to set).

4. When troops are quartered in towns, the hosts are obliged to provide firewood and candles in accordance with regimental instructions. But neither those in service (given their salaries) nor those in retirement are able to provide the firewood and candles. We most humbly request that Her Imperial Majesty free us from this quartering obligation.

5. A private bathhouse is forbidden unless an assessment is paid. We most humbly request Her Imperial Majesty to exempt us from this levy, because our allotted salary is insufficient and hardly provides our sustenance.

5. *Instruction from the Cossacks*
 of Novorossiia
 [1767]

1. When Little Russia [Ukraine] was joined to the realm of Your Imperial Majesty's forefathers, our ancestors (who were long-term residents here) held lands and estates along both sides of the Dnepr that they had possessed uninterruptedly for ages and that were confirmed by charters and decrees. A decree was issued on 12 March 1765 (signed by You personally) that Lt.-Gen. Von Brandt dissemi-

nated to all places in the region of Novorossiia; it graciously encouraged us to hope that all the lands, resources, liberties and other things that we have traditionally enjoyed will forever remain ours. Hence certain in [our claim] to these lands, which we had acquired from one another through sale and purchase of land that has hitherto been our inalienable possession, we servilely request that the claim be confirmed.

2. Once the inhabitants of this hamlet and the entire district completely became part of the Novorossiia region, our superiors issued strict rules that, because of need, the poor not only may not sell their land to anyone, but also may not take any timber from their own woods for essential needs without the commander's written consent. As a result, we have suffered from want and uncertainty.

3. When some of our forefathers died from plague or were captured during the Turkish invasions, they left land and properties on the Dnepr Basin and on the steppes. The commanders neither gave this property to their families nor divided it equally among the residents, but greedily proclaimed it "unoccupied" and held it illegally until the settlement of other servitors. The latter, informed of the existence of this land, requested that it be confirmed as unsettled so that some of this land has already been given to [other] landowners, some has been illegally seized or (upon confiscation from the owners) had been declared to be the state property of Your Imperial Majesty. This oppression has caused the people to be deprived of their livestock and agriculture. As [Your] slaves, we request that you free us from this oppression and order that the lands and islands (both those nearby and at some remove) be divided among those serving in this company and performing obligations for Your Imperial Majesty.

4. Courts have now been established that deviate from prior custom. With respect to land, it is necessary to file suit at the provincial capital and pay a fee for every minor matter. Hence a poor person is more likely to give up rather than go off to file suit in a place which is so far away and in which one has difficulty providing for himself.

5. In the great passion against Ukrainian autonomy, new assessments have been established for spirits and distillates (2.75 rubles per barrel or 18 kopecks per pale), 50 kopecks from watermills, 25 kopecks from windmills, 10 kopecks from the sale and exchange

of horses (5 kopecks for cattle), in addition to the regular assess-
ment of 50 kopecks per ration. The entire population is assessed the
freeman's tax [*chinshevyi oklad*], according to their property. In ad-
dition, each month people of both sexes are recorded on lists, and
that arouses the greatest fear among us that, contrary to tradition,
we will be put in the poll-tax registry and conscription levies.

6. Both in this village and elsewhere in Little Russia, from for-
mer times the lowliest Cossack was called a nobleman but this has
undergone a great change at the present time.

7. At one time the people in this area took care of their needs
through trade with the Crimea in salt, wines and other products, or
through various forms of internal commerce. For this they paid only
Your Imperial Majesty's border duties and no additional assessments.
But various assessments have now been established for trade by Za-
porozhets troops in the towns of various Russian service people, and
[our] people are completely losing the capacity to engage in this
trade and are being deprived of their livelihood.

6. Instruction from Retired Soldiers in Krasnoufimsk (Perm Province) [10 March 1767]

We reside and support ourselves in this suburb by means of agri-
culture. But for this agriculture no arable land, hayland and con-
struction timber have been set aside for us at this suburb. So we have
not only a general want but also shortage of [support]. Hence we give
you this instruction for submission to the city's deputy so that he can
present it at the proper place. 10 March 1767.

C. THE ORTHODOX CLERGY

The half century preceding Catherine's Commission had brought a serious erosion in the status and wealth of the Orthodox Church and clergy. Though still the official confession and still an institution of formidable power, the Church had suffered major incursions—replacement of the patriarchate by a collegial Synod (1721), secularization of church lands and peasants (1764), and a gradual intrusion of state authority over the clergy and even religious practice. That does not mean, however, that the Church had been transformed into merely another arm of the state, and the instruction from the Synod (doc. 7) reveals a tenacious effort to defend ecclesiastical prerogative and privilege. In unambiguous terms, the Synod demanded explicit confirmation of traditional ecclesiastical rights, canon law and clerical interests; it specifically requested equivalency with the Senate (supreme organ in the "secular domain"), vigorous persecution of apostates by state authorities, and various other measures to bolster ecclesiastical authority. The Synod also attempted to reverse a number of government encroachments—for example, in the free recruitment of monks and parish clergy from any social category; it is noteworthy, however, that the Synod felt obliged to demonstrate that the change would in no way injure state interests. Moreover, the Synod attempted to represent the interests of parish clergy—for instance, in its proposals that various state duties be abrogated, that auxiliary economic support be found for them, that they be allowed to purchase serfs, and that higher penalties be imposed for injury to clerical honor. The Synod also gave considerable attention to the problem of clerical appointment and, though implicitly recognizing the parish's right to select clergymen in most cases, upheld the bishop's authority to impose the appointment of the few educated ordinands then available. In sections of the Synod instruction omitted here, these ranking churchmen also devoted considerable attention to the quality of religious life (e.g., measures to combat superstition) and clarification of church law on marriage and divorce.

Despite Catherine's decision not to invite instructions from parish clergy, some in fact did so: like chancellery clerks and miscellaneous townsmen, clergy in some towns attached their demands to the urban instructions. A laconic statement by the clergy in Vereia (doc. 8) registered their acute concern about the Old Belief or schism, no doubt intensified by the waxing tolerance of the secular state. The result, as the Vereia instruction suggests, was not only to cause the schism to increase, but to embolden its adherents and, ultimately, to undermine the financial support of parish churches and their clergy. The final document presented here, a group petition to the Synod in 1773 (doc. 9), expresses the undercurrent of tension between the lower parish clergy and ranking prelates that, in time, would become one of the most powerful dynamics in the subsequent development of the Church. Curiously, their request—that they be allowed to elect a local supervisor—was a direct reversion to the system of elected "priestly elders" [*popovskie starosty*], which had only recently given way to appointed superintendents. As the petition shows, the parish clergy felt alienation and dread for their bishop, but had sufficient audacity to appeal—as many routinely did—to central authorities to temper the will of a local prelate.

7. *Instruction from the Holy Synod*
 [1767]

In accordance with the power and authority conferred by the Holy Synod, [its deputy] is to present to Her Imperial Majesty at the discussions of the impending Legislation Commission our most humble request:

1. That the Most Holy, Governing Synod be confirmed on the same foundations and in all respects as established under the blessed, memorable Peter the Great; and that it hold equal status with the Senate.

2. That, in general, all the canons and laws of the Holy Apostles and Church Councils pertaining to ecclesiastical administration and accepted by our Church remain in full force (through confirmation by Her Imperial Majesty).

3. That the civil laws pertaining to church canons included in our

Nomocanon [a codex of medieval church law], which were established in early times by the pious Greek emperors, be presented to Her Imperial Majesty for confirmation or that Her Majesty issue a special decree on this. Other points of these civic laws which pertain solely to secular affairs are left to the disposition of laymen.

4. That all Orthodox Christians live in unhypocritical fear of the Lord, go to church on Sundays, holidays and imperial holidays, heed the teaching of their pastors, avoid all superstition and idleness, and (as the Christian duty requires) each year make confession and partake of communion. As something fundamental for Christians, the foregoing was confirmed both by the *Ulozhenie* [of 1649] and previous laws, as well as by the specific articles in a joint conference of the Synod and Senate in 1755. For the impending discussion of these matters, add the following: would it not be wise, as support for the clergy, to have lay [officials] supervise compliance here? If anyone is found to neglect these duties, should he not be fined (according to his status), so that others will see and behave properly? At the same time, priests who do not exercise proper control and file false reports on failure to confess and communicate are to receive, without exception, punishment from diocesan authorities. However, there should be no duress from laymen to make false reports on confession and communion; demand an appropriate discussion and reaffirmation in this respect.

5. It appears proper to order that all laymen, regardless of rank, be forbidden to hold debates at large gatherings, whether in jest or earnest, [on the following]: God and His omnipotence; the Holy Trinity; Christ the Saviour; the Holy Scriptures; and all that pertains to reverence of God. The only exception will be respectable discussions in a recent place. For it is such indecent conduct, especially from inflamed arguments, that generate many wild interpretations harmful to conscience and piety, pervert and lead astray the unintelligent, and result in denunciations and investigations that cause these people to endure many great misfortunes.

6. That those who abjure Orthodoxy, or cause others to do so, not be left without the appropriate punishment, as prescribed by past and current law.

7. That, given the reduction in monetary fines for missing confession and communion, people be restrained from this offence by incarceration on bread-and-water rations as well as by the fines set

in 1763. Would it not be wise to order that such people be forbidden to give sworn testimony and receive civil service rank, and that they be excluded from the society of honest people? . . .

ON BISHOPS

1. Bishops are to do everything that they vowed at their oath of consecration and that is prescribed by the Ecclesiastical Regulation [of 1721–22]. Nor (in accordance with canon law) are they, on their own authority, to petition Her Imperial Majesty under any conditions or to enter into any secular matters that do not pertain to the holy church. They are also forbidden to leave their diocese without permission from their superiors.

2. With respect to spiritual matters in their competence, bishops are not to send laymen into exile or to incarcerate them in monasteries on their own authority. But if an investigation shows someone guilty of an offense and deserving of some punishment, he is to be sent to civil authorities. Still less are bishops to subject anyone to excommunication and anathema (even if such punishment is warranted), without first presenting [the case] to the Synod (in accordance with the Ecclesiastical Regulation), which must obtain the consent of the Governing Senate. However, temporary exclusion from entering the church is left to the discretion of the bishop.

3. Ecclesiastical cases pertaining to laymen (in various issues) should not follow the judicial procedures established, for this is exceedingly inconvenient for both the bishops and their consistories.

ON THE PARISH CLERGY

1. The secular priests, deacons and sacristans, as well as seminarians, are to be chosen and appointed to cathedrals and churches by the diocesan bishops. In the case of parish churches in cities and those with benefices, the bishop is to appoint those candidates who have studied in the seminary—even if not requested by the parishioners. If no worthy candidate from the seminarians is available, then the parishioners make the choice themselves, but on condition that they testify to his worthiness (in accordance with the church canons). The diocesan bishops are to be diligent in overseeing this matter and

assuring that the candidate for priest be at least 30 years old, deacons 25, and subdeacons 20.

2. Permit laymen of any rank, if they wish and are worthy, to enter the clergy. Not only should people not disparage this rank, but they should deem it a great honor. Therefore, if anyone from the merchant or the poll-tax population is worthy and has the necessary written release [from his master or community] and wishes to enter the clergy, he is to be accepted and installed. The state treasury will be compensated for the lost poll-tax revenues by the expulsion of uneducated and corrupt people from the parish clergy. If parishioners nominate an uneducated candidate who is unworthy and do not seek one who is, in this case the bishop can appoint—at his own discretion and without their request—someone worthy of the position.

3. [We request] that, in accordance with the imperial decree of 1724, young priests and deacons who become widowers and remarry not be regarded as tainted and, if they wish, be allowed to enter the civil or military service (wherever they are qualified). Offenses they committed in the clergy should be disregarded; they should be appointed and promoted according to their merit and achievements and hence not be treated differently. In that way they will be more zealous in performing service.

4. Clergy are not to become involved in secular affairs or serve as guardians or still less as solicitors. Nor are they to hold power of attorney. Contrariwise, they are not to be summoned to civil courts (except for those affairs which they themselves have instigated or which involve important criminal offenses and bootlegging). In such cases, observe earlier laws which placed the clergy wholly under the jurisdiction of the Synod and diocesan bishops.

5. Set a precise number of priests, deacons and sacristans and indicate how many of each [rank] are to be at each church. Although until now some clerics have been left without positions, under no circumstances are laymen to support in their homes, without the bishop's consent, either these [surplus clergy] or those who have abandoned their church without authorization. If such are found, levy a fine according to old or new laws.

6. White clergy who have been stripped of their rank for misconduct—as well as self-ordained priests and self-tonsured monks, and also vagrants, unemployed and people of suspicious character—

are first to be punished according to the clerical rank they allegedly hold, and then sent to the state. The self-ordained are to be sent into hard labor for the rest of their lives; the other younger ones are to be conscripted into the army, and the others unfit [for the army] are to be dispatched to remote settlements.

7. Although the statute of the Imperial Commission on Church Estates and Revenues and a personal imperial decree authorize the tonsure of people of both sexes to vacant positions in monasteries (on the same terms as described in the Ecclesiastical Regulation), nevertheless ask that this [principle] be forever confirmed by Her Imperial Majesty in the new law code.

ON CLERICAL PRIVILEGES

1. Although billeting in the clergy's homes is not prescribed in previous law, diocesan reports nevertheless make clear that in some places such quartering (as well as the public services and bridge construction) is imposed on the parish clergy and also on the lay employees of monasteries and diocesan institutions. Given their inadequate salaries and straitened circumstances, it is necessary to lighten this burden. The roadways in front of clerical homes should be paved for them; if the police refuse to allow this, then pay for this service from church funds. Where the church lacks such funds, the cost should be borne by all the members of that parish.

2. The Ecclesiastical Regulation enjoined the Synod and Senate to deliberate on ways to provide adequate support for all members of the clergy, and thereby to elminate simony; an imperial decree of Her Imperial Majesty in 1765 did designate the amount the clergy may receive for each rite. But many of the clergy in cities do not receive sufficient support from their parishioners and provide for themselves only with the greatest of difficulty. In rural areas, the clergy support themselves mainly through agriculture and hence are occupied less with the duties of their office than with cultivating their fields. And that is also a great obstacle to the appointment of candidates with formal education to rural parishes. Therefore we request that some method be found to support the clergy in a way that is both sufficient and seemly for their rank.

3. That the clergy be permitted to purchase male and female

servants, but with definite limits (so that they not have excess servants).

4. That appropriate legislation be adopted to handle verbal and physical injury to bishops and other ecclesiastical authorities, but especially the assault and maiming of archpriests and other members of the parish clergy (including their wives and children). . . .

8. Instruction from Parish Clergy in Vereia (Moscow Province) [1767]

1. With each passing hour, the holy churches in the town of Vereia are falling into ever greater destitution and deprivation, and with time could be completely abandoned. This could happen not only because of a large number of the town's wealthy merchants registered as schismatics [Old Believers], but also because many Christians who still belong to the Church are following schismatic teachings and dissipation. Thus they have begun to abandon all Christian piety and to shun the divine churches (which were constructed solely for the people to assemble in order to pray and praise the Lord) with such repugnance that the churches are often empty during the services. As a result, the individual church has not had an increase in its income or generous donations from any quarter, and has already begun to experience shortages and needs for liturgical books and all kinds of church utensils. Likewise, it is necessary to renovate the church for the sake of good appearances, or to repair things that are dilapidated; the lack of church collections means that there is absolutely no way to do this.

2. For the same reason, the priests and parish staffs in these city churches have become impoverished and suffer hardship and penury in all their needs. Nor do they have hope to provide for themselves and their families in the future, for a large part of the Vereia merchants, to the degree they have become estranged from the divine churches, have also become hostile, unfeeling and obdurate in their relations with the parish clergy. All the parish clergy (especially those appointed to parish churches without arable land) will—in the

course of a few years time—be forced by impoverishment either to declare themselves beggars or to leave the divine churches without services. Completely convinced of this, the priests and parish staffs in this town most humbly ask Her Imperial Majesty to use Her authority to order that the piety of Christian faith and good condition of holy churches in Vereia (which have been destroyed) be restored and inalterably reaffirmed, and that a merciful order be issued for a seemly system of material support for the entire parish staff.

9. *Petition from Parish Clergy in Saratov*
 29 October 1773

The presiding members of the consistory in Astrakhan [which included Saratov in its domain] and the district board in Saratov, together with their subordinates (such as clerks and couriers), commit various abuses and oppress us. But we lack the courage to complain to His Grace, Bishop Mefodii, about [his] failure to defend us. Hence, for the purpose of defending us, we have now elected as our deputy the priest Fedor Iakovlev (from the Church of Our Lady of Kazan, located in the city of Saratov), whose merits and constant sobriety qualify him to perform this duty properly.

We therefore request Your Graces [in the Synod] to accept our petition and to appoint the priest Fedor Iakovlev to occupy the above office on the basis of our approval and his merits, and to notify him of his appointment and to apprise our bishop, Mefodii, of this. We request a merciful consideration of this [petition].

D. PROFESSIONS AND EDUCATED ELITES

By the 1760s Russia had only begun to create what would later become the "free professions"—the educated, white-collar groups of teachers, lawyers, engineers, academics and sundry parts of the cultural intelligentsia. Depite the efforts by Peter the Great to establish various schools, it would take many decades before the empire began to construct a more complex system of advanced and specialized educational institutions. Indeed, as a student declaration (doc. 10) from Moscow University reveals, the first generations regarded themselves not as a disaffected educated elite but as civil servants and sought a commensurate salary. And, significantly, Moscow University—not established until 1755—had so little prestige that neither the institution nor its subordinate population was invited to send an instruction or deputy to the Legislative Commission. And for many other future professions, such as lawyers and teachers, institutions as yet were altogether lacking.

But two professional groups—government academics and doctors—did develop more quickly and, through their responsible state offices, expressed their collective interests to the Legislative Commission. Thus the educated elite at the Academy of Science self-consciously endeavored to express the views of Russia's nascent intelligentsia; the Academy's instruction (doc. 11) dealt not with narrow institutional interests, but addressed broader issues—citing the acute need for more schools, comparing Russia disadvantageously to European powers, demanding strict measures against bogus foreign tutors, and proposing steps to improve the commercial viability and censorship of publication. Similarly, the empire's minuscule population of doctors expressed professional demands through the Medical College (doc. 12), which, though nominally a cog in the central bureaucracy, in fact functioned as the profession's legal lobbyist in St. Petersburg. Its demands—for example, for salaries, an increase in apothecaries, and elimination of unqualified medical practitioners—served at once

the needs of medical progress and the vested interests of this social group.

10. Petition from Moscow University
Students to Faculty Board
15 December 1767

Eight years have passed since we began our studies of the liberal arts, and the degree of success that we [previously] achieved in Kazan and here is well known to You, Most August Assembly, insofar as you gave us examinations and officially bestowed on us the title of "student." In consideration of this, we most humbly request that you grant us a university salary from the government (to replace the students who have already separated from the university). For your favor in this, and with the most profound respect requesting your indulgence, we students remain Your Excellencies' sincerest admirers.

11. Instruction from the Academy of Sciences
24 August 1767

1. The deputy is to attend to the benefits that derive from learning, especially as described below.

2. It is highly essential that the Academy make representations about its own needs. However, a new charter is being prepared [for the Academy] at the order of our most merciful autocrat, and if Her Imperial Majesty deigns to give her approval, then unquestionably there is hope that it will eradicate and prevent these deficiencies. Therefore it remains only to speak of the benefit that ensues in general from learning; the Academy deems itself especially obliged to do this since this is the sole learned institution to send a deputy [to the Legislative Commission].

3. If learning is to flourish in the state, it is necessary to establish schools. The main division of these is considered to be gymnasia (or lower schools) and universities (or higher schools); this does not

include the primary schools in almost every village parish and all cities. Lower schools are of various types, but need not be described here in detail; it will suffice to indicate the main division of school. One begins the study of scholarly subjects in lower schools and completes these in higher schools. It is therefore self-evident that a state needs both kinds of schools, that higher schools cannot exist without lower ones, and that lower schools without higher ones cannot yield the anticipated benefits from learning. The educational institutions established in Russia have not up to now produced the kind of benefits that foreign countries enjoy from theirs. Apart from other causes, one of the more important is the poor organization of schools [in Russia]. And they are so few in number that of course our youth is unable to study in them. Therefore, to improve the education of Russian youth, efforts must be made to improve the existing schools and to increase them to a sufficient number (which could probably be determined on the basis of the present condition of the Russian state). The Academy would not hesitate to give its opinion on this question in its instruction if it had at least six months to compile a paper on a matter so important to the state. Although it lacks the time to do this now, and in order to give this matter over to mature reflection and not haphazard treatment, it will nevertheless be able in time to express itself before the Commission and promises to devote all its labor and effort to the most expeditious possible preparation of this work, which will show clearly where and how to establish the schools.

4. Foreign tutors who instruct our youth at home bring, of course, more harm than benefit, for the overwhelming majority of those who come here are not good but unfit. That was already noted in the previous reign when a personal decree of the empress prohibited the employment of any tutors in the future without certification by the Academy in St. Petersburg or the University in Moscow and ordered that those already here appear at the University in Moscow and the Academy in St. Petersburg to obtain their certification. But the decree remained virtually unimplemented, and thus far the ensuing abuses have not in the least diminished, if indeed they have not increased. The Academy believes that an end will be put to abuses if the aforementioned imperial decree is strictly implemented; unqualified people who came uninvited will be forced to return home at their own expense or find some other work. As to what should be done

with those who are brought against their will and those who are brought or come at someone's request, but prove unworthy to hold the rank of teacher and do not wish to take up another occupation in Russia, this is an issue that should be left to the judgment of the Commission. In addition, immigrant tutors (as everyone knows) have a major role in moral upbringing and sometimes have full responsibility for raising many children, at the will of their fathers and relatives. Women and young ladies, in addition, have the privilege of teaching and rearing our youth without formal certification of their own conduct, and in fact many are not only of bad, but even disreputable behavior. Therefore the Academy finds it useful to require that immigrant male and female teachers have reliable certification of their conduct and submit this for examination. Both those teachers now arriving and those already here who have been of good behavior (after examining their knowledge) are to obtain certification; those whose personal behavior is unknown are to be certified only with respect to their knowledge.

5. What is published in one place should not be reprinted elsewhere (except when both parties agree to this). If all institutions with the right to publish duplicate each other's work, this will inevitably cause them harm and undermine the book sales of both. Therefore it seems useful to have a party that plans to publish any book announce this in the *St. Petersburg News* so that no other, out of ignorance, begin simultaneous publication of the same book. Also, institutions with the right to publish can suffer injury when an author or translator sells the same book in two or more places. The Academy requests the Commission to eliminate such fraud.

6. The Academy deems it necessary to consider the question of how books should be reviewed here—i.e., as to which books to publish and which to withhold from publication. In France, special people are appointed for this purpose in various places, and no book may be printed without their approval. In England, one may publish whatever he wishes, without being accountable to anyone for this; however, such tolerance is inevitably accompanied by great abuses. It seems feasible to arrange matters here such that every institution, especially the Academy and University, consult on books that they publish themselves. If free presses are allowed, then the University in Moscow and the Academy in St. Petersburg can grant permission

to publish particular books. The same can be done in other places where free presses are established and where an academy or university is located.

7. For scholars and others in the service of the Academy who have their own private homes, the Academy requests that they be exempted from billeting and agrees, instead, to pay whatever money the Legislative Commission deigns to designate for this.

8. If nothing is said in the new law code about scholars, teachers and students, then because their numbers (especially with the establishment of new educational institutions in Russia) will be quite large, could the Legislative Commission not agree to consider the status of these people, if only to ensure that they enjoy the same privileges and advantages granted them by special charters?

12. Instruction from the Medical College
31 May 1767

1. You, [the deputy representing the Medical College], are empowered, on all matters pertaining to the Medical College and its affairs in the Legislative Commission, to make representations on whatever may be required regarding medical aspects of popular welfare, the occurrence of epidemics among the people, cattle plague, containment of pestilence at the border, and whatever other precautions might be needed. On these and other civic needs, send your own opinion and request an explanation and confirmation from the Medical College.

2. As specified in the instruction to this college, its chief duties include the maintenance of good medical care in the Empire. You are therefore to make every effort to ensure that, when the new law code is drafted, the means and resources be established, whether from private or state assessments, for the pertinent needs: the appointment of doctors in provinces, physicians [lekari] in provincial and the more significant and populous towns (along with the concomitant surgeons and aides); hospitals with the requisite apothecaries in regional [guberniia] and provincial towns for the poor and homeless of both sexes; the apothecaries, beyond providing for sick people in

the hospital, will also serve other local residents; and the arrangement of support for the hospital (both to pay salaries for employees and to provide for the needs and medications of the ill). . . .

3. Wherever state hospitals for the use of residents and the apothecaries (as described above) are not established, permit the establishment of private apothecaries under the following conditions: (1) that they be exempt from quartering and other state services; (2) that they pay the treasury the true wholesale price for the distilled alcohol they need; (3) that all other people, regardless of rank, be forbidden to sell medicines; (4) that apothecaries, in accordance with the Senate decree of 22 November 1752 (on the Kondikov apothecary in Moscow), be permitted to purchase up to fifteen people and land 100 sazhen [213 m.] in length and width for a botanical garden, which is absolutely vital to the operation of an apothecary); (5) in addition, permit apothecaries to maintain and sell every kind of vegetation and fruit preserves; and (6) apothecaries are to dispense free medicine to the poor and homeless (according to a doctor's prescription). . . .

4. Make no less effort in regional (and later in provincial) towns to establish midwives, who have been examined by the medical college, together with several apprentices. . . .

5. Likewise, with respect to infants accepted into orphanages, make representations to the Legislative Commission on all that pertains to better care and supervision of their health from the perspective of medical science. All the relevant published laws and plans are appended here. You should not forget to suggest that special homes (with the requisite supervision) be established in major cities for the incurably ill of both sexes as well as for the insane and crazed.

6. In addition, to improve the state of medicine, it is necessary to reaffirm the published decree of 1721 that no doctor of medicine or paramedic dare practice and give treatment before his competence has been attested by the Medical College. That is particularly needed: individuals lacking certification from the Medical College (as well as every kind of ignoramus) brazenly treat people in virtually all towns and country estates—to the extreme detriment of health and without any punishment whatsoever. . . .

7. Also point out that not only doctors of medicine and paramedics, but people of all ranks are strictly forbidden to sell medicine,

both under universal names and other unknown concoctions, thereby causing harm and losses to the inhabitants. Under absolutely no circumstances is anyone else to sell such medications, publicly or privately, under pain of harsh fines and punishment.

8. With respect to the army and navy, which have various departments and divisions: although medical affairs here are administered and personnel supported according to approved army, naval and other budgets, the Medical College (through Her Imperial Majesty's order for the better administration and orderly support of servitors) has received a significant increase in its budget, which are given in attached appendices. . . . If state offices raise questions about medical affairs, you are to give an explanation on the basis of [the attached financial records]. If the army, navy or other offices make any future changes in their budgets that pertain to medical matters and those serving under the jurisdiction of the Medical College, be especially careful to see that the Medical College is informed of this.

E. URBAN SOCIETY
Manufacturers, Merchants, Townsmen

The urban population in eighteenth-century Russia was notoriously small, constituting only about three percent of the population and confirming foreigners' impression that the Russian Empire was still overwhelmingly rural and backward. With the exception of Moscow and a few other urban areas, most "cities" were more administrative than economic in function and configuration, with few of the corporate and industrial characteristics of contemporary cities in Western Europe. Indeed, even the largest cities of Russia retained a distinct semi-rural appearance, as some inhabitants not only plied commerce and crafts but relied partly upon agriculture for their sustenance. It was no accident that instructions from towns refer to inhabitants' livestock and express concern about the availability of agricultural land; over two-thirds of the towns in Moscow province, for example, raised the issue of land in their instructions to the Legislative Commission. Nothing so distressed the enlightened autocrat and enlightened bureaucrats in St. Petersburg, who were keenly interested in commercial development and in the formation of the "third estate" that seemed so characteristic and vital to the strength of the other great powers of contemporary Europe.

Like the instructions from the nobility, those from the urban population have been the subject of considerable research. That from Moscow—the largest city in the empire—has understandably received particular attention, for no other Russian city came close in size, economic vitality and social composition. Its instruction of 1767 (doc. 13), although partially influenced by the participation of nobles, nonetheless presents a rich mosaic of the city's profile, problems and needs. It is a long, complex, and pointedly contradictory document—with materials appropriate to a semi-agrarian village (e.g., art. 17 on urban pastures) *and* others more pertinent to a

modern metropolis (such as the articles on building and zoning codes, water and sanitation, welfare and vice). The instruction also devoted considerable attention to problems of urban government; like the provincial nobility, townsmen pleaded for greater local self-rule, better courts and tighter public control over officials. The Moscow instruction also devoted considerable attention to problems of trade, displaying less concern about peasant traders than foreign competition, and also made a number of important recommendations to facilitate business—through better regulation of bills of exchange, establishment of effective guilds, promulgation of a bankruptcy law and the like. The townsmen of Moscow also vigorously protested the exclusive status of factory-owners, whose privileged status and virtual exemption from local government was a cause of recurrent complaint by merchants no less than noblemen. Finally, the Moscow instruction was sharply critical of the burdens of state service, whether in the form of "police duties" (a collective term encompassing various forms of individual civic responsibilities) or various kinds of state service (as tax and fiscal agents). Such services, as the Moscow and virtually all instructions endlessly reiterated, severely damaged the well-being of individual merchants and more broadly retarded the development of urban and commercial life.

The urban instructions from outside Moscow were generally much more laconic and presented only the basic complaints and needs of a smaller provincial town. One of the more extensive and interesting came from Kostroma (doc. 14), a commercial and industrial center in the north. Besides its length, this instruction is particularly valuable because the various individual categories of townspeople—industrialists, merchants and petty townsmen—submitted separate statements. At the same time, the instruction offered a fairly inclusive list of the demands that appeared frequently in the instructions of provincial townsmen—demands for better government, fewer obligatory services (personal service, quartering and various levies), restrictions on the commercial activities of peasants, and a reduction in the important privileges accorded to factory owners. Altogether, the Kostroma instruction—like those from most other provincial towns—reflected at once the townsmen's common grievances against such groups as trading peasants and squires, but also their common cause with other social groups in the demand for improved governance and reduced state obligations.

13. Instruction from the Residents of Moscow
[1767]

An instruction from the inhabitants of the oldest capital, the city of Moscow, to the deputy elected to the Legislative Commission, Her Imperial Majesty's General-in-chief, chamberlain and cavalier of various orders, Prince Aleksandr Mikhailovich Golitsyn.

In an imperial manifesto of 14 December 1766, Her Imperial Majesty most mercifully deigned to order that we select a deputy from our midst to the commission, and through him present all our needs and wants. Hence we the undersigned, in fulfillment of the monarch's solicitous order and in accordance with the order prescribed in the manifesto, have elected Your Excellency as the deputy to represent this city because of our general confidence in you. Having given you full powers of representation, we entrust to you the following statement on our needs and ask that you present these wherever appropriate and, in the name of the entire local citizenry, petition:

1. To provide the desired security and tranquillity for all the residents, we request a decree that the present system of street cordons and guard watches by private citizens be abolished, that all burdens of police and public services (public services, repair and upkeep of roads and bridges, and every form of billeting) no longer be imposed upon individual citizens. Replace this with a monetary levy that is bearable, equal for all, and proportionate to the economic status of a given area. As for other public services (upon which the preservation of life, health, honor, security, good order, and equally the advantages and capacity of the citizens is almost directly dependent), we place our trust in the solicitude of the perspicacious, all-merciful Empress for corrective measures or their abolition.

2. For protection against fires (which have repeatedly come very close to destroying this city), we deem it necessary to establish sufficient measures based on the model of other European cities. Certified masters should be specifically appointed to inspect the construction of stoves, fireplaces, hearths, and chimneys and flues. But given the great number of wooden structures crowded together here in a disorderly fashion, hardly any means could be devised that would act

quickly enough to contain a fire. Under the circumstances, it is necessary to request that wooden structures be banned from the best sections of the city and that residents be obliged to cover stove structures and heated service buildings with tile.

3. But not every citizen has the means to build a stone house. To promote [such construction] as well as the splendor of the city, it appears legitimate to trouble Her Imperial Majesty with the city's most humble request that state factories be founded to manufacture tiles and bricks. Or, a bank could be opened to make loans of money or raw materials to inhabitants (for a fixed period); the borrower would pay a fixed interest rate and, as collateral, use either the newly constructed building, some other form of real estate or personal property, under reliable guarantees (especially from those who own their own homes).

4. Private brickmakers should be subject to strict supervision in the preparation of clays as well as the forming and baking of bricks, and a standard size and weight should be established for the length, width, and thickness of each brick. Moreover, producers of white stone should be strictly required to trim the stone evenly on both ends so that it not bulge on the sides and cause unnecessary work and delays in construction. In general, all materials necessary for construction (including logs and boards), besides possessing the proper quality, should bear a price that is fixed and fair to both sellers and buyers. Prices should also be regulated for iron products. We entrust all this to the good judgment of the central government.

5. To ensure the internal and external cleanliness of the city (which is absolutely essential to public health and also promotes beauty, tranquillity and good air), we ask that adequate public services be established at the inhabitants' own expense, but within reasonable limits. For state properties, the treasury is to pay that share itself. Further, hospitals should be moved outside the city and the fish market relocated to an appropriate section elsewhere in the city. For the transport of human waste and garbage, special places should be designated outside inhabited areas. In addition, cemeteries often foul the city's air and should be moved outside the city.

6. Clean water for human consumption is just as necessary as the above, but at certain times of the year Moscow's inhabitants experience severe shortages of good water. To prevent such acute shortages, we request efforts to find good water in convenient places and a strict

ban on the dumping of garbage and rubbish into the Moscow River or any other waterway running through the city, or the hauling of such refuse onto the ice [in the winter]. In addition, it should be forbidden to build tanneries or other polluting factories upstream. It also appears necessary to deepen the city's rivers by diverting water to them from nearby areas, if this is deemed good and feasible.

7. Because the Neglinaia River is only slightly higher than the usual water level of the Moscow River [into which it empties], apparently the only way to avert floods is to build dams. Such dams were constructed in various places long ago, but the reservoirs formed as a result have become so polluted that the stagnant water in them produces a terrible stench in the summer. Therefore, we request an order to have these ponds dredged and maintained hereafter.

8. It is simply mankind's duty to extend a helping hand to those unable to take care of themselves. Every day we see here a great number of people of both sexes (chiefly from the common people), who had earlier experienced a mild disease but lacked any means of treatment, and finally suffered a premature death or, at least, incapacitation for the rest of their lives. Likewise, the lack of special hospitals for contagious diseases causes healthy people to become infected. We most humbly request a decree that, after consideration by the central government, hospitals be built in the city. The amount needed to maintain such hospitals should be taken into account, and people of both sexes should be treated for a fair price; the poor and homeless should be treated at state expense.

9. It is simply impossible to determine how many unfortunate women and infants fall victim to the ignorance and incompetence of midwives. But, given local conditions, the number of victims presumably exceeds anything imaginable. Hence, to prevent somehow such unpunished homicide, we request an effort to increase the number of midwives certified as competent and to distribute them throughout the city (four to six per area, depending upon the number of dwellings and residents). They should also have signs on the buildings where they live so that, in event of need, one can find them more easily.

10. Equally regrettable is the fact that sudden, unexpected strokes reduce the number of inhabitants. In such cases these unfortunate people die primarily because there are not enough apothecaries, doctors and general physicians for so large and populous a city. Hence

the ill person must send a long way for a doctor, general physician or medicine; because first aid is not immediately available, he is subject to great hardship and loss of life. Request that the number of apothecaries, doctors and general physicians be increased, that they be distributed throughout all parts of the city (leaving the exact number to the judgment of the central government), and that a fee be set to govern how much doctors and general physicians receive for each visit to the sick.

11. The generosity, magnanimity and mercy of Her Imperial Majesty toward all Her subjects is great and indescribable. Even without a most humble petition on our part, we hope for a most merciful decree to establish state grain reserves (and similar measures) so as to guarantee a sufficient quantity of grain to provision all the city's residents. In that way there will never be a shortage of grain or an onerous price rise.

12. The various factories, plants and breweries that are increasing here always require a great quantity of wood fuel. At present, its careless consumption has caused a sharp rise in prices, for local forests have become exceedingly thin. Therefore request that the factory owners and brewers be shown (following the example of other states) profitable ways to build furnaces that conserve wood fuel, and that hereafter no more factories be built in Moscow or its environs.

13. It is absolutely essential and vital to the city that the food and other provisions to feed the inhabitants never be in short supply. Food supplies must also be within the means of every townsman (through his own labor and work), for the price of every artifact is determined by the cost of satisfying basic needs. Therefore we request the necessary measures as well as strict supervision to ensure that weights and measures in the city always be the same.

14. It is not possible to prevent altogether the presence in the city of citizens who, despite diligence in their handicrafts and trades, suffered misfortune through various accidents and illnesses that entailed poverty and destitution. These are the proper recipients of Christian charity and generosity; the charity given them is more pleasing to God and more useful to the state than alms dispensed indiscriminately to all who shamelessly thrust out their hands. This impels us to ask imperial assistance for the poor and maimed; they are to be distinguished from idle vagrants and parasites—who, for

the most part, simply do not wish to work, bother those who do, and sometimes cause great evil.

15. The great expanse of this city, which is continually growing, and the resultant problems are well-known to all. To prevent this needless sprawl, it would be good to put a limit to the city's borders and thereby cause empty areas within to be built up. It is also necessary (both for the inhabitants and for visitors from other parts of the empire and other countries) to establish a certain number of reliable hired service people, carriages and barouches for hire, and inns and cabmen.

16. The construction of a special place to care for the insane and the necessary means to be allocated for this depends upon the mercy of Her Imperial Majesty. It is impossible (and this is confirmed by everyday experience) for a great city like Moscow not to have such people who do not commit any major offense, but lead a dissolute and licentious life of vice, sin and constant disorder. Both for their own sake and for the tranquillity of the entire community it is necessary to construct a house of correction or *Zuchthaus* (after the model of other lands), where such dissolute people—who cast shame upon their parents and entire clan and bring themselves to certain ruin— could be used in constant labor until they became contrite and abandon their mischief. Or, if they do not, then they can spend their entire onerous lives [in these institutions] as a warning to others. To restrain shameful drunkenness, the vice that is so endemic to the common people and generates virtually all other forms of vice, it should be ordered that all commoners found lying unconscious in the streets from intoxication, regardless of their rank, free or serf, be taken without exception to the police and sentenced to a government work-gang for at least one week.

17. From earliest times, the city's residents have been assigned places to pasture their cattle, as circumstances permit. But as the great city grew in size, these areas have been mostly given over to construction and settlement, and the remaining amount of pastureland is now quite small. Hence it is now almost impossible to pasture livestock in the summer. Therefore, we most humbly ask of Her Imperial Majesty that, as circumstances permit, she most graciously grant additional pastureland to our city.

18. Certain sections of the city have land plots of diverse legal status, namely: "musketeers' land" (for which an annual quitrent is

paid to the treasury) and "lands of the Moscow merchant suburbs" (the so-called "tax-bearing" land). Although no payment is made from the latter category of land, its inhabitants are obliged to service the roadways; for that purpose land titles are composed and go from one person to the next, but only for the structures built on these lands. For better order and equality among townspeople, could it not be ordered that the owners pay once and for all a single sum and that they receive these lands in permanent, hereditary possession? The properties should remain under the general terms and obligations of regular townspeople and in all respects bear the legal title of city land.

19. To secure better order and justice among citizens for affairs among townsmen, we most humbly request the establishment here of a city court after the model of European cities. To provide one and all with prompt administration and satisfaction in the elimination of slanderous denunciations and red-tape, we hold it necessary for the court to be oral [and not employ formal, written procedures]. Here citizens—without exception, regardless of social rank or official position—could enjoy dispassionate justice. As to the competence of these auricular courts (including the maximum value of suits within its jurisdiction), we leave that to the good judgment of the central government. As for the people serving in these courts, we ask that they be chosen from townsmen by the entire citizenry [including nontownspeople residing in the city], or by electors voting under the supervision of the mayor (with the stipulation that nobles comprise no more than a third of the electors or the judges, and that the remaining two thirds be merchants). So that these people, who are honored by particular trust, not suffer needless financial loss during their judicial service (through distraction from their regular business affairs), it seems only fair that they (together with other lower officials in the city courts) be granted a salary. Judges are to be changed every year or two, with new ones elected according to the above procedure. The only reservation is that anyone who has served two years as judge may not serve for another ten years; anyone who served one year may not be reelected for another five years. If a former judge (at the request of the town's citizens) agrees to allow his reelection before these terms expire, it is left to his discretion to do so. Therefore, designate exact times for these elections—first, for the election of electors, then for the election of judges to the city

courts. In the event of injustice and dissatisfaction, appeals against the court are to be made on the basis of the laws.

20. May this city court be granted jurisdiction over all merchants and guilds, as well as administrative authority over their contracts, the apportionment of their taxes and public duties, elections and everything that pertains to their internal order. The Chief Magistrate for Cities [in St. Petersburg] and its office are not to govern the merchants and townspeople in any respect. We also most humbly ask that this court be able to appeal and seek protection from the Governing Senate.

21. As the civil court that we most humbly request establishes the election of judges in the presence of the mayor (which we hereby confirm), we authorize [our deputy] to ask that Her Imperial Majesty most mercifully allow the election of the mayor in the future.

22. The forgery and abuse of bills of exchange cause some people considerable harm. But as these are extremely useful to all the merchants when they travel to purchase goods and transact other business, it is impossible to eliminate these without causing great harm to the merchants. Therefore, we ask that the law on bills of exchange actually be observed by all (with strict enforcement of its provisions), irrespective of the person, his official position or his social rank. However, to eliminate the perfidy and fraud that sometimes occur, we deem it necessary to order that dubious bills of exchange be taken to the board of merchants or court within six months [from date of issue]; if action is not brought against them within this period, the courts are not to accept complaints against them.

23. It is the responsibility of the police to see that no one ever suffers violence anywhere. If someone is summoned to a court, at no time is he to be taken by force from his own home or rented residence; the sole exception is criminals in felonious offenses. Rather, if a person fails to appear at court after three summonses and has signed the summonses (showing that he received them), and still does not come to the court or send an authorized representative to give valid reasons for his failure [to comply], he is to be found guilty without a court hearing. We leave it to the good judgment of the central government to decide how to design these summonses so that they are free of doubt and falsification.

24. All non-noble outsiders residing in the city [*raznochintsy*]

(and coming from within the empire and from foreign countries), who are here with passports and labor contracts (as servants or other positions), must be registered with the police. Clerks working for merchants, salesclerks in shop stalls, and workers employed by artisan-merchants are to register in the civic court. Once the term of the passports or contract has expired, all these people must obtain a statement of their orderly life from their [former] master, employer or master and may not be accepted by others without such certification.

25. Many foreigners have their own homes here, but bear no civic duties; they should be ordered to bear the various duties along with us. In addition, other foreigners who come here should be under the jurisdiction of a single court in all instances of disputes with local inhabitants.

26. State lands under various government agencies should have only official, not private buildings on them. We ask that no one be allowed to construct private buildings on these lands, that such buildings not be rented out, and that they also not be used to house outsiders.

27. Although Her Imperial Majesty is here only for short visits, the quartering and support of court servitors cause a considerable hardship for the households to which they are assigned. We most humbly ask that we be freed from this quartering.

28. There is no inheritance law to regulate merchants' moveable and immoveable properties; as a result, they sometimes suffer various difficulties. We ask that this deficiency be eliminated either by promulgating a new, specific law or by permitting merchants to use general inheritance laws.

29. As for guilds and other artisans, we experience an acute need, for the present guilds exist only in name and are totally unsatisfactory in all other respects. Indeed, masters not only lack certification of competence, but also do not possess reliable documents and papers showing their domicile and status. As a result of these disorders, it is impossible for one to seek justice against them, or vice versa; hence the injured party cannot obtain satisfaction to his complaints. To avoid this, may it be ordered that all artisans (both Russians and foreigners) be put into a detailed registry and that a real guild then be established, fixing the seniority and special privileges of each? Then have a proper decree forbid any free person or serf who is not regis-

tered in a guild to engage in a commercial handicraft in the city; nobles' serfs who live in the city, however, may work for their masters' or their own household needs. The masters and artisans in the guild are also to be reported by the courts to the merchant board [*ratusha*] and city court and to bear all the burdens imposed upon townspeople. If there be a requisition to perform any state work, guild members are not to be taken by force, but hired through voluntary agreement.

30. To sell salt and perform many state services, each year local merchants select a considerable number of people, whose official duties require them to depart for service and thereby to abandon their own business. Most important, this protracted enlistment in state service causes them considerable hardship and great losses. Therefore we most humbly ask for imperial mercy to release the merchants from state service, so that, by enjoying total freedom, they might apply themselves without impediment to increasing the merchant population for the benefit of the entire state. In return, they take it upon themselves to pay each year the sum needed to support the people who will perform this service in their place.

31. Above all, the merchants most humbly request annulment of the 1763 law setting an 8 percent levy on all bills of exchange that are challenged—in consideration of the bad publicity for the merchants and other harm inflicted on the credit and exchanges of the merchants.

32. Many foreign merchants, who register themselves for a time as merchants and engage in business, accumulate considerable capital, transfer this to their own lands and then leave the [Russian] state. When they resign from the merchant list here, they always make a fraudulent declaration of ruin and destitution, thereby depriving the treasury of the 10 percent levy due on their capital when they leave Russia. Besides this injustice, they permit [other] foreign merchants who have not registered as merchants to trade with their wares and to import products into Russia under their name; as a result, they deprive the treasury of its right to transit duties. In addition, they engage here in retail trade and peddle from house to house, but do not have to bear the obligations of registered merchants. Under the circumstances, the merchants of Moscow most humbly request special consideration so that the state not be deprived of its due and the merchants not suffer loss in such cases.

33. The merchants of Moscow, who also engage in trade at various ports but especially in St. Petersburg, request that foreign merchants—unless registered as Russian merchants—be strictly forbidden to keep any kind of wares in their buildings. The only exception is perishables, to be kept under customs certification. This rule can only be enforced, however, if they are forbidden to take wares from customs to their houses, and if they are obliged to possess the necessary documents on all wares imported or purchased here (as stipulated by the customs statute). If any foreign merchant has unsold goods left in the warehouse, he must submit a customs declaration after one year; these goods are to be inspected annually and a transit custom is to be assessed if anyone has more than what he declared.

34. A well-established order in all states requires that every rank and official position engage in a specific form of activity so that people from other groups not dare to intrude in this. In acknowledgment of this, the merchants here most humbly request that no one undermine or interfere with their business and commercial activities, and that foreigners residing in private homes as teachers, valets, madames and the like—under pain of confiscation—not engage in commerce.

35. Commercial buildings were established long ago for merchants' business and constructed at considerable expense (before the establishment of markets and construction of stalls) in order that inhabitants be able to purchase near their homes those provisions and fresh wares that are regularly consumed. This matter we leave to the better judgment of the central government.

36. For better trust and more reliable supervision, local merchants request that the oral courts accept contracts and signed documents for consideration. In the case of individual debts that have been established by a court but are still unpaid at the due date, the legal interest should be collected each year from the debtor; this will force all to make a prompt, immediate settlement. When someone is found guilty of having a private debt (with or without a promissory note), information on repayment is to be collected when his property is seized for defaulting. The court should interrogate all witnesses, regardless of their social rank and official position, according to the code of military procedure and with confirmation of a witness's oath.

37. All disputes between business operators and their employees, clerks and workers are to be adjudicated by the auricular court.

38. Merchants must be strictly required to employ people as shop

assistants and salespeople (or to accept them for training) for only six years or more. Moreover, when this period expires, the merchants are to give them written certification of their good behavior and service. If these shop assistants and saelspeople go to distant cities for their own commercial activities, they are to be given the appropriate certification by their employer.

39. Not only merchants, but the entire urban population suffers considerable hardship from the fact that owners of plants, factories and distilleries are exempt from holding various official posts as well as from all state dues and civic duties. Indeed, the exemption holds not only for these people but also for their authorized representatives as well. We most humbly request that all these people, as true residents of the city, without fail be subject to the same law as all members of the city and bear equal duties and responsibilities. If they engage in commerce or other business, they should be treated on the same basis as merchants, with the reservation that as manufacturers they suffer no interference in their production.

40. For want of a statute on bankruptcy, the merchants suffer great losses and ruination. To protect honest people from perfidy, to establish good and mutual faith among people (as the first protection for merchants), and to distinguish involuntary accidents and misfortune from deliberate fraud, we all fervently request that a statute on bankruptcy be issued. It should be augmented by the rule that punishment for all fraud, no matter who perpetrated it, be commensurate with the damages inflicted.

41. So that they not suffer offense, local merchants request that no merchant be appointed to any form of Her Imperial Majesty's service without first obtaining permission from the Board of Merchants or the city court, conducting an audit of his business and settling accounts with creditors. Those given such a release and enlisted in service should be counted against the list of military recruits, and a receipt for this should be given the board of merchants.

42. We also request that no monopolies be given in this city (save those customarily farmed out by the treasury), and that escheat of townspeople not be given to military hospitals or confiscated by the state, but be reserved for the use of city schools and other [local] needs.

43. May it be decreed that merchants departing for other coun-

tries, in accordance with earlier statutes, provide surety on their own, without requiring this from others?

44. Children who have debts, but whose own parents are still alive, are themselves to be liable to the courts and to be treated in accordance with the general laws on indebtedness that will be promulgated. In addition, orphans and widows, who have received no property from their deceased [parents and husbands], are not to be liable for repayment of debts incurred by the deceased. However, parents whose children have died are to inherit the latter's moveable and immoveable property; other heirs are to receive none of this. . . .

14. Instruction from the Residents of Kostroma 10 April 1767

This instruction, together with the most humble petition to Her Imperial Majesty, is given from the inhabitants of Kostroma to its deputy, Vasilii Ivanovich Strigalev (a merchant in Kostroma and owner of a linen factory), who is leaving Kostroma to attend the Legislative Commission. The entire citizenry of Kostroma most humbly petitions Her Imperial Majesty about the following.

MERCHANTS

1. That the all-merciful imperial, autocratic authority grant and confirm the rights and privileges of merchants and that their precise terms (in accordance with Her Majesty's decision) be clarified. That will prevent anyone who does not hold the rank of merchant from enjoying these. All cases concerning [solely] merchants and factory-owners (unless important matters of state are involved) should also be judged by city magistrates—as was previously established by the blessed and eternally praiseworthy Emperor Peter the Great (in chap. 9 of the regulations on the chief magistracy) to protect merchants from being ruined by false accusations. Hence anyone who has suffered injury should petition these magistrates, not some other office of the government. The court procedure is to be solely based on in-

vestigation, not formal [written] evidence; the latter usually tends to be long and drawn-out, is not well-known to every merchant, and can delay a settlement because it is so slow. If circumstances permit, a verbal decision is superior, for it always affords the injured party the quickest satisfaction.

2. Most mercifully order the establishment of commercial houses in cities (for the import and storage of wares) as well as a single, standard system of weights and measures under the supervision of the magistrate and board of merchants (similar to that established by the Governing Senate in 1755 for the salt trade). If fraudulent weighing is suspected, government scales should be brought in to verify the weighing. All merchants and other people are to have weights and measures with inspection tags, which, after comparison with state instruments, are to be attached by the magistrate and boards of merchants (not in provincial chancelleries, since the former are more appropriate).

3. Do not permit the nobility to engage in commerce or to have factories and plants, and permit no one to purchase the rights of a merchant. The nobility has its own rights, which are accompanied by great privilege; they should sell only what their own estates produce, and should be prohibited from buying anything from others [for resale]. In the event their peasants take any surplus products [to the city], they are to file a declaration at the city magistrate, obtain certificates for transit, and on that basis bring their wares to those places listed in the certificate; after obtaining certification of delivery, they are to file a [second] declaration at the magistrate that issued the certificate. This will prevent them from transporting any other products for sale (under the pretext of selling surplus wares). If any noble is found to have engaged in commerce and thus in an activity unworthy of his rank (i.e., he begins to buy and trade or, under the pretext of selling surplus, to transport other products to the city), then Her Imperial Majesty's treasury should confiscate everything that he purchased and imported without certification.

4. According to established rules, peasants living in major villages and hamlets on primary roadways may conduct trade only with travellers and only with what they produce in their capacity as peasants (on a small scale [to satisfy] the travellers' most essential needs). However, during the annual fairs and on [weekly] trading days, peasants in many villages violate these laws: they keep shops, trade in

brocade and other silk wares, and buy linen of various quality in ports and cities, thereby causing great injury and difficulties for merchants. To aid the merchants, may it be ordered that this peasant commerce be prohibited in all villages and hamlets and that, except for cities and suburbs and places with large grain wharves, no other place have markets, shops and manufactories (in order to eliminate unauthorized commerce). But if anyone from the peasantry or various other ranks wishes to exercise a merchant's rights, order him (in accordance with Emperor Peter the Great's decree of 13 February 1722) to register at the local magistrate as a permanent merchant and in all respects to be equal to other merchants.

5. Merchants are not to sell their rights to anyone, nor to give bills of credit to peasants and people of various other ranks [*raznochintsy*], nor to send wares with them (except for people hired to haul wares). Under no condition are merchants to put such people in shops; as stipulated by the customs statute (ch. 2, art. 11), merchants are to use their own people as shop assistants and salesmen; however, annul the requirement for notarized contracts (which are usually prepared in provincial chancelleries) and accept signed documents (with guarantees) that the merchants alone authorize as the legal equivalent of notarized deeds. If anyone else from the peasantry or various other ranks engages in commerce, even if acting under consignment from merchants, his entire property is to be confiscated by the state; no excuses are to be considered. That will enable the smaller merchants, rather than people of other ranks, to enjoy this commerce and augment their wealth; in the contrary case, people of other ranks will occupy the place properly belonging to [regular merchants] and force them to support themselves by working as peasants.

6. In general, all the peasants in villages and cities should be able to sell to people of any social group what they produce in their rural economy. But peasants are not to purchase products from others for resale on pain of confiscation of everything that they purchased (the proceeds to be given for the benefit of military hospitals). In accordance with the Law Code [*Ulozhenie*] of 1649 (ch. 19, art. 15), only merchants are to possess houses, factories, shops or inns in towns; leave this trade to the poorer merchants so they can improve their affairs, as ordered by the Regulations of the Chief Magistrate.

7. Peasants and people of other ranks are not to engage in trade at seaports or in internal cities located along rivers; the only exception

concerns grain and whatever exceeds their personal needs. However, only merchants should haul grain or any other wares on boats and barges.

8. It is useful for merchants to make representation on the following: according to the customs statute and decrees, shopkeepers are forbidden to purchase grain and other provisions brought by peasants until the afternoon. In the city of Kostroma, the grain trade on market days lasts from morning until 4 in the afternoon. But by afternoon, there are almost no sellers and merchants left and hence the shopkeepers have nothing to buy; as a result, they experience considerable disruptions and difficulties in their business and commerce. Therefore, allow the shopkeepers, like all inhabitants, to buy grain and the like before noon without interference.

9. Decrees from the Chief Magistrate [in St. Petersburg] have reiterated the admonition to regional, provincial and district chancelleries that they are not to issue guarantees for merchants on immoveable property or deeds without consultation and contact with the magistrates in those cities. This is so that no merchant who has collected money for bills of exchange or who has served in tax collection can sell his property without an audit; otherwise, he might harm the interests of the treasury or deprive his creditors of money given for bills of exchange. However, through various ruses (both in their home city and elsewhere), many debtors write sales and mortgage documents without approval from the magistrate, thereby depriving creditors of any claim against the bills of exchange. Therefore [request] a provision in the new law code that no one write deeds or loan agreements without notarization by the magistrate and boards of merchants; unnotarized agreements are to be cancelled and declared null and void.

10. Request that regional and provincial chancelleries not demand tellers from the merchant population to count petty silver and copper coins and that the chancelleries not dispatch them to serve in other towns (so that in their trade and business merchants not suffer disruption, still less ruination, because of such absences). Each state office should rely solely upon its own staff.

11. Leave the police in this city on the same terms as established in Emperor Peter the Great's regulations for the magistrate. Recognizing the great benefit for the merchants, the all-wise monarch (in

chapters 10, 13 and especially 14) ordered that only the magistrate administer justice over urban citizens, keep the police under his supervision, collect the revenues assessed from townsmen, manage city finances, and represent its interests before the Chief Magistrate [in St. Petersburg]. In matters pertaining to the civil court and finances, townsmen are not to be subordinated to the provincial governors and district governors [*voevody*]; moreover, neither in civil nor in military matters is the chief state official to summon a citizen to his chancellery for judgment, but to petition the magistrate for judicial action.

12. A decree of the Governing Senate in 1761 directed that [the accounts] on salt and money, filed by tax collectors present at the sale of salt, be audited by provincial and district governors jointly with a member from the city magistrate. On the basis of this law, the salt assessors from Kostroma (together with their records and other documents) are sent each year to the provincial chancellery in Kostroma. But because of the increase in provincial chancellery's current business and because of the numerous queries to the magistrate, these audits last a long time. Some assessors spend three years and more at this audit and, during this entire time, are not permitted to leave Kostroma for business. The result is considerable difficulty and disruption for merchants. Therefore, may it be ordered that—as the best assistance to merchants—salt and other tax duties be assigned to the magistrate alone and that the audit be sent (with the magistrate's certification) directly to the [central] colleges responsible for the particular tax? The [provincial] chancelleries should have no role in this, for such audits should be completed and sent without any delays and red-tape. In the event of misfeasance by tax collectors, restitution of missing funds can be made more promptly to the treasury.

13. Both the merchants and chancellery clerks are sorely in need of people to work in their homes and to perform the public services due the city. For, lacking their own house serfs, merchants must abandon their business (and clerks must neglect their assigned duties) to do the work necessary at home and to perform the obligatory public duties. More important, when they are away on business, they have an acute need for their own reliable people. Therefore, could not permission most graciously be given for merchants to purchase male souls (first guild up to five male serfs and second guild up to two male serfs, with an equal number of female serfs); chancellerists

should be allowed to purchase as many serfs as the [Legislative] Commission decides. Serfs previously purchased are to remain permanently with them.

14. Townspeople suffer considerable hardship from the billeting of regular and staff officers: many officers choose quarters at whim, while others accept assigned quarters but, if the least dissatisfied, oppress the owners and drive them from their homes; the only possible outcome afterwards is disputes and animosity. Therefore, could not Her Imperial Majesty mercifully deign, for the tranquillity and placidity of townspeople, to forbid the assignment of regular and staff officers (and others who hold such positions) to [private quarters]? That was ordered by the blessed and eternally praiseworthy Empress Anna Ioannovna in a decree of 11 November 1738, which ordered officers to be satisfied with the rented quarters that they choose; the lower ranks (i.e., noncommissioned officers and soldiers) are to be assigned to townspeople in turns, without omitting any household, so that no one experience hardship or advantage over others.

15. According to previous laws, chancellerists and merchants owning property in excess of 50 rubles must pay an annual bathhouse tax of one ruble. However, because many pay this tax but many others do not (by resorting to various devices), for the sake of equity among townspeople it would be [an expression of] Her Imperial Majesty's maternal compassion if the bathhouse tax were abolished for [all] these people (as was done for the lower ranks, both those in the poll-tax rolls and those not, in a decree of 1725). Although that would entail a loss for Her Imperial Majesty's treasury, a prosperous merchant group that increases trade will more than compensate for the loss through customs duties.

16. The merchants of Kostroma feel duty-bound to request that the Legislative Commission send the strictest order to the city governments in this province, directing that merchants who travel without passports (like fugitives) be received by neither nobles nor merchants, but be returned to their domicile, as soon as possible and without the slightest delay. Those who violate this rule—like anyone who takes in a fugitive—should be fined, for many of the merchants' and artisans' people, after committing a crime or obtaining a large sum from bills of exchange, leave without permission and live in other places without the slightest fear. The merchants who remain behind

must pay the poll-tax for them and bear their other obligations, causing the merchants considerable hardship.

17. It has been observed in previous incidents that fathers and mothers give their property to their children and then live with them. But by the will of God the children sometimes die first. In the event the children die first, fathers and mothers should not be deprived of their own property; it seems fair to return the property to their mothers and fathers. Likewise, if sons and daughters have no children of their own and die [before their parents], no one can be a closer heir to their property than their own parents. It seems equally fair for a widow who has children to manage her husband's household until her death, remarriage or monastic tonsure; likewise a widower who has children should hold his wife's estate until his death, remarriage or monastic tonsure. In all other matters pertaining to the rights of inheritance we defer to the supreme judgment of Her Imperial Majesty.

18. It would be a special act of maternal mercy toward the merchants if Her Imperial Majesty would permit them to establish linen and other manufactories on whatever scale they wish. However, these manufacturers and plant-owners should not be exempt from civic duties and taxation, but should be under the jurisdiction of the magistrate, like all other merchants.

19. These following decrees were issued in prior years: (1) a decree of 11 August 1731 ordering that all factory owners and merchants, without exception, participate in city elections and councils and be obedient to these, and (so as not to oppress other merchants) that no owner of plants and factories be exempt from civic obligations; (2) a decree of 1737: once manufactories have been established and fully put into operation, the manufacturers and merchant-owners are again under the magistrate's jurisdiction; (3) a decree of 22 December 1746: so that manufacturers not engage in commerce gratis [without bearing merchants' obligations] and thereby cause hardship for other townspeople, manufacturers are to hold the same status as merchants and are categorically bound to pay taxes for essential expenditures per the decrees of 1724 and 1742 (which levied tax assessors according to one's wealth). But, as is well-known, for a long time factories (especially for the production of linen) have been increasing in many cities of the Russian empire. Even in recent times, some merchants of the first guild have established old-fashioned linen

factories solely for their own profit and enrichment; moreover, they make use of a manifesto (the regulations of the colleges) to be subject only to the college of manufactures and to be exempt from civil courts, the payment of taxes and the performance of civic duties along with merchants; they also [now] wish to be exempted from the poll-tax. If the latter is granted to the factory owners, other upper and middling merchants, desiring the same privilege, also will eagerly want to establish factories (even if as a joint operation) and abandon their commercial activities. The remaining poorer merchants (who lack the means to establish a factory) will be unable to pay the present poll tax because of their poverty, old age, or minority. In addition, the remaining population of poorest merchants will be obliged to pay the poll tax for the deceased, for those drafted into the army, and the large number of other people who have left the city on various occasions. Furthermore, this remnant of the poorest merchants will then have to provide all basic expenditures for the city as well as various public and other services, which previously had been performed jointly with the entire population of merchants and factory owners (and with considerable assistance from the richest townspeople). As a result, they will be totally ruined and be deprived of their business; in the event of their ruination, they will be subject to forcible tax collection, put in prison and die of starvation. In the event manufacturers commit an offense, the remaining merchants will have no way to seek justice from the College of Manufactures because of their poverty and because the College [in St. Petersburg] is so far away; hence they will have to endure such offenses without obtaining satisfaction. Therefore, will Her Imperial Majesty, as a special act of her monarchical mercy, not protect the above poor merchants from ruination and (in accordance with earlier government laws) order that those merchants and factory owners with canvas plants not be exempted from all civic services and taxes, and that they remain under the jurisdiction of the city magistrates together with ordinary merchants, as these (prior to the establishment of factories) had been from the earliest times?

MANUFACTURERS

20. It would be a special act of maternal mercy by Her Imperial Majesty if manufacturers who presently own factories were excluded

from the poll-tax registers and placed under the jurisdiction of [the central] government, not [local city] office. That would stimulate every entrepreneur to reduce the use of European products (for the general benefit); [that applies] not only to those activities already existing (and bringing fruit and glory to Russia), but to others which could be established and be the object of diligent efforts. This would serve the state's interests and the needs and benefit of society. A personal decree of Her Imperial Majesty (signed by Her Majesty and given to the College of Commerce on 9 December 1762), exempts all factory and plant owners from unseemly services. But the manufacturers from the merchant population in Kostroma are assigned to every kind of civic service and the production in their factories is thereby interrupted; as a result, state interests are harmed and some manufacturers suffer losses. In addition, beyond the payment of port taxes for linen, Her Imperial Majesty's personal decree of 15 December 1763 ordered that manufacturers pay one ruble from each mill, as well as the poll tax, regular levies on merchants, and also every kind of assessment by the city magistrate. No social rank pays so many different assessments as manufacturers. The manufacturers most humbly request that Her Imperial Majesty deign to have the Legislative Commission consider this article.

21. As is well known, the state derives considerable benefit from manufactories through the payment of customs and imposition of other duties. But when these manufactories were introduced, equipped and granted privileges a decree signed by the blessed and eternally praiseworthy Emperor Peter the Great (in his regulations for the College of Manufactures, dated 3 December 1723) declared: whoever establishes a factory, together with his children and brothers, is exempt from service obligations (pt. 13). [Furthermore], whereas previous imperial laws forbade merchants to purchase [populated] estates (so as to prevent anyone except merchants, for the benefit of the state, from having factories), it is now apparent to all that many people have formed companies and, in order to contribute to the benefit of the state, have undertaken to establish various manufactories and plants, many of which have begun operation. Therefore, so that factories proliferate, both the nobility and merchants are permitted, with the consent of the College of Manufactures, to establish factories in the countryside. But a decree of the blessed and eternally praiseworthy Empress Elizabeth Petrovna (27 July 1744) and a de-

cree of the Governing Senate (8 April 1752) prescribed a proportion for the purchase of serfs and land for such plants and factories: 28 male souls per mill. But according to the personal decree of Her Imperial Majesty (8 August 1762), until the new law code is confirmed by Her Imperial Majesty, factory and plant owners are forbidden to purchase [serfs], with or without land. But it is impossible for the manufacturers to increase and improve their plants and factories without their own serfs, because free hired labor can never be so obedient as are one's own serfs (or peasants consigned to work in factories); hence free labor can never be so effective. Therefore any improvements that a manufacturer might consider for the state's benefit and glory seem objectionable to the [hired laborers] because of their novelty, and one cannot compel them to comply for any amount of wages; they are willing to work only in accustomed ways. That is not true of factories, as in Iaroslavl and elsewhere, which have their own large populated estates [of serfs] and where these factories have been brought into superb condition. Other factories could be raised to this level through the same means. And if this appears unobjectionable to the imperial, wise judgment of Her Imperial Majesty, permit (in accordance with previous laws of the Russian Empire) the purchase of male and female serfs for those factories and plants, even if not per the former rates. But for linen factories it is necessary to set no less than three males (together with any female dependents) per mill. For, unless a factory has its own serfs, it cannot be made to thrive (for the reasons given above). Moreover, free hired labor does not suffice to expand linen factories. That is especially true in the summer, when factories cannot perform half their work because the peasants leave to work in the fields. [Two final points, from minor civil and ecclesiastical servitors, are omitted here—ed.]

F. PEASANTRY

In the mid-eighteenth century the peasantry included a congeries of distinct sub-categories—from the freer state peasants at one end to the lowly serf at the other, often living cheek by jowl in the same district. State peasants (themselves comprising a host of legal categories) held a relatively higher status; though they had to pay various taxes and render dues to the government, they enjoyed a high degree of individual independence and personal rights. That higher status found further confirmation in the fact that they were explicitly invited to submit instructions to the Legislative Commission. Nevertheless, as these instructions stressed, their economic condition was far from satisfactory, for their land and other resources were simply not sufficient to enable them to satisfy the various government demands. That was particularly true for state peasants in northern Russia, where the land was simply so infertile and so reduced by merchant encroachments that (so the peasants claimed) they could not pay the poll tax, especially in the wake of recent harvest failures (docs. 15–18). Significantly, these peasant supplicants did not challenge the levies or labor obligations in principle (or, understandably, the state's right to impose or increase them), but rather based their argument on traditional appeals for charity and relief, even if given only temporarily. Like other groups, peasants tended to make "negative supplications": whether from convention or conviction, they seemed to anticipate negative responses, phrased their requests as beggarly pleas, and bargained away their demand into a temporary concession.

Not all peasants were so humble and reticent, however. Particularly strident were the petitions from "single homesteaders" [*odnodvortsy*], a category of farmer-warriors who had ranked somewhere between the service classes and peasantry in seventeenth-century Russia. But in the eighteenth, they gradually descended into the lower, poll-tax population of state peasants, a change that not only entailed important new obligations to the state, but also exposed them to depredations and abuse by the nobility, especially the un-

lawful seizure of their land. In addition to passionate complaints about such injustices, the homesteaders' overriding demand was that they be removed from the poll-tax population and restored to their allegedly noble status, as a community in Simbirsk stressed in its instruction (doc. 19). Significantly, instructions from some state peasants were exceedingly articulate and comprehensive, perhaps because they had closer ties to urban life (through seasonal employment, already well developed in the central non-black-soil provinces), or because they had easier access to outside editorial assistance (such as an urban clerk). Illustrative was the instruction from a community in Tver province (doc. 20): unlike those from north Russia, it is exceedingly long, provides a detailed critique of state duties (such as quartering and convoying), and even makes bold demands for local self-government.

Seignioral serfs, denied the right to participate in the Commission, have therefore bequeathed us no rich stock of instructions. It would, however, be wrong to assume that they silently suffered and patiently endured: while other categories of peasants were probably even more inclined to revolt in the mid-eighteenth century, the serfs were anything but silent and submissive. Indeed, the 1760s witnessed a sharp increase in serf insubordination, marked by a high rate of flight, the refusal to recognize the squire's authority, and the submission of petitions to the tsar for protection. Historians have of late shown increasing interest in these petitions, which are still mostly unpublished but invaluable for understanding serf psychology. It bears emphasizing that the serf petitions cannot be taken at face value, for they often contain gross distortions or exaggerations, perhaps because the authors believed that facts were not easily verified, or that only flagrant injustice could impel government authorities to intervene in the internal affairs of a nobleman's estate. Significantly, the serfs often aspired to the status of state peasants, basing their claim on various pretexts (purportedly disproving the squire's rightful ownership of their estate) or upon various ambiguities in carelessly composed (or bogus) imperial decrees. Somewhat exceptional are the serf petitions to Pugachev—the pretender Peter III—amidst his insurrection in the mid-1770s; as the materials presented here (docs. 21–22) suggest, they regarded Pugachev with a combination of awe and anxiety (especially his uncontrolled military detachments), had to resist

strong state pressure before supporting his cause, and made haste to
seek his support against their squire or local authorities.

15. *Instruction from State Peasants*
 of Vondokurskii Township (Vologda
 Province)
 [2 March 1767]

We state peasants, who live in Vondokurskii Township (Dvina Sec-
tion, Velikii Ustiug District) as sharecroppers under merchants in
Velikii Ustiug and various other landowners, submit this statement
of our wants and needs. Because we cannot take refuge in our own
land (our forefathers and fathers sold and used familial lands as
collateral for unknown sums), the merchants and landowners keep
us as sharecroppers, as though we were their serfs, for we are reg-
istered under their names in previous and present poll-tax rolls.
Your Imperial Majesty's decrees authorize movement for those who
so wish; but when we ask to move from these landowners to town-
ships of state peasants, the elected officials and peasants in these
townships refuse to accept us, because they do not have sufficient
land and because they are [already] overburdened by an excess of
poll-tax registrants. Nor do landowners, because of collusion among
themselves, agree to accept us. We are given no help as sharecroppers
and, together with our wives and children, just perform onerous toil
for these landowners. We receive nothing from the landowners for
our work; we do not have enough grain and hay. And other land-
lords collect money from long-term residents and for recruits. And
though one could petition about the landowners, we hold them in
fear and dread and do not dare do this. Such are our needs and
wants. The instruction is signed by the priest of Troitskii Bogoiavlen-
skii Church, at the request of his spiritual children, the peasants of
Vondokurskii township.

16. Instruction from State Peasants of
Shaskaia Township (Vologda Province)
23 February 1767

1. The harvests for every kind of crop have been poor in recent years, and the hay has rotted because of the spring rains, causing great harm to the livestock.

2. Half of the males in many households have died [since the last poll-tax census]; no one remains in these households to pay the poll tax. It is burdensome for many peasants to pay the assessment for such deceased souls.

3. Harvest failures are causing the population in this area to decline; nor is there any grain for [the next] planting.

17. Instruction from State Peasants of
Kobyl' Township (Vologda Province)
24 March 1767

. . . 1. We peasants have small plots of arable land and meadows in the township. They are on the south side of a river; almost every year, the very high waters wash away the crops and cover some of the fields with sand.

2. Moreover, as a result of insufficient hay and poor harvests (due to a shortage of seed grain because of our poverty), we constantly suffer the greatest difficulty in supporting ourselves, for our land is near the White Sea and poorly suited for the cultivation of grain.

3. And on our land are inscribed the landless and deceased, as well as minors and old men, who are put in the poll-tax rolls along with the peasants in the township. As a result, we have considerable difficulty paying the poll tax, which has reduced us to a state of dire poverty and want.

18. Instruction from State Peasants in Upper Tolshemskii District (Viatka Province) 24 March 1767

. . . 1. In the upper half of the township, the arable land has hills, clay, gravel, stone and the worst possible soil (listed as "poor soil" in the land cadastre). It will grow grain only if fertilized with manure.

2. In previous years (until 1766) rye was sown as a winter crop, but then God punished us: worms ate the roots after planting; some plants came up after the worm infestation, but were then damaged by the cold air. The kernels of the grain are extremely small. We suffer extreme and great dearth.

3. After the rye, oats, barley, wheat and other crops have been sown, God will, we hope, grant a harvest. In a good year the yield is 3:1 [in harvest: seed-grain ratio]; in other years it is 2:1. Last year we sowed rye which, in contrast to previous years, not only failed to yield a profit but did not even return the seed used for sowing. Because of the frigid air in our northerly area, the crop froze. Not only do we not have grain to sell, but we even lack grain to feed ourselves. Hence many are buying grain in town from other districts at high prices.

4. Our animal husbandry suffers from the extremely small amount and the infertility of our haylands and meadows, which produce little grass. We are greatly in need of [such] land.

5. According to the previous poll tax, each male soul paid 1.10 rubles per year. But this has now been increased by 0.60 rubles, so that each male now pays 1.70 rubles. The result is great poverty for peasants who are responsible for many tax-bearing souls.

6. According to the third poll-tax revision, many peasant [households] in our township have 6, 7 and 8 souls registered in the poll tax, but they have very small plots of arable land. But some peasants have only one to three peasants registered in the poll-tax, yet have a full land allotment. As a result, the peasants [responsible for] many poll-tax souls suffer deprivation and ruin.

7. We have neither hunting nor fishing trades and have only our work as peasants. At present, in the upper half of the township we

have only infertile soul; for lack of meadowland, we have little live-stock and cannot fertilize the fields with manure, which therefore yields little. From the poor grain harvests and heavy poll-tax payments, we have fallen into great need and want. Our poverty also makes it impossible to acquire handsaws [for lumbering].

8. Merchants in Vologda own arable and meadow lands in our township, and the proprietors of the Tot'ma saltworks own two villages (Irkina and Kubliki). We do not know how they came to possess these. But they do not pay the requisite levies together with us for the upper half of the township. And we suffer great poverty from our lack of land.

9. A merchant from Tot'ma, Lev Zaitsev, owns arable land and meadows in the upper half of the township in the hamlet of Frolov (equal to one and one-half allotments), but pays no poll tax whatsoever. He also owns the hamlet of Podol'na, but pays the poll tax for only one soul. He also has the unpopulated settlement of Ustinova and Ogafonova under quitrent. This merchant causes us peasants considerable ruin and offense.

10. Because of our land-shortage, the peasants of the upper half of the township haul wood and work continually all winter at the saltworks of the Vologda merchants, Iakov and Aleksei Isaev. These merchants employ us [to deliver] salt to other towns and districts, but keep us without salt; nor will they sell us salt. We suffer great need and want as a result.

In addition, we the undersigned experience hardship and material ruin from the large poll tax, for our upper half of the township is attached to various government offices on the river Sukhon, but we are 80, 100 and more versts from these. And as a result, we have been ruined and left in poverty and great want.

19. Instruction from Single Homesteaders in Simbirsk District [1767]

. . . 1. Our forefathers, grandfathers and fathers were born members of the Russian nobility. In earlier years, they were awarded

estates and resources (together with peasants) in various provinces and regions, and had to perform cavalry and dragoon service.

2. Thereafter our fathers and we remained on these lands of our forefathers, and none of us were ever in any taxpayer rolls before the first poll-tax census [in 1719-27]. During this census our grandfathers and fathers submitted reports on themselves and their underage sons; throughout Simbirsk district, our fathers were thereupon inscribed in the poll tax as single homesteaders. But each of us can prove his claim to Russian nobility, for even now many have relatives in service as staff and senior officers; others are at home and do not deny this birthright. And therefore we request Her Imperial Majesty's maternal mercy to have those single homesteaders, who prove their nobility, to be excluded from the poll tax and listed as nobles.

20. Instruction from State Peasants of Zubets District (Tver Province) [1767]

. . . 1. When troops and officers are billeted on the lands of state peasants, many of the regimental servicemen occupy quarters in private homes on their own authority; others heed the instructions of the chancellery in Zubets, Rzhev and Staritskii, but behave irresponsibly in these homes. And they cause much damage if the households fail to supply food. They have also taken timber from private woods to build stables for horses belonging to themselves and to the state, they have also made many other illegal demands. Armed units have, without legal authority, rounded up peasants and their elected leaders, held them under arrest, and subjected them to abuse, beatings and other torments. The injured have been denied satisfaction; no matter who suffered and regardless of the nature of the offense perpetrated by the military service people, one is obliged to endure this and not to file a complaint. To avert any further great offenses (like those which have previously occurred), [some] people have complained (all had valid cause); but rather than freeing them from this, those responsible have reacted with the greatest abuse—

making [the community] responsible for military hospitals, penal stockades, regimental households and other absolutely irregular forms of billeting and provisioning. And when the troops take up winter or long-term quartering, the government chancelleries do not distribute the troops in shifts (to take previous quartering into account); other state properties (because of favoritism by the chancelleries) never have to provide quartering. In this respect other state peasant communities always enjoy greater freedom than we and suffer no oppression. These other communities, compared to ours, have two or three times as much land; yet, despite the fact their land is much greater than ours, [officials] of various ranks have taken our lands for their own use and built settlements on our lands. As a result, we have endured injustice; because of our land shortage and the poll-tax payments that we must make, we have become totally impoverished. We have filed petitions about the seizure of our lands, but have received no satisfaction. Moreover, as we state pleasants in Zubets, Rzhev and Staritskii districts (of Tver province) have suffered because our lands have been seized by force and occupied by the buildings of merchants in the towns. We suffer oppression because of our want.

2. Each year, we state peasants on these landed properties elect people to collect all the state taxes and to settle all kinds of disputes. The only disputes beyond their competence concern written matters under the Zubets, Rzhev and Staritskii chancelleries. But these chancelleries do not permit our elected officials to resolve disputes and collect all these matters in their own offices for judgement. Because these [provincial] centers are far away, and because these offices work slowly, many people do not obtain a settlement of their disputes; just a lot of people are kept under arrest. [We request] an order that, except for the most urgent written matters, these government chancelleries not handle petty disputes and that the peasants' elected officials be allowed to resolve these matters themselves.

3. With respect to billeting in the towns of Zubets, Rzhev and Staritskii, could Her Imperial Majesty not deign to order the construction (where the land for this suffices) of quarters for officers and lower military service people? [This could be financed] by poll-tax assessments, according to the number of souls, for the amount it costs; a levy for the amount, proportionate to the poll-tax on households, is deemed best. If this act of mercy does not come to

pass, the inhabitants will always have to suffer the greatest oppression and abuse. Out of pity for the inhabitants, and to free them from burdens, the Sovereign Emperor and Autocrat Peter the Great (to his blessed memory and glory) signed a decree on 26 June 1724 ordering, inter alia, the construction of such quarters (art. 19). The decree provided that households and quarters be built for soldiers and officers [by the army itself]; if there are no regiments [stationed in an area], the housing should be built by peasants and townspeople in the poll-tax registry. Timber for construction and other wood materials are to be delivered by entire districts. After 1738 and even to now, the army has been billeted in our towns of Zubets, Rzhev and Staritskii, whereas other districts—because of the immense size of our state—have had no troops or even officers (including the Ostashkov settlement in Rzhev district, which has more inhabitants and buildings than the district town of Rzhev). . . .

4. As for our economic condition, we state peasants are despised not only by the well-born nobility, but also by the lowliest state official. [We endure] every kind of physical abuse and affront to personal honor; with the monetary dues of our poll tax [and our corresponding low status], almost anyone—especially in the army—who wishes to inflict injury upon us can do so. They do this with the knowledge that a state peasant has neither the time nor the means to prosecute those who inflict such injury (not to mention the futility and expense of such efforts). If indeed a state peasant does file suit against such offenses, he does not obtain any satisfaction and only suffers losses. Therefore, to avoid abuse of state peasants in the future, could not it be ordered that if [nobles] injure or abuse an honorable state peasant, they must pay material compensation in accordance with the sums set to compensate nobles for injury to their honor? As people familiar with laws, the nobles should more than all refrain from acts contrary to the law and by their behavior set an example of good deeds for others. Other people who hold office but do not come from the nobility should be punished for physical abuse by a penalty or by a fine in the amount for insults inflicted on them. In this way abuses and attacks will be diminished.

5. When troops (per instructions of state chancelleries) march past these towns, they make demands for carting and materials from us, but not from noble estates. But a particular landed [community], because its various villages are remote, cannot satisfy [these demands]

immediately. In such cases, the regimental officers, together with state officials, subject the peasants and their elected officials to intolerable beatings, which leave some of them maimed and crippled. In the future, many will not have the resources to pay state taxes or to support themselves, and will become impoverished.

6. In the town of Zubets, the ferry over the rivers (Volga and Vozuz) is run by the local chancellery, and the officers and troops march here often. The chancellery summons us state peasants to ferry military people at peak work periods and resorts to coercion. As a result, we have been ruined both by the disruption in our work and by the physical beatings.

21. *Petition from Serfs in Kungurskii District (Perm Province) to Peter III (Pugachev)* [1774]

Most brilliant and autocratic Great Sovereign Peter Fedorovich, Autocrat of Little and White Russia, etc., etc.!

This declaration comes from the Guselinkova part of the village of Spasskoe in Kungurskii district, in the name of an entire community through its authorized representatives, Kornilo Prokopov'ev Shiriaev and Ustin Ananienich Medvidev. It addresses the following points:

1. By the grace of God, we have heard that Your Imperial Majesty— from the southern part of the country, in Orenburg province—has great strength. We praised God that our beautiful sun of old, after having been concealed beneath the soil, now rises from the east and wishes to radiate mercy on us, Your most humble and loyal slaves. We peasants bow to the ground [before You] in total unanimity.

2. We slaves, all the peasants in this community, most humbly petition for tsarist mercy from the military officers and do not wish to oppose [them]. Your Majesty did not declare his anger and punishment toward us, and we request that the commanding officers spare us of the destructive sword and that they obey Your Majesty's orders.

3. We also nourish the great hope that his tsarist majesty will mercifully spare us of vicious, wild, poisonous animals and break off

the sharp claws of the miscreants, the aristocrats and officers—like those in the Iugov state factories, Mikhail Ivanovich Bashmakov, also (in the city of Kungurov) Ivan Sidorovich Nikonov, Aleksei Semenovich Elchanov, and Dmitrii Popov. . . . These magnates make us indignant through their order that whoever invokes the name of the great Peter Fedorovich is a great evildoer and [to be punished] with death.

4. Therefore we slaves, all peasants, have sent reliable people to discover the truth about Your Majesty and to bow down before Your military commanders, not to resist them. Therefore, if you please, give them encouragement so that we slaves know of Your Tsarist Majesty's health, for which we slaves would have great jubilation.

5. Show Your merciful judgment upon our most humble petition, so that we suffer no damages from Your armies.

22. Petition from Serfs in Alatyr' District (Simbirsk Province) to Peter III (Pugachev) 20 June 1774

The peasant chieftain [burmistr], Vasilii Zakharov, and the elder Kuzma Egorov, together with the peasants of the village of Alafer'ev (Verkhomenskii Township, Alatyr' District), submit this petition to Peter Fedorovich [Peter III, alias Pugachev—ed.] The petition consists of the following:

1. We humbly petition You, merciful great sovereign Peter Fedorovich, that You deign to inform us what our condition is to be. We do not know what we are supposed to do; although You sent a military command to us, it did not announce Your will to us.

2. At present we have our squire's grain, as well as his horses and cattle, from the estate. What do You deign to order with regard to these things? What about the property in the squire's house? We ask You, Great Sovereign, to give a merciful order about this.

We also petition You, Great Sovereign, about the peasants in the village of Verkhnii Talyzin, who belonged to the same squire as we. These peasants were on quitrent, and we planted the squire's grain on their lands (which the squire had confiscated for his own use). But now these other peasants no longer belong to the squire and

refuse to give us the grain [that we cultivated]; however, this grain belongs to us, not them. We ask that you, great sovereign, issue an appropriate order.

23 June 1774.

[Postscript:] However, our estate, Great Sovereign, has many who are ruined, who do not have even the means to feed themselves, not to mention pay the poll-tax. And they ask You, Great Sovereign, for mercy—that it be ordered to give the squire's grain to us [for sustenance] and for spring planting. For this we, Your orphans, should eternally pray to God for the health of the great sovereign.

G. INDUSTRIAL WORKERS

Despite traditional images of Russia's industrial backwardness, in the 1760s the empire—by contemporary European standards—had a surprisingly high level of development, with small but important pockets of mining and manufacturing. Actively promoted by the state and a variety of entrepreneurs, the factory and plant sprang up in the very shadows of serfdom, as nobles and serfs—not just merchant entrepreneurs and free laborers—actively competed in this early phase of Russian industrial growth. But, as the complaints about labor shortages and demands for the right to purchase serfs suggest, Russia's first industrialists had serious difficulty finding labor in sufficient quantity and quality.

The early working class actually consisted of distinct subcategories—free laborers, seignioral serfs, attached peasants (state peasants consigned to work specific periods each year for industrial enterprises), and factory serfs (who belonged to a specific enterprise). Significantly, this contingent of early workers—despite its small size—already constituted one of the most volatile groups in Catherinean society, as their responsiveness to the Pugachev Rebellion in 1773–75 showed. In addition to the relatively rich documentation on early industrial disorders, the instructions from attached peasants to the Legislative Commission provide exceedingly rich data on the life and labor of Russia's early workers. Characteristic and revealing of their attitudes and expectations was the instruction from Kazan (doc. 23), which voiced protest not only against the onerous factory regime, but also dismay over the opportunity cost—it denied them the capacity either to support themselves or to hire substitute labor. The statement by workers at a copper-smelting plant in Perm (doc. 24) also provides a clear portrait of their condition and—like serfs seeking to become state peasants—vigorously protested their transfer from state to private management.

23. Instruction from Attached Peasants
in Kazan District
June 1767

1. In 1758 and 1759 Capt. Khostov of the Kazan Guberniia Chancellery assigned us to the newly established iron-works of His Excellency, Count Petr Ivanovich Shuvalov. The iron-works have since been transferred to the state jurisdiction of Her Imperial Majesty. We have worked there without interruption ever since and now live in various settlements, villages and hamlets (which, according to the third poll-tax census, encompass 18,000 male souls). Of this number, 350 men have been transferred as masters to the Kama plants; each of them was given five rubles for food and clothing by the community. There is a number of aged, incapacitated, underage and deceased, who are unfit not only to perform the assigned work but even to support themselves. Hence we have to send fit workers in their place to perform the state work; for this we have to pay each year 1.735 rubles per soul to those performing the work.

2. At the Votkin and Izhevsk state iron-works, we perform the following work. We cut wood by the cubic *sazhen'* [49 cubic feet] for making charcoal; five to six days work (one cubic *sazhen'*) is reckoned by the treasury at 25 kopecks a person. We continually haul earth to a dam more than a verst away. A man with a horse, for five or six days work, is reckoned at 30 kopecks; a man without a horse is figured at 5 kopecks in the summer, 4 kopecks in the winter. We haul the timber to a woodcutter, stack it in piles of 20 cubic *sazhen'*, and cover this with manure and soil. Two men with horses work at this for a minimum of three weeks; two women toil constantly on these mounds for a minimum of seven weeks. This labor is reckoned at just 3.40 rubles per mound. If someone is ill or has to plant his fields to feed himself, or if (because of the distant location and the long time spent traveling back and forth) we cannot manage to do the work ourselves, we are forced to hire outsiders at very expensive rates, namely: 50 kopecks a cubic *sazhen'* for cutting timber, 1 ruble a cubic *sazhen'* for hauling the earth, 20 kopecks a day for men (without horses) to do the stacking, sodding and covering with earth; 7 rubles and more per stack for burning and breaking

up the charcoal. Hence per mound we spend 9 rubles for two persons.

3. For the operation of those plants, we haul the charcoal from various kilns located at least 22.4 kilometers from the plants. For this distance, the treasury reckons the work at just 8 kopecks per load (or 6 kopecks for 16 km, and 3 kopecks from 7.5 km). The [longest] distance takes a man and horse, using the best roads, two days for a round trip in the winter; other distances take varying amounts of time, depending upon the quality of the horse—perhaps a day or two days for weaker horses. Anyone who is ill and cannot haul the charcoal is forced by the factory office to hire day-laborers at an expensive rate: 50 kopecks per load for 21 to 26 km (or 25 kopecks for half a load, regardless of the distance). To haul the factory's charcoal in the winter we purchase hay at 50 kopecks per load. Some lack the means not only to feed their horses but even to support themselves, and consequently their horses die of starvation, for we are paid very small sums for all our work. We suffer ruination especially from hiring others to do the work.

4. On 23 February 1767, four hundred eighty attached peasants were sent from our settlements for the trip from the Osliansk and Dokshinsk piers on the ships with pig-iron. They arrived with the flotilla on May 8, and the treasury paid them 2.20 rubles per man. Just as many men were demanded [for this work] in previous years, too. Our settlements are located 640 km and more from the Oslansk piers; in addition to the labor required for the plants, 310 men have been demanded. The journey with the ships carrying iron up the Volga to the fishing villages takes place at the best time of the year, when we harvest the spring wheat and make hay.

5. We are sent each year to haul pig-iron at the above government plants, and we pull the ships up the Siva and Votka rivers to the plants. This hauling and unloading occurs at the peak times for plowing and planting (i.e., in May) [and lasts] for six or seven weeks. As a result, many are unable to cultivate their land to raise crops and have become impoverished; the annual payment for pulling these ships and for unloading the pig-iron at the plant is 60 kopecks per man. Our people in Saralinsk are required to send 120 men each year for this work; other villages must send an equal number. If someone is sick or unwilling to forgo planting his grain and starve, he hires someone else to do the hauling at 3 to 4 rubles per man.

6. Iron from the Votkinsk plant is shipped to the Kama River (via the Votka and Siva rivers) by peasants in our settlement of Saralinsk and other peasants attached to the Votkinsk plant. The delivery of the products and loads on those ships takes two weeks to reach the Kama River. The treasury pays each man twenty kopecks, but to hire others to do this work, we pay 1.50 rubles per man. In addition, the Votkinsk plant requires our Saralinsk settlement to provide 2,750 pounds [44,990 kg.] of bast this year (we delivered the same amount in previous years). Because of the mandatory factory labor we cannot provide the bast ourselves, and each year purchase the bast for 9 kopecks a pood—but are paid only 2 kopecks per pood of bast. Our settlements are distant and it takes ten or more days to reach the plant. But this is not taken into account by the [1724] poll-tax manifesto: we perform all the factory work for the poll-tax assessment at the rate of 1.40 rubles per man, and the plant office demands that we pay the balance of 33.5 kopecks [of the poll tax].

7. For the operation of the Votkinsk and Izhevsk plants, we deliver each year from our attached villages 7,000 buckets [each *vedro* or bucket equals 12.3 litres] of tar per year. Because we do not have suitable woods of our own, we buy the tar at high prices, which (including delivery to the plants) costs 25 kopecks a bucket. But a bucket is reckoned at only 3.5 kopecks by the plant.

8. From the moment we were assigned to these plants in Votkinsk and Izhevsk, we subjects (the most humble slaves named below) have performed this factory work for both the fit and unfit—the elderly, incapacitated, underage, blind and deceased. In addition, they send us at the peak work times of the year, do not permit us to do our peasant [agricultural] work, and although they do let us go home, it is only for short periods: so we are constantly in transit. As a result, it is impossible to do our own work at home. Although some settlements plant small quantities of grain to feed themselves, we are not permitted to harvest during work periods at the factory. As a result, some did not raise any grain, lost their homes and for the sake of sustenance remain permanently at the factories. Consequently, they not only cannot pay their poll taxes, but are able to feed themselves only with great difficulty. As a result of the burdens imposed here, many—the majority—work in the plants and have fallen into extreme poverty and hardship.

24. Instruction from Workers at a Copper Plant in Perm Province March 1767

1. In accordance with imperial law, we the undersigned were drafted from the rural state peasantry for military service. But by these decrees we were taken and assigned to various shops at state factories in Siberia and Perm. Others were taken from the soldiers of garrison troops in Siberia and Kazan guberniia and assigned to various plant shops when these were first opened (i.e., from 1722). Male children who are born to them and us have been (and are still being) assigned to the same shops and works where we have been permanently attached. Previous decrees put neither us nor our children in the poll-tax registry at the plants, but the last general census revision (1747) placed us and our sons in the poll tax at 71.5 kopecks, which we have paid ever since. Then, except for our young children (who were not registered in the poll tax until 1747), a decree from the chancellery of the main plant administration set payment for older servitors at 1.12 rubles until the present revision (i.e., the second half of 1764); only from then until now have we been paying 70 kopecks. But according to a decree of the Governing Senate, those who are at plants and factories—regardless of rank or station—are not to be placed in the poll tax; according to point 5 of the current census, we should not be put on the poll-tax rolls. The poll-tax assessments are rigorously collected by the plants here in Iugov. We have, however, no land to raise grain; indeed, according to the law, we are neither to possess arable land nor to engage in commerce of any form (on pain of a substantial fine and corporal punishment), but to support ourselves through fixed earnings [at the plant]. Yet, in accordance with that census, the poll-tax levies—as well as the conscription of recruits and dragoon horses (when levied)—are all assessed on us. We were paid a salary according to the days worked; until the Iugov plants were transferred to private management, these monetary wages were faithfully paid according to rank and achievements (per a schedule issued by the Governing Senate in 1737); furthermore, we were given rest from work on Sundays, holidays and state festival days. If anyone, by the will of God, fell ill, he received

one-half of his wages for support. If anyone was injured at work and unable to work as a result, he received full support until he was able to work again.

2. According to a decree by the Sovereign, Empress Elizabeth Petrovna (of blessed and eternal glory), on 17 September 1757, the state plants in Iugov were transferred to private management under His Excellency, Ivan Grigor'evich Chernyshev. It was ordered that the plants and we remain on the same terms as under state management. But His Excellency's representative, collegiate assessor Fedor Sannikov, changed the salary schedule set for us and prescribed for all a piece-rate wage, which gives less for each workday than the legal salary had. This wage hardly suffices for the most modest food for us, our wives and our children; we perpetually suffer great want in our clothing and footwear and have come into the most extreme ruin and destitution. Those who do not work on Sundays, holidays and state holidays, or by the will of God fall ill or become incapacitated through an accident at work, receive no payment whatsoever. Moreover, because of this small wage, substantial arrears in our poll taxes have piled up. Although Count Ivan Grigor'evich Chernyshev's representative at the Iugov plant tirelessly seeks to collect these arrears, the only way we can pay them is through deductions from our piece-rate wages. Many (to speak only of the elderly and incapacitated) can no longer work in the plant or anywhere else; hence they do not work and support themselves by begging. The poll-tax assessment (both past arears and that due for the current year) is levied upon those now present, but we cannot pay even for ourselves and our underage sons, let alone the others. Elderly and incapacitated workers, according to the law, should be released from work: when the plants were under state management, many had already retired from work because of old age and incapacitation. But Sannikov paid no attention to these retirements and assigned these people to work; because of illness, however, they do not work. Hence the current poll-tax census should not have inscribed them in the registry, but listed them as retired and in the almshouse. But the poll-tax census-takers, upon Sannikov's instructions, listed them as capable of working and healthy, not as retired and in the almshouse. With respect to the poll-tax, might it not be ordered (per previous decrees, as indicated in pt. 5 of the census) that we be removed from the registry and left as previous decrees ordered?

H. MINORITIES AND WOMEN

Ethnic and religion minorities, alien subsocieties in an empire officially Russian and Orthodox, had been known in medieval Muscovy, but their number, diversity and distinctiveness sharply increased in the modern era. Religion was still a primary factor in defining ethnic identity and the legal status of sundry communities—schismatics (Old Believers), Moslems, pagans, and non-Orthodox Christians. These groups had long-standing grievances and no doubt felt encouraged to press their demands in the more enlightened era of Catherine the Great, who took important measures to improve the status of these domestic outsiders. As the instructions from such groups as Old Believers (doc. 25) and Tatar Moslems (doc. 26) make clear, both deeply resented religious persecution, demanded not only freedom but respect, and raised their expectations vis-à-vis the state. More complex still was the status of Jews, long excluded from immigration, but suddenly—as a consequence of the Polish Partitions (1772–95)—entering the empire in large numbers. Thus commenced a difficult relationship, profoundly affected by mutual animosities and local traditions of Judaeophobia that bred suspicions of "blood sacrifice" (doc. 27) and eventually provided anti-semitic stereotypes to shape official thought and policy in St. Petersburg. But, at least in earlier phases, the problem of Jewish integration derived less from religious bias in the capital than from the broader phenomenon found throughout the empire—the tension between universalistic, leveling aims of enlightened despotism and local traditions and prerogatives. Thus the Jews in Belorussia had traditionally had the right to distill and sell spirits; when the government decided to enforce the nobility's monopoly over this important economic enterprise, the Jewish communities appealed—on the basis of local tradition—for recognition of their special rights (doc. 28).

Women—in contrast to minority communities—possessed neither traditional corporate status nor practical opportunities to articulate

their interests and grievances. Though Russian law carefully distinguished gender and in certain respects even accorded them unusual privilege by European standards (most notably, in the property rights of noble women), neither statute nor the Legislative Commission gave women an opportunity to draft collective statements. But some insight into the life of an educated noblewoman is afforded by a petition of 1768 (doc. 29), which describes not only her marriage but indirectly articulates the normative role of women to justify her appeal for formal separation.

25. Instruction from Old Believer Community (Chernigov Province) [1767]

1. From the very inception of these villages (located in the Starodub and Chernigov Ukrainian regiments), the original inhabitants of these villages (our forefathers) built prayer chapels, where vespers, matins and the Hours were performed (and still are) according to the old-style Muscovite [liturgical] books. [We ask] that we be expressly permitted to assemble unimpeded in the future to hold prayer services before God.

2. In 1715, in accordance with a personal decree of the Sovereign Emperor and All-Russian Autocrat Peter the Great (of blessed and eternally glorious memory), these villages were inventoried and their description put in state fiscal records. These included priests, monks and nuns; the priests conducted church services (except the liturgy) without [external] interference at these chapels. But after Colonel Radishchev and others arrived in Starodub, restrictions were imposed and various detachments were sent in: flight ensued and the above priests, monks and nuns fled in large numbers from these villages to Polish and Turkish territories. Now, during the successful reign of Her Imperial Majesty, in 1762 and afterwards, Her Imperial Majesty published most merciful manifestos regarding the return [of fugitives] from abroad and the permission of church services. The priests and monks of our community returned from abroad, and other laymen also came back in considerable numbers to live in local villages. All have been inscribed in the poll-tax books and in the revision

records. We request that these priests be allowed to perform freely matins, vespers and prayer services in the chapels and also to conduct the service of the divine liturgy and other church services in the churches brought from abroad (from the village Vetka), with the permission of the Russian military command under Major-General Maslov, and erected near the villages of Klimov and Matkouka. A report on this has been presented to the Regional [Guberniia] Chancellery in Kiev.

26. Instruction from Tatar Nobles in Kazan Province [1767]

[Non-religious demands are omitted.—ed.] . . . 12. We the undersigned believe that nothing is more offensive to a person, regardless of his faith and rank, than to suffer disrespect and insults toward his religion. This makes one extremely agitated and provokes unnecessary words of abuse. But it often happens that people of various ranks say extremely contemptuous things about our religion and our prophet (also during our religious worship), and this is a great affront for us. Therefore, we request a law that anyone who curses our religion be held legally accountable (in a manner that the commission for the preparation of a new law code sees fit.) [We further ask] that we Tatars and nobles not be forced to convert to Orthodoxy, but that only those who so wish (in accordance with petitions that they file themselves in government offices) be baptized. . . .

15. If any of our people are voluntarily baptized into the faith of the Greek confession, they should be ordered to move to settlements with Russians and converts the very same year in which the conversion takes place; meanwhile they are to remain in the poll-tax under our name, but for less than a quarter share. We ask that, under no circumstances, are converts to be permitted to sell their houses, garden plots, and hayland to Russians or people of other ranks, but are to sell only to us Tatars; they must sell either to unconverted kinsmen or other Tatars. For this it could be ordered that households and garden plots in our settlements (according to square meters), as well as haylands near these settlements in Kazan, be evalu-

ated in terms of hay yield (in accordance with the Law Code of 1649 and other decrees) so that, when the converted people resettle, they will be satisfied with the compensation and raise no disputes. Also, without a special personal order from Her Imperial Majesty, no churches should be built in our suburbs and thereby put pressure upon us. And if anyone constructs a church in our settlements without a decree of Her Imperial Majesty, could not a decree be issued against this while the law code is still in preparation?

27. Complaint by Brusilov Kahal (Kiev Province) 10 June 1768

Itsko Leibovich, an inhabitant of the town of Brusilov, in the name of the entire *kahal* of Brusilov filed a complaint at the Zhitomir city office against Antonii Vaskovskii of Ezerchan because, on 4 March 1768 in Kiev, he accused the Jews of Brusilov of causing the death of his son. The latter apparently became lost in a woods, could not find his father, died of starvation and afterwards was bitten all over by ants. When his body was found eight days later, Vaskovskii sought to blame the Jews for the death of his son. When the people who prepared the child's body [for burial] did not corroborate [his accusation], he appealed to other people and, with their support, seeks to blackmail the Brusilov Kahal into making payments.

28. Petition from Belorussian Jews [1784]

1. Some [Belorussian Jews] who live in towns engage in trade and, especially, in the distillation of spirits, beer and mead, which they sell wholesale and retail. This privilege was also extended to them when Beloroussia joined the Russian Empire [in the partitions]. Hence everyone active in this business used all their resources to construct buildings suitable for distillation and pursuit of this trade in the cities. After the Belorussian region joined the Russian Empire, the Jews in some towns constructed more of these in the same fash-

ion and at great expense. The imperial monarchical decree [on Jews] emboldens them to request tearfully some monarchical mercy.

2. According to an ancient custom, when the squires built a new village, they summoned the Jews to reside there and gave them certain privileges for several years and the permanent liberty to distill spirits, brew beer and mead, and sell these drinks. On this basis, the Jews built houses and distillation plants at considerable expense. The squires, at their own volition, farmed out the inns to Jews, with the freedom to distill and sell liquor. As a result, the head of the household and his family employed other poor [people] and paid their taxes. A new decree of Her Imperial Majesty on 3 May 1783, reserved [this right] of the squires to their hamlets and villages. But a decree of the governor-general of Belorussia has now forbidden the squires to farm out distillation in their villages to Jews, even if the squires want to do this. As a result, the poor Jews who built houses in small villages and promoted both this trade and distillation have been deprived of these and left completely impoverished. But until all the Jewish people are totally ruined, the Jewish merchants suffer restraints equally with the poor rural Jews, since their law obliges them to assist all who share their religious faith. They therefore request an imperial decree authorizing the squire, if he wishes, to farm out distillation to Jews in rural areas.

3. Although, with Her Imperial Majesty's permission, Jews may be elected as officials, per the imperial statute on provincial administration), Jews are allotted fewer votes than other people and hence no Jew can ever attain office. Consequently, Jews have no one to defend them in courts and find themselves in a desperate situation—given their fear and ignorance of Russian—in case of misfortune, even if innocent. To consummate all the good already bestowed, Jews dare to petition that an equal number of electors be required from Jews as from others (or, at least, that in matters involving Jews and non-Jews, a representative from the Jewish community hold equal rights with non-Jews, be present to accompany Jews in court, and attend the interrogation of Jews). But cases involving only Jews (except for promissory notes and debts) should be handled solely in Jewish courts, because Jews assume obligations among themselves, make agreements and conclude all kinds of deals in the Jewish language and in accordance with Jewish rites and law (which are not known to others). Moreover, those who transgress their laws and order

should be judged in Jewish courts. Similarly, preserve intact all their customs and holidays in the spirit of their faith, as is mercifully assured in the imperial manifesto. . . .

29. *Petition from Russian Noblewoman August 1768*

This petition comes from Aleksandra Ivanovna Krotkaia, the wife of Life-Guards Captain Vasilii Fedorovich Karamyshev and the daughter of Ivan Krotkii, and addresses the following points:

1. In 1762 I was given in marriage by my father, court councillor Ivan Egorovich Krotkii, to the husband named above.

2. Prior to our wedding, my husband did not have the slightest affection and love for me (as became apparent from his subsequent behavior), but his sole aim in marrying me was to exercise his rights as my husband and to enjoy the landed estate which my father deigned to grant me. That is exactly what happened: after we married, he not only did not leave his mistress (his serf girl Dar'ia Moiseeva, who had been such prior to our marriage), but with no shame or sense of decency, and to vex and humiliate me, he treated her like his legal wife. And all the time he constantly subjected me to every conceivable mistreatment.

3. No matter how insulting such behavior may have been, I tried to conceal my feelings from my husband, and always sought to perform the duties of love and respect that are required of me by law. I continued to hope that, by being patient and by submitting completely to his will and wishes, even if I could not elicit mutual love toward me (in accordance with our marital union), then at least I could make him feel pity for my condition. But all this only made him even more brutal and unfeeling. Thus, in spite of everything, he subjected me to even greater mistreatment: he was not content to have the serf girl occupy my place as his legal wife, but to satisfy his wild lust and passion, went to my estate [where he] forcibly took wives from husbands and daughters from fathers (including underage girls) and raped them. I can prove all this with incontrovertible evidence.

4. For the four harrowing years that I lived with him, the words

simply do not exist to describe all the vexation and disappointment that I experienced at my husband's hands. So that my patience is now fully exhausted. No matter how much I wished to remain patient, I could see that I lack the strength to restrain his gross misconduct and therefore—under the pretext of visiting my mother—had to leave my husband.

So may Your Imperial Majesty have the Most Holy Governing Synod accept my petition with regard to the adultery committed by my husband with his serf girl Dar'ia Moiseeva and with others, and for the unendurable maltreatment. And order that I the undersigned be separated from him and be permitted to live a peaceful secure life until the end of my days on my estate. My husband is presently now at his village in Moscow District, in the village of Nikol'skoe.

Most merciful Empress, I ask Your Imperial Majesty to have a decision made on my petition. August, 1768. (For submission to the Most Holy Governing Synod.) [Signed:] Aleksandra Ivanovna Krotkaia.

Part Two

The Era of Great Reforms: Society in the 1860s

The catastrophic debacle of the Crimean War, which coincided with the death of Nicholas I and the accession of Alexander II to the throne, heralded the onset of the "Great Reforms" in Russia. In traditional historiography, which tended to idealize reform in general and the "Great Reforms" in particular (as the very terminology suggests), this era forms the main watershed in Russian history between the Petrine reforms of the early eighteenth century and the great revolutions of the early twentieth. The list of statutes is impressive—emancipation of serfs (1861), the new liberal censorship regulations (1865), the establishment of a new organ of self-government called the *zemstvo* (1864), reorganization of urban government (1870), the radical reconstruction of the judiciary after Western models (1864), and a complex series of measures to improve the army, church, police, education, and many other public and private institutions in the empire. Such reforms, inevitably, affected not only institutions but also their subsidiary corporate groups—the legal estates subordinate to each institution, from Cossacks to Jews, from state peasants to priests.

No less important than the terms of reform was its process: society, not just the bureaucracy, was summoned to help draft and implement these reforms. Party because the Crimean debacle had

shattered the bureaucracy's erstwhile self-confidence, partly because liberal officials wanted to "awaken" public initiative, and partly because the state simply lacked the resources to finance reform and renovation, the government consciously—if circumspectly—drew society into the reform process. That marked a dramatic break with previous practice, but even hardened bureaucrats admitted their ignorance of local conditions and the need to rely upon society for concrete knowledge and new resources. Hence the government published preliminary drafts of reforms and invited society to comment, both through the press and various local committees. That kind of *glasnost'* [publicity], at least within limits, precipitated the first relatively open and broad-based discussion since Catherine's Legislative Commission a century earlier. At the same time, authorities actively summoned society—by forming official commissions, by facilitating the formation of private societies—to establish formal associations that could address common problems and articulate, in an authoritative manner, the special needs and interests of the particular group. Although nothing like Catherine's Commission or the later Duma existed, most groups took advantage of the reformist atmosphere and openness to express their particular aspirations and grievances.

To be sure, not all had equal opportunity or facility to respond; none had the special advantage of the nobility, whose corporate assemblies provided a natural instrument to express their collective opinion. But through special ad hoc committees, the regular press, and illegal underground publications, most groups found substantial opportunities to voice their consent, dismay and wishes. Compared to the 1760s, the social order had become enormously more complex, with entirely new categories or very different meanings for old ones; engineers and women, priests and officers—virtually silent a century before, now began to address the regime or society under these identities and—tactfully, but not obsequiously—to seek legal recognition and improvement in their condition.

A. NOBILITY

The emancipation of serfs, from the emperor's first confidential intimations in 1856 to its promulgation and implementation five years later, dramatically changed the nobility's attitudes toward the government. Despite some early pledges to accord the nobility a role in framing the legislation, their hostility to emancipation and pursuit of naked self-interest finally impelled authorities to draft the emancipation statutes with only minimal participation by the various provincial committees of the nobility. No less offensive than the politics of emancipation were its terms, above all the complex scheme for a transitional period of continued noble-serf relations. By the end of 1861, when the nobility assembled in various provinces to elect new marshals and discuss various issues, the Minister of the Interior justifiably feared an eruption of discontent.

He was not disappointed. Indeed, many nobles not only remonstrated about the terms of emancipation but also raised a shocking demand for political reform—a shift of power from the bureaucracy to "society." The most famous declaration emanated from the nobility in Tver, a bastion of gentry liberalism that had already earned notoriety for its role in the struggle for emancipation; its address (doc. 30), while careful to observe proprieties toward the emperor, subjected the bureaucracy and top officials to scathing criticism. The address from Moscow (doc. 31) was somewhat more tempered but nonetheless concluded that only a national assembly could prevent the repetition of such misrule in the future. The Moscow nobility, even as it espoused ostensibly liberal political demands, nonetheless sought to protect their own economic interests—as their resolution of the problem of rural labor (doc. 32) unambiguously reveals. Other noble assemblies, as in Tula (doc. 33) and Smolensk (doc. 34), showed more caution, yet did not conceal their belief that only a change in the political order, with greater acknowledgment of local interest and representation, could ensure legislation that was effective and feasible.

30. Address of the Tver Noble Assembly February 1862

Having assembled for the first time since the legislation of 19 February 1861 [on serf emancipation] was published, the nobility of Tver expresses its greetings to the Russian Tsar who undertook to free the peasants and to excoriate every injustice in the Russian land. The nobility of Tver solemnly avows its sincere affection for Your Imperial Majesty and its readiness to follow You on the pathway to prosperity for the Russian people. As proof of our readiness and complete trust in the person of Your Imperial Majesty, we have decided to make a sincere statement of our ideas for Your consideration, without any deception and concealment.

The manifesto of 19 February, which proclaimed the people's freedom, improved the peasants' material welfare somewhat, but did not free them from servile dependency; nor did it eliminate all the lawlessness caused by serfdom. The people's common sense cannot reconcile the freedom proclaimed by Your Majesty with the current obligatory ties to the squires, with the artificial separation of social estates. The people see that, in time, they can become free of obligatory labor, but must forever pay quitrent, which is now shifted to the authority of those same squires, [now] called peace mediators.

Sovereign! We sincerely admit that we ourselves do not understand the Statute [of Emancipation]. Such enormous confusion puts [our] entire society in a hopeless situation, which threatens to destroy the state. What prevents elimination of this situation?

We not only do not regard the obligatory conferral of landed property to the peasants as an infringement on our rights, but consider this the sole means to guarantee the tranquillity of the country and our own propertied interests. We ask that this measure be immediately implemented through the general resources of the state, without placing the entire burden on the peasants alone, who are less responsible than all other social estates for the existence of serfdom. The nobility, by virtue of its social privileges, has thus far been exempt from fulfilling the most important civic duties. Sire! We consider it a mortal sin to live and enjoy the benefits of the public order at the expense of other estates. No order can be just if the poor man pays

a ruble and the rich man not a single kopeck. This could be tolerated only under serfdom, but it now places us in the position of parasites, who are completely useless to their fatherland. We do not wish to retain any longer such disgraceful privilege, and we do not accept responsibility for its further existence. We most loyally request Your Majesty's permission to assume a share of the state taxes and obligations, according to the wealth of each. Besides property privileges, we enjoy the exclusive right of providing men to govern the people. In the present day we deem this exclusive right unlawful and ask that it be extended to all social estates.

Most Gracious Sovereign! We firmly believe that You sincerely desire the well-being of Russia, and therefore consider it our sacred duty to state frankly that between us and Your Imperial Majesty's government there exists a strange misunderstanding that prevents the realization of Your good intentions!

Instead of that true realization of freedom that You promised the Russian people, high officials have devised a "temporary-obligated status" that is intolerable for both the peasants and squires. Instead of a simultaneous and obligatory transformation of the serfs into free and independent property-owners, the dignitaries have invented a system of voluntary agreements that threatens to reduce both peasants and squires to complete ruin. They now find it necessary to maintain the privileges of the nobility, whereas we ourselves, who are more concerned about this than anyone else, desire that these be abolished. This universal discord serves as the best evidence that the reforms now so urgently required cannot be achieved by a bureaucratic order. We ourselves do not presume to speak for the entire people, despite the fact that we are closest to them. And we are firmly convinced that good intentions alone are insufficient, not only to satisfy, but even to identify the people's needs. We are convinced that all the reforms will fail because they are being undertaken without the consent and knowledge of the people.

A convocation of elected representatives from all the Russian land represents the only means for a satisfactory solution that was outlined, but not achieved, by the Statute of 19 February [1861]. In presenting this petition to Your Imperial Majesty to consider convoking an assembly of the land, we hope that the Tver nobility's sincere desire for the general good will not be subjected to perverse interpretation.

31. Address of the Moscow Noble Assembly
January 1862

Most Gracious Sovereign! Moved by love of the fatherland, the Moscow nobility have many times had the joy of proving this love by serving the state in moments of grave trial. Still fresh in our memory is the unforgettable year of 1812, and the arrival of Your Most August namesake [Alexander I] in the original capital [Moscow] when the enemy unexpectedly invaded the territory of the empire. Confident of Moscow's sympathy, Emperor Alexander I appealed then to our nobility and called upon it to save the fatherland. The emperor's voice touched the hearts of his loyal subjects. Both money and troops appeared within a few hours as Moscow rose up—and, after her, the rest of Russia. Our fatherland came from the struggle with glory, and the state became more powerful than ever.

But then the threat was an external enemy. Now the threat comes from an internal, no less potent, danger as some kind of ferment reigns at all levels of society; the laws are not strictly observed; neither person nor property is secure from arbitrary administration; social estates are pitted against each other and their mutual antagonism steadily increases because of actions by administrative officials that do not satisfy local needs. There is also a complete lack of money, fear of a state financial crisis (expressed in the instability of the currency), a complete lack of credit, and finally a multitude of false rumors that agitate people's minds. That, in a few words, is our present situation. Out of love for the fatherland and devotion to the throne, the nobility of Moscow deem themselves duty-bound to speak out to their Sovereign.

The cornerstone of all abuses has been removed: serfdom has been abolished. But there is still much to do in order to rebuild the shaken edifice of the state on firm foundations. To root out evil, to march forward behind their Sovereign along the path of peaceful reforms in order to satisfy society's needs, to establish complete order, to prevent any possibility of disorder in the future—such are the wishes of the Moscow nobility, and they address themselves to their Sovereign and submit for His consideration the following measures, which can extract our fatherland from its difficult position:

1. The greatest possible expansion of the elective principle in state service, and greater scope for local self-government. In addition: strict observance of the laws, not only by subordinates but also by superior authorities; and strict personal accountability and responsibility before the law for each and every official in state service.

2. Security of personal and property rights for all citizens of the state through the introduction of verbal and public court procedure and a jury court.

3. Elimination of hostile relations between the nobility and their peasants by means of obligatory, immediate separation of resources, simultaneous with grant of land charters, securement of quitrent [*obrok*] and redemption payments by the government (with a guarantee for the entire amount, not of 80 percent).

4. Publication of state debts and the budget for state revenues and expenditures in order to allay fears of financial crisis.

5. Public discussion in the press of questions in all spheres where the government contemplates changes (in conjunction with the impending administrative and economic reforms).

Here are the means that can promote the well-being of our fatherland. Your Imperial Majesty has many times turned confidently to Your devoted nobility, who have always responded zealously to their sovereign's call.

Sire! You have said many times: "I trust you, have trust in Me." And the nobility has always confidently awaited the fulfillment of their Tsar's beneficent undertakings. In this difficult moment they are once again ready to become a firm support for the Russian throne and, with all their strength, to assist their Sovereign in fulfilling His beneficent intentions. With this aim, the Moscow nobility most humbly request that Your Imperial Majesty permit them to elect a committee from among their midst: to discuss the main principles upon which future regulations on [noble] elections should be based, to review the statute on local obligations and dues, and to discuss the question of rural credit and local needs. Deputies from other social estates should join in [this committee's] work, for these questions concern the entire rural population. The committee's work [then should be] reviewed by a general assembly of elected persons from all social estates of the realm, summoned from the provinces to Moscow (that city being the heart of Russia) and then submitted to the good judgment of Your Imperial Majesty.

32. Moscow Noble Assembly: Rural Labor Reform December 1861

[Response to a query from the Ministry of Interior about legal measures required to regulate the employment of free hired labor]

With regard to the question of rules for the employment of rural laborers, the nobility of Moscow province finds that the main difficulties encountered in hiring people from the free social estates consist in the following: the poor organization of the system for internal passports; nonobservance of laws through arbitrary implementation; the failure to punish free workers for violating their employment terms, their [premature] departure, and their deviation from voluntarily assumed obligations; the illegal organization of strikes; the enticement of workers by other employers; and, finally, the inactivity of state authorities in exposing abuses. These causes, together with others, have brought a halt to the development of argiculture (and, to some extent, manufacturing), and if appropriate measures are not promptly taken, could completely ruin the landowners. New legislation, together with its strict enforcement, are now most urgently needed and the nobility of Moscow province therefore presents to the government for its consideration the following changes in the laws, which, in its opinion, are necessary: (1) replacement of the passport system with labor books (without time limits); (2) new strict laws to restrain workers from willful behavior; (3) conferral of greater rights to peace mediators to make a final resolution of disputes between workers and employers, and strict accountability of officials who fail to perform their duties; (4) prompt assessment of fines from employers found guilty of selfish enticement of laborers; (5) application of article 188 of the General Statute on Peasants and articles 247 and 264 (pt. 3) of the local statute to workers who are indebted [to their employer].

33. Address to the Tsar from the Tula Noble Assembly 22 December 1861

Most gracious Sovereign!

On the basis of the Imperially conferred right of the Russian nobility to confer about their needs and to make the most humble representations about these to the Monarch himself, the nobility of Tula makes bold to submit for Your Imperial Majesty's most merciful consideration the plight in which the nobility now finds itself.

The Statute on temporarily obligated peasants and house servants has thus far proven unsatisfactory. The difficulties and conflict of interest ensuing therefrom have undermined the economy, sown fatal discord between peasants and noble landowners, and caused incalculable harm to agriculture, which constitutes the main source of national wealth of Your Majesty's vast empire.

The nobles, deprived of more than half of their land in return for quitrent that does not correspond to its value, have no possibility of obtaining an income from the land left in their possession, because obligatory labor by free people is nonsensical. Nor is the use of hired labor profitable, given the surplus land alloted [the peasants at emancipation]. As a result, the volume of grain brought to market has declined and will continue to do so. Losses to the state are inevitable. If one takes into account the rapid destruction of forests (which their owners cannot defend) and the destruction of numerous factories and various kinds of industrial and economic enterprises (which their owners lack the means to sustain), then the damage to the state's economic power will be incalculable. And the noble estate, which always precedes all other estates along the pathway of enlightenment and good intentions, is innocently heading toward its final ruin.

To alleviate so deplorable a condition and to avert disastrous consequences in the future (which are by no means something remote), the nobility of Tula have no other recourse than to petition most humbly before the throne of their magnanimous Monarch for the following:

1. Permission to transfer peasants from labor dues to quitrent,

with or without their consent, under state guarantee of the quitrent, in order to eliminate as soon as possible the daily conflicts and to establish peaceful relations between noble landowners and peasants, which is vital for both parties.

2. Permission for prompt separation of economic resources; without this, proper cultivation (both by landowners and peasants) and redemption itself are impossible.

3. Sale of peasant allotments to the treasury by landowners if the peasants themselves do not wish to acquire this allotment. Redemption of a reduced allotment (in the full amount set by the Statute, without the 25 percent deduction), with transfer of the debt to credit institutions, will not cause the government hardship, for the debt is guaranteed by the peasant quitrent. Payment of the balance [after the deduction of outstanding debts] could be made, in lieu of the prescribed certificates, through special 5 percent notes, which would be liquidated through the sale of various kinds of state properties as well as usual means. Permit those landowners who do not wish to sell peasant allotments to the treasury to shift their debt to credit institutions (after the other remaining noble lands have been freed from mortgages). Until this is resolved, suspend the sale of estates in arrears.

4. The fastest possible grant of sums owed to extremely needy, small noble landowners (as due them according to the Statute) and transfer of peasant allotments to the state or of peasants to state land.

Finally, for the welfare and tranquillity of the state, for the well-being of all the citizens of Your Imperial Majesty, it is necessary to eliminate in future legislation those aspects that have so often been found to be unrealizable. The sole way to achieve this is to establish, in place of separate commissions preparing proposals for various aspects of state reform, a single commission and to appoint members (through election in each province) at least several landowners, who will be joined by experts from those parts of the administration affected by the legislation being planned. Such a commission should have the right to present its drafts of proposed laws directly for consideration by Your Imperial Majesty. Only in this way can our legislation satisfy the essential needs of the people, promote development of all its moral and material forces, and correspond to the local conditions of the country for which they are designated.

Most gracious Sovereign! With feelings of boundless devotion and

firm trust in the magnanimity of the Monarch-Liberator, the nobility of Tula most humbly present their most urgent needs for consideration by Your Imperial Majesty and raise sincere prayers to the throne of the Almighty. May our Fatherland prosper on the path of the reforms undertaken by Your Majesty, through the peaceful and legal path for the benefit of Russia and for the everlasting glory of its beloved Monarch.

34. Resolutions of the Smolensk Noble Assembly 5 December 1861

On 5 December 1861 the provincial assembly of the Smolensk nobility heard the report on questions raised in a memorandum from the governor on 21 November and, with the Emperor's consent, presented for the nobility's consideration. The questions pertain to changes in the statute on local elections, the administration of local obligations, the establishment of land credit and medical care, and the employment of free labor. After hearing the report, the assembly took note of the following circumstances:

1. The promulgation of a single set of general principles is inadequate for a full and satisfactory resolution of the questions submitted for deliberation by the nobility, because knowledge of local conditions, the needs of agriculture and local administration of public affairs are still more required for the preparation of details. Hence it is desirable to compare the detailed proposals of people who have a close knowledge of local needs, advantages and interests.

2. To establish order in local affairs and agricultural relations, it is equally important to combine and supplement the above questions with others. It is absolutely vital that the nobility's opinion be expressed with due fullness and coherence, and that their proposals embrace all dimensions of rural life and the governance of local interests.

3. Because the proposals of the nobility from various provinces may contain divergences on any given question, it is desirable to find a means to reconcile the drafts from different provinces so that the general project, so far as possible, satisfies the needs of various localities.

After reflection on the above circumstances, the provincial assembly resolved:

1. To elect a special commission of twelve men (one for each district in Smolensk province), charged with compiling detailed proposals by the end of 1861.

2. To guide the commission in compiling its proposals and define those principles which the nobility deem necessary for resolving the above questions.

3. To petition the central government for permission to elect a commission to begin compiling detailed proposals on the matter discussed below.

4. To request that, once the proposals are prepared, a provincial assembly of the nobility be permitted to convene in May 1862 to review the prepared drafts.

5. To petition that, after the provincial assembly has discussed these proposals, the nobility be allowed to select authorized representatives to discuss the draft programs jointly with representatives from other provinces. After these deliberations, the authorized representatives from the provinces could combine the various proposals into a single, general proposal and submit this, together with the requisite explanations, to the government for confirmation.

Convinced that only this method can secure local interests and lead to the compilation of satisfactory, comprehensive legislation that encompasses all dimensions of rural life and local administration of district and provincial interests, the noble assembly recommends that the drafts on the proposed questions be formulated as follows:

(A) The Rural Statute. According to the program that the Emperor approved for guiding the former provincial committees [to advise on emancipation], compilation of a detailed rural statute was supposed to be within their sphere of activity. But at present, of the subjects that are supposed to be included in the rural statute, the only question that the nobility have been authorized to discuss is that concerning the employment of agricultural labor. But it is absolutely vital to issue a full rural statute because existing laws on the rural order are incomplete and unsatisfactory, and because the emancipation of peasants requires the insertion of many revisions in the pertinent laws. Moreover, the nobility deem it necessary to add that, in their opinion, the rural statute must include small towns, which are necessary for increasing the population on the nobility's land, for

developing trade in agricultural products, and no less for promoting fixed residency by former house-serfs and serfs freed without land. But for a full and satisfactory resolution of the question of the order in small towns, local data and decisions (which the nobility hopes to present in its draft proposals) are needed.

(B) The Charter on Local Administration for Public Affairs, which should include the proposed questions on the electoral order and on the system of local taxation and medical care.

(C) The Charter for a bank in Smolensk. The need for agricultural credit in Smolensk province is so great that the nobility finds it absolutely necessary to begin immediately to prepare a bank career and to establish a separate provincial bank. A separate resolution explains why, in their view, it is impossible to follow the principles espoused in the statute of a General Land Bank that the Ministry of Internal Affairs distributed.

Having elected a commission to draft proposals on the basis of the above principles, the provincial assembly of Smolensk nobility resolves: the provincial marshal of the nobility is to submit the present resolutions to the provincial governor and to petition His Excellency's permission for the commission to undertake the above activity.

B. BUREAUCRACY AND ARMY

The century from 1760 to 1860 witnessed extraordinary growth and development in the empire's civil and military services. The emancipation of the nobility in 1762 had, in effect, separated service from noble status and provided the government with greater freedom not only to demand but also to obtain higher educational qualifications. At the same time, it significantly expanded both the size of its bureaucracy and its standing army; between 1800 and the mid-nineteenth century, the empire's population doubled, but its army grew four-fold and its bureaucracy six-fold. Such institutional growth, given the empire's meager resources and marginal economy, meant chronic under-financing, as ministries and armies simply lived beyond their—and the empire's—means. The onset of the Great Reforms necessarily had a dramatic impact upon these institutions and their subordinate populations, as the anti-bureaucratic spirit, fiscal crisis and military defeat precipitated far-reaching reform plans in both civil and military services. Though neither, given their official status, had an opportunity to assemble and address collective grievances or aspirations, the decade of the Sixties did produce some significant statements.

The diverging perspectives in the bureaucracy are clearly evident in docs. 35–38. The first of these, an official memorandum from a high-ranking bureaucrat (doc. 35), addresses the "bureaucratic question" from the perspective of an enlightened official who demanded sharp reductions in the size of civil service to increase its efficiency and professionalism; his primary commitment was to the interests of the institution, not its servitors. Even without such retrenchment, the lower civil servants—despite their high social status—had neither good incomes nor security, as the private petition of a former civil servant (doc. 36) shows. But the retrenchment of the 1860s posed a still more serious threat, provoking some articulate—if rare—petitions and protests (docs. 37–38). Although such peti-

tions, especially to the underground emigré paper *Kolokol,* were hardly typical of civil servant behavior, the collective statements testify at once to their profound sense of social insecurity and dependence, as well as to their exceedingly traditional monarchist sentiments.

Military servitors were hardly more articulate. That applies above all to the soldiers, that mass of silent and downtrodden conscripts who were most vulnerable to the army's hardships and injustices, but who rarely took the extreme step of penning collective protests that were tantamount to mutiny. Although no such soldiers' declarations from the 1860s have been published, secondary studies have shown that they focused primarily upon various service grievances—material hardship and unfair punishment by officers. More articulate protest emanated from the officer corps, especially its enlightened segments that wanted not only a modern army but also the values and institutions that sustain one. Of particular interest is an anonymous review, published in an official army paper but devoted to an underground emigré tome (doc. 39). The review is significant not only because it was surprisingly favorable, but still more because of its clearly stated desire to professionalize the officer corps and improve social relations inside the army. A final military source (doc. 40) emanates from the Cossacks, a traditional agro-military society that felt the full impact of both agrarian and military reform. As the article (published in a local Cossack periodical) shows, the Cossacks encountered difficulty not only in adapting to new military standards, but even in performing their traditional service.

35. *A Bureaucrat's Memorandum on Civil Service Reform 22 March 1863*

At the present time the Economic Department has 84 civil servants and 71 chancellerists, whose salaries were set by the staffing budgets of 1838, 1840 and 1849, and by special orders of His Imperial Majesty. . . . [The corresponding tables are omitted here—ed.] As these budgets plainly show, officials in the Economic Department presently receive salaries that were set 25 years ago. But, with the

passage of time, the prices on everything have risen significantly and hence these salaries no longer cover even the most basic necessities of officials, especially if they have families. This fact has the untoward consequence that the majority of civil servants are obliged to supplement their inadequate income by finding some kind of private employment outside their service. This is invariably bound up with more or less harm for the service. On the other hand, the people who are most capable and who have higher education, because the remuneration for their work in the service of this department is so unsatisfactory, try to transfer to other branches of the government where salaries are larger, or even devote themselves completely to private service. These ills are now already apparent, especially after a significant number of positions in the excise administration were recently established; but these problems will become still more apparent in the near future as the salaries in other bureaux are increased and, above all, after the judicial reform is introduced. The latter service will attract those people with a legal tradition currently serving in the Ministry of Interior.

Under these circumstances, it seems absolutely essential to take measures right now to prevent these ills. Since it is impossible to count on an increase in the budgetary allocation for the department's support, the sole means to improve this state of affairs is to reduce the existing *number of officials* and, through the savings achieved by this reduction, to *increase the salaries of the officials who remain.* They can then devote all their activity to state service.

A reduction in the current number of civil servants not only is simple, but can also be exceedingly useful. Under the present staffing schedules of the department, separate from official positions for the management of specific sections and responsibility over their proper operation (i.e., the positions of department and office chiefs), official positions have also been established only to assist and strengthen the staff, but these do not impose on the holder any direct responsibility for the bureau's work; such positions include assistant office heads, assistant accountants and comptrollers. Such assistantships, which entail no responsibility, make it entirely possible for those who hold them—if they have no inner drive to work—to assume a casual attitude toward their responsibilities. It is quite natural, given the insignificant compensation for their work, that many will not show particular zeal; hence the entire mass of work, in all its onerousness, quite often

falls on the people directly responsible for the section: the heads of divisions and offices. In general, it is not so simple, as might at first appear, to cashier those who were appointed to regular positions as assistant heads of divisions and offices but who later proved inadequately zealous or basically incompetent, because such actions are possible under existing law only if a more or less major act of nonfeasance was committed. Furthermore, such measures cannot be of much benefit, for the new appointees to the vacant position will be no better than their predecessors.

The present condition of office work could, no doubt, be significantly improved if the list of regular staff positions in various departments were to include only posts with definite responsibilities (as heads of divisions and offices) and then, after eliminating all other positions, each office were given a definite sum which could be disbursed at the division head's discretion to compensate staff for preparing materials and other activities in the office, to employ copyists, etc. Since the privileges of state service have considerable importance in our country, such employees could be considered to be in the service of the ministry, with special assignment to this Department (which is also presently done). Under these circumstances, these people would be prepared to occupy new vacancies and hold regular staff positions when the holders of the latter are ill or absent, with full responsibility in this case for the proper running of business. Because they receive compensation only for real work, these people of course will be incomparably more useful as assistants to offices than the current staff officers, who receive a definite salary for indefinite work.

36. Private Petition for Civil Service Pension [1864]

Lacking any private wealth or even land to support myself and my family, I constantly face shortcomings and acute need in everything and will ultimately be left totally destitute. Therefore I [must] hope for His Imperial Majesty's monarchical favor and Your Excellency's generous assistance for my request. I make bold to request most

urgently that, as my [former superior], for your part you take all the measures you can to obtain an award for my long, zealous, untainted service and special assignments.

37. Address of Civil Servants to the Governor-General of Novorossiia [August 1861]

His Imperial Majesty, in His ceaseless concern for the welfare of the people entrusted to Him by God, has deigned to make many millions happy through His favors. High dignitaries are rewarded with permanent hereditary ownership of state lands; the serfs have been freed; the fate of all His subjects has been in general ameliorated.

The future promises many useful reforms, among which we see a reduction in the staffs of the state administration and, consequently, a reduction in the number of civil servants. But once these plans are put into effect, we civil servants can be cast in the most calamitous condition. The emperor, having compassion for every undeserved misfortune, will of course not ignore our plight if Your Excellency will give us your protection.

At the present time, when the Tatars are being relocated from the Crimea, His Imperial Majesty deigned to allow foreigners to settle the area. We dare to propose that we can be just as useful as foreigners, if not more so, for settling this abandoned area or any other lands, for we know the conditions of the country, its needs and the customs of our fellow countrymen.

At the same time, after exhausting the best years of our lives in state service, and having no means to provide for our families after our release, we will be left without food or shelter, for we have been preoccupied from our earliest years with our duties in service and have had no opportunity to use our abilities for anything else. We find the sole means for our survival is agriculture, which does not demand great scientific knowledge and, with good will, can be easily learned through practical experience.

Hoping that our monarch's magnanimity will bring us joy with his favors, we dare to trouble your excellency to petition that we be

allotted land in the Crimea or anywhere else in Novorossiia (at the authorities' discretion), on the following principles:

If His Imperial Majesty deigns to make us happy through a free grant of land as personal property for our service, then we are prepared to pay all the quitrent and land taxes from the day that the ownership documents are given to us. If this proves impossible, then allot us such land as private property, with repayment for its assessed value over a fifty-year period; but on condition that this begin only after a five-year term of exemption.

We do not dare to indicate the places where we would like to have land, for we ask only to save us and our families from destitution; nor do we indicate the quantity of land. But we propose that, in the first case (i.e., if the land could be given gratis), then it would suffice to grant a family 200 dessiatines [540 acres] for each five years of service; those without families should receive half that amount. If the land must be purchased, the principle is the same: a family person would receive 500 dessiatines, a single person half that amount. And since the poll tax will no doubt be replaced soon by a quitrent on land, we will bring no less benefit to the government than foreign colonists.

The condition of state officials must be perfectly well-known to Your Excellency, and we are convinced that you will not leave us, the undersigned, without your protection and representations before our all-merciful sovereign, that you will petition for the support of our fate in the above manner, especially since many of us are presently in no condition to provide our daily sustenance.

In addition, we have the honor of attaching a list of petitioners, indicating their years of service and family status, and we most humbly request your excellency to inform us [the outcome of the petition].

38. *Letter from Civil Servants to Kolokol*
 [Before 1 May 1862]

We read with pleasure the address of civil servants published in issue No. 114 of your journal. We are extremely grateful for its publica-

tion, for only in that way did it become public, and special attention by the [editor's] prefatory note, which quite justly noted that we officials "are, after the peasants, practically the most unfortunate of people." But we would say that we are much worse off than peasants.

We wish to thank you, sir, for the publicity about us, which was practically the first, but at the same time we most humbly ask that you supplement your article with the following. The petition published in your journal was really intended for submission to the minister of interior, but—on the occasion of the emperor's visit to the Novorossiia area—we hoped that Count Stroganov would be gracious to us and report the case to the sovereign; hence this petition (from 111 individuals) was submitted to Count Stroganov in early August. But he ignored the petition and kept it secret, so that no one knew of it. Nevertheless, we are convinced that, had this petition been submitted to the sovereign, he would either have approved our request in its entirety or in part—or, at the very least, he would have issued a single decree to provide for our future once and for all. The need for this is obvious from the report of the minister of state domains (in the paper *Severnaia pochta,* nos. 8–10) that about 13,000 civil servants were released from service between 1857 and 1860. And that does not take into account other ministries, where just as many have been reduced in the last two years. Furthermore, over the next two years, according to reform proposals, this number will increase twenty-fold. One must take note of the fact that all, or almost all, of the officials released from service are extremely poor and live entirely from what they earned in service. At the present time, these unfortunates are being cast out and, faced with starving to death, will have to resolve to do something terrible.

You will perhaps say that they are obliged to commit themselves to some other kind of work. But can you believe that state service is all they have? Because of the profound prejudice against the service nobility and especially civil servants, neither a civil servant nor a military officer can find employment anywhere in Russia—no one will hire him. A landowner can become a business clerk; a merchant a solicitor; a master an apprentice; a nobody a coachman or yardman. In a word, if a civil servant or military officer is released from service, his situation is hopeless, and he is threatened with poverty and starvation. Therefore *the sole means* at present is to grant land to

those who want it, and they will become useful to themselves and their loved ones.

Russia has an incalculable amount of land—the whole virgin lands of the conquered Caucasus, Samara and Saratov provinces are endless, not to speak of Novorossiia, where, after the allotment of land to the former military colonists, there are hundreds of thousands of dessiatines that no one has bought or will buy.

In the last two years the sovereign has granted more than 40,000 dessiatines to magnates and rich dignitaries for their achievements.

We cannot deny that these gentlemen deserve favors. Although we have no right to count upon such grants, we also were of use, and for that reason we ask not for gifts, but to provide us and our families with support by selling us land, which we shall pay for over an extended period. This will be a supreme favor for us; and the government will spare itself of beggars and proletarians. We will go to the Caucasus and Samara province; just sell us the land. At the same time, this measure will form part of the reforms occurring in Russia: the unfortunate civil servants and military officers will be taken care of once and for all, and the new generation, raised in the spirit of contemporary demands, will find other means to support themselves, so that such a surfeit of civil servants will never recur. Moreover, the very transformation in Russia will eliminate this caste. Hence there will be no need for the government to concern itself further about future civil servants.

The proliferation of civil servants and military officers occurred, as is well-known, not at the choice of the people, but through the will of the government.

With limits on general education and coercion into service—thus have the centuries passed. But all this is now collapsing, apparently once and for all. Hence the government should provide for its officials' future, given the abrupt change that it has undertaken. With respect to providing for the fate of its civil servants, we should say that the government itself will benefit from this—not only because of the annual payment for land, or because of the elimination of groans and lamentation, but perhaps because of something more important: villages and towns will spring up in these rich and bountiful, but unpopulated areas; trade will develop; etc.

Who does not know of the riches of the Caucasus? But it is still

in a primitive state and lacks labor. But we—and the many who have spilt blood in the Caucasus—would bring these treasures to the light of day.

You, sir, have written and said much on behalf of the peasants in Russia—thanks to God they are free, and their condition is improving. The time is close when they will be completely happy. Raise your voice on behalf of the truly and really unfortunate bureaucrats—make public all our hardships, show the government the full horror of our condition; perhaps through your journal all this will reach the emperor, and he will probably feel sorry for us and save us. Little reaches him, for they conceal everything from him—as is shown when Count Stroganov concealed our petition. If it had only been reported, it perhaps would have been approved. Or, at least he would have thought that it is impossible for hundreds of thousands of his subjects to die of starvation, especially at a time when hundreds of thousands of foreigners use land with every conceivable favor and privilege. Finally, let him know that we are ready to subject ourselves to the rules for foreign settlers in Russia under the special protection of a guardianship committee. Or to any new rules that the government might establish if we are given land on the terms expressed in the petition you have published.

39. *Military Officer: The Army and Its Needs*
8–10 August 1862

. . . Mr. Schedo-Ferroti undertakes to prove (and, alas, one must concede that he succeeds most cogently here) that *in essence we do not have any military discipline at all!* No matter how strange that idea might seem, a detailed investigation unfortunately proves that it is absolutely just. . . . "Fear of punishment," says Mr. Schedo-Ferroti, "[and] the custom of being harassed for all kinds of trivia in no wise constitutes true discipline. All this can only provoke fear and impel people to quiver in dread before their superiors, whose anger is enough to destroy a subordinate. But, at the same time, this can only evoke hatred, a feeling that is unquestionably contradictory to *true discipline, which consists of unqualified, voluntary*

and constant obedience to the will of one's superior, which can only be the result of respect and trust.

"Such discipline never requires fear for its support: it becomes a habit, an unconsicous necessity, and finally becomes complete respect for the military art, veneration for those who hold a higher rank, respect for one's own rank—as a rank without any ulterior motives of our personal dependence." It is precisely on these foundations that the present discipline of the French and Prussian armies is based.

We do not entirely agree with this [last] conclusion: we submit that discipline [in those armies] too is just a mere formality and performed without the slightest conviction. Still, it seems to us that even this routinized performance of formalities is much better than the complete and total disrespect for senior ranks that one encounters here. If our people salute their superiors, then mostly it is just out of fear of punishment for disrespect. Our officers, especially those with connections and wealth, almost invariably not only fail to salute their worthy seniors in service, but flagrantly ignore them. It is possible to be convinced of this at every step, at every theatre, at every public gathering. This disrespect toward superiors is especially manifest toward those people upon whom we are not directly dependent. But on the other hand, how these very same officers are transformed as soon as chance brings them together somewhere with their immediate superiors: the disrespect vanishes and gives way to a polished attentiveness and ingratiating behavior. Each stands stiffly at attention and endeavors to have his superiors notice his bow. All that is not discipline, but an expression of fear toward one's superiors, of servility before the authorities upon whom our fate depends. Truly, is not all this extremely sad? At the same time, one can only concede that Mr. Schedo-Ferroti has quite aptly captured a characteristic feature of our officers' community when he observes that, if people show respect to their superior here, it is only to one's immediate superior, not to superiors in general. . . .

As for the relations between soldiers and officers, here too, as Mr. Schedo-Ferroti attests, discipline is totally based on purely external formalities, absolutely not on conviction. To be convinced of that, one need only listen to how soldiers pass judgment on their officers. . . .

Among the factors that prevent a correct view of military dis-

cipline from developing among us, Mr. Schedo-Ferroti also considers the fact that our officers have no common bonds in their way of thinking, no spirit of collegiality—what the French call "esprit de corps." . . .

One must concur that all the author's comments are absolutely just and deserve our full attention. Indeed, there are great differences of personal wealth in the guards, while in the regular army the dispersion among villages seriously impedes the development of a collegial spirit among the officers. But even under these conditions, collegiality would be possible if the military officers in a particular branch had more common elements in education and devotion to their work. Then fellow servitors in a particular branch, and especially people in the same regiment, would seek [to establish] ties among themselves; they would wish to exchange views on their service duties, on the maximal improvement of that service branch to which they belong. Unfortunately, we have none of this.

Somehow, our officers have little interest in studying their military profession, but instead seek to acquire an encyclopedic knowledge. They want, in a stroke, without effort and toil, to be initiated into all the secrets of contemporary learning. Such an aspiration is of course laudable. But since the positive, general educational background of most officers is too weak, they grab at everything and grasp onto nothing—not only at an advanced level, but even at a middling one. Meanwhile, they completely neglect what they should know above all else. They wish to stuff themselves with general, encyclopedic knowledge, but because of their very lack of preparation, they acquire nothing more than superficial knowledge, i.e., what is most easily accessible to their abilities. Thus it is no rarity to encounter among our officers someone who has read something on political or natural sciences, become acquainted with the entire gamut of French and even English belles-lettres (of course, primarily in translation), has a vague (though often a distorted) notion of our contemporary literature, music, and especially opera, of the best representatives in art, and whatever else you might think of. But, at the same time, are many of our officers familiar with military literature, not to mention foreign, but even our own Russian military literature, which is by no means rich? It is, after all, embarrassing to say that there are even officers in the guards who do not know, for

instance, which journals are published in Petersburg for soldiers. Why is that? Because the majority of our officers, ever since they were in school, are used to grasping after everything and to acquiring only a superficial layer of knowledge in all branches and then, after they entered service, are still drawn more to secular literature than their service responsibilities. This last circumstance is entirely understandable and natural; a young officer here almost never has any regular responsibilities; his entire service consists of duty watches and observation at training sessions, exercises in which he plays an absolutely passive role. If he does not have a novel at his disposal, he constantly has a mass of free time. How is he to use it, if not by visits to neighboring squires to strike up various acquaintanceships?

If he has an inclination toward self-education and reading, then of course he does not pick up a military work, but rather a novel, contemporary journals and newspapers—to be ready for conversation in polite society. But what is the purpose of military writings? If the officer decides to devote himself to obligatory readings in the military arts, then he enters the Military Academy, where a professor will lecture from the podium on all military wisdom. If, however, he intends to remain at the front, then experience and example persuade him that it is possible to rise to a higher rank without ever laying his hands on a single military book—except, perhaps, the military code. To see the justness of this, one need only look at regimental libraries (where these exist): what kind of works comprise the majority of these libraries and, in particular, which works do the officers primarily borrow to read? *Not* military ones, of course. Consider, for example, the plight of our specialized military journals, which should have played a major role in our country, especially in view of the general rise in prices on books and separate publications. . . .

In order that so unpleasant a situation not arise, it is vital that our officers have greater love and desire to make a serious study of the cause they serve, that our military family develop and strengthen a spirit of collegiality, and, finally, that we establish *true discipline, based on mutual respect and trust of all military service people among themselves and toward their military work.* . . .

But, in our opinion, the most important object of our attention should be to encourage our officers to love and devote themselves to their military work. The best way to do this would be for the army to

take only those who feel a calling for military service. Otherwise, as in earlier times, almost every officer could boldly repeat after [the satirist P. A.] Fedotov that he serves solely because

> fate, his father and mother
> forced him to march.

There was not the slightest sense of vocation, indeed there could be none, in a person who—often from the time he was still in swaddling clothes—was predestined for military service. Now, thank God, in this respect much has already been done, and a great deal is planned. The attention of an enlightened government to the internal development of state forces should inexorably attract to positions in civil administration many of those who earlier, without a feeling of vocation but simply because of fate and their parents' will, entered military service. In this way the estate of military servitors could be subjected to a strict process of selection which, without doubt, would not remain without favorable consequences. One can also hope that a society of our officers would exist when, for the most part, it consists of people who serve out of a feeling of vocation, who would be totally devoted to their work and conscientiously would serve it. Greater collegiality and mutual respect toward each other, as well as respect for their military work, would arise naturally. It is difficult to believe that, out of the enormous mass of population in Russia, one cannot find some thirty to forty thousand men who have a solid general education and who are completely devoted to the military. But precisely when they are chosen and especially when they are evaluated for service, it is important to be absolutely rigorous so 'that the officer corps—the foundation of every well-ordered army—be staffed in the most critical, selective fashion.

40. Letter to a Don Cossack Paper
 6 September 1860

A significant number of works describing each of the three branches of the Russian regular army have recently appeared in our military literature. Many of these descriptions have been wonderfully successful and have contributed to the renewal of what is old—in accordance

with the requirements of our time. In general, our regular army has a proper systematic organization in administration, training and armament, but our irregular branches have lagged somewhat behind. Why is that? Does our Don Cossack Host really have so few intelligent minds that are capable of making a public analysis of our Host's shortcomings and needs in military and administrative matters, and thereby facilitating our government's tireless efforts to achieve a proper organization? Are we really to remain for a long time half-asleep and indifferent to the interests of our service? Will we forever continue to depend solely upon the measures of the government, without any effort on our own part to facilitate its work? My goal here is to solicit the sympathy of my fellow landsmen and to summon to this field of endeavor people more capable and positive in these matters than I. Having entered service two years ago, I deem it possible and within my powers to describe only our regiment's appearance in the Caucasus and its service in Daghestan.

About one third of our regiment consisted of youths, who had no knowledge whatsoever of military arts, who came straight from the plough and who were not entirely equipped as required. One had to accompany them to places that were constantly on military alert and endeavor not to besmirch the great glory earned by our fathers; but during the two-month camp and march—apart from assigning people to quarters, disbursing fodder, acquiring provisions, and generally taking care of men and horses—one had scant opportunity to train them for their service at the front, to have meetings with superiors, etc., in a word, to give the regiment a military education. That is why the Cossacks, when they first arrive in the Caucasus, are called "bumpkins."

It is bitter and painful to recall that the natural abilities and sharp-wittedness of the Cossacks give ground for such irony, but we cannot contest its veracity. . . . [sic] I regard the comparison apt, for the land of the Don Host has become increasingly remote from the borders of hostile people, so that the Cossacks have completely forgotten the threatening raids of Tatars and Cherkess, have gradually lost their ardor for the earlier military life, and have turned to peaceful activities—cultivation of fields. It has come to the point where the people in the upper part of the Don differ only slightly from Russian peasants. But everyone knows how difficult it is, in short order, to turn a green recruit into a military person! And Cossacks, especially in the

Fourth Military District, as I said, differ little from Russian common-
ers at their initial induction into military service; hence the two-month
camp and march to their place of service proves utterly inadequate
for instilling a martial spirit, especially since our form of service in
the Caucasus gives regimental authorities little opportunity to train
people on the spot for line service. We must therefore find a means
to give the Don Host a proper appearance from the very outset of in-
duction into service.

The best solution, in my opinion, would be to establish permanent
regiments from several large Cossack villages [*stanitsy*] so that the
youths from the same villages replace those leaving the regiment.
Then the regimental commander, when Cossacks are free from their
field work, could check his district, examine the living condition of
his subordinates, and taking into account their needs, provide them
with the means for the obligatory, correct uniforms, arms and study of
the statutes on Cossack service, and at the same time give attention
to the regimental economy, which, at present, is in a rather pathetic
condition. . . .

C. THE ORTHODOX CLERGY

For the Orthodox Church, no less than lay society, the Great Reforms brought much animated discussion and wide-ranging efforts at reform and revitalization. Contemporaries, even those sympathetic to the Church, found much awry and in need of fundamental reform—the curriculum and moral conditions of seminaries, the inefficiency and injustices of ecclesiastical administration and courts, the clergy's miserable economic condition, and their limited role in community life and, especially, education. From the late 1850s, reform discussions were actively underway inside and outside the Church, and after several false starts the Emperor finally established an elite committee of ranking churchmen and bureaucrats to direct ecclesiastical reform. As one of its first acts, in early 1863 it summoned bishops and parish clergy to submit their "reflections" and "opinions" on the problem of Church reform. Not that the survey was wholly open-ended: to preclude overly ambitious aspirations, the committee designed a questionnaire that focused on four specific issues—the clergy's material condition, their social and legal status, their children's education and status, and the clerical role in public education.

Diocesan bishops, instructed to address all four issues, sent long, complex replies (with elaborate legal references and discussions of local conditions), often compiled with the assistance of the consistory or a special diocesan committee. Although the opinions vary considerably in detail and perspective, a fairly representative statement (doc. 41) on central Russia emanates from Bishop Feofan (Govorov)—later known as "Feofan the Recluse," one of Orthodoxy's most famous spiritual writers in late nineteenth century. Feofan demonstrated deep sympathy for the clergy's plight (contrary to the stereotype of the arrogant prelate widespread among many parish clergy) and wrote candidly of problems in the clergy's legal and social structure. Nevertheless, like many prelates, Feofan looked askance at inordinate "modernization" in the Church, and he specifically re-

sisted suggestions that the Church be democratized through the election of diocesan authorities.

The parish clergy, by contrast, were permitted to address only questions about their economic status and role in parish schools. Although the overwhelming majority of parish clergy simply supplied data (on their income, number of parishioners and the like) and in despair concluded that "there are no local means to improve our living condition," a smaller minority in each diocese proved more articulate. Typical of such replies was that from the village clergy in Skomorokhovo, a parish in Feofan's own diocese (doc. 41). The parish staff listed their meager resources, emphasized the gap between their means and the prescribed clerical lifestyle, and bitterly complained of the parishioners' indifference both to their material needs and to the establishment of parish schools. Still more extraordinary—and atypical—was the statement (doc. 42) by the minority faction of a committee of priests in St. Petersburg, which the local prelate had summoned to help draft his report for the reform committee. In contrast to Feofan, the priests urged a broad democratization of the Church, a perspective as yet uncommon, but one that would gradually gain enormous influence among the parish clergy.

41. Bishop of Vladimir Diocese: Reflections on Ecclesiastical Reform
31 October 1863

A. IMPROVEMENT OF MATERIAL SUPPORT

The parish clergy gave a good description of their needs but say little about how this material support is to be provided. Given that this support must come from local resources, and that in designating these one should keep in mind not only their suitability and sufficiency, but also that they be more respectable than the present means of support, I would emphasize the following [measures] (mainly with respect to the rural clergy, the most numerous segment): (1) the construction of houses for the clergy by the parishioners, together with all subsidiary buildings, fuel for heating, and upkeep; (2) cultivation of church lands and harvesting of crops by the parish community; (3) bulk issue of various cereal grains from public storehouses (in lieu of the

small payments in kind [for performing rites]); (4) an annual salary from parishioners (in lieu of the customary payments given when rites are performed); (5) responsibility for fulfilling the [above] measures is to rest with parishioners.

The clergy themselves have indicated the first four measures and the Minister of Interior has noted the last point in a memorandum. These measures are obviously appropriate and feasible; most have already been adopted [in special cases]. The monetary salary and issue of grain is merely a change in the form of current support. The change is necessary in order to eliminate caprice and dishonor, and to increase—or at least to make more definite—the support given clergy. In addition, mandatory rites must be distinguished from voluntary ones: clergy must perform the former gratis, but should receive a fixed sum for administering the latter.

The parish church's land provides the securest support for clergy, but at present is not entirely profitable. If the clergy now cultivate the land themselves, they have to spend a great deal to hire workers; if they lease the land, they derive little benefit. Consequently, this resource does not yield all that it might. If parishioners were obliged to cultivate the land and harvest the grain, the return—to judge from the clergy's opinion—would increase more than two-fold. But this duty—three or four days work per year—will not constitute a major burden for parishioners. And in fact the parishioners often help the clergy work the land through so-called "group assistance." But this entails considerable expense and is not beyond reproach, given the time [the Sabbath] when it must be performed.

Public housing for the clergy already exists in some places now, and heating fuel is also provided by a few parish churches. Hence no experiments are needed [to test] this support; if it does not exist everywhere, that is only because it has not been introduced. This aid will bring considerable relief to the clergy, not only when they first settle or transfer (under various circumstances), but constantly [throughout their service]. Upkeep of the house and heating, say the clergy, will provide a considerable increment to their income. It is possible to introduce this measure on the same terms as was done in the western provinces [after 1842].

Responsibility for all the above forms of clerical support and their implementation should be assigned to the parishioners, above all because these [matters] depend directly upon the parishioners. But this

is still more the case because it will provide the most convenient way to eliminate importunities in the interaction between clergy and parishioners—which are disagreeable for both parties and almost always bear an unedifying appearance. Parishioners should choose two or three respectable, prosperous people from their midst to serve (for a year or more) and form a parish council to oversee fulfillment of the parishioners' obligation to provide material support for the clergy in all the indicated categories (like the *epitropilii* of the East). It is necessary, however, to organize this council so that it can capably and effectively perform what is expected of it. . . .

When one examines what each parish gives [the clergy], it turns out that many do not provide sufficient support. The main reason for this is the small size of parishes, making a more substantial collection of grain and money impossible. Many of the parishes in Vladimir diocese have less than 100 male souls, and in a considerable number of these the parish staff receives less than 50 rubles per year. . . . [As statistical data show], more than half the parish staffs in Vladimir diocese receive only a very paltry income, about a third have mediocre or barely satisfactory support, and only a tiny fragment have adequate material support. One has to ask, then, how to supplement the insufficient means of local support available in the poor parishes. . . . [After listing various forms of outside assistance, including state salaries, Feofan concludes:]

The provincial commission on clerical needs is to clarify all the above possibilities and determine to what degree each is suitable in a particular place. But it cannot tackle this for fear of taking a step that is not approved by the superior instance. Therefore, I suggest that the Main Commission on Clerical Needs, after receiving the program proposed here, either approve some of them for particular places, or having combined them all, compose a single comprehensive program and give this to the provincial commissions as a guide. If that were done, then this work would proceed more decisively and promptly towards its conclusion. Furthermore, I suggest that unless the secular government is instructed to act more energetically, all our proposals and considerations will come to nothing. We have to coerce our people to do things, and they'll get done. You will achieve nothing with exhortations; the people will not assume any burden voluntarily. Hence the solicitous wish of the Minister of Interior to rely

chiefly upon the parishioners to support the clergy, without the exercise of authority to identify the means for involving parishioners in this matter, will remain a proposal that is simply not feasible.

B. ON THE EXPANSION OF CLERICAL RIGHTS AND PRIVILEGES

The rights accorded to the clergy are generally good. One could in fact only wish certain supplements and additions.

1. Regarding Family Life
(a) It has become customary for clergy to marry within their own social estate. Although no canons forbid marriage to people from other estates, this old custom has virtually become a law, and people fear or are forbidden to violate it. An announcement could be made that those entering clerical positions may select a fiancée from all social estates (within the Orthodox Church).

(b) It has become a law that anyone ordained a priest or deacon must be married. Although this law incorporated a wise precaution, it is nevertheless quite possible that some people are ready and qualified to be a priest or deacon, but on condition of celibacy. If they feel a vocation for this form of service to God, they could act with great freedom. Why could this not be permitted, especially since it is allowed by church canons and the practice of the Eastern Church offers examples of it?

2. Regarding the Rights of their Social Estate: The rights of clergy in service are adequately defined, but their children's rights require certain additions.

(a) Children of ordained clergy who did not graduate from the seminary and were released from the clerical estate are subject to inscription in the poll-tax population if they fail to obtain appointment to civil or military service within one year [after leaving the clerical estate]. Hence they are deprived of the rights granted their estate (*Digest of Laws,* vol. 9, art. 291). Would it not be just, when such children who (through no fault of their own, but because of circumstances beyond their control) fail to obtain an appointment within a year of their release, the term is to be extended for a certain period? Would it not also be just to give them the right to enter urban social

estates on the same basis as those which personal nobles enjoy when they enter civil or military service—i.e., with the rights of honored citizens (vol. 9, art. 576)?

(b) The children of sacristans are forbidden to enter the civil service. This applies not only to children who failed to complete their education, but also to all those who graduated below the first division of their seminary class. But sacristans' sons who graduate in the second and third divisions have the right to become ordained clergy [priests and deacons] and acquire the attendant rights, which are then transmitted to their children. This last advantage binds the sacristans' sons to clerical rank, even though they sometimes feel no calling; more so than priests' or deacons' sons, these progeny of sacristans contribute to the proliferation of ordained clergy who feel no vocation and who carry out their duties unwillingly and unsatisfactorily. To overcome this, it would be helpful to give the sacristans' sons who complete the seminary or its middle division (as people whose education qualifies them to become ordained clergy) the same rights of ordained clergy's sons for entering civil and military service or the urban estate (in accordance with their ability and interest).

3. Regarding Rights in Service

(a) Clergy in official positions serve without salary. Uncompensated work is sometimes performed without zeal; or in hopes of an unjust reward, it is frequently performed at the expense of justice. Therefore, equity and usefulness demand that a salary, corresponding to their work in service, be set for clergy who hold official positions in ecclesiastical administration.

(b) These people are nominated for awards, but this incentive for diligence could be increased. A superintendent is given the order of St. Anna (Third Degree) for twelve years of zealous, useful service. This award could be given on the same basis to members of the consistory and district boards, to clerical deputies [assigned to state courts], and to ecclesiastical investigators. One could also grant the Order of St. Vladimir for thirty-five years service on the same terms as set for civil servants in vol. 1, art. 428 [of the *Digest of Laws*].

(c) In accordance with vol. 9, art. 33 [of the *Digest of Laws*], ordained clergy whose grandfathers and fathers held those positions irreproachably and for not less than twenty years could be given the right to request hereditary nobility.

(d) When ordained clergy retire because of old age or ill health, they are left in the care of kinsmen and do not always end their days in the serenity that they have honorably earned through an entire lifetime of work. If their service is of significance to society and the state, then justice demands that the state and society take care of them when they are old and no longer have the strength to serve by granting an adequate pension (in accordance with the general regulations on pensions).

(e) Some administrative offices, though not very visible, involve much work and could be important—for example, exhortators for oath-taking and deputies at civil and criminal courts. These offices could be given more weight in order to inspire more zeal in their holders and give them greater room for influence.

(f) Religion teachers in public gymnasia and district and community schools, despite having the same legal status and education as [lay] teachers, are not equal in the school or in their role in pedagogical councils, where the law does not make clear the clergy's role. Justice and the interests of the cause demand that this matter receive attention and that each be given his due.

4. Regarding Property Rights: There is no need for more rights, but for property itself. The last circumstance awaits a more favorable resolution. Certain practices, however, do not contribute to an improvement in the clergy's poor condition; thus clerical homes in cities are burdened with assessments just like the homes of other social estates, and sometimes other civic obligations are imposed as well. An exemption from these obligations could ameliorate the difficulty of supporting the cleric and his family in cities; concern for this should not be alien to the townspeople.

The clergy is perhaps not alien to wanting a certain degree of self-administration, as has been voiced in discussions about the electoral principle and estate conferences. Although these principles cannot have the same meaning for clergy as they do for other social estates, they could [in some fashion] be introduced—so that it would not appear that, because of prejudice, the clergy do not wish to adopt things already established elsewhere [in society]. But this can be permitted only under the following conditions:

(a) Subordinates cannot be allowed to elect their superiors. But it is possible, or desirable, to permit them to elect people who, in event

of need, can defend their interests. Therefore, in permitting use of the electoral principle, it is necessary to distinguish between those [officials] who serve by election and those who serve through appointment by the authorities. The first category includes confessors (as indeed is already the practice), deputies [to state courts] and investigators; the latter category consists of superintendents and members of boards and consistories, who are deemed to represent official authorities.

(b) It is possible to permit consultative assemblies of the clergy, with an agenda to discuss good order in the clergy in all aspects—the performance of religious duties, way of life, behavior, the condition of retired clergymen, widows and orphans, the rearing and placement of children, etc. The result of this [discussion] is the presentation of detailed information to diocesan authorities on the condition and needs of the clergy, with suggestions on how these might be satisfied.

C. ON INCREASED PARTICIPATION OF THE CLERGY IN PUBLIC EDUCATION

The villages have both schools which were established by the government and [those established] by the clergy (the so-called "free-curriculum" schools). The first have satisfactory support and organization; the latter require better order.

1. The village community in some parishes has played a role, but virtually everywhere this has amounted to nothing more than providing space. For the most part, the schools are housed in the homes of the clergy, who have taken it upon themselves to educate the [parishioners'] children. In this case, the number of boys studying is always very limited because the homes are cramped and the cleric's family is sometimes large. In general, these unsupported schools encounter considerable difficulty in instruction for lack of educational materials, which the teacher has to acquire himself. In addition, because he receives no compensation for this work, his zeal—at first so fervid—is not easily sustained by sheer moral impulses, especially when one knows that elsewhere they are not alone in supporting the education of children. I therefore suggest that the clergy could take a much greater role in the education of the peasants' children: (a) if special buildings, presently lacking, were constructed for the education of pupils; (b) if those who toil to educate children were ac-

corded a reward commensurate with their work; (c) if the acquisition of educational materials were not the teacher's obligation; and, (d) if both the teaching and administration of these schools remained in the clergy's hands, under the supervision of diocesan authorities.

Concern about the support of these schools should be given to the village community, but such that it not be entrusted to [village] clerks and other unreliable people.

In addition, assistance of the government is needed, because the parishioners—who have begun to recognize the value of educating their children—for various reasons nevertheless shy away from establishing these schools.

2. Regarding the [state-run] schools, one might only observe that the clergy employed there to teach children could be given greater participation in the management of the schools or greater independence from rural authorities (and generally from all those who have little understanding for education).

There is no small need, given the proclivities of contemporary literature, to establish the rule that literate people have access to books only after these have been examined by qualified people to determine that these books contain nothing contrary to the laws of the Church and the fatherland.

42. Questionnaire from Parish Clergy in Skomorokhovo (Vladimir Province) April 1863

[ON THE CLERICAL ECONOMY]

From [the data on our] income, it is obvious that the material support of our staff—both in money and in kind—is unsatisfactory. The land does not fully reward the labor of the cultivator. The monetary means are not quite sufficient, because they vary according to the parishioners' prosperity and their attitude toward the clergy. Ordinarily, for performing the various Christian rites, our staff receives an amount set by the parishioners themselves; not a single parishioner, no matter how well off he might be, pays more. There are even instances where some parishioners are unwilling to pay the set sum for a rite—not because this amount is large (on the contrary, it does not

in the least correspond to current needs), but rather because of their indifference to the needs of the clergy—and sometimes because of antipathy. It would, however, be good if the sum assessed from parishioners for the performance of rites corresponded to the urgent needs of the present day. But that is not the case; the parishioners donate what their fathers and grandfathers paid fifty years ago, when all the living conditions were quite different. Now everything is expensive, from the cost of labor to cultivate [church] land to the most basic necessities. It is also necessary to be decently dressed, to support sons at the seminary, and to give daughters a proper upbringing; hence the amount of our annual income hardly corresponds to present-day needs. One cannot expect that parishioners will improve our circumstances on their own, for the common people—given their low level of education—as yet are little able to appreciate the clergy's work and achievements. For the [economic] improvement of our staff, the following might be done: (a) enlarge our parish by attaching the two hamlets, Khvostovo and Klimkovo, which belong to the parish in the village of Miagkovo; these two hamlets are 7 versts from that church, but only 2 versts from ours; (b) require the parishioners to provide heating fuel from their woods; (c) provide some kind of assistance to the clergy for the cultivation of their land—especially for the priest, for nothing so preoccupies his time as economic activities and he could [better] use this [time] for the benefit of his parishioners. Apart from this we see no other means to improve our condition.

[ON THE CLERGY'S ROLE IN PUBLIC EDUCATION]

1. The parish in the village of Skhomorokhovo has one free school, established by the local priest, with the permission of diocesan authorities, on 1 February 1860. It is housed, without compensation, in the priest's own home; the school has no fixed income; the priest himself provides heating.

2. The priest himself supervises the school and gives instruction to the children. There are constantly ten to twelve pupils, as can be seen from the monthly reports to the ecclesiastical superintendent.

3. The primary shortcoming of our school is the lack of means for a firm existence. All the efforts on behalf of the school rest solely with the priest; there is neither assistance from superior authorities nor support from parishioners.

In order that popular education be successful, one could do the following: give parish schools the sum now collected from state peasants for township schools. Our parish has five hundred male souls, all of whom are in the state domain; if each soul paid 15 kopecks per year, this would produce 75 rubles a year—a sum that would suffice to support the school, excluding the salary for the teacher (who may be unnecessary if the local priest is the teacher and if the parishioners agree to support him by cultivating his land). In this way they would make it possible for him to be engaged constantly in educating their children.

43. St. Petersburg Priests: Memorandum on Church Reform September 1863

[Only the section on ecclesiastical democratization is given here—ed.] [We request] permission for the clergy, under the guidance of diocesan authorities, to convene for periodic assemblies, not only to elect superintendents, members of the consistories and similar officials, but also to hold general discussions of our common concerns. These assemblies could be ordinary and extraordinary, at the level of the superintendency, district and diocese. At some, all free ordained clergy could participate; at others, only elected deputies of the clergy. Ordinarily, the diocesan assemblies could be summoned once a year, but the district and superintendency assemblies, two or three times a year.

Until now, unfortunately, our clergy has represented one of the least unified social estates. Given their [geographic] dispersion, naturally they cannot properly embody and be animated by common interests—moral, ecclesiastical and material; nor can they, as they should, act as a unified group, in a concerted and energetic fashion, for the benefit of the Church and faith. The result, among other things, is the fatal apathy that is frequently observed in the clergy even with respect to affairs of direct pertinence to themselves; this frequently paralyzes many useful initiatives and measures taken on their behalf by ecclesiastical and state authorities, as well as by private people. This very disunity inexorably leads the clergy, especially

in rural parishes, to stagnation in the matter of their appointment, to coarseness in their public and private lives, and to a narrow interest in their material needs and calculations. However, there is no need to recite the fatal consequences of clerical disunity; they are obvious to virtually everyone. Nevertheless, one of the most effective measures for overcoming their present disunity (with all its consequences) would be to permit the clergy to hold extraordinary as well as regular meetings. Here the ordained clergy could exchange ideas and facts from real life; they could help each other with their advice, experiences and support; they could draw on new inspiration and forces for productive pastoral activity; they could proclaim the clergy's true needs and practical ways to satisfy them; they could organize societies for literary, charitable and other useful undertakings. At the present time, when the government deems it useful to give all social estates in the realm the right of general assemblies to discuss their particular needs and draw members of the social estates closer together, it would only be fair not to deny this right to the clerical estate—the most educated, conservative and at the same time [most] disunited estate.

D. PROFESSIONS AND EDUCATED ELITES

By the mid-nineteenth century the empire had finally begun to develop a broader range of professional and semi-professional groups. The government had first begun to establish the necessary schools and training institutions in the eighteenth century, but greatly accelerated this process in the first half of the nineteenth century. Although general education remained abysmally low, the empire did expand sharply its system of elite institutions—first in the university reform (1804), later in specialized schools like the Practical Technical Institute (1831), the School for the Study of Law (1835), the Surveying Institute (1835), and the Construction Institute (1842). The result was a sharp increase in the number of graduates from gymansia and higher institutions who came to comprise an increasingly self-conscious professional intelligentsia. The medical profession, for example, grew with extraordinary rapidity—from a mere two thousand doctors in 1803 to nearly seven thousand by 1860. Besides the quantitative growth, the empire's professions had become increasingly complex and diversified, including not only doctors and elite academicians (as in the eighteenth century), but such important new professions as teachers, lawyers, psychiatrists, engineers, and veterinarians.

The following documents reflect several major tendencies among the professions. One was an intense interest in the creation of professional organizations, partly to disseminate their corporate knowledge and interests, partly to create mutual assistance funds. Thus the charter for a psychiatrists' society (doc. 44) and a more tentative suggestion for a similar organization among engineers (doc. 45) are fairly typical of such efforts at self-definition and organization, normally with the aim of pooling resources, emulating European peers, and augmenting their influence vis-à-vis the state and the other social groups. A more established profession like medicine, which had long had legal recognition, was particularly successful at such self-organi-

zation efforts and proceeded to issues of collective interest, including the formation of pension plans (doc. 46). In Russia, as indeed elsewhere, the teaching profession encountered greater difficulty as a lower-status and semi-professional group, with inferior prestige and income. It was only much later that teachers were able to form collective organizations to articulate their needs, but the material presented here (doc. 47) provides a trenchant statement of their fundamental grievances and demands. Far more overtly political was the student movement of the 1860s; as the petition to the emperor (doc. 48) shows, the students endeavored to observe the traditional monarchical rituals even as they demanded more democratic policies and their own corporate rights.

44. Charter of St. Petersburg Society of Psychiatrists 7 December 1861

GOALS OF THE SOCIETY

The goal of the Society is the mutual encouragement of ceaseless, scientific study and its greatest possible development. The Society seeks to familiarize non-specialist doctors and the public with the scientific concepts of the best contemporary psychiatrists and their practical conclusions on the means to assist, care for, and treat the insane in specialized institutions. It aims to eliminate public prejudice toward the insane in special institutions and to arouse general interest in this branch of science. Finally, it follows the development of juridical rules pertaining to the mentally ill and all improvements concerning the structure and administration of psychiatric institutions. Thus the object of the Society's specialized activities consists in: (1) anatomy, physiology, and pathological anatomy of the nervous system; (2) psychology; (3) symptomatology, pathological anatomy, diagnostics, and therapy of the insane; (4) the geography and statistics of the insane and mentally retarded in Russia; (5) rules for the establishment of mental hospitals, their support and administration; and the Society's concern is also directed at what can be adopted in Russia; (6) examination of the existing juridical rules (in Russia and abroad) on the insane, with an indication of advan-

tages and shortcomings; development of juridical-medical branches and psychiatry.

MEANS FOR ACHIEVING THE SOCIETY'S GOALS

1. Discussion of the above questions at regular monthly meetings of all the Society's members present in St. Petersburg.

2. Publication of essays in existing journals.

3. Separate printing, at irregular intervals, of members' works that the Society has recognized as worthy of publication.

4. Recommendation of awards for solving questions that the Society deems scientifically important.

45. *Proposal to Establish an Engineers' Society 10 April 1863*

Every industrial enterprise requires knowledge, capital and labor. It is still possible for our industry to find the last two elements, but we have too few specialists and engineers. This is a large and important gap in our industry; as a consequence, many industries trod along old, routine paths that will not lead to the desired goal.

One might think: how can there be no Russian engineers, when many receive a technical education and the time to learn and master this in practice? How can one not find them among the engineer-technicians, the skilled workers of the Moscow artisan school, and finally among the self-taught who have acquired their special knowledge through experience, working as skilled craftsmen in factories and plants? All these engineers could establish an impressive *corporation* from whose midst every entrepreneur could invite them to work in a cause to which they could dedicate their labor and skill. Although it would seem that all this is easy, nonetheless we encounter an acute shortage of engineers and technicians here. And this is why: who among them publicize their work and knowledge in print? Very, very few. Has any of them, just once, brought his experience and scientific findings to the realm of technical literature? Almost no one. Finally, have any of the educated technicians and skilled craftsmen written a description of the factories or plants that

they managed or [now] manage? Such statements would not number ten over the last twenty-five years. But Russian engineers cannot and should not remain mute; such indifference would besmirch their good name and betray the expectations of society. It is upon the engineers and technicians, as upon the most educated people, that the gaze of industrialists, factory-owners and plant-owners is particularly directed.

Candor has beneficent consequences, for it can return many to their noble duty. In this vein, we permit ourselves to say what should inspire us to have the energy appropriate for people who claim the distinction of a specialized technical education. Reproaches for our inattention to scientific work and to the improvement in our specialized knowledge should lead us to desire what has [already] been expressed in the literature—not by accident or because of bias, but because industrialists do not see in us what they have every right to expect. And they do not see it because we do not publicize our knowledge, particularly in front of factory-owners and plant-owners. . . .

We repeat: it is our duty to establish a corporation of *Russian* engineers, and all of us—Russian specialists in mechanics, chemistry, and technology, skilled workers, machinists, technical engravers and draftsmen, painters and dyers, and other people who participate in the factory and plant industry with their arts—should form a union under the title: "Association of Russian Engineers." Forgetting every privilege of origin, rank and wealth, and inspired solely by devotion to the attainment of a public goal, we appeal to Russian engineers and technical personnel for cooperation in establishing the "Association." Its goal is to make the useful activity of each of us known to the public, to assist one another with advice and suggestions needed for contemporary science and our skills and, finally, to seek the possibility for free, honest, Russian work and art to establish ourselves so securely in industry that Russian engineers and technical personnel can replace foreigners, who occupy revered positions and do not permit the development of Russian skills and practice.

We must recognize the need to give Russian practice the chance to study manufacturing and skilled work in plants and factories, which have hitherto not been accessible to Russians, for foreign management has put its heavy hand upon this. With the cooperation of factory and plant owners, our "Association of Russian Engineers

and Technical Personnel" can securely establish the initiative of the productive Russian element. . . .

46. Medical Paper Editorial: Proposal for Doctors' Pension Fund January 1861

The work of medical personnel is onerous, but it does not easily catch the eye of outside observers, and hence rarely receives a fair evaluation. This is natural. Whoever stands before an entire society is judged by the entire society; but the doctor is mostly occupied with individuals—persons of no [public] significance, fame or (often) means—until fate and helpful superiors promote him to a position where he is visible to a more or less significant number of people. What it costs to reach this position is well known only to the poor toiling [doctors], who sometimes pass their entire lives nourished only by hopes and who go to their graves without realizing them. Work for the sheer love for work is perhaps praiseworthy. But such work is not productive and therefore not rational; nor is it fair—or even reasonable—to condemn doctors to this kind of work.

Be that as it may, the doctor's work is onerous and not fully compensated. That it is onerous can be demonstrated statistically: in no other profession is the average life expectancy as low as in medicine; no other social estate makes as many daily sacrifices to death as the medical estate. That it is not fully compensated is a proven fact that stands in no need of further evidence. Two or three individuals, who stand above the general level in this respect, ordinarily are such exceptions that the entire world is amazed, without ever suspecting that these exceptions are the best confirmation of a general, sad fact. We are not speaking here of those "entrepreneurs" among doctors who know how to extract a kopeck from each step they take in their duties; these are medical *condottieri,* whose very existence each honest working doctor is embarrassed to admit and who in no sense can be taken as a model.

No matter how onerous a doctor's work may be, no matter how badly it compensates him, it nonetheless does provide partial re-

muneration so long as it exists: a doctor in service, at least, does not die from starvation, and his family does not have to beg on street corners. But if the possibility of work is terminated for six months or a year, the doctor's family sinks into the most pathetic proletariat, into complete and helpless poverty. Those doctors who managed to serve long enough to earn a pension of course consider themselves fortunate, although this pension suffices only to avert complete penury. But what of those who did not serve long enough to earn a pension, who fell along the workway, who died from exhaustion before reaching the end? What becomes of them and their unfortunate families amidst such an unexpected interruption and termination of work?

A similar fate threatens each of us, and it is too close and obvious to allow the somnolence of an Oblomov. We must look to ourselves, take pity on our families and find the means to help ourselves. And our [professional] family is so large, so full of life and energy, so permeated with love for good and understanding of human needs, that there is no need to look for suggestions from the outside and to wait for initiative from others. If we recognize the general solidarity of our path in life, if we have a feeling of fraternity in science and vocation, then this consciousness should not remain an abstract idea, for it needs realization. We share a duty to realize this idea. Up to now our estate has not recognized its unity; its dispersed members have neither understood nor wanted to understand their mutual obligations and relations. Private, individual interests took precedence over general professional interests; amidst the general apathy and torpor, our estate slept soundly. But the time for sleeping is over; we must at last consider the means to help ourselves, without counting any longer upon outside assistance and support. And one of the first questions to be addressed is that of material support for those members of our profession who are most in need of support because they are less fortunate or less able to help themselves. This is the question of establishing a supplemental medical fund to aid needy doctors and their families.

It would serve no purpose to list instances where our own assistance fund could render help of incalculable value: almost everyone has such cases before his very eyes. But we deem it our duty to say a few words about the means to establish such a fund. It should be established as something voluntary for doctors and be under their

own control; consequently, when contemplating its establishment, no consideration should be given to any kind of automatic deductions from salaries. A "voluntary [automatic] deduction" is a contradiction in terms; it is as absurd as saying "alkaline acid." And what can be deducted from the salary of a district doctor, whose salary barely suffices for his daily food? In addition, a mandatory salary deduction should also provide for corresponding returns from the assistance fund—as, for example, is done in the military retirement fund (i.e., those with larger deductions receive more from the fund). But in this case the assistance fund would not attain its goal, because those in need are not the ones who can give more, but those who have nothing at all to give. Furthermore, *it is essential that the assistance fund not be established as part of any administrative institution.* The government has so much state business that it cannot possibly take care of private interests; even if it wished to do so, our bureaucratic order would mean that the larger part of the fund's collections would be spent on building chancelleries, on committees, etc. The fund of the Society for Writers and Scholars has managed to do without government tutelage, and in two years has accomplished more real good than any government department with five branches and a countless number of "incoming" and "outgoing" papers will achieve in ten years. And we will not even mention how the bureaucratic manner, displayed sometimes to a widow who has come for a crust of stale bread for her starving children, poisons this bread even before it is dispensed. Only the private establishment of a fund can eliminate the disunity of doctors [divided] into military and civil service, a disunity that is harmful and senseless. For these reasons, a medical assistance fund must be a private institution and be under the control of private individuals endowed with public trust, which should be guaranteed by means of complete publicity.

Of course, the establishment of such a fund is no easy matter, but it is realizable. And we know that this idea has been long harbored among doctors, who, individually, could not implement this themselves. We offer it now for public consideration, opening the columns of our paper for all communications that can facilitate the realization of this cause—a vital necessity for us.

47. Letter to Teachers' Paper:
On the Rights of Teachers
March 1863

Those serving in elementary schools, as is well known, enjoy the rights of state service. But these rights are so inconsequential that, it seems, no other domain offers anything similar. We think it necessary in a few words to discuss these rights.

The elementary schoolteachers attain the rank of collegial assessor after twelve years of zealous, irreproachable service, and upon attaining this rank, are obliged to serve another ten years (altogether, 22 years). Only then may they transfer to another branch of service or retire; the latter, however, is permissible only because of illness, with the obligation to return after the convalescence to serve out the ten-year term.

If the teacher of an elementary school, after having served ten years or more, transfers to teach in a district school or to hold another position in the educational system, then the time he served as an elementary schoolteacher does not count toward his service for a pension and rank: it was spent in vain, and the poor teacher must begin all over again at his new place of service. Finally, if the teacher of an elementary school is forced by various circumstances to leave service, then even if he lacks only one year of service to attain an official rank, he must choose a [commoner's] status (i.e., register in the poll-tax population), because he is deprived of all rights to enter [government] service and serve out the 12-year term for an official rank.

We frankly confess that we have looked through volume 3 of the *Digest of Laws* and have not found any position which, in the insignificance of its rights, could be placed on the same level as that of the elementary schoolteacher. One has to be in the most desperate condition to become an elementary schoolteacher, given the rights indicated above. It is absurd even to think that anyone would enter this position as a "calling." What kind of calling can there be here, when [one faces] the prospect of 22 years of onerous, joyless, obligatory service—a service where today one is sated, but God only knows whether tomorrow one will be left without a crumb? Tell me, does

any other service have a regulation whereby those who transfer to another branch of service forfeit all the years they have previously served? No, it seems. An illiterate copyist of a district or local court, let's say, becomes chief of an office in some administrative domain; the years of his prior service are not spent in vain, but count toward his rank and pension. But the years of service by an elementary schoolteacher, if he transfer to a different domain, even as district teacher, are lost!

We do not even know how to explain this shocking rule. One can only admit that elementary teachers are regarded as unskilled laborers, and therefore the laws, heeding public opinion, have ranked them even lower than chancellery clerks. It is difficult to imagine how this hapless service could possibly be made any more degrading.

Critical literature on education has exposed, in the profuse detail, the whole groundlessness and insignificance of the contemporary elementary schools and their teachers. The poverty, the beggarly condition of schools and teachers, and the cold indifference of society toward educational matters have been cited as prime causes [of the schools' problems]. The explanatory memorandum, attached to the new draft proposal [on school reform], also confirms the unsatisfactory state of elementary schools, but it attributes the teachers' failure to the lack of capable, well-trained teachers. We agree with this idea, but at the same time wish to know, which able and well-prepared teacher would become an elementary teacher? Where would one find such an ideal person who, sacrificing his better future, would *voluntarily*—for a salary of 4 to 10 rubles a month—decide to indenture himself for 22 years of service? True, elementary schools have not been left without teachers, but what kind of teachers are they? People fleeing from military conscription, payment of poll taxes, or the necessity of sinking into the poll-tax population. They indentured themselves for 22 years of service, having in mind the sole joy of "a blessed [rank of] collegial assessor," and perhaps a pension of 50 to 90 rubles, if of course the teaching of literacy in Russia did not send them to the grave before they served out the twelve-year minimum.

Yes, for that rank, the elementary teacher [must] decide to endure 22 years of famine, penury and everything as hopeless and joyless as one could imagine. He [must] resolve to become obtuse, turn vulgar, get bald, lose his health, and endure all kinds of criticism

and cavils—all this [must] the elementary teacher resolve to endure just to receive the rank of collegial assessor and realize his cherished dream. . . .

48. Address to the Emperor from Moscow University Students December 1861

Your Imperial Majesty! The favor you have steadfastly shown the students in Moscow University, the lofty patronage that you have constantly deigned to provide, give us the temerity to address our request directly to Your Imperial Majesty! We would feel terrible if the events that recently transpired in our midst were to cast a dark shadow upon Moscow University in the eyes of Your Imperial Majesty. In all good conscience we affirm, Sire, that there is no one among us who would not consider strict observance of order and intelligent obedience to the law as his most sacred duty.

We did not think of betraying this duty when we intended to elicit Your Imperial Majesty's attention and relied entirely upon Your well-known magnanimity when we decided to tell You of our needs.

We dare to petition before the person of Your Majesty to abolish the fees for auditing lectures that were recently established. Sire! This measure lays like a heavy yoke on our poorer comrades and, at the same time, has raised an obstacle to education for all those young people who are poor. We further dare to ask Your Imperial Majesty's permission to have a properly organized student treasury, which would enable us to aid our poor fellow-students directly and openly. Finally, wishing to counteract disorders that often erupt when a mass of students confront authorities, we resolved to ask Your Majesty for permission to select from our midst comrades who, serving as intermediaries between us and our superiors, could explain our needs in a legal manner.

Here are our needs, Sire, about which we decided most humbly to petition Your Majesty. The desire to find a legal means to express our needs has had unexpectedly bitter consequences for us. All our acts were, unfortunately, given a malicious interpretation, and we were alleged to have aims that we neither could nor should have had.

We had not completely settled the matter of a general petition, Your Majesty, when several students were suddenly arrested. Shocked by this sudden and unprovoked action of the police, many of us decided to go to the residence of the governor-general [of Moscow] to petition respectfully, through three of our comrades, on behalf of the students who had been seized the previous evening, and at the same time, to verify the veracity of a wide-spread rumor that the governor-general was willing to send our petition to Your Majesty.

But it was disgrace and unwarranted violence that awaited us on the square before the governor-general's house. We were given no time to express any request; we were not asked about the reasons for our presence; without any prior invitation to disperse, we were attacked by an armed force and subjected to brutal abuse. Some who were not at the square experienced the same, if not greater, violence in remote parts of the city as they went about their private business. A great many of our comrades still have not recovered from the blows they received.

The entire community, all of Moscow, Sire, can tell you that on the ignominious morning of 12 October the student uniform caused intolerable, unprecedented and unprovoked insult for all those wearing it. Everywhere, on every street the student uniform provided sufficient grounds to be beaten by a gendarme's club or trampled by his horse.

Sire! We turn to You for justice! Defend us from degrading and crude violence, which was provoked by an unfounded suspicion that we find deeply insulting. Give us the chance to refute the rumors—which are so degrading for our honor—that have been disseminated about us in print and orally. Give Your gracious attention to those of us who were seized before the governor-general's residence as petitioners, beaten and therefore ailing, and now held and judged as criminals. Your Majesty, our faith in the magnanimity of Your heart is strong. We firmly hope that this request will be favorably received by You and evoke a response in Your Majesty's heart.

E. URBAN SOCIETY
Manufacturers, Merchants, Townsmen

To address various urban problems, the government formed a special commission, which not only analyzed European models for good urban order, but also convoked local committees in 509 Russian cities and towns to comment on the proper design and functions of urban governance. The resulting data, carefully summarized and assessed by the central government, displayed at once the enormous complexity in cities, which included not only merchants and artisans, but sundry other legal categories of the population, from priests and princes to Jews and aliens. Significantly, most urban commissions proposed to keep these legal distinctions, even while admitting most (if not all) to participation in urban governance. At the same time, most townsmen aspired—as they had a century earlier—to enjoy greater local autonomy, to expand the amenities and public services, and to tighten community control over local administration. The response from a small provincial town in Vladimir province, Gorokhovets (doc. 49), aptly illustrates sentiments that were fairly widespread among townspeople. It would be very misleading, however, to imply that the Gorokhovets statement was archetypical; on the contrary, replies from each locale varied considerably—it required considerable work for the central authorities to make even a summary overview of the range of opinion. A number of issues were at stake, but the most important was the precise composition and structure of the city's populace; as the vigorous protest from the artisans in one case illustrates (doc. 50), the principals understood clearly what was at stake when various groups were suddenly merged into a single *Bürgertum*. Little wonder then that urban reform proceeded slowly; the first model reform was promulgated in St. Petersburg in 1842, but it was not until 1870—after another twenty-eight years—that statutes for the whole empire were finally enacted.

Whereas the special urban committees tended to voice general attitudes of townsmen, the urban population—in social reality as well as law—consisted of quite distinct, often antagonistic, social groups. Most articulate of all were the urban elites—the industrialists and merchants who controlled influential organs of the press and participated directly in various ministerial committees and advisory councils. An unsigned article in the newspaper *The Stockbroker* (doc. 51) reflects the merchants' disgruntlement with tariff policy, their antipathy for "English" free-trader theories, and their explanation for Russia's relative industrial backwardness. The industrial elite, if less political than their peers in the West, nevertheless attempted to influence government policy through a variety of measures, such as the formation of special lobbyist societies (doc. 52). The status of ordinary merchants, however, was considerably more modest; the vagaries of trade, backwardness of corporate law, and general insecurities of urban life encouraged even merchants—the juridical elite of the towns—to take an interest in mutual-aid societies (doc. 53). The industrialists, contrariwise, faced strong pressure from the government and public opinion over the "labor question" in the 1860s; as their comments on child labor demonstrate, they had very little sympathy for the reforms being contemplated by the state (doc. 54).

It is, by contrast, considerably more difficult to discern sentiment among petty townsmen. Most articulate were the artisans, a corporate group interposed between townsman and worker and marked by divided sympathies. Although most evidence suggests that the guilds (established by state fiat under Peter the Great) were moribund and inert, at least in some—but certainly not all—cities the artisans composed a cohesive, self-conscious population. Not that all the artisans accepted the legitimacy of this control; as complaints against artisan boards show (doc. 55), younger artisans resented the various restrictions on their independence and rights of free enterprise. On the other hand, the artisans—perhaps imitating educated society, perhaps out of genuine empathy—showed sympathy for the unskilled workers subject to exploitation in factories and plants (doc. 56).

49. Urban Reform: Opinion of Townsmen in Gorokhovets (Vladimir Province) October 1862

[GENERAL DESCRIPTION OF GOROKHOVETS]

The city of Gorokhovets, in terms of its residents' activities in trade and production, should be put in the category of commercial-business towns. The inhabitants are so inclined because of their proximity to the Kliaz'ma River, the Nizhnii Novgorod roadway, and the railroad. These convenient transportation routes favor the sale of building materials and fuel supplies (purchased here at inexpensive prices), as well as local products, and such circumstances make Gorokhovets in no way inferior to other cities in a commercial sense. If at present one observes among the inhabitants stagnation and lack of success, the causes are to be found in unfavorable circumstances: a shortage of capital and entrepreneurship, the inhabitants' commercial backwardness, their lack of education, and their habit of living as they always have (a distinctive characteristic of local residents) are all impediments.

[COMPOSITION OF THE CITY]

The law establishes ownership of immoveable property in the city and registration as a merchant or petty townsman as conditions for the right to be considered a member of the city community. On these terms, the following may be members of the city: (a) hereditary nobles; (b) personal nobles, honored citizens, and other ranks not belonging to the merchant or petty-townsman estates; (c) merchants; (d) petty townsmen; (e) artisans. Our city has handicrafts, but not artisan guilds; both merchants and artisans, without distinction, engage in handicrafts production, and there are no barriers between them and no division into separate estates or categories. This not only does not impede, but it positively promotes the development and improvement of all branches of handicrafts. There are very few hereditary and personal nobles with immoveable property here; even these are in no way separate and different from other social estates in the city and have no interests in the urban or public order that

would be exclusively confined to the noble estate. In practice, there is rarely any need for separate meetings of the merchants. The petty-townsmen, a poll-tax estate, do more often need special meetings to handle their own needs; yet none of these are remote from the heart of all other residents in the city. Therefore, in lieu of divisions into social states or separate categories, it is necessary to fuse all estate elements into one consultative *duma* [council], into a single unit, an undivided urban community. . . .

[ON THE PROPER ACTIVITIES OF CITY GOVERNMENT]

1. Public Finance: . . . According to the [government's reform] prospectus, the regulations on city revenues and expenditures are to receive particular attention, the goal being to give city communities greater freedom and autonomy to control their finances as part of the improvement in urban government. In taking note of all this, one can only be grateful to the government for its concern in this matter. To improve its financial condition and services, the city requires complete freedom and independence of action in public administration; indeed what control (not that of an executive *duma*) can be more searching, substantive and useful than the control of a general consultative *duma,* especially when it is empowered, after the executive *duma's* financial statements have been audited, to publish these in the *Provincial Gazette?*

2. Services and Improvements in the City: . . . To construct any kind of useful, essential public building, it is now necessary to petition twice—once for authorization to spend a certain amount of public funds, then for permission to construct the building itself (according to the city plan that has been officially approved in conformity with the government's standard facades). This correspondence, given the complex forms and distance between the district and provincial capitals (besides the fact that the petitions do not always end with the provincial offices, but sometimes require the permission of central authorities), often drags on for a long time. Once permission has been obtained, next come the estimates, a definitive authorization, preliminary cost estimates, public announcement, auction, contract, and (after the construction is complete) certification, travel expenses, and finally an audit by the construction commission. All these formalities, which raise the cost of public buildings in cities, hardly

encourage provincial city governments to take much interest in civic improvements. To promote this concern, it seems to us convenient to permit city communities to construct, at local discretion, buildings deemed useful and necessary from city and public funds but under the control of public opinion. Private construction also encounters difficulties, and that is one of the main reasons why so many half-collapsed, roofless buildings are to be seen in district towns. The petition for permission from the police and construction commission to repair a broken fence or to replace a roof on some building, taking into account the time lost on petitioning (and time is money for an artisan or businessman), often costs the proprietor more than the buildings themselves. At the same time, the city plan and all possible facades for the construction of various buildings in the city are in the city *duma,* right before your eyes; it would only be necessary to appoint to the city *duma* an architect or, at least, an experienced architect's apprentice, and the *duma* would be able to permit, without delay and difficulties, every kind of urban building and in accordance with the laws and local needs. . . .

3. Public Services and Improvements in the City: . . . All public institutions will develop more quickly if there is public recognition of their need, if satisfaction of this need is left directly to the judgment of the community, and if the city administration is made to face its responsibility before the court of public opinion—that is, if it fully recognizes that it bears a high obligation, without waiting for directives and pressure from higher authorities, if on its own it takes all conceivable measures to remove every possible public misfortune and to develop public services, if it acts at its own discretion and on the basis of legal directives.

[INSTITUTIONS AND OFFICIALS NEEDED FOR CITY GOVERNMENT]

. . . [It would be useful to] form a general consultative *duma* with deputies from all estates named above (on the basis of the 1785 charter to the cities) and to designate up to 25 deputies for the general *duma.* The *duma* need not be divided into estates or separate categories; however, since the individual interests, rights and privileges of each estate should be preserved inviolate, the Commission believes that each component of the city community should have its own special advocate in the general *duma*—in the person of an estate

elder [*soslovnyi starshina*]. There are three estate elements here: noble, merchant and poll-tax townsman. It is not necessary that the elder of the noble estate unfailingly be a noble himself, or the merchant elder a merchant, or the townsman elder a townsman; the election of all three elders is most conveniently left, without any restriction, to the complete discretion of the city communities themselves, [who may choose] whomever they trust most in the circle of city inhabitants. The only important thing is that these elections proceed on a correct and legal basis. The elected elders, no matter which estate they might belong to, in matters of public services and order in the city, are obliged to uphold and defend unfailingly the interests, rights and privileges primarily of that estate which elected them. The office of estate elder, next to that of city mayor, must be the most respected office in the city's public administration; the rank of elder obliges those who have accepted this position to place public interests above their own personal interests, to guard and take true care of the rights of the estate they represent, and in all respects to be accountable to the legitimate judgment of public opinion for negligence and demonstrated nonfeasance in public office.

[FRANCHISE]

The city resident acquires the right to vote in public assemblies under the following circumstances: (1) if he is of sound mind and capable of freely expressing his thoughts; (2) if he is of irreproachable, honest conduct; (3) if he is inscribed in a given city in the merchant guild or poll-tax rolls, which constitutes the collective guarantee of native members of the petty-townsman community. Otherwise, for the right to vote it is necessary to own immoveable property that yields at least 30 silver rubles per year.

Women, who have the right to vote under the above conditions, have the right to give their vote to whomever they wish, but only to those who themselves have the right to vote in the city.

50. Voronezh: An Artisan's View on Urban Reform
December 1862

When the city commission considered the subject of establishing public administration, many members proposed to divide the inhabitants of Voronezh into three estates: nobles, merchants and petty townspeople (the latter including artisans, workers, and various people attached to the city). At the same time they propose to abolish the artisan board and to establish a single estate administration for all these categories of petty townsmen.

Taking into account the material life of petty townsmen and artisans, and in accordance with the wishes of my fellow artisans, I have the honor of submitting my [dissenting] opinion.

1. The inhabitants of the city are divided into *four* estates (nobles, merchants, petty townsmen and artisans), because petty townsmen and artisans have utterly different rights and interests. The townsmen are interested in commerce based on capital and trade turnover, whereas artisans are engaged only in handicrafts and obtain their sustenance by working with their own hands. Consequently, the townsmen's interests are more akin to those of merchants and most certainly not to those of artisans.

2. The merger of artisans with townspeople, furthermore, is inconvenient because the size of the petty townsman community is five times that of artisans. Therefore the former could compel the other to bear, without cause, various taxes and assessments. A petty townsman who engages more in commerce than handicrafts cannot be so visible as the artisan, who, apart from his specialty, endeavors to earn the respect of his customers and must make himself highly visible, even if he has no special means other than his work. Therefore a majority of the voters, without really knowing the artisans' condition, could burden them with assessments exceeding their financial means. By contrast, an artisan community under the administration of an artisan board can freely and without inhibition bear all public demands, including the recruit obligation, without any difficulty.

3. The special directives published for artisans and the artisan board can exist where there are few artisans, but our city has more

than 1,000 artisans, with their own public building for the board. Of the artisans, perhaps only one-tenth do not engage in handicrafts; at the same time, there are many merchants, petty townsmen and people of other ranks who are artisans and who, in matters related to their work, have dealings with the artisan board. So is it not better to turn townsmen-artisans into artisans and, at the same time, to give the artisan guilds jurisdiction over all merchants, people from other towns, and other people who engage in any kind of handicrafts whatsoever? They should perform all the temporary and [permanent] service obligations imposed upon the artisan class. Then the artisan class can be improved in its composition and flourish. But the merger of artisans with petty townsmen and governance by a non-artisan elder (even if assisted by two artisan aides) does not seem to augur well for the future of handicrafts.

4. If all the lower estates are merged into one estate, then this estate will form three quarters of the entire population of the city, with the nobles and merchants forming another quarter. But this last quarter is divided into two [estates], each of which has a voice and representative, whereas the entire mass of lower estates have just a single voice and a single representative. But what can the voice of the lower class do against the two upper, most educated classes? Can it often be heard? And if I am not wrong, then I can positively say that the lofty goal of the government is to give the lower class equal participation in public affairs. And the lower estate can be just as deeply concerned about the public welfare, so why should it not be divided into two parts (parallel to what is done with the upper classes), because the upper estates cannot always know properly all the needs and wishes of the poor people. It would be entirely just if the lower estate were divided into petty townsmen and artisans, and then an equal voice would be closer to the goal of public discussions.

51. Textile Manufacturers: Opinions on the Tariff 9 June 1862

Cloth manufacturers are wholly preoccupied with considering the reasons for their difficulties in selling cloth of superior and even

average quality, the enormous backlog of which threatens to bring them very significant losses. They have come to believe the following:

1. The increased import of fashionable, colorful cloth and wool from abroad has blocked the sale of domestic textiles. Articles 311, 312 and 313 of the existing tariff, with its different nomenclature . . . have caused customs officials, either from caprice or confusion, to mistake one classification for another when assessing duties. As a result, only 80 kopecks per pound is assessed for all the popular textiles, regardless of their properties and types, prepared from yarn with a mixture of silk, angora, etc. That is no more than 20 kopecks per arshin [28 inches], or from 7 to 10 percent of the value of the cloth. Such a small duty is lower than anywhere else for European factories; it has enabled a significant increase in the import of fashionable woolen goods and given them an enormous advantage over simple, monotone cloths.

2. The import of finished clothing from abroad, which made multi-colored wool material fashionable here, has further weakened the demand for plain cloth. One can say categorically that merchants who import finished clothing have taken away virtually the entire market from textile manufacturers' products in the western part of the empire—to say nothing of the fact that this import has deprived the majority of poor urban artisans of their wages. This result is positively harmful and especially so now, given the rise in prices on basic necessities and the general stagnation in domestic industry.

In view of the above, the manufacturers consider [the following measures] urgently necessary:

1. A prohibition on the import of finished clothing.

2. For the import of manufactured goods, customs inspection for the entire western area should be authorized [only] in St. Petersburg, Riga, Verzhbolov, Warsaw and Radzivil.

3. Prohibit the import of manufactured goods [through] other customs offices in the western region. These are remote from central roadways (and pose no advantage for the importers) and, at the same time, importing through second-class customs offices gives reason to suppose that this encourages attempts to obtain illegal advantages. Otherwise, it is difficult to explain what would be the advantage and purpose of importing goods without using the railway, which offers all the advantages and cheaper costs for the transport of goods.

4. In lieu of articles 311, 312 and 313 of the current tariff, which contain sundry classifications (some of which are even archaic), establish the following method for levying import duties: (a) all woolen materials, prepared from the yarn of a single textile substance, smooth, monotone, with or without nap, is to be assessed 1.40 rubles per pound (i.e., without any change in the existing tariff, in accordance with article 311). . . . (b) all woolens (regardless of nomenclature) that are prepared from the yarn of a single substance, which is multicolored or calico, with or without nap, with a compound of silk, angora, Tibetan, alpaca and other lustrous wools, are to be assessed 2.80 rubles a pound. This change, even if one disregards the [present] abuses, represents a most insignificant change in the amount of customs revenues. . . .

It was not long ago that cloth manufacturing, both for domestic consumption and for export to Asia, was still at an early stage in its development. It owes its development to intelligent measures, to a correct view and profound understanding of our industry's interests on the part of the late Count Kankrin [Minister of Finance under Nicholas I].

Prior to 1832 Russian sheep-raising existed only on the most limited scale, and wool exports barely reached 70,000 poods. But Russian sheep from Spanish breeds now produce up to 1,000,000 poods for domestic consumption and 700,000 poods for export, which yield an income of 17,000,000 rubles for domestic production. But this branch of the national economy has developed because of the demand from domestic factories, and we must not forget that, without the protection of our textiles, factories for the production of better-grade cloths would not exist at all. . . . [sic] But at present the conditions of demand and fashion have changed; tricot, a fashionable product, has become a consumption item predominantly for the wealthy and prosperous and has replaced cloth textiles; hence the production of tricot demands special protectionist measures, both to introduce this and to support our sheep-growing.

It may well be that, amidst the current fashion of discussing and speaking of our industry, and relying upon the views of English publicists, we will be rebuked not only for old-fashioned opinions but even of a greedy desire to get rich at the consumers' expense. But this reproach is utterly unfounded; as proof, one need only compare the protectionist tariffs of many European states, especially

Germany. Finally, we permit ourselves to ask: what kind of results did these views yield after the tariff was changed—over the objections of practical people, who predicted ruinous conditions for our manufacturing? Such have come to pass; the results are there for all to see. With the decline in cloth production, the price on first-class wool has dropped by 25 percent and still greater declines can be expected—as the economic data of the Princes Kochubei, Count Gur'ev, Chertkov and many others indicate.

What can our enormous sheep-growing industry expect in the future if Russian factories are forced to make a significant reduction in their demand for wool? Wool export, on its own, does not yet give favorable results, for many years' experience have shown sheep-growers that wool prices at trade fairs are supported primarily by domestic demand; higher prices on wool are not generated by Berlin or Breslau Jews, but by Russian manufacturers. One may positively say that, under the existing customs laws, Russia will soon be left without its own wool. . . .

In addition, we ask that attention be given to the following [factors]:

1. Dyes and other necessities that must be imported (e.g., indigo, sandal, tartar, teasels, etc.) are subject to import duties, and cost our cloth-manufacturers 30 percent more than foreign producers.

2. There are only 255 working days a year in Russia [because of numerous state and Church holidays].

3. There is no working class [in Russia], whereas foreign countries have whole corporations in every branch of production.

4. We do not produce our own machinery; foreign countries have an enormous machine-building [sector].

5. Our fuel is more expensive and requires more time for its use.

6. Shipping costs here run into rubles; abroad it is a matter of mere kopecks.

7. Transportation here consumes weeks and months; abroad it takes only hours, at most a few days.

8. [To borrow] capital we pay 7 to 12 percent; abroad it is 2.5 percent, at worst 4 percent. But no one pays any attention to this important subject, although we all—from the rich landowner to the poorest rag merchant—suffer because of it.

9. We pay skilled craftsmen thousands of rubles; abroad they cost a tenth of that.

10. Abroad, technical schools have been established in all manu-
facturing cities, especially amidst the current demand for popular
wares. But our only technological institute—during the entire time
of its existence—has not produced a single skilled craftsman for tex-
tiles, even though it had every possibility to send its most gifted
pupils for advanced hands-on training at plants in Belgium, England
and France. In all these places the Ministry of Finances has its own
agents, who could have rendered a truly great service to the govern-
ment by taking under their protection young people sent there for
this purpose. It would have sufficed then to have had a few dozen
good craftsmen to have hundreds now. . . .

52. Charter of the Society to Promote National Economic Prosperity January 1862

1. The goal of the Society is: (a) to oversee the inspection and
clearance of wares imported through customs. For this purpose it
elects and supports authorized representatives [to serve] in customs,
designates inspectors to assist these representatives, and collects the
necessary funds for this; (b) to remove obstacles to the development
of manufacturing and trade in Russia, and to help promote their
well-being. For this purpose it learns the needs and requirements of
manufacturing industry and trade, and makes representations to the
government.

2. The Society is established in Moscow, primarily from [the ranks
of] Russian manufacturers, factory-owners and merchants, who make
annual monetary contributions to the society (according to a scale
[from 7.30 to 150 rubles]). In addition, people who are distinguished
by erudition or useful work in one of the branches included in the
Society's sphere of activities, are accepted as members without the
obligation to make a monetary contribution. But their appointment
can follow only after election by no less than two-thirds of the cur-
rent members of the general assembly.

53. A Merchant's Proposal for a Mutual-Aid Society 12 January 1862

The security of a merchant's prosperity and capital always depends upon a host of different factors, and it very often happens that a merchant's family is ruined solely by the death of one of its active members. We see such cases quite often. The family was accustomed to live in prosperity or at least without need when this member was alive, but if its head dies unexpectedly or his business collapses, the family is suddenly left without any means. Given assistance from no quarter, it is totally ruined and forced to resort to begging. Timely, even if modest, assistance could sustain the family, not only in terms of subsistence but also in a moral sense, and save it from complete destruction. In addition, the estate of merchants' shop clerks (one of the most important employed in commerce) has so far not elicited any attention. But as these people devote their labor, time and health to the benefit of the proprietors who employ them, and through their work help the latter to accumulate capital, in all fairness they deserve the complete sympathy of society. A certain number of them attain the rank of proprietors and acquire the means of existence, and even capital, but for a variety of reasons the majority of them, when they are too old or ill to work, are left without any means, and their families also have to resort to charity.

To support merchant families that are ruined for the above reasons, and to alleviate their plight (as well as that of the poor and aged shop clerks and their families) through assistance that does not bear the stamp of charity, but represents a reward for past work, the Russian Merchant Society is being established to provide this mutual assistance. But as explained above, so that this aid not have the appearance of charity, this Society is established as a club, whose members (for an annual monetary payment) have the opportunity to spend their free time in a circle of acquaintances and relatives, in reading books and journals, and attending family dances and concerts. At the same time, a portion of the dues are set aside to form a philanthropic capital: (1) for giving pensions and aid to the elderly and impoverished members and their families; (2) for placing ill

and infirm members and their spouses in charitable institutions, and their children in educational institutions as wards of the society; (3) for granting aid to the daughters of poor members when they marry (as dowry); (4) in the event a member dies, for giving assistance for his burial; and (5) in the event of illness by a member or his family, for financing free visits by a doctor and free medicine.

54. Manufacturers' Opinion on Child Labor Legislation [1861]

The owners of a cotton-spinning mill in Egorev (Riazan province), the Khludov brothers (both with the rank of honored citizen), while accepting a total ban on child labor at night in their factories in the summer, hold that minors (from age 11) should be allowed to work up to thirteen hours at night in the winter (dividing the work with one hour for lunch and one hour for breakfast). In the Khludovs' opinion, this would not be onerous for the children, since they perform the lightest work in a cotton-spinning factory. As for the ban on night labor by children in the winter, the Khludovs find this rule exceedingly restrictive, since the elimination of child labor will cause adult workers to lose their jobs. "Thus the children, having been deprived of wages from the factories, will not bring their parents any material assistance, will resort to idleness (which is harmful for their age), and shatter their health, for they will not be in the light, healthy surroundings of the factory, but in the stuffy atmosphere of their [peasant] hut."

Manufacturers and plant-owners in Tula find that it is impossible to limit the work of minors from 12 to 16 years of age, since it is only with their assistance that the adults can work. Adoption of this measure, observe the manufacturers, on the one hand will—in the highest degree—have a pernicious effect upon industrial factories, and on the other hand will not bring the slightest benefit to minors, since development of their strength, given the lightness of the work, cannot be impaired because of the long hours.

The manufacturer Shilov (a cotton-spinning mill owner in Vyshnii Volochek, Tver Province), finding in this article an attempt by the

government to eliminate entirely night work (which, without the use of minors, is impossible), observes that given a reduction in the latters' employment, it is necessary to reduce the work of adult laborers, which will lead to a reduction in their wages and deprive them of the chance to educate their children. In general, this measure violates the freedom of popular work. Furthermore, the manufacturer Shilov explains that the goal of the government to improve the plight of minors by regulations cannot be achieved, because the parents will hand over their children to work for artisans and other places, where the work of minors is not prohibited by law.

Count Baranov, the governor of Tver province [commenting upon Shilov's statement], observes that in this opinion one sees only "the wiliness of a manufacturer in defending his unjust cause and contradictions in his own statement. The cotton-spinning mill-owner, consequently a protectionist, living an unnatural life through a protectionist system, seeking to retain this for an unlimited time, raises his voice for the freedom of popular labor! Such [hypocritical] methods (worthy of [J. Molière's] *Tartuffe*) are inexcusable, because it is obvious that the manufacturer is concerned neither about the people's prosperity nor about the education of their children, but only about his own pocketbook. [Even] if production does bring money to the people, obviously the manufacturers ought not to boast that they are the patrons of the people; they are simply exploiters of the people's strength and capacities, exploiters in the full meaning of the word, since they do not care in the least about the health or morality of their workers. A more perverted population of workers and youths, a more life-shortening [system] exists nowhere. In most cases, there is no medical assistance or school; when these do exist, they are established without any sympathy, but just for show."

55. *An Artisan's Critique of Guilds December 1862*

Handicrafts, or the production of goods by hand, is one of those inventions to satisfy the needs of man, and hence it is closely linked to factories, art and productivity. After a recession, this branch of industry has recently (especially abroad) attracted the attention of

the governments, which seek to improve both the plight of factory production and also of those who rework materials into a certain form (i.e., skilled craftsman, apprentices and their pupils). For this reason, foreign governments have abolished all corporations which could impede the development of free labor. But, amidst this dissemination of new improvements and innovations, each of us artisans must now work not only physically, but also with our brains, to improve his craft. In desiring to achieve this, one must think—but that is only possible if work is free and unencumbered by that control over each individual craft known here as guilds.

This corporation, by adhering to traditional ways, serves as a barrier to every kind of new idea. The corporation sometimes consists of elderly men, who look askance at young artisans and seek only to extract some gain from them, or to oppress those who strive for the title of master and then to shackle them to their old position. As proof of this, I will cite two facts that speak for themselves.

A young tailor ([newly] arrived from Vienna, where he perfected his skills in this craft for ten years) used a new method to make one gentleman a coat, which was distinguished by its embroidery and taste. The old masters impatiently waited until this coat was turned over to the client (to his complete satisfaction), but found an opportunity to persuade him that the coat had been spoilt—i.e., cut improperly, not according to the old method that they themselves observe completely. They ruled that the young tailor must make restitution to the client for the cloth and pay them a fine. And once these judges had drunk the blood of his earnings, his reputation was utterly ruined (even though he was entirely innocent). Thereafter, he was constantly persecuted by them until he finally established belief in his abilities in surrounding areas outside the town.

Another fact. A gentleman gave a tailor some cloth to make several pieces of clothing; just as the work was completed, however, the gentleman suddenly died. His brother appeared to collect his inheritance; when the tailor presented the clothing that had been ordered, with a bill for the work he had performed, the brother did not want to accept this and demanded that the tailor pay him for the cloth. The misunderstanding between the two parties came before the judgment of the guild or the artisan board, which ruled: since the tailor was guilty of spoiling the cloth, which would not have looked good upon the deceased, it fined him 8 rubles and also obliged him

to replace the cloth for the heir. To such a judgment there is no appeal, and the poor tailor—from his last possessions—was obliged to satisfy the demand of the guild authorities, who censured the workmanship of the clothing, not because of the deceased man's opinion, but their own. . . .

Let these two facts serve as evidence of the condition of our handicrafts, at the head of which stands an artisan board, comprised of people who do not understand their purpose.

56. An Artisan Paper's Comment on Factory Conditions May 1863

It should be obvious to everyone that, the better a worker is supported, the better he will work. A healthy, well-fed horse will haul more and live longer; a satisfied worker, if he has enough time to rest and receives a decent wage, will work more willingly and not spoil his products and cause waste. If he gradually becomes more skilled, his work will not be penal servitude but something that he enjoys. Anyone can understand this, but by no means everyone abides by it. It became necessary for the government to establish various commissions, such as those founded several years ago in St. Petersburg, Moscow and several other places to examine the workers' housing and to collect information on their material support. This is not the place to discuss what the commissions found and did, or to discuss the cruel treatment and incredibly bad support of workers and apprentices in various shops and plants. These [places] all want to turn a quick profit and to save as much money as possible—at first it goes well enough, but the work deteriorates and the shop gradually goes under.

Among our industrial villages for iron and steel production, two stand out: Borsma and Pavlovo in Gorbatovskii District (Nizhnii Novgorod province). Here the factories—some large, some small—are as common as houses. Both villages produce about 3 million rubles worth of iron and steel products a year. The products of Borsma and Pavlovo are generally of high quality, but they would doubtlessly be better if the workers were given better support. It might well be that,

in this case, competition from certain good English steel products (known for their excellence) would not pose such a threat to our factories.

In Pavlov the workers rise at 3 a.m. in the winter, at sunrise in the summer. They take breakfast at 7 a.m. and lunch at 1 p.m.; only some of the factories have a rest period after breakfast and lunch. In winter work ends at 9 p.m. and in the summer at dusk. The pay is six to eight rubles a month; if one calculates 25 workdays a month, and 18 hours a day, then a skilled craftsman works 450 hours per month. Hence he earns 1.5 to 2 kopecks an hour.

And, for this insignificant wage some workers must also risk their lives. To finish knives, so-called "stones" are used, but these emit a fine dust that the workers inhale during the work. This dust is harmful to one's health. Some factories have partially eliminated this condition, but that is not true at all plants, however. A recent visitor to the village of Pavlovo was told that, at one factory, up to 35 workers in the finishing department had died over the last five years. The men working in this department are often housed in filthy, wet and stinking basements, which of course are at once harmful to their health and bring the factory proprietors still more profit. Where is the sacred dictum: "Love thy neighbor as thyself?"

F. PEASANTRY

When autocracy, after decades of dallying and secret deliberations, finally resolved in the mid-1850s to emancipate serfs, it unleashed a wave of disorders and wild expectations among the peasants. The incidence of peasant disobedience increased dramatically, arousing acute consternation among Petersburg authorities and cold terror among provincial nobles. But the turbulence palpably subsided once the government publicly committed itself to "improving the material condition" of the serfs; evincing their traditional faith in the tsar, most peasants retired to await the full proclamation of "freedom" and grant of land they currently utilized. The emancipation of 1861, however, proved as incomprehensible and unacceptable to peasants as it did to squires, and the year 1861 recorded the greatest number of disorders and conflicts since the Pugachev Rebellion nearly a century earlier. Though few peasants actively resisted local authorities or openly repudiated the emancipation statutes, most put up passive resistance, adamantly refusing to compile the necessary documents or to perform their duties as "temporarily-obligated peasants."

The documents presented below cast valuable light on the peasants' response to emancipation. The petition from Saratov (doc. 57) is noteworthy for its addressee—Grand Duke Konstantin Nikolaevich, the well-known liberal brother of the emperor—and for its faultless bureaucratic style; to judge from its handsome chancellery penmanship and style, it was most likely prepared by a petty clerk—to be sure, on the peasants' behalf, with the characteristic demands for land and complaints of physical maltreatment. The following petition, addressed to the emperor (doc. 58), contains a long catalogue of purported atrocities and illustrates the typical preoccupation with the land question; this document is also noteworthy for its unqualified monarchism, embellished with religious overtones and avowals to pray for the emperor's soul. The petition from Vladimir (doc. 59), addressed to the Minister of Interior, graphically demonstrates the staggering complexity of emancipation, not merely in cajoling obdurate squires and serfs to cooperate, but in determining what belonged

to whom; the bitter legacy of serfdom's lawlessness left property re-
lations as tangled as it did human relations. The petition from an-
other village in Vladimir (doc. 60) reveals a savvy understanding of
the central bureaucracy, where a petition to the Tsar was simply
transmitted to the appropriate arm of the bureaucracy (in this case,
to the Land Department of the Ministry of Interior). These peasants
presumably reached their understanding through bitter experience
for, as the text indicates, this was not their first such appeal. That,
too, was characteristic of peasant petitioners: indefatigably, time and
again, they appealed about the same issue, evidently persuaded that
sheer obstinacy could eventually prevail. But perhaps the most inter-
esting part of their petition is the clever attempt to undermine the le-
gitimacy of *local* authorities, not merely by challenging the gover-
nor's report, but also by basing their whole argument on the special
political connections of their squire. Finally, peasant petitions were
considerably more sophisticated than earlier; no longer content with
traditional appeals for justice or compassion, they offered more com-
plex arguments to establish their legal and moral claims.

57. Petition from Peasants
in Balashov District (Saratov Province)
to Grand Duke Konstantin Nikolaevich
25 January 1862

Your Imperial Excellency! Most gracious sire! Grand Duke Konstan-
tin Nikolaevich!

Most magnanimous prince, given by God for the welfare of people
in the Russian Empire! The countless acts of mercy and humanitari-
anism of Your Imperial Excellency toward the loyal subjects have
emboldened us to fall to your feet and plead:

Show your steadfast and just protection of oppressed humanity!
Following the example of our fathers, grandfathers and ancestors,
we have always and without complaint obeyed the laws of Russian
monarchs and the authority of its rulers. Hence, as peasants in the
hamlet of Blagoveshchenskoe and three villages (Avdot'evka, Alek-
sandrovka and Uspenskaia) in Balashov District of Saratov province,
we and our families, while under the authority of the squire, a retired

colonel, Prince Vasil'chikov, have always enjoyed the blessings of the all-merciful God: fertile land.

The monarch's mercy—which has no precedent in the chronicles of all peoples in the universe—has now changed the attitude of our squire, who has reduced us 1,500 peasants to a pitiable condition. . . . [*sic*] After being informed of the Imperial manifesto on the emancipation of peasants from serfdom in 1861 (which was explained to us by the constable of township 2 of Balashov District), we received this [news] with jubilation, as a special gift from heaven, and expressed our willingness to obey the square's will in every respect during the coming two-year [transition] period [and to remain] on the fertile land which we occupy, where we could realise our life. . . . [*sic*]

But from this moment, our squire ordered that the land be cut off from the entire township. But this is absolutely intolerable for us: it not only denies us profit, but threatens us with a catastrophic future. He began to hold repeated meetings and [tried to] force us to sign that we agreed to accept the above land allotment. But, upon seeing so unexpected a change, and bearing in mind the gracious manifesto, we refused. Then Prince Vasil'chikov, with terrible threats, went to the city of Saratov, and soon afterwards the squires, Prince Prozorovskii, Golitsyn, Colonel Globbe, and the peace arbitrator Baishev came to our township office. After assembling the entire township, they tried to force us into making illegal signatures accepting the land cut-offs. But when they saw that this did not succeed, they had a company of soldiers sent in and said that they had been sent—by the Tsar!—to restore peace between us and the squires. We heard this and, despite the unsuitability of the land, we were ready to accept it—at first as 3 dessiatines per soul, then later 4 dessiatines. But we did not give the demanded signatures, suspecting here a scheme by the squires' accomplices. Then [Col.] Globbe came from their midst, threatened us with exile to Siberia, and ordered the soldiers to strip the peasants and to punish seven people by flogging in the most inhuman manner. They still have not regained consciousness.

These inhuman acts and intolerable oppression have forced us to fall to the sacred feet of Your Imperial Excellency: 1,500 voices most humbly ask for just, most august defense, which can save weeping families from certain death, and [we ask] that You issue a decree [on our case].

58. Petition from Peasants in
Podosinovka (Voronezh Province)
to Alexander II
May 1863

The most merciful manifesto of Your Imperial Majesty from 19 February 1861, with the published rules, put a limit to the enslavement of the people in blessed Russia. But some former serfowners—who desire not to improve the peasants' life, but to oppress and ruin them—apportion land contrary to the laws, choose the best land from all the fields for themselves, and give the poor peasants (who are just emerging from their domination) the worst and least usable lands. To this group of squires must be counted our own, Anna Mikhailovna Raevskaia, [who acted thus] during the division of fields and resources, which the 600 peasants of the village of Podosinovka (Krasninskaia Township, Novokhopersk District, Voronezh Province) have used from time immemorial. Of our fields and resources, she chose the best places from amidst our strips and, like a cooking ring in a hearth, carved off 300 dessiatines for herself. Other places—characterized by sand, hills, knolls and ravines (with the sparsest amount of hayland)—were designated as the peasant allotment; altogether, including the household plots, we were given four dessiatines per soul and assessed a quitrent of 12 rubles per soul. But our community refused to accept so ruinous an allotment and requested that we be given an allotment in accordance with the local Statute [of emancipation], without injury, even if the quitrent must be increased. The peace arbitrator Iakubovich and the police chief of Novokhopersk District informed the governor of Voronezh of our refusal [to accept the inventory]; in their report they slandered us before the governor, alleging that we were rioting and that it is impossible for them to enter our village. The provincial governor believed this lie and sent 1,200 soldiers of the penal command to our village of Krasnoe to inflict ruin upon us innocent people; three days after sending the troops, the governor himself came to our village (with the peace arbitrator, the district police chief, and the township constable) and summoned our township head Epat Chergin, his aide Vasilii Kirsanov, the elder

Khariton Iartanskii and other representatives of the peasants. Without any cause, our village priest Father Peter—rather than give an uplifting pastoral exhortation to stop the spilling of innocent blood—joined these reptiles, with the unanimous incitement of the authorities (including eleven ill-wishers). They summoned nine township heads and their aides from other townships (Bulaevo, Pekhovo, Sadovo, Aferovo, Zarazivskoe, etc.) In their presence, the provincial governor—without making any investigation and without interrogating a single person—ordered that the birch rods be brought and that the punishment commence, which was carried out with cruelty and mercilessness. They punished up to 200 men and women; 80 people were at four levels (with 500, 400, 300 and 200 blows); some received lesser punishment. The governor ordered the township constable to punish the women; using his superiors' authorization, the constable cruelly punished innocent women with 100 blows each and struck them in the cheek with his fist, so that the punished were left without consciousness and reason. Of the men punished, most had earlier fought for the faith, tsar and fatherland, and when the inhuman punishment of these innocent people had ended, the provincial governor said: "If you find the land unsuitable, I do not forbid you to file petitions wherever you please," and then left.

Having explained the inhuman acts of our local authorities and our final ruination through the oppressive allotment of unusable land in strips, we dare to implore you, Orthodox emperor and our merciful father, not to reject the petition of a community with 600 souls, including wives and children. Order with your tsarist word that our community be alloted land according to the statute for this area, which peasants used prior to the publication of the all-merciful manifesto, and not in strips, but as the law dictates (without selecting the best sections of fields and meadows, but in straight lines) for the quitrent payment as fixed in the local statutes. [Order that] the meadows and haylands along the river Elan be left to our community without any restriction; these will enable us to feed our cattle and smaller livestock, which are necessary for our existence.

Most august monarch! If our former owner Raevskaia uses all her means, in hopes of protection from local authorities (so as not to give us, in accordance with our wish and laws on apportionment, usable field land and hayland), if our allotment is so oppressive, we will not have the strength to pay such a quitrent or to feed our families. Then,

Sovereign, give your blessing to those of us who wish to have land allotments that might be indicated by your wisdom. Merciful emperor, permit us to be called state peasants. Such monarchical mercy, your all-merciful father and liberator, will echo in our hearts with eternal gratitude, and our prayers (not only of the old and young, but of infants in their cribs) will profoundly rise to the heavenly creator for the health and long life of God's anointed, and for all the members of your imperial family.

59. Petition from Peasants in Rozhdestvino (Vladimir Province) to the Minister of Interior August 1862

At the Sovereign Emperor's very first summons to the nobles to grant their serfs freedom, the peasants on Mrs. Naryshkina's estate (the village Rozhdestvino and hamlets Karskova and Shubina in Vladimir District) filed a complaint of various abuses committed by the owner. The essence of this matter was explained in petitions to the Land Court of Vladimir, the governor of Vladimir province, His Excellency Grand Duke Konstantin Nikolaevich and Your Excellency. Although the government gave all these petitions proper treatment, they lose their real meaning in the local government that has been established over serfs. Namely:

The Committee for Peasant Affairs in Vladimir Province, after examining the case of the peasants of Naryshkina, decreed on 28 August 1861 (among other things): "From this case, it is evident that the mill (about which the peasants had petitioned) had previously been in common ownership between Naryshkina and the other heirs, and was leased out. After an inheritance settlement, the mill became the sole property of Naryshkina, who leased it to the peasant Bazhenov, without conferring to the peasants the right to mill their grain there gratis." But this is an out-and-out lie. The mill, which Naryshkina's peasants seek to have in their possession, was never the joint property of Naryshkina and her heirs; rather, under the previous squires General Vsevolodskii and Count Zubov, it was simply in the possession of the peasants of the village Rozhdestvino and hamlets

Shubina and Kraskova. It was they who constructed and leased it to the state peasant Vasilii Nikiforov Bun'kin (of the village Stavrov); this can be confirmed by the peasant [Bun'kin] and other long-term residents in the surrounding area. That Mrs. Naryshkina never shared in this mill with her heirs (whom the peasants of the village Rozhdestvino and hamlets Shubina and Kraskova do not even know) can be seen from the case in the Vladimir District Court, which contains the will and testament of Count Zubov: according to this, we (not through an inheritance settlement) were given entirely to Mrs. Naryshkina. In accordance with these facts, and on the basis of article 37 of the Imperially confirmed regulations on the emancipation of serfs, we hold this mill to be our property, as part of the peasant settlement, not that of Mrs. Naryshkina, on the grounds that the mill (as explained above) was constructed at our own expense.

With respect to the petition of Mrs. Naryskina's peasants for land, it emerges that Mrs. Naryshkina compiled the inventory with terms that have forced us to lodge a new complaint. The inventory declares: "Part of the unsettled property of Medneva from the land of the hamlet Orekhova on the right side of the Lednev ravine along the second spur of this, bordering the squire's woods (called the Large Birch Grove): in addition to including the first spur in this section, 68.5 dessiatines are left to Naryshkina." The inventory on this subject was compiled on 4 April 1862, confirmed by the assembly of peace arbitrators on 8 May, and implemented on 2 August. Throughout this period, we were given no information before we received a copy of the charter. Thus we cite a resolution of the Commission for Peasant Affairs in Vladimir Province, which declared that in general we should possess what we currently utilize, and we have fertilized this entire territory with manure and have plowed it for cultivation. But now Mrs. Naryshkina has taken this land from us (with its fertilized and cultivated soil) and given it over for the use of those peasants on this estate who support her position. We shall identify them during an investigation.

Further, the inventory declares that the unsettled property of Demkova and Prokoishko, which encompasses 18.5 dessiatines, have also been assigned to the squire. In these areas the main part of the land belongs (through private purchase) to the individual ownership of Mrs. Naryshkina's peasants; consequently, such land should not even be included in the inventory. Peasants have their own right to these

lands, as well as proof [of ownership], which give them these rights; this can also be demonstrated by the peasants in a formal judicial inquiry.

Moreover, the inventory stipulates that the squire is to take meadows and hayland for her use from the surveyed church lands, along the left side in a straight line to the Strelets ravine (with a total of nearly 56 dessiatines). But this stretch of land has previously been used by Mrs. Naryshkina's peasants; it will be very difficult or even impossible to live without it.

Of course, article 20 of the Imperially confirmed Statute orders the squires to keep one third of the total land included in the inventory, as our squire has done. But, according to article 54, cut-offs are permitted only from unfertilized land that is distant from the [peasants'] settlements. Consequently, according to the terms of this law, Mrs. Naryshkina has no right to deprive us of the above fertilized land, especially since these existed (and exist) within our farmlands. Therefore, and in accordance with article 53 (which gives the peasants permanent use (in return for dues) of those resources which they [previously] used), we thought it best to retain possession of these lands by means of government force, with payment of dues for a full allotment of our legal strips.

In addition, there is an unsettled area called Pestrikova in Pokrovskii District, located no more than six miles from the village Rozhdestvino. According to the terms of the written documents, this is designated as Mrs. Naryshkina's property. But in fact it is our own personal property, because the purchase money for this was given to Mrs. Viatkina and Mrs. Kupriianova by our forefathers, not the squires. This can be confirmed by old residents of neighboring villages, who are well informed about this. Now Mrs. Naryshkina has taken this property away from us and is selling it.

We find ourselves deeply harmed by the cut-off of Mrs. Naryshkina's land and mill (the inventory is even silent as to who should possess these things), because the land (in its full amount previously left for our use) does not compose the appropriate allotment (per our condition). Denied the possibility of raising this matter in Vladimir (since they regard our just requests as disorders and subject us to torture merely for petitioning), which is known to Your Excellency (from the fact that, without cause, a military company was sent to our estate), we have decided to submit the above matters for the

good judgment of Your Excellency, and most humbly request You to show us mercy and protection: order a reliable official from the ministry to investigate the overt oppression on our estate from the side of Mrs. Naryshkina, which the local authorities (especially the marshal of the nobility for Vladimir District) have covered up in the Committee for Peasant Affairs in Vladimir Province with unjust assertions that we have full use of these lands. But that is false. And on the basis of the investigation do not deny us the use of both the mill and land, which the squire has taken from us. To keep these, we will give up, if need be, the unsettled land in Pestrikova that belongs to us. In addition, we must bring to Your Excellency's attention the fact that the government in Vladimir is so hostile to us that they do not explain clearly the decrees of higher authorities. For example, with respect to the abuses of Mrs. Naryshkina in December of last year, a complaint was sent to the Sovereign Emperor, but the peace arbitrator (after reading it in its entirety), in response to our query about the outcome, only said that "your case is not subject to consideration."

60. Petition from Peasants in Berezino (Vladimir Province) to the Minister of Interior 31 October 1862

A most humble petition to His Excellency, Minister of Interior and cavalier of various orders, from the temporarily-bound peasants of the village Berezino (Aleksandrov District, Vladimir Province).

Our most humble petition to His Imperial Majesty on 14 July of this year was given to Your Excellency for your disposition. We received notification from the Land Division of the Ministry on 25 August that our request does not require any action on the part of the ministry, because the governor of Vladimir province removed the military contingent from our village, and with respect to the average land allotment, he allegedly explained everything to us and eliminated all our perplexity. This report from the governor of the province is absolutely unjust; not only have we not obtained satisfaction, but constantly encounter pressure from our squire and all the district and provincial authorities. The reason is that our squire holds the

rank of marshal of the nobility, and because of his wealth, he is a friend of the governor as well as all the other provincial authorities. In examining our case, the governor made a personal visit to our village, but limited himself to removing the military contingent which had been here to punish us (because of the squire's caprice and the authorities' desire to please him). But we have obtained no satisfaction with regard to our request: (1) The squire has not changed the land allotment and does not want to give us land in one place. (2) When the military command was here to inflict punishment, the constable, peace arbitrator and squire took away 23 cows and 33 rams, allegedly for [unpaid] quitrent, but we have never refused to pay quitrent; nor do we refuse now. But our livestock has not been returned. (3) Our grain has been inventoried (in shocks) and we have been forbidden to sell it; and we have also been forbidden to use it. (4) Seven innocent people from our village are incarcerated in the stockade at Aleksandrov; their suffering families and young children do not have a crust of bread and depend entirely upon us to take care of them. (5) The squire has totally ruined us, and the authorities (who do his bidding) have even forbidden us to leave the village and threaten to exile the entire community to Siberia if we do not ask the squire's forgiveness. But we do not know what wrong we have committed.

Under such calamitous, murderous conditions we have fallen into the most extreme poverty and despair. It is impossible for us to fight the squire, a marshal of the nobility who is a friend of all the government authorities. Our only escape from this situation is intervention by dispassionate, higher authorities. We fall to the feet of Your Excellency and weep not tears, but blood at your feet, most valiant dignitary of our merciful monarch! Put yourself in our place, send a trusted official to investigate our case—an official who is not inhibited by our squire's wealth and high station and who can conduct a humane, dispassionate investigation. Most valiant general, order that our fellow-villagers be freed from arrest in the stockade. Order that the livestock taken from us be returned. Release our grain and other property for our own direct use. And designate for us a land allotment in one place. 31 October 1862. Because of the illiteracy of the petitioners, at their personal request the townsman Fedor Timanov Makarov signs this petition on their behalf.

G. INDUSTRIAL WORKERS

Though relatively small by contemporary European standards, the Russian working class in the 1860s had nonetheless undergone considerable growth and development since the Catherinean era. One important change was the sheer increase in size; though Russian industrialization was still in an early stage, with the great spurt still ahead, it had already brought a substantial increase in the number of factories and workers. More important, such enterprises were no longer confined to gentry estates or Ural foundries, but had appeared in important areas of central Russia, most notably St. Petersburg and Moscow. It was here, in fact, that full-time, even hereditary working-class families made their appearance, the nucleus of city-bred and factory-savvy workers that provided the genesis of the later labor aristocracy. Though strikes were still without legal recognition and treated like a peasant uprising, a select core of workers had already begun to write and press for the kind of demand that later became routine in Russian labor history. One such demonstration of collective will, emanating from a major machine-building plant in St. Petersburg, is given in the first petition below (doc. 61). Even so, it was essentially a supplication, addressed to the Minister of Transport, not a strike proclamation.

Most labor disputes, indeed, still bore the stamp of earlier factory relations. Thus the petition from Penza workers emphasized their unsatisfactory working and material conditions, and simultaneously noted the lack of land to ensure their sustenance (doc. 62). The industrial depression of the early 1860s, provoked primarily by transition difficulties in the emancipation of factory serfs, caused some state plants to shift their labor forces from the patriarchal, semi-official relationships of earlier times to a regular, market economy. As the petition from northern workers in a salt-producing enterprise (doc. 63) emphasizes, the workers profoundly resented such changes and plainly preferred the secure employment of the state. It was in

the same spirit that others, who had in fact worked for state firms, applied in 1864 for state pensions—in a manner more like government officials than conscious workers (doc. 64).

61. Petition from Petersburg Machine-Plant Workers January 1860

To His Excellency, the Director of Communications and Public Buildings, Adjutant-General of Infantry and Cavalier of various orders, Mr. Konstantin Vladimirovich Chevkin, from the workers of the Aleksandrovsk Machine Works, a humble petition.

The justice and favor which Your Excellency has rendered to all in need have given us the boldness to report here all the misfortunes that we are enduring.

Most of us are burdened with families of five to ten members, including females (for example, very old parents, wives, sisters, and daughters), but only one person is a bread-winner, namely, the head of the family, who works the entire day in the factory and receives from five to eight rubles a month from the contractor. This provides the entire means for food and clothes—for five to six people in some families; hence the poverty of some of us has reached the point where we do not have even the most beggarly rags to work in.

Two years ago, with indescribable compassion for all, Your Excellency told us that all factory people who work for others would be blessed with freedom, just like the people of settlements who were at liberty in former times—who even in earlier times were at liberty, at least insofar as they earned their daily bread and sustenance by honest labor. [Marginal note in pencil by Chevkin; "I never said anything of the sort; this is either a completely distorted interpretation of my words or pure invention."] However, to this day our expectations have not been realized, and we have reached the point of complete ruin.

It is impossible not to sin and envy the life of the workers in the factories of the Mining Department. They pray to the Lord and will pray to Him from generation to generation for the well-being of Your Excellency, as the main person responsible for their happiness

and well-being. These people receive wages from the Crown far exceeding ours but work less than we in the factories.

Your Excellency! Save thousands of people from misfortune, improve their well-being by increasing the wages of each according to performance. With this favor, you will deliver all of us from poverty and will give thousands of people the chance to extol Your Excellency's name as benefactor and to pray warmly to the Creator for Your Excellency's health and prosperity.

62. Petition from Worker Deputies in Penza to the Provincial Governor 20 March 1861

1. We received from our factory-owner Dmitrii Stepanovich Seleznev provisions every month to feed ourselves and our families. But now the factory office has categorically refused to give this and has dispatched us to work at outside jobs. We have the honor to inform Your Excellency of the fact that, at the present time, our factory owner Mr. Seleznev has reduced us to such poverty that we cannot even feed our families one day a week. But when a person has to leave for outside work, he must leave his family provisions for at least one month; however, because of our poverty, we cannot do this. As a result, up to now our children have been forced to go about and live off hand-outs given in Christ's name and to wait until one of us earns something to send for their support. If, however, anyone falls ill and the hope of the children (who had been waiting for money to be sent) proves in vain, then there is no place to obtain help; they must wander forever as beggars and live off charity in Christ's name. We must humbly ask: do not deprive us of support. [Order] Mr. Seleznev, until our case is resolved, not to deprive us of provisions; or [order] that he restart the plant so that we can support ourselves by working at the plant.

2. There are absolutely no woods attached to our plant, and we obtained heating and light through our own work: we cleared new fields for state peasants gratis, and for our work received only the stumps, which we used to heat our houses. When we go to work for

outsiders, our family will be left without heat and [will] endure cold from the severe frosts and [will have] other needs from the lack of firewood. We do not sow any grain whatsoever; from necessity we would have heated [even] with straw, but completely lack this.

3. We also have no hayland, and we are exhausted from leasing hayland at our own expense; there is no way to get money for this. Earlier, the plant office leased this for us, but now we have to obtain hayland ourselves and to mortgage our very last piece of property for this. Last summer, many left their pawned items unclaimed and will lose them; we cannot reclaim them because our property has been exhausted. We, the community of craftsmen of the Riabinskii plant, most humbly ask Your Grace that we not be deprived of Your legitimate defense.

To this petition, in place of the authorized representative of the Riabkinskii Cast-Iron Foundry, Peter Safrygin and comrades and at their personal request, Ivan Alekseev Sobolev, a townsman from Krasnaia sloboda, has attached his signature.

63. Petition from Former Workers (Vologda Province) to the Main Committee for Peasant Emancipation 28 January 1863

On the basis of the imperially approved Statute of 8 March 1861 (on workers in state mining enterprises; on the lower and worker ranks, which were assigned to the state salt plants of the Ministry of Finance), the Onega Salt Works has completely discharged us and our children. . . . We were given a certificate, in accordance with article 3 of this statute, transferring us to the free rural population, with the right to enter factory work, but only after a voluntary hiring and agreement with the plant administration. After our release, they announced the rates for each kind of work, i.e., in monthly salary or piece-rate. At the same time, they explained that those of us who wish to enter service in the plant as voluntary employees should come to the plant manager to conclude a contract. For that reason, and because we had no way to support our families, we came re-

peatedly to the plant to request work corresponding to our abilities. But the manager always replied that the factory has no such work. He did accept some of us, but in time rejected them as well.

But as each of us has served irreproachably in the factory for 20 to 33 years, and as we have lost our strength from working for the government, we can barely feed ourselves, much less our young children. For this reason, we have asked the Onega Salt Administration, in accordance with article 7 of the imperially confirmed Statute, to admit us to factory work to serve the required years to qualify for a pension; or at least, to support our young children, to accept us into the factory as freely hired labor and to petition higher authorities for some kind of assistance for our long and irreproachable work. But the Salt Administration gave no satisfactory response to our petition. For this reason, we were obliged to petition twice (12 February and 16 July 1862) to the Mining and Salt Department, but so far no order has been issued. In expectation of some positive result in the course of our unemployment (which has lasted 1 year and 8 months), and having no kind of work from the plant or land plot (except the land that has been obtained in small quantities and cleared through our own toil), we have been reduced to total penury. So, for the two months of provisions issued to us by the Salt Administration, our homes were inventoried, and with time we shall inevitably, together with our children, be forced to starve to death or to support ourselves by begging in Christ's name. That is especially so because of the harvest failure in the area around Ledengskii plant (where the price of grain has risen to 1.20 rubles for a pood of rye flour) and the general inflation in the price of all provisions; we have absolutely no way to feed ourselves. Therefore, presenting all this to the attention of the Main Committee on the Rural Population, we most humbly dare to petition that it deign to approve our request, take pity on the impoverished condition of our life and help to feed our young children. [We ask for measures] to arrange our material condition and, given the harvest failures and inflation on all basic necessities, for a monetary subsidy, as far as the treasury permits.

64. Petition from Workers
(Ufa Province) to Alexander II
9 April 1864

Most august monarch! Most merciful sovereign!

We, the undersigned skilled craftsmen (from the craftsman rank) of the Zlatoust Mining Plant, entered the service of Your Imperial Majesty and were in various works and shops. Efim Komyzarov served from 1806 to 1846; Kondratii Buzunov from 1807 to 1847; Grigorii Stroganov from 1807 to 1847; Prokhor Koshov from 1814 to 1854; Andrei Zuev from 1814 to 1854. We served irreproachably, and for this (in accordance with the law) we receive a pension: the first [named above] receives 57 kopecks, the second 40 kopecks, the third 37 kopecks, the fourth 27 kopecks, and the fifth 35 kopecks per month. In the course of our retirement, we have completely exhausted our property just to buy food (because our pension is inadequate), and we now find ourselves in the most destitute condition. In addition, we completely wore ourselves out at the factory and now cannot support ourselves in our old age by working. Hence we have repeatedly sent petitions to the plant management to give us, as old men, free provisions from the plant's grain reserves (1 pood per month from the day we were released from work in accordance with art. 321 of the *Digest of Laws,* Mining Statute, 1857 ed., which declares: the lower ranks and workers, who, because of their old age, infirmity, illness or injury, are released from factory work and cannot support themselves, or cannot be placed in a charity institution for lack of space, are to be given free food). [We ask this] even though we receive a pension. But the plant management ignored our petition and refused to comply, without any explanation; at present we have no hope of feeding ourselves. For this reason, we fall to the most holy feet of Your Imperial Majesty, as to the defender of the poor, and most humbly ask an order to whomever appropriate that we be given provisions until the end of our lives.

H. MINORITIES AND WOMEN

The Great Reforms stirred hopes not only in the disadvantaged classes, but also in various religious and ethnic minorities. And in fact the regime did make some concessions. The change was all the more striking in the wake of prereform policies, which had been highly illiberal and repressive. Thus Old Believers, who had been under intense pressure in the 1830s and 1840s, hoped to achieve an improvement in their status. Indeed, by the late 1850s the state gradually retreated from its erstwhile persecution—and fueled Old Believer hopes for still more concessions. Nevertheless, as the protest petition to Alexander II (doc. 65) shows, their demands were still essentially defensive, appealing to historic rights to hold minimal religious services, but did not assert full civil and religious equality.

Another important and self-conscious minority, the Jews, had also experienced similar repressions in the pre-reform era, but after 1855 enjoyed a more liberal policy, as the government began to dismantle some discriminatory restrictions. As the petition from one community (doc. 66) suggests, the new policy aroused hopes for still further concessions toward Jewish emancipation. But, as in contemporary Europe, that very liberalization also generated Judaeophobic warnings of Jewish dominance, especially from the nationalistic press. Jewish response in turn was diverse, some assimilationists denying any distinctive ethos, but more self-conscious segments (as in doc. 67) adamantly defending both their Jewishness and their right to an equal role in public affairs.

The Great Reforms also marked the first public discussion of "the women's question" and indeed the appearance of an organized, articulate "women's movement." Inspired by contemporary European literature, mobilized and divided by the domestic revolutionary movement, Russian feminism was unquestionably one of the most significant new phenomena of the 1860s, for the repudiation of traditional female roles formed an integral element in nihilist subculture

and anti-nihilist *Angst* of the time. While such flamboyant redefinition of sexual roles and marriage captured public (and police) attention, the movement had a much more subtle, but far-reaching impact upon more staid segments of the population. Some reflection of this broader (not merely nihilist) interest in the women's question is reflected in the programmatic statement of a journal founded in 1866 and specifically devoted to the discussion of women's rights, roles and responsibilities (doc. 68).

65. Petition from Old Believers (Bessarabia) to Alexander II January 1862

This petition comes from the undersigned Old Believers in the village of Kunichnaia (Sorok District, Bessarabia Region), and pertains to the following.

1. The beneficial laws of Russia protect us from every kind of persecution for our religious views. In spite of that, and contrary to all our expectations, we have experienced bitter persecution, which has forced us to bring the following [matter] to the attention of justice.

2. Prior to 1809, in the village of Kunichnaia, our forefathers had already built a church (in honor of the holy martyrs Flor and Laur), which was consecrated after its construction. A charter of 9 January 1805 from the former ruler and prince of Moldavia, Aleksandr K. Muruzi, confirmed [the right] to perform religious services freely. After Bessarabia became part of Russia, we were not prohibited from having priests, and in 1822 (in the glorious reign of the sovereign and emperor, Alexander I) this right was confirmed by imperial decrees. On this basis, we had priests for several consecutive years, but then we were forbidden to have them for religious rites; we were authorized to keep our church, however, in strict compliance with the rules promulgated by the emperor on 17 September 1826. We assemble in this sacred place for prayer services according to the old printed texts, do not espouse perverted interpretations of the faith, and pray incessantly for the health of the tsar as well as the entire imperial house, government officials and the Russian army.

3. In the midst of our peaceful rural work, we were suddenly struck by the following event: on 13 November 1861 the constable from Sorok District came to our village of Kunichnaia, together with the ecclesiastical superintendent and three local officials. They were accompanied by more than 500 men on horseback and another 1,000 on foot, and together they surrounded our village, our homes and the church itself, as though to desecrate it. Then they entered the church where the constable gave orders to collect everything from the church, the icons on the walls and iconostasis; all this was done. They piled up the icons *on the ground,* with blatant contempt for the depiction of holy figures. But when one local official reminded the constable that the icons should not be taken, he halted the seizure of any more icons from the walls and iconostasis. Then the constable and ecclesiastical superintendent, together with several people, entered the altar through the left doors, tore off the cover and altar cloth from the communion table, and the priest took the communion cloth. Then one of the chairmen went up to the royal gates [of the iconostasis] and tore the church screen from the gates. The superintendent, meanwhile, opened the royal gates and then took everything kept in the altar from the earliest times—chasubles, service vessels and liturgical books; they also took five large icons from the former altar, and they carried all this out through the royal gates. The constable himself and the superintendent also went out through the royal gates, contrary to the church canons, for only a priest during the liturgy may go through the royal gates (and must be wearing a chasuble). Then the constable sealed up the altar and left the church with his people and the property he had confiscated. During all this time, the Lord's chapel formed a most distressing sight—every element of decency was violated. In addition, they searched our homes and in many confiscated holy books and icons. After spending two days in our village and receiving provisions from us for all his people, the constable departed and sent the confiscated property to the ecclesiastical authorities in Kishinev. We have learned, however, that church authorities were told that all this [property] was found in our homes; nothing was said of the fact that the chasubles, service vessels and liturgical books were taken from the church; nor was anything said about the communion cloth, which they hardly had any right to seize.

4. We complained of these actions by the district constable and

ecclesiastical superintendent to the military governor of Bessarabia. As a result of this [appeal] and after correspondence with the diocesan authorities, only our books and icons were returned. But they did not return the chasubles, service vessels and liturgical books, and the altar has also remained sealed. Although we made an oral request to His Grace Antonii, the Bishop of Kishinev and Khotin, to return our property and remove the seal from the chapel, we were told that it rests with higher authorities, not him, to satisfy our request.

5. We cannot understand what could have been the cause for such an insult to our sacred objects, and do not feel any guilt on our part. Therefore all of us, young and old, have been cast into the deepest sorrow; in particular, if authorities want to confiscate this property, it was unnecessary to resort to the above measures, for we never had any thought of resisting the authorities. How joyous it is to see that Old Believers elsewhere in Russia enjoy the freedom to perform their religious duties; how sorrowful it is to see the mockery of us. And it is impossible to understand why! If we had chasubles, service vessels and a communion cloth in the altar, then these remained from earliest times and were preserved as sacred objects strengthening our spiritual strength. Hence by taking these from us, we experience spiritual sorrow over the seizure of these things. Under such tragic circumstances, we most humbly request an order to give attention to the above case and to issue a directive that the chasubles, service vessels and communion cloth be returned to us, that the seal on our altar be removed, and that we be protected in the future from similar persecution.

66. Address of Jewish Community
 in Bobruisk
 April 1863

Most August Monarch! With the dawn of 17 April, Russia will celebrate Your Imperial Majesty's most festive birthday. This day, sanctified by a great event, by the birth of the Tsar-Liberator, emboldens the Jews of Bobruisk to join the voices of millions of sons of Russia to express their most loyal feelings.

Complete loyalty has always been a distinctive characteristic of the Jewish people in all historical periods. In the blessed reign of Your Imperial Majesty, this fealty has acquired new strength, as a result of our people's profound gratitude for the civic life that you have granted them. The Jewish social estate is profoundly sensitive to the great deeds that have flowed so generously from the monarchical hand in nine years of rule—nine years of unceasing favors that are truly equal to nine entire centuries.

These good deeds have implanted faith and devotion to the monarchy deeply in the hearts of all Jews—which cannot be shaken by any deceitful worldly temptations on the false rumors of evil-intentioned people.

Sire! A profound devotion to the throne and a passionate love of Russia are the only feelings of Jews, who raise up their jubilant thanks before eternal providence for the great gift bestowed upon us in Your person. And we pray fervently for the defeat of the foes of the fatherland [and] for a long and prosperous life of Your Imperial Majesty and the most august [imperial] house. May the Lord God protect it for the good of the peoples, for whom the scepter of our most merciful monarch is a blessing.

67. Jewish Newspaper Response to Judaeophobic Attacks in the Press May 1862

We were not in the least surprised (nor could we be) by the article in issue no. 19 of the Moscow journal, *Den'* [16 Feb. 1862], although this article differs sharply from the generally harmonious tone in Russian journals (which only recently have had occasion to speak out in support of the Jewish cause). Indeed, there was no reason to think that the Jewish question, which is only now receiving serious attention in Russia, would instantaneously obtain final and favorable resolution. On the contrary, it was easy to foresee that once the fashion of rebuking Jews without cause gave way to the fashion of voicing sympathy toward them (but without sufficient conviction), a period of recriminations would set in. And the latter would be supported by a certain patina of real substance. It is even possible, without being a

prophet, to predict that as soon as the Jews really begin to attain a fitting status in Russia, people will appear and seek to prove that Jews already dominate the state, that they have seized control over all the financial means of the country, the administration and even public opinion. Further, it is also possible to predict what kind of journal will become the organ of such accusations. It is most natural for this [opinion] to be taken up by an organ that holds one-sided nationalism dearer than general humanitarian principles; an organ that turns its vision backwards, not forwards; an organ that seeks its political and social ideals in neither the present nor the future, but in some more or less remote past. In Germany, for example, zealots of German nationality and medieval orders quite naturally took this path and came upon the idea of a German Christian state, which they apply quite zealously to the Jews, in the spirit of religious and national exclusiveness. As we shall see, this idea (to be sure, with a change of national banner) prevails in the article of *Den'*, although perhaps the honorable editor of this journal, Mr. [I. S.] Aksakov, would deny its non-Slavic origin. In Germany such theories are losing their practical force and meaning with each passing day; among the Russian people, which is distinguished by incomparably greater down-to-earth, common sense, and which at the same time can draw on the results [of others], these imported theories will dissipate without a trace, like an apparition. . . .

The essence of the article in *Den'* is as follows. Russia is a Christian state: "Christianity provided the special foundations for the entire moral and spiritual world of man (and hence for society) and on the basis of these principles [everything] has been and is being transformed—the private, societal, civil and governmental way of life; education; learning; legislation; inter-personal relations; in a word, the entire domain of human activity." To this Christian land has come a handful of people, who completely deny the Christian teaching, the Christian ideal, and the [Christian] moral code (consequently, all the foundations of the public life in this country) and who profess a hostile, opposing teaching. "The Christian land, following the spirit of their teacher, also gives the Jews the means for existence," but "the proprietors cannot put them in their place and give dominant authority to those who preach the overthrow of every kind of order." This entire syllogism is constructed for the sake of a modest practical conclusion—to demonstrate that "the defenders

and zealots of Jewish interests have improperly understood the law (on granting Jews, under certain conditions, the right to enter state service), and in any event have not made clear to themselves what its practical implementation may lead to." We shall consider, so far as possible, the essence of all Mr. Aksakov's propositions, and will have no difficulty showing that they all belong to the domain of pure fantasy, and that their first contact with historical criticism will cause them to vanish like smoke or fog under the bright rays of the sun.

"Christianity," says Mr. Aksakov, "transformed and continues to transform the private, public, civic and governmental way of life; education; learning; legislation; [and] inter-personal relations." If that were really so, then there would be no wars among peoples, no conflicts and disputes among individual people, no crimes or offenses, no punishments for them. There would then be no need for armies or judicial courts; poverty, pauperism, and the extreme inequality of estates would disappear by themselves. But not only have these goals not been achieved, it is not apparent that either Christian or non-Christian peoples strove to attain them, or even considered them attainable. We would gladly believe Mr. Aksakov, if he had proven (or even *could* prove) that the state, social, or private life of Christian peoples in fact is based on (or even *could* be based on) the high principles of Christian moral teachings, the spirit of self-sacrifice and self-renunciation, the spirit of infinite love and forgiveness.

It was not we Jews who were opponents and an obstacle to the realization of the Christian ideal; unfortunately, this ideal proves altogether unrealizable. Everything that a real (not ideal) state and society of our present, more enlightened age demands is identical to that demanded by pagan states and societies—viz., that justice and fairness be observed with respect to one and all. There would not have been that grand progress of our time had not this one (pagan, if you please) demand been completely realized among people in their mutual relations, both in society and in the state. Is Mr. Aksakov not violating the charity and justness that the Russian government has exhibited toward our people? How are we to dream of boundless fraternal love and self-sacrifice, when we are indignant over a case of incomplete justice, when we would wish to keep the Jews on the level of homeless beggars, unfit for our state and society? We do not in the least deny the great banner of Christianity for the fate of man-

kind; we can boldly regard the beginning of this religion as an era for all educated peoples. In this respect, we follow many famous Jewish authorities who, firmly committed to their own faith, from their own religious viewpoint regarded the great achievement of Christianity to be the elimination of idolatry and the dissemination of justice on earth. But it is impossible to acknowledge that the ideal principles of Christian teaching form the foundation of the state and social order in Christian lands. . . . *Den'*—in the name of a religion of love and justness—repudiates Jews, as unfit for administrative and legislative activity in a Christian land. Unfit? But how so? Are they really not people too? Are they really, just because they are Jews, incapable of upholding justice and fairness with respect to others, both in society and in the state? Does their religion not inspire in them at every step a feeling for fairness, love and charity?

But *Den'* says precisely that "Jews, by recognizing as true the teachings of the Talmud, can act in no other way except *in the spirit of its teachings, which is opposed to all the principles that constitute the foundation of the private, social and state life of a Christian land.* Even from the point of view of Mr. Aksakov, who assumes that these foundations are Christian, the words we have quoted from his article are devoid of any basis, and we categorically and unqualifiedly assert that *the moral idea of Judaism does not in the least contradict that of Christianity.* It may be that our categorical assertion here will astound the editor of *Den'* as a completely unexpected piece of news. But it is not our fault if he happened to write an article on a subject that he did not know the first thing about and to talk in the vaguest generalities. Indeed, he spoke in the most general, vaguest terms. You should have shown right there how the teaching of the Talmud contradicts the moral foundations of Christianity! Then we would hasten to give the most positive, most candid reply. Otherwise we have to battle with a windmill, and that is why, while awaiting until *Den'* gives direct and specific references, we involuntarily counterpoise its blanket assertion with an equally categorical denial. . . .

But, asks *Den'*, "is it desirable and profitable for the Governing Senate, State Council and legislative institutions generally to be overrun with Jews?" To this we reply that the *inundation* of government institutions by Jews is in fact not feasible; however, it is highly desirable and feasible that, with the passing of time, these institutions

include a corresponding number of Jews, so that as a result Jews will work for the general cause, even if in the spirit and interest of their fellow believers. Only good can ensue, as has been shown in the example of other Christian lands: The United States of America, England, Holland, France, and at the present time Italy in particular. . . . [Signed: The Editors of *Zion*].

68. *Program for a Woman's Journal*
September 1866

In undertaking to publish a new, monthly literary journal, we deem it necessary to say a few words about our goals, direction and program.

The familial and social position of women, their upbringing and activity comprise one of the most important questions that have long occupied the attention of the entire civilized world. The significance of this question has recently been recognized in our country as well. Some years ago, our journalism made its first efforts to elucidate the familial and social position of our women and to indicate, so far as it was possible, the abnormality of their position. Society looked upon these efforts with deep sympathy, which it demonstrated by practical initiatives to improve, so far as possible, both the moral and material condition of women. As is known, private communities were founded in the capitals and in many provincial towns to organize female labor correctly and to provide assistance to needy women. The sphere of private activities open to women has of late expanded significantly: now a woman is often seen not only behind a shop counter, but also in the office of the cashier, the bureau of notaries and in other places, giving her room for activity and reinforcing her independence. Of course, all these beginnings are still too inadequate and hasty, and therefore do not fully achieve their goal, but they are important to us as facts, which speak eloquently of the urgent need to resolve the women's question. They serve as evidence of this [need]: society itself already recognizes that the woman's present condition is unsatisfactory, both inside and outside the family, and therefore strives to give women greater scope and significance. Our government, for its part, also has done everything that

it could to improve the condition of the Russian woman. Since the woman's question pertains properly to a number of purely social questions, in this respect the government has undertaken only those measures that depend directly upon it and that are necessary in the first instance. Thus it has made important reforms in the system of female upbringing and permitted the establishment of private societies whose goal is both the moral and the ethical improvement of the life of our women.

It is clear that, in order to have a thorough and detailed discussion of the question of women's condition and the improvement of their condition, we need a literary organ directly aimed at addressing this question. It is necessary to have intelligent, systematic propaganda by means of the written word, which—more reliably than any other means—can exert an influence upon public self-consciousness. Such an organ is all the more necessary since our journals have broached the women's question only in passing, as if by accident, and only to the degree that it could interest society at a particular moment, amidst the other questions of our social and political life. The idea of publishing a journal, dedicated primarily to working out the women's question, has been expressed in our literature before. Although this idea, because of various accidental barriers, could not be realized, society nonetheless responded with profound sympathy. This gives us the right to hope that our appeal will not remain a voice crying in the wilderness.

The chief goal of our journal is as follows: through a discussion of the contemporary condition of the Russian woman from various perspectives, to seek the means to improve her condition in all areas by intelligent and useful activity, so far as possible to expand the sphere of this activity, to assist the development of the intellectual and moral forces of a woman, and finally to make practical indications of those areas of work where a woman, by independently improving her economic condition, can be more useful to herself and to society.

Recognizing the enormous influence of a woman as mother, nurturer and educator on the fate of future generations, we are nevertheless convinced that only a correctly and intelligently organized marriage can achieve, with respect to society and the family, those beneficial results which, given its purpose, one could expect from this.

The question of the condition of woman is integrally related to

many other questions of our private and public life. The goal of the journal on this question is too complex, and hence *Women's Herald* cannot fall into the list of those specialized publications that interest only a small circle of people, devoted to the cause of their own specialty. On the contrary, one could positively say that there is not a single dimension of our civil life which does not have some kind of relationship to the question of women. . . .

Part Three

Society in Revolution, 1905-1906

The wave of strikes, rural disorders, pogroms and mutinies in 1905–7 were the bitter harvest from tensions and animosities that had mounted steadily since the Great Reforms of the 1860s. By 1905, with the regime debilitated by foreign war, domestic terror and economic recession, only a tiny minority of society—even within elites—stood ready to give even qualified support to autocracy, still less the bureaucracy. Whether in the form of workers' strikes, student demonstrations or even gentry cabals, such opposition to the government drew upon a broad range of malcontents which, at least in their opposition to the government, had sufficient cohesion to form a powerful liberation movement. But even as groups mobilized to combat the regime, they also endeavored to organize themselves into cohesive associations with concrete goals, programs and unity. In that important sense, 1905 was not just a year of revolution but still more a year of autonomous social organization, as diverse local groups—from plumbers' aides to accountants, from priests to musicians—refurbished old corporations or constructed entirely new ones. The result was a profusion of formal organization, a phenomena that gained legal—but tenuous—recognition in the Law of Associations of March, 1906.

But the decisive turning point in this process was the October

Manifesto of 1905. However reluctantly and conditionally, Nicholas II recognized society's right to share power in the new State Duma and, concomitantly, conferred an unprecedented range of de jure individual civil rights. Between the promulgation of the manifesto on 17 October 1905 and the prorogation of the Duma on 10 July 1906, virtually all social groups—juridical estates, occupational categories, minorities—took advantage of the new, transitory liberty to express demands and complaints. Not that censorship or fears of reprisal did not temper the courage of many. But most, even the more moderate segments, believed that it was both legally acceptable and politically vital for them to express the particular needs of their own group amidst the counter-claims from other groups in society. What resulted was a stupendous profusion of material, with formal declarations—strident, unambiguous, collective—emanating from virtually every quarter of society. With their resolute tone, declarative form, and non-tsarist addressee (more often the Duma or society rather than Tsar), these documents demonstrate how profoundly both the social structure and political attitudes had evolved in the post-reform era.

A. NOBILITY

The decades following the Great Reforms brought deep changes in the status, profile and mentality of the empire's "first estate." Alienated by the experience of emancipation, squeezed by old debts and falling grain prices, surrounded by sullen and land-hungry peasants, by the 1890s many nobles found themselves in desperate straits and put most of the blame on the government and its industrializing policies. Such sentiment fueled the rising opposition, of both conservative and liberal varieties, that by 1905 had turned into a broad-based noble fronde. But the harrowing experiences of 1905, when the countryside exploded in violent disorders, was a sobering experience for many noble landowners and encouraged them to put the highest priority on restoring law and order. By the time the Tsar issued the October Manifesto in the fall of 1905, most nobles had seen enough peasant violence and demanded the reestablishment of law and order—and security of their property rights.

The new attitude is dramatically expressed in the following documents. A gathering of marshals of the nobility in early 1906 (doc. 69) emphasized their demand that the countryside be pacified, partly through the display of "firm government," but also through the convocation of a Duma to quash the acquisitive fantasies of land-hungry peasants. More emotional was the address from nobles in Ekaterinoslav (doc. 70), who emphasized the need for vigorous repression and modestly identified the survival of their own estate with the very survival of civilization. By the spring of 1906, noble organizations had also appeared at the national level—including a self-proclaimed "Circle of the Nobility." As its resolutions show (doc. 71), these arch-conservative nobles insisted not only upon firm government but also upon unlimited autocracy—as well as a host of measures to bolster their economic and cultural predominance. And like other conservative nobles, they categorically rejected demands for compulsory expropriation (even with compensation) and reaffirmed their rights as landowners and grain producers.

69. Resolutions of Moscow Congress
of Noble Marshals
January 1906

I. The provincial and district marshals of the nobility have assembled in Moscow and have heard, in reply to their most humble greetings [to the Sovereign], a most gracious invitation to collaborate, through their work in the provinces and districts, in actively assisting in the establishment of peace and tranquillity in the fatherland. We consider it our duty to declare that, as before, we are prepared at the present difficult and troubled time to apply all our energies to serve the Tsar and fatherland in helping to pacify the country and to implement correctly the state reforms announced in 17 October [1905]. At the same time, the marshals deem it their moral duty to declare that they must fulfill their official duty under extremely difficult and adverse conditions.

Government decrees like the manifestoes of 17 April and 17 October [1905], have proclaimed freedom, but did not define its limits or indicate the laws or provisional rules by which the life in the state was to operate until convocation of the State Duma. Confidence in authority has been shaken and indeed could not exist when the government stood idly by as the revolutionary movement unfolded, thereby giving cause to the widespread notion that it was consciously promoting revolution. All this has prepared the ground for anarchy. The marshals deem it their duty to announce that only of late is a certain calming to be observed at the local level, thanks to decisive steps the government has taken. We must say, further, that in our opinion these necessary measures must be continued until the turmoil has been suppressed and terminated in order to protect the peaceful population from revolutionary actions and uprisings. Moreover, it is necessary to eliminate the fatal vacillation in the upper levels of the government that has had so catastrophic an effect at the local level—where, even without this, government authority and institutions are fragmented and disunited. Mutual distrust is now particularly evident in the relations between administrative and judicial authorities; the latter should act within a strictly defined

legal framework and should not, as is sometimes observed, treat state crimes (and incitement to the same) as civil offenses.

The situation is made all the more difficult by the lack of confidence that the State Duma will be convoked, and this uncertainty is being successfully exploited by revolutionaries; it plays into their hands. Confidence that the Duma will meet is absolutely vital—notwithstanding the threats by revolutionaries to prevent its convocation through railway and post-telegraph strikes and every kind of obstacle. The government has the obligation—and always has the power—to avert this if it so wishes. To assure that the Duma elections be conducted correctly, firm authority must protect the freedom to vote and hold pre-election meetings (exactly defined by law). All this will help to establish the government's authority, serve to pacify the country, and strengthen the entire state. In view of this, the marshals deem the following necessary: (1) a strong, firm and orderly governmental authority, implementing consistent and sensible measures to suppress the revolutionary movement and to protect the population from violence; (2) confidence that the State Duma will be convoked; (3) protection of freedom in the elections and legal pre-election meetings.

II. The congress deems the earliest possible convocation of the Duma to be extremely necessary.

III. The congress deems it desirable that the government's announced deadline for convocation of the Duma (15 April) be regarded as the latest possible term.

IV. The congress most humbly petitions His Imperial Majesty to issue a statement on the term set [for convocation of the Duma].

On the Question of the unity of Russia, the assembly recognized:

V. Russia is a single, indivisible whole. Given this fundamental principle, no separatist demands whatsoever are acceptable.

VI. The general state interests of the Russian Empire require that these take precedence over the interests of individual nationalities.

VII. Borderland policies must be decisive and unambiguous, and preclude the possibility of erratic opinions of individual administrators that violate the stability of the system built on the above principles.

VIII. The civic and religious interests of the Russian population must be protected from violations by the nationality that is numerically predominant [in a particular area].

IX. Under the broad freedom of conscience conferred by the manifesto of 17 April [1905], the Russian language and Orthodox faith should preserve the preeminent significance that befit them.

On the agrarian question, the assembly recognized:

X. It is necessary to give the borderlands broad self-government in an economic sense; at the same time, the interests of the Russian population must be safeguarded.

XI. A fundamental solution to the agrarian question must be placed in the first instance in the State Duma.

XII. The principle of the inviolability of private property must be established as the foundation for a resolution of the agrarian question. Note: Exceptions are admissible through application of the *Digest of Laws*, vol. 12, art. 575.

XIII. [The Congress recommends] a broadening and regulation of the colonization question, with the widest possible participation of local public organs, and the fastest possible registration of state lands due for assignment to migrants.

XIV. [The Congress recommends] a change in our financial policies in terms of improving the culture and development of agricultural production and organization of the sale of agricultural products.

XV. [The Congress recommends] an obligatory survey and separation of peasant allotments (at state expense) and, in general, better means and order to facilitate land demarcation and to eliminate mixed-strip holdings and plots.

XVI. [The Congress recommends] broad measures to facilitate a free transfer from communal landholding to separate and household landholding, with the unrestricted right to sell a plot when moving to another residence.

XVII. (A) The Peasant Bank should make its chief goal the promotion and encouragement of land purchases by agriculturists who are truly short of land and in need. It should also make such purchases (at its own expense and at current local prices); it should abandon the character of a credit institution operating solely on generally recognized principles of mortgage operations. (B) It is deemed necessary that the government provide financial support for these purchases, which should take the form of having the state treasury assume not less than one percent of the periodic payments for loans. (C) Peasant communities should be empowered to use their allotments as collateral for land purchases and to sell their land to the

Peasant Bank upon leaving the commune. (D) The wish has been expressed that existing loan payments of the Peasant and Noble Banks be made equal: payments to the Peasant Bank should be lowered to [the level of) payments to the Noble Bank.

XIII. [The congress recommends] that arable state lands and forests (which could be converted to another form of resource) and also crown lands be made available to agriculturists with payment set according to assessed value. Note: This rule does not apply to crown lands that were acquired from private landholders. Twenty-four marshals hold a separate opinion: twenty one marshals regard crown lands as private property, and three oppose consideration of this question at the congress.

XIX. [The congress recommends] a strong state authority at the local level that can really defend private property from plunder and, in general, take energetic measures to establish order in the country, to defend peaceful inhabitants from violence and robbery, and to prosecute vigorously every incitement to violence.

XX. [The congress recommends] the immediate preparation and widest possible dissemination of temporary rules that really protect individual liberty from violence, especially in the sphere of labor (strikes, removal of workers), and set prosecution promptly in motion.

70. *Address of Ekaterinoslav Nobility to Nicholas II 8 March 1906*

Your Imperial Majesty, Most August Monarch!

In this difficult time that the entire Russian land is experiencing, the nobility of Ekaterinoslav most humbly dares to address the following words of truth to its Sovereign.

The glow of fire from the burning of hereditary noble nests and the estates of other landowners has lit up the fields and steppes of our region and many other provinces as well. Where whole generations have worked so hard, obstinately seeking to improve agriculture through the creation of improved ways of working and through the dissemination of knowledge and enlightenment, all that remains are

smoldering ruins—and, in some places, desolate wilderness. Priceless artifacts of the past—scientific and artistic treasures that were collected over the centuries—have been destroyed. A significant part of the noble landowners (permanent inhabitants of rural areas) cannot return to their estates and have been deprived of a roof over their heads and a refuge; some have even lost their means of subsistence. Nor is there any guarantee for the security of persons and property in the village.

That, Sovereign, is the dismal picture of the condition of the majority of nobles—who have from earliest times served their sovereigns and [who] fervently love their motherland. The incomprehensible and absolutely unjustified passivity of authorities, which (prior to the introduction of martial law for the prompt eradication of looting) was manifested in the absence of further legal protection of private property at the first signs of encroachment, regrettably compels us to file a most humble report to Your Majesty.

With no less pain in our hearts, the nobility of Ekaterinoslav observes that, simultaneous with the looting of estates, when the owners of destroyed estates find themselves in total despair and depression, the ministry of finances (without any legal basis) is taking vigorous measures through the Peasant Bank to accelerate the transfer of their lands at low prices—the last remnants of the nobility's landed property is slipping out of their hands. We fear, Sovereign, that an equally tragic fate may befall those of us as yet untouched by the destructive hand of revolutionary elements—who consciously direct the credulous popular masses in the village to destroy all the centers of culture that are capable of combatting manifestations of lawlessness, arbitrariness and violence. We fear, Sovereign, that the fatal moment—when the work performed by the nobility over the centuries for the benefit of the fatherland is destroyed—is drawing near. Conscious of the rightness of our cause, we have decided in this sorrowful hour to raise our voice to the throne.

The basic principles of fundamental reform in the state system, outlined in the great act of 17 October, still require much cultural work at the local level in order that the civil freedom and political rights proclaimed in Your Majesty's manifesto fully become part of the consciousness of the popular masses. Then these rights can serve the people as a source of well-being—not suffering, [as will happen]

if they are perversely understood, falsely interpreted and incorrectly applied.

The nobility of Ekaterinoslav, which is loyal to You, Sovereign, and always devoted to serving the fatherland, cannot hold as just the forcible exclusion of the Russian nobility from such work at the local level.

Let the stormy waves of future historical events wash away our estate without a trace, but the nobility must perform their duty to the very end. They must, to the end of their days, be a bulwark of legality and order, and the main element of constructive work. Hence this possibility must be safeguarded for the nobility. Sovereign, if Your loyal nobility is still needed for the good of Russia and for constructive work in this new era of the state's life, order that they be given the means to return to their villages and the chance to live there without fear and to enjoy the civil rights of inviolability of person and home as proclaimed in the manifesto.

Great Sovereign! Having experienced the full weight of the results of unpunished violation of the rights of property, the unjustified and merciless destruction of the fruits of many years' work, we look with trepidation at the uncertain future and foresee a threat to the stability and integrity of the state.

Believe us, Sovereign, that it is not the narrow interests of our social estate which impel us to speak openly to Your Majesty about all that is transpiring. Not a single state in the world can be secure without securing the right of property and its total inviolability through strong state authority—no matter whose property it is and no matter to whom it belongs. In noting the calamity that has befallen the nobility, one cannot help foreseeing that other useful, active people from non-noble estates will be placed in equally onerous conditions in the face of the terrible violence against property that has been observed recently. The development of this violence—unless given a proper rebuff—will affect every type of property, without distinction as to its size and significance.

All the inhabitants of the villages and hamlets of our expansive fatherland require the fastest possible reinforcement of legality and stability of legal relations, but only the State Duma can establish respect for the law and its strict observance. Therefore it is absolutely essential that it be convoked without delay.

The above statement, and the need to strengthen, in popular consciousness, a firm belief in the inviolability of private property (and [awareness] that any violation of others' property will entail strict punishment and material responsibility) impel the noble assembly of Ekaterinoslav province to bow to Your Majesty's feet and most humbly to petition Your Majesty to order:

1. That compensation for losses suffered by landowners be provided before the onset of the spring field work (on the basis of the personal Imperial decree of 10 April 1905).

2. That decisive measures really be taken to prevent any possible repetition of pogroms and plundering of landowners' estates.

3. That in cases where a crime was committed, a prompt and public trial be convoked where the pogrom occurred and that severe punishments be meted out to the guilty.

4. That, under the protection of strong authority, landowners be given the opportunity to continue their peaceful cultural work in the villages.

5. That the activity of the Peasant Land Bank—which now tends to depress prices—be altered.

6. That, in the name of Your Imperial Majesty, 15 April be announced as the final date for the convocation of the State Duma.

71. Resolutions of the "Congress of Noble Circles" 22–25 April 1906

A. The State Order as Recognized by the "Circle"

1. The basic foundation of the Russian state—the unlimited autocracy of Russian tsars—must be inalterable and inviolate.

2. It is on this principle that all state and public institutions and organizations must be built, free from all alien elements contrary to these foundations.

3. The law on the State Council and State Duma, as contradictory to the principle of unlimited autocracy, should be amended and changed to comply fully with this principle.

4. These supreme state institutions should be the tsar's advisory organs, with the right of interpellation of ministers and chief officials.

5. Those elected to these institutions should be from social groups that have been organized into estates [*sosloviia*]. Further, on the borderlands where Russians comprise a minority, no matter how few they might be, they should be represented separately from the surrounding non-Russians.

6. The ministers and all higher authorities in the state, as well as members of the State Council and State Duma, are accountable to the Governing Senate in the matter of supervision over legality. Accordingly, the Senate is also to be reorganized with a reestablishment of the general procurator (separate from the Minister of Justice) and its central and local organs.

7. Local, public, zemstvo [rural organs of self-government] and city institutions are likewise to be based on the estate principle and to embrace all estates, proportionate to the value of property. In addition, the provincial zemstvo should be abolished.

8. The grant of freedom of religious belief should not preclude the predominance of the Orthodox faith, and state laws should not at all contradict the canons of the Orthodox Church.

B. The Question of Social Estates (Its Material and Public Meaning)

1. By "estates" the Circle of Nobles understands social groups [*bytovye gruppy*] or juridical categories [*sostoianiia*], which have been formed historically through common traditions, corporate ideals, work, upbringing, etc. Such are our historical estates: nobility, clergy, merchants, townspeople, and peasantry.

2. The noble estate, having always been the most culturally advanced, should continue to bear its age-old service before Tsar and people. In view of the significant contingent of landless nobles, it is necessary to induce such people to participate actively in the work of the noble societies to which they are attached. This is conditional upon landless nobles' paying a certain sum (the amount of which is to be determined by noble assemblies) and upon agreement of these assemblies to accept them.

3. The rules on conferring nobility for state service should be changed and, except for direct grants by the emperor, the right to petition for ennoblement should be reserved exclusively to noble assemblies. Likewise, the rules for the exclusion of unworthy members and aliens with inappropriate bloodlines from noble societies should also be reexamined.

C. Participation of Nobles in the Development of Parish Life

1. The landed nobility should participate most actively in a parish social organization, established for purposes of local charity, welfare, medical assistance, primary education, and church finances; this will further strengthen the natural tie between the peasantry and nobility.

2. The small zemstvo unit [at the community level] should be coterminous with the parish, not the township.

D. Gentry landholding

In recognition of the fact that the nobles' landed estates are of state significance, it is necessary to strengthen noble landholding and to promote its establishment in those areas where it is absent or weakly developed.

E. Education

1. Arrangements for the upbringing and education of the next generation of nobles is a question of cardinal importance: the very survival of the nobility depends upon a correct solution to this question, for the whole idea of [this] "estate" consists in its state service, and the inability to serve will leave the noble a legally inferior, dead member of his estate.

2. The existing educational institutions do not satisfy the nobility's requirements with respect either to education or moral upbringing.

3. Education is inseparable from moral training and hence both should be in the same hands. The present boarding schools of the nobility directly contradict that principle and should be transformed into closed and autonomous educational institutions.

4. The Circle of Nobles wishes to have these schools established, so far as possible, on traditional noble properties in the countryside— to avoid sundering the tie with rural agricultural life. These schools are to have the full rights enjoyed by state schools, so long as the latter have such rights.

5. In accordance with basic noble traditions, education and upbringing should be firmly based on a strict national and religious spirit and give serious learning and training that are sufficient for an independent life, not mere diplomas attesting to the completion of studies.

6. Each such school is to have a Board of Trustees, elected by

members of the Circle of Nobles and empowered to appoint or dismiss the entire staff of the school, including the director. Direct intervention by parents in the education and moral training of the schools cannot be permitted.

7. Given the shortage of educational personnel, propose to noble societies that part of the susbidies and stipends under their jurisdiction be devoted to the training of young nobles for careers in education.

F. The Press

It is necessary to have a press organ that examines questions concerning the nobility and state life from the Circle's point of view.

B. BUREAUCRACY AND ARMY

Although the army and the civil service weathered the storms of 1905–07 and enabled the old regime to survive for another decade, they nevertheless exhibited deep fissures and faults. Since the 1860s, both had continued to expand and to professionalize, with higher standards of education, greater specialization and expertise, and increasing diversification in social origin. At the same time, the post-reform bureaucracy enjoyed a recrudescence in self-confidence, as the failure of the Great Reforms and the elite's demands for firmer order renewed the bureaucracy's self-assurance that the state can and must direct society along the proper path. The military reforms of the 1860s and early 1870s, which aimed to professionalize the officer corps and modernize the lower ranks with universal military training, contributed to the army's improved performance in the Russo-Turkish War of 1877–78 and its gradual recovery of respectability after the debacle of the Crimean War. Yet precisely these very changes—more educated bureaucrats, more professional officers, more democratic soldiery—diluted the traditional, personal loyalties that had once made the army and bureaucracy such reliable instruments of rule and repression.

The following documents reflect these profound changes in the structure and attitude of the civil service. Perhaps most striking was the development of a large public service sector, chiefly in transportation and communications, where personnel were legally state employees but occupationally—and politically—much closer to private employees. By late 1905, these technical employees of the state had established autonomous unions (doc. 72), organized crippling strikes, and expressed support for the liberation movement (doc. 73). In response, the government took vigorous measures, not only against individuals, but also to reaffirm the public employees' duty to serve the state and resist involvement in political issues (docs. 74–75). This repression evidently took its toll, even among the unionist-

minded post and telegraph workers, who were plainly on the defensive by early 1906 (doc. 76). Nevertheless, oppositionist and unionist activities persisted both among that leading segment (doc. 77) and, in a somewhat more shadowy manner, among various self-proclaimed civil service unions (doc. 78). It is striking indeed that in contrast to the numerous petitions and letters from most other segments of society, the Duma received few—even anonymous—communications from the civil service; only an occasional individual (doc. 79) made bold to address the Duma on behalf of the civil servants. But as his letter and a defiant statement even from the prison guards at Moscow's infamous Butyrki Prison (doc. 80) reveal, disaffection among the civil service may have been repressed but not eliminated.

The army, dealt a humiliating defeat by Japanese forces and demoralized by revolutionary agitation, was neither zealous nor reliable in pacifying the countryside and city squares in the Revolution of 1905. Although the officer corps largely performed dutifully, some officers—whether from liberal conviction, military professionalism, or fear of irate soldiers—showed sympathy for the liberationist movement (doc. 81) or even tried to organize their own union (doc. 82). Far more volatile was the mood in the lower ranks, who alternately engaged in vicious repression and insurrection, sometimes with highly political proclamations (doc. 83). But particularly suggestive of the dangerous instability in the army was the behavior of the Cossacks, who felt enervated by the prolonged mobilization and denigrated by their role as internal policemen (doc. 84).

72. Declaration of Nizhnii-Novgorod
Postal Workers
12 November 1905

We, the undersigned postal and telegraph employees, joining with the Nizhnii-Novgorod Provincial Committee of the All-Russian Post and Telegraph Union, give this written assurance to our elected deputy and to all the members of the Union: (1) that we will remain true to the program of the Moscow Bureau of the Union (published in the newspaper *Vechernaia pochta*, 1905, No. 258); (b) that we take

a sacred, unswerving vow to carry out all decisions and resolutions adopted by the majority of delegates to the All-Russian Congress of Post and Telegraph Employees; (c) that we swear to devote all our zeal and energy to our common unification so that no kind of internal dispute arise among us and cause the disintegration of our Union. All those not on duty must attend assemblies. In the event of arrests, dismissal or other acts of coercion against delegates and members of the All-Russian Post and Telegraph Union, we swear that, by uniting closely together, we will take all measures (the most extreme of which will be a strike) to defend those who have suffered. [Signed by 142 members].

73. Resolution of Perm Postal Employees
16 November 1905

1. The immediate convocation of a Constituent Assembly on the basis of universal, direct, equal and secret elections without distinction as to sex, nationality and confession.

2. Immediate implementation of the principles proclaimed in the Manifesto of 17 October—i.e., freedom of speech, press, association, strike, assembly and inviolability of person and residence.

3. Complete amnesty of people who have suffered for their political and religious convictions, and their return to former places and positions.

4. Abolition of capital punishment.

5. Legal recognition of the Postal-Telegraph Union.

6. Immediate and unconditional abolition of laws on extraordinary emergency and martial law, as well as all other laws and administrative orders that limit the rights of Russian citizens; transfer of police into the hands of self-government organs and abolition of the gendarmes.

7. Complete [job] security for all strikers and material support for them during strikes.

8. Acceptance into [government] service of all people who have been released and who have suffered for participation in the organization of the union; restoration of their former rights.

9. Abolition of dismissals on the basis of point 3; discharge only on the basis of judicial decisions.

10. Abolition of the decree appointing the official Medvedev to the Mordovian Postal-Telegraph Division.

[Signed by 104 employees.]

74. Council of Ministers: Directive on Civil Service Loyalty 14 January 1906

After discussing proposals for special measures to deal with persons in government and public service who support the anti-government movement, the Council of Ministers resolved: Articles 270 and 277 of the General Statute on Provinces (1892 ed.) makes it the permanent duty of governors and the chief officials of regions and cities to recommend to local provincial and district authorities that appointive officials be dismissed if they violate the state or public order. These local authorities are hereby ordered to implement such notifications by governors immediately, through enforcement of articles 788 and 838 (pt. 3) of the Statute on Civil Service. With respect to officials in the State Comptroller, the regulations in article 951 of the Statute on Ministries is to be observed. In the event that authorities deem it impossible to satisfy the demand of the governor, they are to send him all the necessary explanations and information for submission, if he deems this necessary, to the ministry of interior and the chief officials of the appropriate service branches.

[Signed by Nicholas II, 14 January 1906]

75. Directive to Survey Office Employees 7 January 1906

Of the phenomena that have accompanied the present turmoil, the Council of Ministers cannot overlook the actions of certain people in state service and their involvement in events in ways that violate the basic principles of service discipline.

It is intolerable for officials, who receive their authority from the state and act under its authority, to be secret enemies of the existing order, to counteract the government's initiatives and to support antithetical strivings.

The loyalty oath and a sense of honor require that everyone in His Majesty's service, irrespective of rank and position, be punctilious and conscientious in executing the Sovereign's will, share the government's opinions and assist as much as possible in their realization.

At the present time, the government's main goal is to restore order and to implement the manifesto of 17 October. This difficult transitional period demands, of course, great efforts and the dedication of the entire spiritual strength of those who wish, within the scope of their assigned tasks, to serve the motherland honestly. But it is precisely in these difficult circumstances that a dishonest attitude toward one's duties and a criminal violation of the sworn oath are so dangerous, for they help to promote anarchy.

The government will no longer tolerate in state service officials who oppose its views and who do not obey legitimate authority. Such people should abandon their positions and surrender them to others who wish to devote their energies to serving the state.

76. Declaration of Postal Union
[Early 1906]

To all Postal and Telegraph Employees

The Central Bureau of the All-Russian Postal and Telegraph Union sends its warm greetings to all those who have suffered in the terrible, but glorious struggle, to all who have steadfastly fought to emancipate post and telegraph employees from the yoke and arbitrariness of a servile, criminal bureaucracy!

So be it, comrades, that many of us have suffered grave adversities, that our families have been left in poverty, that the terrible blow which we have dealt the government (which is detested by the entire people) has brought disorder into our own ranks. But we have honorably performed our first and most important task: we have openly demanded that the humiliating chains of our slavery be

sundered and that the rotten arbitrariness which has ruled and mocked us working people be buried once and for all. We have done our duty!

In its final convulsions, this dying and shame-covered government continues even now to oppress us with its filthy, bloodied paws. But these pathetic, revolting attempts do not in the least frighten us employees, who have awakened to a new life and who have recognized the imminence of an indubitable and joyous victory. Our long-suffering motherland will be reborn, and we, her loyal sons, will hereafter march forth in the first ranks of those fighting for her liberation.

Certain unworthy comrades—cowards and plotters, who have smeared themselves with dishonor, who have suppressed the voice of their own conscience—seek to gain for themselves and their fellow collaborators the good will of their superiors by grovelling before the government, which has given them money and promotions as a reward for betraying their comrades' cause.

Take action, comrades! The Central Bureau of the All-Russian Post and Telegraph Union appeals to all post and telegraph employees and summons them to unite as one in their local organizations under the leadership of their committees and in their creative work to adhere strictly to the Charter of the All-Russian Post and Telegraph Union, drafted and approved by the First Congress of delegates of the All-Russian Post and Telegraph Union. Those post and telegraph organizations which do not have this charter will receive it immediately upon request from the Central Bureau.

The Central Bureau of the Post and Telegraph Union proclaims to all local organizations that it has completely finished the work for a central organization, has worked out detailed plans for imminent action, and at present is totally devoted to the task of fully restoring the union in general. To work, comrades! Every day is precious. No one can doubt in the imminent, clear success of a cause so dear to us all. The entire history of the union speaks to this. Yes, our Union already has a brilliant beginning in its history. You know very well that, after being completely disorganized earlier, in just one month we were able to unite in an All-Russian Union. Just think what power we would have if our Union, after just one month's existence, was able to cause the entire world to shudder and be astonished by a strike whose steadfastness and solidarity had no precedent and had never been seen before. We forced all European post and telegraph

unions to move forward. You know all about this from the newspapers. We now have had battlefield experience: we received our "baptism as strikers," of which every conscious employee can be proud. So unite!

Comrades, we firmly shake your honest, working hands, and summon you to take the most vigorous action!

Central Bureau of the All-Russian Post and Telegraph Union.

77. *Proclamation of Moscow*
Post-Telegraph Employees
June 1906

To all Post and Telegraph Employees from the Moscow Committee of the All-Russian Post and Telegraph Union

Comrades! For many years we have been oppressed by the arbitrariness of various superiors. For our work, we are given just enough compensation to keep from starving to death. All our time, all our life is passed in stuffy, damp and cold offices; we have only a few hours of free time in a twenty-four hour period, which hardly suffices for sleep to gather one's strength for the next day of penal servitude. We are not given a single free day during all our service, and to get time off, we must either humiliate ourselves or deceive.

All these conditions deny us the chance to live like human beings: we cannot devote even a little time to our families, give our children upbringing, or supplement and sustain our own development. Notwithstanding our repeated requests and petitions for an improvement in our difficult condition, the authorities not only have disregarded these, but also have done everything possible to complicate our work through senseless circulars and directives. All they do is promise to increase our salary and to reduce our work time.

Finally convinced that we cannot improve our condition through peaceful means, we have resolved to achieve this through force. On the basis of the manifesto of 17 October, we have united to form the All-Russian Post and Telegraph Union in order, through a common effort, to change the onerous conditions of our service. But the government has deprived us of our rights as citizens by declaring that the manifesto does not apply to the post and telegraph department. In-

sulted by such arbitrariness, we decided to defend our rights by force and proclaimed an All-Russian strike until our demands are satisfied. That was eight months ago. The government was, however, still sufficiently strong to deal with our young organization and took a whole series of repressive actions against us. Our Union suffered great losses and, seemingly, was totally destroyed.

But no, comrades, it exists—it cannot be destroyed by any efforts of the government, because it stands in defense of freedom and justice. Therefore, comrades, pay no attention to the threats of the authorities and join the union again. Persuade your comrades of the need to organize so that, together with the entire working population, we can strike a last, decisive blow against the moribund autocratic order.

Victory is near. With each new day the government's forces are growing weaker and weaker. The army and navy—its main supports—are experiencing ever greater unrest and are adding their voices to the demands of the insurrectionary people.

Just one more blow, and the autocratic government will not withstand the collective pressure of the infuriated people. It will cease to exist. It will be gone and before us will open the broad road to light, justice and a free life.

78. Bureau of State Employees: Open Letter to the Duma April 1906

Members of the State Duma!

The population of Russia, which participated in the elections, has empowered you to express the people's hatred for this antiquated regime and their strivings for political freedom and power.

But behind you stand not only the segment of the population that elected you, but the entire people—with the expectation that you will obtain full political amnesty; that you will bring to justice those agents of oppression and violence who have gone unpunished; that you will defend the basic rights of man and the citizen; and that, having cleared the way for the convocation of a national government, elected through universal, direct and secret ballot, you will affirm the unshakable foundations of popular sovereignty.

In solidarity with the people in their hopes and demands, we civil servants experience a bitter feeling from the awareness that we ourselves firm a barrier to laying the new foundations for a democratic order, because we are the rank-and-file of an administrative army, over which the [elite] bureaucracy reigns—as if over an organism without a will, voice, reason, or soul.

That is why, in the present historic moment of the impending struggle for popular sovereignty and freedom, we deem it our duty to address you. Do not forget that, for democratic reform to triumph, our legal position must also be changed in the most radical manner.

The new freedoms will remain a dead letter and the principle of civic responsibility will not come into being if we, as the instrumentality of executive authority, preserve the privileges that so degrade us—by remaining unaccountable before public control, publicity and the courts. In vain will legislative power be given to the people; arbitrariness will continue to prevail until the entire system of administration has been transformed and until legality and public good become its guiding principles. An impassable gulf, separation and enmity between the people and their servants will persist as long as all the restrictive laws that deprive us of rights and the chance to participate in the general civic and public life are not annulled. The defeat of the bureaucracy will have been for nought if officialdom remains stagnant and dark, if the means are not found for its spiritual regeneration by means of autonomous organization in free unions.

If it were merely a matter of expunging the shame that deservedly rests on all our profession because of its past activities, if it concerned only us and our liberation from servile dependency, at the present time we would not begin to speak about ourselves and our position. But we appeal to you in the name of the country's interests, in the name of the irreversible triumph of democratic reforms; we are prepared to execute only the popular will, which you should authoritatively proclaim. Therefore we have the right to demand of you that you extend to us all the rights of citizens.

Bureau of the Union of Civil Servants in State Institutions.

79. Kherson Official:
Letter to the State Duma
2 May 1906

Mr. Chairman of the State Duma!

As their defenders in the State Duma, the artisan and peasant have those who comprise the Trudovik Party. The "unskilled workers" of the chancellery—the so-called couriers, accountants, copyists and other low-ranking servitors in state institutions—have no representatives, since the bureaucratic officials, against whom all Russia is battling, cannot be considered their defenders.

To become even a minor cog with authority in the bureaucratic Russian chancellery, one needs neither knowledge nor experience, nor a capacity for hard work for the sake of the motherland. Rather, in addition to a diploma from an institution of higher learning, buttressed by kinship connections, from the first day of service one requires the ability to express clearly that talent most prized by one's superiors: to spew out words, to accomplish nothing, to knuckle under.

I dare ask the Duma for something quite modest: "give us humble workers the chance to be confident about tomorrow." One needs the assurance that he does not depend upon the caprice of his superior. . . . [sic] That dependency is onerous, since it cannot be dispassionate, and corporate control, in the person of a union of civil servants, cannot be just.

I will not attempt to present a fully completed program for a union. But I dare to hope that I can indicate its main points: (1) For service one needs not diplomas or kinship ties (which lead to appointments, medals and other regalia for serving a specific term), but rather knowledge, honor and a capacity for hard work. (2) Equal, just security is needed both for old age and for disability. (3) The chief official of an institution, on his own authority, should not be empowered to discharge any regular employee (from the watchman on up), if he has passed the probationary period of service. Dismissal from service is only to be possible through a decree of an imperial court for a criminal offense or through a fair decision of the union (for disorderliness and laziness). (4) Vacant positions are to be

filled in each area from at least three candidates nominated by the union. (5) The union of our institution protests—and even has the right to refuse to perform—work by a higher institution if this can be successfully performed by the superior institution. (6) The union is to see that salaries correspond to the demands of life and to be concerned about medical assistance. It is to present its views on the distribution of unspent budgetary funds and allocations in the event of illness or some other misfortune of their fellow servicemen.

If this petition, for some reason, proves to be the first, I request that it be published. Dionisii Ivanovich Pimenskii.

80. Moscow Prison Guards:
Letter to State Duma Deputy
June 1906

Mr. Deputy, P. F. Savel'ev!

We, guards of the Moscow Transit Prison (Butyrki), greet you as representative of the working people, and also all other deputies, and ask God to help you overcome these embezzler-bureaucrats and to attain land and freedom for all, amnesty, and the abolition of capital punishment. For a long time we have tolerated all the goings-on at Butyrki prison; but it has finally become impossible to endure this any more, and we decided at last to file a complaint. We submitted the complaint, but it was ignored. We are sending this complaint to you, Mr. Deputy [of the Duma]. There are 150 guards here, who draw different salaries, starting at 27.10 rubles a month; those who have served twenty years receive 60 rubles. Those who receive 60 rubles live in [free] government housing, while those earning 27 rubles (this includes twenty people) live in private apartments [at their own expense]. The latter are also supposed to receive government housing, but there are not enough of these [apartments]. Guards are also supposed to receive government firewood for heating fuel, kerosene, uniforms, and greatcoats—but in some mysterious manner all this disappears. These [items] are under the control of the prison's deputy director, a former conductor on the Krugo-Baikal Railway, Blok. For his rude behavior, the railway workers carted him away in a wheelbarrow and threw him out with the fillings. Then he came here. Since

the director of the prison, Von Rhein, does absolutely nothing, Blok has taken all the power into his own hands; he discharges and fines the guards whenever he catches anyone dozing during the night watch (for two or three minutes, the fine is three to five rubles). There is never enough cabbage soup for the prisoners, but Blok has everything: he goes into the kitchen and eats up all the prisoners' soup and meat. The other superiors here are no better than Blok, however. The only time they give us government issue to wear is when some kind of outside authorities come [for inspection], and afterwards it is all taken away again.

[Signed:] Guards of the Central Moscow Transit Prison.

We ask that our letter be published in the newspapers. We have not signed it, because we are afraid of being sacked from our positions. But the times are such that there is no where to go, so one involuntarily has to tolerate things. . . .

81. Declaration of Army Officers in Chita (Siberia) January 1906

After arriving in Chita, we were outraged by the extremely absurd rumors that the Chita regiment belongs to some kind of party that strives to inflict violence on the citizens of Chita. Therefore, we officers of the Chita regiment declare:

1. We are in complete sympathy with the contemporary liberation movement in Russia and with the transfer of legislative authority to representatives of the people.

2. The army, in our opinion, belongs to the entire state, but since the state is composed of all the people, it should not belong to one of the existing parties or unions. Otherwise, the party to which the army adheres would be tempted to use military force to suppress the other parties, which is contrary to the freedom that has been recognized in Russia.

3. The army has only the goal of protecting the homeland from external foes who attack through overt force. It obeys the orders of the government that at a given moment is recognized as the legitimate government in Russia.

4. The army or its units, in view of the inviolability of person that has been proclaimed in Russia, cannot commit either murder or any other act of violence against the peaceful citizens of Russia, no matter which parties the citizens might belong to and no matter who in the army might issue demands to perpetrate this violence.

5. We deem it disgraceful to suppress any political party by force of arms and to use the latter against peaceful demonstrations and meetings.

6. In the struggle of various political parties, the Chita regiment assumes no political responsibilities; however, in the event of an outbreak of disorders that threaten to end in bloodshed, we of the Chita regiment—until a militia of sufficient strength is formed—will deem it our duty, at the demand of civil authorities, to participate in warning and terminating fratricidal war and conflict.

7. We have long since recognized that the most fundamental reforms are needed in the army and will welcome these through a legislative process. At the same time, we believe that the army will be harmed by dissemination in the lower ranks of ideas aimed at undermining discipline in the troops and arousing antagonism between officers and soldiers. We will strive to educate the lower ranks in the spirit of honestly performing their duty to their motherland.

[Signed by the regimental commander and other officers]

82. Charter of the Union of Russian Army Officers [June 1906]

The union unifies the officers of the Russian army outside the framework of existing political parties [and] as a specialized military organization. Goals and purposes of the Union:

1. The Union sets for itself the goal of assisting the liberation movement through: (a) the refusal of Union officers to perform police duties and to use arms to suppress the liberation movement; (b) broad propaganda of this view among the Russian officer corps.

2. Resistance to every attempt to make the army a blind instrument of politicians who accidentally [hold power] in this archaic or-

der. [This resistance will rely upon] measures and means that the Union deems most expedient in each individual case.

3. Reorganization of the army on terms that are consistent with the dignity of a constitutional people.

4. Improvement of the material and moral life of the lower ranks of the army.

As the fundamental principle of its activity, the Union deems the complete solidarity of its members and the unswerving performance of the obligations it has assumed. So far as possible it will provide support to those comrades who have suffered for executing the concrete and general orders of the Union.

The form in which the Union expresses this support will depend upon the Union's decision in each individual case.

The internal organization of the Union is not to be made public.

83. *Appeal of Soldiers in the Bobruisk Regiment November 1905*

Comrade Soldiers!

In almost every city, soldiers are coming to the defense of their downtrodden human rights. They demand a better life, a better order both in the troops and in the state. In Ekaterinodar on 16 November the soldiers, at a given signal, seized the arsenal (a warehouse of weapons), drove out the officers, on the spot elected a commander, set up patrols throughout the city, and as a whole unit numbering 700 men (and armed with rifles), went to the battalion commander. They marched with a banner. The weapons seized in the arsenal were passed out to the workers. The same thing happened in the following cities: Stavropol, Kiev, Odessa, and Elisavetpol. In other cities (for example, Batumi, Vyborg, Riga, Warsaw) the soldiers announced their demands for an improvement in their life and in the barrack orders. . . .

Comrades! It is onerous and intolerable for us to live under the yoke of our brutal superiors. Cattle are fed better and given more compassion than we. Why did they take us out of our home villages,

from our fathers and mothers? It is impossible to live like this for a long time! We've had it! Our comrades are fighting all around us. Will we really be the only ones to tolerate torment and keep quiet? Have all the companies assemble tomorrow morning with their arms at the square, demand [to see] the regimental commander, and tell him that we have had enough of this life and do not want to be tormented any longer. Be bolder, comrades! The entire people, the workers and the educated people, are for us. We do not want to mutiny, but to obtain real human rights. Enough of this oppression and violence. Freedom and a better share! Is that not so, comrades?

[Signature:] the Soldiers of the Bobruisk Regiment

84. Public Statement by the Urupskii Cossack Regiment January 1906

Citizens! We turn to you for a fair judgment of our case. We have done this openly and want the entire Russian people to know how it all happened. We remain loyal servants of His Imperial Majesty, the Sovereign Emperor, and we stand ready to defend our fatherland from external foes to our last drop of blood. Called up in the mobilization of 22 November 1984 during the war against Japan, we were prepared to prove to the entire world our loyalty to our motherland and, [though] thirsting to fight this enemy, we were left—by the will of the government—to perform police service inside Russia. Blindly obedient to our superiors, we zealously executed all their orders: we beat the people with whips, dispersed them with the butts of our rifles, shot down unarmed citizens in the streets, trampled them with our horses, guarded hotels and brothels, and came under the command of city authorities (who used us for their own benefit). Though cold and hungry, we bore our service silently and complacently, believing that in this way we were carrying out the Sovereign's will. But when the tsar gave the people their freedom in the manifesto of 17 October [1905], when it became obvious that he wants to ameliorate the plight of the poor, and when our life (which is like penal servitude) was made no easier, we finally began to understand what it is all about. Our superiors have fixed it so that the manifesto did not in

the least apply to us, as though we were some kind of Turks instead of the Sovereign's loyal subjects, as though we were not sons of the motherland, as though we were not the same kind of citizens as you, as though we were not defenders of the fatherland.

At the same time, it became increasingly difficult for us to live, and we simply did not have the strength to endure it any more. We were forbidden to attend political meetings where people spoke the truth; we were forbidden—under fear of punishment—to assemble and discuss our needs. And when we announced to our superiors that they should feed us whole bread and that the government rolls have rubbish in them, one of the officers (B.) said with a sneer that "at home you ate worse than my dog, but here you don't like government food." They put us on the same footing as dogs and ignored our petition. They used us to replace horses: they had us haul horse manure from the courtyard (as happened with the fifth company). They fed our horses rotten fodder (as happened when our regiment was stationed at the camp in a Cossack village in the Crimea); some of the horses died from this fodder and many others became sick. We complained several times about our onerous life to authorities, but they [only] responded to our petitions with promises of a court-martial, with choice swear-words, with threats to shoot anyone who dared to complain about his situation. They forced us to protect in silence those "institutions" where the officers amuse themselves.

Citizens! We've had it hard—so hard that it's impossible to describe. We became bitterly offended when, after the manifesto of 17 October, the government forced us—against the will of the Sovereign, who granted freedom of assembly, speech, conscience and association—to break up meetings, to kill people who demand their legal rights (as happened in the city of Ekaterinodar). We understood what a crime we were perpetrating before our dearly beloved motherland when we carried out the insane orders of our superiors. We therefore refuse categorically to bear political service, regard it a crime, and deem it incompatible with the military duty of a Cossack.

We gave a demand for disbandonment to our officers, both the younger and older ones, and explained to them that the war is over, that they are keeping us just to pacify the people (who want freedom), that our farms have been ruined in our absence, that many of us have become completely impoverished, that our wives and children are starving even as we perform police duties. We explained to

them that no one is taking care of our families. We said that we want to go home.

What did our government do? Did it come halfway to meet the Cossacks' demands? They began to accuse us of mutiny, of betraying our oath to the Tsar and Fatherland, did not want to satisfy our petitions, and sought to repress the voice of our pained souls with obstinate, coarse bluster. But when our superiors saw that we were united, they did not give a final answer, but tried to avoid this and to incite the unmounted Cossacks against us. For example, at the order of Major-General Babich, two cavalry companies were sent to a palace to guard a Cossack ataman, but two unmounted companies were already there and were told to fire upon us (like mutineers). But they refused—just as we did when they wanted us to fire upon the 252nd reserve battalion.

When the perfidious schemes of our superiors had thus failed (thanks to the refusal of the unmounted Cossacks), when we learned that the government was mobilizing new Cossacks, perhaps with the purpose of sending them against us, we thought it better to leave Ekaterinodar and go to our own area.

We decided to do this because we did not want bloodshed; we did not want a fratricidal war that our superiors wanted to provoke by sending soldiers against Cossacks, Cossacks against soldiers, brothers against brothers—so that they could later sit more firmly upon our necks. We want peace and tranquillity; we want happiness for all citizens. Having understood, at last, the conduct of our superiors (who forced us to slay our own people), and thirsting for justice and freedom, we add our voice to that of all Russia and demand:

1. That the State Duma be convoked immediately and on the basis of universal, direct, equal and secret franchise, since only that kind of Duma can bring peace and tranquillity into our much-suffering motherland.

2. That all those people who have suffered for the cause of freedom be immediately set free.

3. That our discharge be legalized and publicly announced at training camps in Cossack villages.

4. That we be given everything that the treasury is supposed to give regular troops—viz., salaries, an allowance for repairs, food, rations, fodder (provided by the towns), and money for uniforms and the railroad.

So that none of those who make these demands suffer, the entire Urupskii regiment will stand up in defense of every Cossack who is arrested.

Henceforth, until these demands are satisfied, we have decided to retain our weapons. [Signed]: The Second Urupskii Regiment.

C. THE ORTHODOX CLERGY

The half-century after the Great Reforms not only failed to alleviate the various ills in the Orthodox Church, but aggravated relations between bishops and bureaucrats, priests and parishioners. The ecclesiastical elite, several dozen monastic prelates who ruled the Church and dominated its intellectual life, grew increasingly distressed both by irreligious tendencies in lay society and by the state's wanton intrusion into ecclesiastical affairs. The natural conclusion—that the Church required greater independence—was by no means novel, but it had been a long time since ranking prelates expressed it as bluntly and insistently as they did in 1905 and after. At the same time, the parish clergy had their own causes for discontent, above all, the failure to provide better material support, but they were also increasingly moved by feelings of anxiety over religious disaffection, concern for the people's material welfare, and overt sympathy for the political liberation movement.

Perhaps most surprising for conservative quarters was the bishops' fronde in early 1905, with demands that a council be summoned to engineer fundamental reform in the Church. The government agreed only to a "pre-conciliar commission," but that provided the occasion for the Synod to solicit opinions from diocesan bishops on the proper direction of reform. Their opinions vary considerably in detail, but generally concur on the urgent need to address such issues as Church-state relations, economic support for clergy, diocesan administration and justice, church schools, and the role of laity in church affairs. The opinion produced below (doc. 85), submitted by Bishop Germogen of Saratov (subsequently notorious as an arch-reactionary), reveals how even so conservative a prelate as he demanded far-reaching Church reform. But his conception of reform was thoroughly "episcopal," aiming to increase—not diminish—the bishop's authority over priests and parishioners.

Parish clergy had been sporadically involved in the liberation move-

ment throughout 1905, but the main surge of political activism came after the October Manifesto—notwithstanding stern admonitions from the Synod and vigorous repression by civil authorities. In part responding to the general euphoria, in part convinced of the legality of such involvement, a significant element of the clergy—certainly its most organized, articulate and visible wing—vigorously supported liberation in politics and reform in the Church. While some gave particular emphasis to the social responsibility of the church (doc. 86), most stressed the ecclesiastical ramifications of democracy and liberation for the Church. The most sweeping, carefuly crafted statement of such views came from the leaders of the "renovationist" movement (doc. 87), and provincial clergy—like those in Viatka—issued liberal pronouncements on secular as well as ecclesiastical issues (doc. 88).

85. Bishop of Saratov: Opinion on Church Reform January 1906

[ON THE COMPOSITION OF THE CHURCH COUNCIL]

Many bishops of the Russian Church have already proposed that the council be composed exclusively of bishops, and I share that opinion. I deem it absolutely irrefutable and most consistent with the urgent need for church reform in a spirit and direction that are consistent with the canons of apostolic and ecumenical councils. At present, we may be experiencing a unique moment in our history and, to prepare our flock properly for conscious entrance into a new era of its historical existence, it is absolutely necessary to shield the council, above all, from possible pressure in the spirit of contemporary anti-Christian and anti-Church teachings as well as other inventions. One must remember that the entire fate of the council, the entire character and content of its resolutions, the degree of success in its mission, will be determined by a correct answer to the question of the Council's composition. One must also keep in mind that, at no time in our history, has our self-deprecation and self-humiliation reached the degree that it has now. Never have the foundations and institutions of our fatherland, the order of our country, our laws and customs—in a

word, everything that Russia and the Russian people have lived and still live by—never have they been subjected to so vicious, so persistently false criticism. And, quite naturally, amidst this unfounded hatred of the foundations and institutions of the Russian Church and Russian life, criticism and abuse have been heaped upon not only real shortcomings and failings but also upon things that do not merit ridicule and criticism—indeed, things which constitute our distinctiveness and achievement before other peoples and civilizations, things which gave (and continue to give) Russia and its people the strength to bear and perform their historic mission. Under such circumstances, the dogged effort of the liberal press, various private individuals and a certain segment of the clergy—none of whom acknowledge the ancient canons and customs of the ancient Orthodox Church—seek to have priests and laymen included in the council. I regard these efforts not only as illegal, but also as exceedingly undesirable and even dangerous to the Council's preservation of the teachings of our Orthodox Church in all their purity. I hold these efforts as illegal in view of the canons and customs of the early Church, whose councils were composed exclusively of bishops with full power to make decisions. That councils be comprised exclusively of bishops, as governing the Russian Conciliar Church, is also justified by the idea that individual parts of the Church are governed by a single bishop, under the general supervision of the Holy Synod (as its collective patriarch, so to speak). The participation of those other people is undesirable and dangerous because representatives of the clergy and laity, by forming the great majority, would determine the basic substance and whole idea of the council's work; in the event these people participate in the council, we face the terrible danger of receiving resolutions from a Russian Church Council that are based not upon the decisions of bishops, but of *accidentally or tendentiously chosen people*—who perhaps support the contemporary destructive tendencies in public life. In other words, the guiding resolutions and canons of the Russian Church Council could be prepared not only without respect to the opinions and influence of bishops (the legally established prelates of this Church), but even contrary to them. "There can be no Christians without bishops," said the blessed Simeon Solunskii. Accordingly, all the ecumenical fathers and teachers of the Church have taught that the Church always had bishops—nor could it be otherwise. But those who favor the participation of priests and laymen in the Council have

come to hold that the Council be constituted without giving Church prelates final authority. These opinions are not based on the canons of apostolic and ecumenical councils, but on the contemporary views of liberal segments of society (which is utterly alien to the spirit of the Church and true Christian piety) and the liberal parts of the white clergy. Further, the penetration of these opinions into the sphere of the Council's legislation and the views of bishops of the Russian Church could incite turmoil and disorders that could shatter the entire harmonious work of the Council. One should also fear that such an intrusion might even undermine the Council, as often happens in various diocesan assemblies, especially in those where representatives of our intelligentsia participate. Unfortunately, the general spirit of a significant part of educated society and also the liberal segments of the white clergy can be described as bearing elements of parliamentarian and republican aspirations. Such strivings are completely contradictory and completely alien to the spirit of the conciliar apostolic Church.

I am firmly convinced that the disease of disbelief and religious indifference of Russian society, the ailments of the clergy, and also all the general shortcomings in the contemporary social life of the Church, cannot be healed and reformed by the sybaritic learning that has so far worked tirelessly in a spirit alien to the teachings of the Orthodox Church; nor by the external forms of political and social order, no matter how ideal they might appear to our liberals, social-democrats and similar obedient supporters of the "party" principle; nor by any kind of commissions and collegial institutions, no matter how carefully they might be created and established in this case; but only by the basic, free and powerful spirit and life of the Christian Church. And the latter pervades the primary, responsible bearers of this spirit and this Christian life—a council of prelates. . . .

[PARISH CLERGY]

The secular press, representatives of lay society and a certain part of the clergy seek to give parishioners the right to elect the parish clergy, while the well-known "Group of 32 St. Petersburg Priests" even came in their deliberations to the point of demanding the election of bishops. Such views, in all fairness, must be pronounced positively insane, since these priests are pointing a weapon at themselves: in asserting

the necessity to reelect the bishops who ordained them, they naturally should declare that their own ordination into the priesthood was illegal. Apostolic and ecclesiastical canons affirm, with absolute clarity, that only a council of bishops can select a bishop. True, in past times the "election of priests" was practiced. But this order naturally outlived its time, that is, it died out. Who does not know, for example, that now (fortunately, this happens but rarely), in order to obtain parish agreement to establish a second priestly position, the aspirants to this position get the peasants drunk? The peasants "elect" as pastors those who treat them more lavishly, or who have more sonorous voices, or who agree to less support, without the slightest attention being paid to the moral worth of the person they have elected. Indeed, if the people are permitted to elect their pastor, then—taking into account their low level of education and moral upbringing, the victory of the most cunning and ingratiating parties that is always observed at the meetings of laymen, the uproar and disputes—the Church will be threatened by the constant danger of having pastors who do not measure up to their high purpose. If the common people elect from their own midst, the dearth of qualified candidates for the priesthood in villages and hamlets undoubtedly means that they will, in most cases, be individuals who have absolutely no knowledge of the faith, morality and popular religious education and who can become a pathetic object of ridicule among non-Orthodox people. Is it necessary to prove that this rule is undesirable, that it would be even disastrous for the dignity and welfare of the Holy Orthodox Church, given the present spiritual level of the laity? The bolder and more capricious part of the parish community, indifferent to questions of church order and piety, will choose for pastors who are unable to interfere with their way of life, etc. . . . [sic] For its part, history shows that those chosen by the parishioners have been subject to persecution, while those appointed by the bishop have been beloved by their flock to the very end; of the latter, we see many examples even in contemporary life, despite all its disorders. The present method of selecting ordained clergy should be recognized as more appropriate to current conditions. The bishop now has the full opportunity, through his staff, both to test and to train the candidates of the parish and to listen to the voice of the people. That is the way it was most often done; even in the days when priests were elected, the laity recommended their candidates to the bishop as individuals worthy of

the clerical rank, and he then confirmed them in their position. If the bishop found, however, that the nominated candidate did not merit the priestly rank, he proposed that another suitable person be found, or recommended candidates himself. In this manner the final elevation of candidates to the holy rank was pronounced by the person who bears the fullness of grace—the bishop. This order developed beneficially and historically and is capable of improvement through the work of the best representatives of the church's consciousness. Therefore it would be strange to dream of forbidding this [electoral principle], which has been buried by history itself; it would be strange simply to nourish wishes for "an elected clergy" without any supporting data to show that the electoral principle can morally uplift or improve the pastor.

[PARISH-CHURCH LIFE]

To rejuvenate church life at the local level, in individual cities and villages, it is urgently necessary, above all, to breathe life into the foundations or primary cell of church life—the Orthodox parish. I shall not discuss at length the juridical organization of this ecclesiastical-social unit, since this will doubtlessly be raised and examined at the Council itself. On the basis of historical data and the ancient decrees of the Church, a certain foundation of this church organization can apparently be observed in our parish councils [authorized by a decree of 1864]. However, the latter were not designed with sufficient scope and diversity; also, they were further impaired by the fact that the parish priests' participation in those councils is seemingly tangential to its activity. As the true foundation for a healthy parish-church organization, the Synod has already proposed to create a parish-church council under the chairmanship of the parish priest. Following this spirit and direction, the diocesan bishop and clergy in Saratov diocese have already undertaken measures that are possible under present conditions at pastoral assemblies to make a comprehensive study of questions regarding both the organization and the very operation of church parishes. . . .

86. Resolutions of Clerical Assembly in Yalta District 21 November 1905

The clergy of churches in the Yalta district deem it necessary (as the duty of their pastoral conscience) to express clearly their relationship to the exceptional events now taking place.

1. According to the testament of the Savior Christ (Matthew 22: 21) and Holy Apostles (1 Peter 2: 17; 1 Timothy 2: 1–2; Romans, 13: 1), which enjoin us to pray for governing authorities, we pray for the Tsar [but not Autocrat].

2. We recognize that much is unjust and burdensome in our social life; that the condition of many members of the state is intolerable; that resolution of these injustices and establishment of a just Christian life can best be achieved by popular representatives, freely elected on the broadest possible basis [of franchise]. We regard the Russian liberation movement to be just and consistent with divine law, and we can only welcome it.

3. We recognize Christ's path, that of peaceful agreement, to be the only correct way for universal organization. Everywhere minds have been excited and passions inflamed; the Christian in man has been silenced and the worse instincts have come to the surface. A limit to mutual brutality is not in sight. Each act of violence by one side provokes still more from the other; who knows what catastrophe will ensue from all this. Above all, one must acknowledge that human blood is sacred, that not a single drop of human blood should be spilt by either side; that violence now perpetrated, regardless by whom, should not provoke new violence. The government should be the first to recognize this [principle] and to proclaim it to the entire people; citizens from all political parties should recognize this as a law binding for them, too. Each act of violence, no matter who has committed it, should be liable to public trial, without application of the death penalty.

4. The Church, as well as its servitors, should stand outside and above all parties: as the Church cannot be the Church of any one po-

litical group, so too the priest cannot be the priest of any one party of citizens. In a spirit of Christian love and forgiveness, the Church should illuminate the truth in each party and direct all toward greater good, both for the entire people and for each individual person.

5. We express regret that, in these tense times, high authorities in the Church have acted (and continue to act) without appropriate energy—partly because of the abnormalities in the organization of the Church, and partly because of their own fault. They have not explained clearly their relationship to the events transpiring around them; they have not addressed the government about the needs of the people; they have seen no need even to enter into closer contact with priests and other members of the Church. This, so to speak, temporizing position of Church authorities has not unified the clergy in these difficult days and has put them in a false relationship vis-à-vis the people. We recognize that, as a consequence, some members of the clergy have not shown themselves to be at the height of their rank and that, among many people, they have aroused animosity toward the clergy and even the divine Church.

6. It has long been recognized, both by the clergy themselves and by village communities, that an All-Russian Spiritual Council is urgently required for the real resolution of the critical questions in Church life. Recognizing that such questions can only be resolved successfully in places where life itself has raised them, and profoundly regretting that the clergy of our diocese has thus far not participated in the work on these questions, we deem it necessary to ask His Grace, the bishop of Tauride, to order as soon as possible meetings in the superintendencies and a general diocesan assembly of clerics and laymen (with several electors per superintendency) to clarify the present needs and demands of the clergy.

In view of all this, we resolve: First, to transmit the present resolution to His Grace, the bishop of Tauride. Second, to contact other superintendencies of the diocese, send our resolutions, and ask them to express their view on the questions raised here. Third, having clarified at the diocesan assembly our strivings, having calculated our forces, having assembled information on the people's mood from city and rural priests and from laymen, having established a common, definite perspective on events and necessary reforms in the church, to contact other dioceses and urgently request superior church authori-

ties to convoke an All-Russian Church Council on democratic foundations, with bishops, ordained clergy, and laymen.

[Signed by two archpriests, nine priests, five deacons and seven sacristans.]

87. *Program of the Union of Church Renewal*
January 1906

1. The Union of Church Renewal posits, as its general goal, service to the cause of rejuvenating church life in the sense of a free, all-sided church work that is true to ecumenical Christianity and based upon the all-encompassing Christian truth.

2. With faith in the Church as an eternal institution, the Union strives to emancipate the very idea of the Church from entanglement with state ideas, and to emancipate the Church's life from the tutelage and subordination to the state and other human associations (as temporary institutions).

3. The Union holds that the dogma of Church unity imposes upon it, as upon all Christians, the duty to strive for a true unification of all members of the Church. This will begin with two or three gathering in the name of Christ and continue with the unification of young and old until full and living unity among all Christian churches has been achieved.

4. The Union holds that the principle of church unity finds its realization in Church councils. This should be realized in all church organizations, from the bottom to the top (parish, diocesan and regional councils with attendant organizations), and in all aspects of Church life, in all the Church's work, in Church administration and ecclesiastical courts.

5. Hence it is to be understood that future councils of the Russian Church should include both members of the parish clergy and laymen.

6. Establishment of the conciliar principle in the life of the Church demands the most rapid possible reestablishment of the electoral principle in the appointment to all Church service positions, including that of bishop.

7. The conciliar concept demands the abolition of privileges of social estates and groups in serving the Church. In conformity with the

canons of the Church, it also denies that episcopal authority is indissolubly linked with monasticism.

8. Together with the abolition of the above privileges, the estate-ecclesiastical character of Church schools should be eliminated. In their present form they support the existence here of an ecclesiastical authority that has been condemned by the Church. The existing secondary ecclesiastical schools should be converted into general-educational schools. Specialized church education and upbringing in an entirely new order should be a matter of free choice for those who graduate from the secondary school. The organization of higher theological schools should correspond to the spirit and character of a rejuvenated order and life in the Church.

9. The Union denies any right of dominance over the Lord's legacy, whether it be the dominance of clergy over laity, or laity over clergy, or bishops over priests, or priests over bishops.

10. The Union welcomes all efforts to clarify the Christian teaching, to breathe life into the liturgy, to create an effective Christian public consciousness by implanting in Christians more modern forms of fraternal association, in the spheres of both social and material relations.

11. The Union recognizes that the Church has a covenant to renew the entire world and that free science, art and culture represent not only powerful means to achieve this renewal, but are also eternal elements in the Kingdom of God.

12. The Union holds that the principle at the foundation of Christian relations in all non-Church unions and organizations should be set by the following: (a) the law of Christian love after the example of the infinite love of the Heavenly Father; (b) the view of the entire world as a domain that Christians are to transform into the Kingdom of God.

88. *Telegram from Parish Clergy in Viatka Diocese to the Duma 27 June 1906*

The clergy of the 1st Superintendency of Sarapul'sk District, Viatka Diocese, greets the State Duma and wishes it complete success in its

work. May the Lord help it realize, through the legislative process, freedom of speech, conscience, assembly, association, press, petition and the inviolability of person and residence. [We] demand a complete amnesty, abolition of capital punishment, and resolution of the agrarian question in accordance with the wishes of the people.

D. PROFESSIONS AND EDUCATED ELITES

The development of professions—in variety, size, organization and consciousness—was one of the most pregnant, dynamic processes at work in post-reform Russia. Once confined to a small congeries of traditional specialists, the professions grew sharply in size and complexity, as engineers, teachers, lawyers, agronomists and the like graduated in ever larger numbers from a host of advanced institutions. Concomitantly, the professions became increasingly self-conscious of their power and potential, gradually obtained the right to establish formal organizations, and collectively assumed a major role in late imperial politics. Their political attitudes, though doubtless molded by the values and ideologies inculcated in schools and universities, also derived in large measure from a deep sense of professional frustration: stymied in attempts to apply Western institutions and technologies, they were wont to blame an archaic autocracy and obtuse bureaucracy for many of their disappointments and failures. Indeed, a central dynamic of the 1905 Revolution was the politicization of the professional intelligentsia, who used their organizations to articulate broader political demands of the liberation movement. And, in one of the most vigorous efforts of all to mobilize and organize society, the Union of Unions, it was the professional intelligentsia that played so salient a role in assisting other social groups to develop at least nascent forms of organization at the national level. Behind all this feverish activity lay the consensus that political reform was a fundamental precondition for the development and successful pursuit of their profession. Hence it was not simply students (who, as earlier, kept the universities and schools in an uproar with strikes and demonstrations [doc. 89]), but also members of the white-collar intelligentsia who joined ranks against autocracy. Particularly activist were the teachers, who had deep professional and status grievances as well as unusually close ties to the lower strata of the population; their list of professional grievances and their commitment to popular welfare

fused inextricably in their public statements (doc. 90). Distinctly more elitist—and more moderate—were the doctors and lawyers; nevertheless, if less numerous and radical, they too deployed their national and local organizations against autocracy and its repressive policies (docs. 91–92). Engineers also had their share of activists, who mobilized colleagues in professional societies to issue declarations that combined politics and professionalism with a broader vision of social-economic progress (docs. 93–95).

89. *Demands of Students at Railway Technical Institute in Eletsk (Orel Province) 8 November 1905*

1. Reduction of work in the shops to 3 days per week.

2. Requirement that all teachers treat every pupil politely, without ridicule or insult to his person.

3. Abolition of the three-hour period without classes; termination of classes one hour earlier.

4. Unrestricted use of holiday clothing whenever the pupil has free time (with the permission of the dormitory supervisor).

5. Grant of overgarments to the pupil as private property upon graduation from the school.

6. Demand that the department for formal study provide an engineer-specialist to teach each subject.

7. Issue of new books, guides and instruments in all subjects for the students.

8. Abolition of external supervision over the pupils.

9. Abolition of military discipline.

10. Freedom of association; grant to students of the right to discuss, within the walls of the school, all possible questions involving the school.

11. Establishment of a self-education circle and a library for this purpose; subscription to newspapers and journals that the students themselves wish; establishment of a self-help fund for this purpose.

12. Freedom to visit public libraries, lectures and theaters—without special, prior permission from [school] authorities.

13. Immediate abolition of punishments that are humiliating or harmful to one's health.

14. Abolition of the requirement that the students clean the shop and study rooms.

15. Grant to the pupils the right to elect from their midst representatives (three per class) to meet with the pedagogical council of the school in order to defend the pupils' interests.

16. Improvement of material support for the pupils' dormitory.

17. Abolition of persecution of any kind of convictions among the pupils; conferral of the right for students to give their explanations to school authorities in defense of their interests.

18. Improvement of medical assistance.

19. A pupil's bad behavior should not influence the evaluation of his success for determining promotion to the next class.

20. Transfer of pupils with an annual average of "3" [satisfactory], without examinations, to the next class.

21. Petition by the pedagogical council before the appropriate authorities to increase the salaries of technicians who graduate from the school and enter into service.

22. Complete inviolability of all students who sign this declaration (on the basis of the imperial manifesto of 17 October 1905).

90. Appeal of National Teachers' Union
January 1906

In June [1905], the national congress of delegates from local groups of the Union of Teachers of Elementary and Secondary Schools and others involved in public education was held in St. Petersburg. The congress confirmed a statute (appended) and outlined certain tactical measures for the immediate future.

The union's goals include the struggle for general political change and the basic rights of the individual, and the struggle for the emancipation of schools from the bureaucratic regime. Based on the principles of self-government, and obliged to work directly with living reality, the zemstvo and city public organizations from the first days of their existence have developed a negative relationship toward the

bureaucratic structure of our state life. With the passage of time, this relationship has gone from what was at first latent into an open struggle of a highly tense character. Consequently, one must recognize that the union's goals agree completely with basic tendencies in the activities of the zemstvos and city governments. As a professional organization, the union also stands close to the zemstvo and city governments: public education is one of the most important subjects of local organs of self-government and enjoys their primary attention. The composition of the Union (which, at present, numbers up to 7,000 individuals) includes primarily the teachers of zemstvo and city schools.

Based on these considerations, the Union's [Central] Bureau recognized its duty to inform the zemstvos and city government about the measures that the union intends to adopt in the immediate future for the gradual elimination of barriers to the rational organization and success of public education.

1. One of the present obstacles to learning is the detailed regulation of this complex, living process, which is inextricably linked to the individual characteristics of the persons directly involved—teachers and pupils. Among the subjects regulated are the course plans as well as the textbooks and teachers' manuals, which are all exceedingly important. In these matters the teacher is deprived of all rights of initiative and choice; he must teach according to the official course plans and for instruction use books that have been approved by the Educational Committee of the Ministry of Public Education. Having recognized the necessity of realizing the right of free instruction, the Union will not pay heed to official course plans and [lists of] approved books; members of the Union will teach according to the plan they have freely chosen, following only the guidelines of rational pedagogy; they will use the educational materials that they find most suitable for their work. In those cases when, in the interests of the school, a certain planning and coordination in work is needed, this will be guided by the directives of local and nationwide teachers' assemblies and congresses. With the goal of facilitating the transfer of the union's members to the new order in education, the Central Bureau will soon prepare model course plans for elementary schools and will distribute lists of the best textbooks and teachers' manuals. To compile the plans and lists, the most competent people in education will be invited to participate. It will be left to local teachers' or-

ganizations to make a final adaptation of these plans to local conditions and to apply them in practice.

2. The restrictive catalogues [for book acquisitions] by public school libraries serves as an extremely serious obstacle to acquainting the people with the best works of literature and, at the same time, impedes the propagation of correct views among the people on the most important and most interesting questions. Members of the Union will not heed these catalogues; in selecting books and periodicals, they will pay attention only to the value of the works and the needs of the people.

3. Members of the Union will not tolerate the humiliating status of the teacher that results from his treatment by the [state] administrators and their subordinates. Nor will they carry out the demands of the educational administration, which bear purely official significance and are not justified by the interests of public education, properly understood.

4. Recognizing that the success of schools depends chiefly upon the personality of the teacher, the Union will make a particularly determined effort to improve pedagogical personnel—both in their general development and in their professional preparation. With this goal in view, the Union will endeavor to achieve the broadest possible development of contact among teachers, the dissemination of publications among them, the organization of lectures and courses, as well as the arrangement of assemblies and meetings. In addition, it will resist in every way the government's efforts to remove the best teachers from education and to use people who manifestly fail to satisfy the high standards of their calling.

By informing zemstvo assemblies of its first tactical steps, the national union of teachers permits itself to hope that the zemstvos, for their part, will render assistance in these measures. The support could be expressed: (1) by giving teachers the opportunity to order textbooks and library books at their own discretion; (2) by assisting in the organization of congresses, assemblies, lectures and seminars; (3) by permitting teachers to participate in meetings on the appointment, discharge and transfer of teachers, and also on other questions pertaining to public education; (4) by supporting and defending teachers in cases of persecution by the [state] administration.

Involving teachers in the administration of public education could be achieved: (1) by establishing special school commissions under

[zemstvo] boards (after the example of medical-hygiene commissions), which would include representatives from the teachers of a given district or city; (2) by establishing under these commissions general teachers' assemblies to decide the most important questions on public education and the condition of teachers; (3) by having the teachers elect representatives to the school commission and to the zemstvo assembly or city council [duma]; and, (4) by giving these representatives to the zemstvo assembly and city council the right to vote when reports on public education are under discussion.

This path of gradual emancipation of the school from the oppressive, bureaucratic yoke will doubtless evoke widespread repression of teachers and a whole wave of directives that they be discharged from their positions. The members of the Union are ready to go to the limit in such cases: they are determined to recognize only dismissal orders that emanate from the zemstvo or city government when the latter have established the schools and libraries. But this step would only be of real consequence if the zemstvo and cities meet the teachers' intention half-way and resolutely act as the full proprietors of the educational institutions and public libraries that they have opened.

The indescribably onerous, extremely confused condition in which our fatherland now finds itself, and the obvious inability of the existing government to comprehend and satisfy the people's demands (which have matured and ripened) and thereby to establish order and tranquility in the country—all this leaves no doubt about the necessity of society, on its own initiative, to set forth immediately on the path of freeing its homeland from the yoke of bureaucracy. For zemstvo and city governments, the time has come to show the country that they really deserve the trust and sympathy that they have enjoyed in such abundance from progressive Russian society. The Russian teacher, with profound interest and intense attention, will await a response to his present appeal. This reply will show him whether he can count on activists in the zemstvo and city [government], as upon friends and like-minded people in the struggle for freedom and enlightenment of the motherland.

91. Resolution of Pirogov Medical Society
25 February 1906

Of late, news has been arriving from all sides, with ever greater frequency, about brutal administrative persecution of people in auxiliary medical services, who have been arrested in droves and discharged from service at the order of local authorities. Sometimes they have been beaten and, very recently, exiled to remote parts of the Russian state. Among the peaceful public employees, these penalties have affected medical personnel on a particularly large scale, and the population has been thoughtlessly deprived of medical care and information, while families of the exiled have been placed in the most desperate condition. All this repression is directed at enemies, allegedly political criminals, without trial and investigation, on the basis of denunciations from petty police officials and black-hundredist elements. Several doctors have been arrested and put in prison for refusing to attend when a death sentence is carried out, or for protesting the arrest of sick people currently under medical care in a hospital, etc. The freedom of assembly and speech, proclaimed by the manifesto of 17 October, has served for the bureaucracy only as a means to remove "unreliable" elements from the population. What is one to call such conduct by those who have dared to turn the imperial manifesto into an instrument of blatant provocations? The Board of the Pirogov Society cannot find words that are strong enough to express adequately its feelings when it observes the positively outrageous brutalities (which are absolutely futile) transpiring before the eyes of all. On behalf of all Russian doctors, united under the banner bearing the name of Nikolai Ivanovich Pirogov, the Board of the Society openly expresses its adamant protest against the lawlessness committed under the mantle of emergency security measures. In the firm conviction that this regime of malice and vengeance, bearing the seeds of its destruction and degeneration within itself, cannot long survive, we send our fraternal greeting to all those people of the medical profession who have suffered from the arbitrariness of administrators.

92. Resolution of St. Petersburg Lawyers
February 1906

1. Executions by firing squads and other forms of capital punishment, now being applied by military courts-martial and so-called "penal expeditions," do not represent the punishment of the guilty, but crimes on the part of government organs.

2. The general assembly of lawyers entrusts to a specially elected commission the duty to collect materials on the murders, torture and destruction of property now being committed by state organs so that all these materials will later be presented to a court of freely chosen popular representatives. The following lawyers have been elected to the commission: A. I. Turchaninov, V. I. Liustikh, P. A. Potekhin, A. A. Dem'ianov, N. D. Sokolov, L. A. Bazunov, V. V. Berenshtom, V. I. Novikov, Prince L. N. Andronikov, and university instructor M. B. Gol'dberg.

93. Resolution of the Union of
Engineers and Technicians
13 May 1906

A general assembly of the Union of Engineers and Technicians welcomes the courageous reply that the State Duma gave to the bearers of arbitrariness and violence, and it joins the demand that the ministry of [I. L.] Goremykin, which has insolently trampled the people's rights underfoot, be replaced.

94. Tersk Engineering Society:
Statement to the Duma
24 May 1906

The Tersk Branch of the Russian Engineering Society examined the question of the industrial development in our country and came to the conclusion that this requires, above all, a market for the sale of production. This market depends upon the purchasing power of the

population; however, the purchasing power of the population in Russia is at an exceedingly low level. The people are exhausted and enervated by taxation and the government's misguided policies. The peasantry does not have enough land, earns no profit for its work, and has been reduced to penury.

The first, fundamental measure needed for the development of industry is an improvement in the economic well-being of the population.

In this respect, the first task is to grant supplementary land to land-hungry peasants and to improve the position of the working class.

The Tersk Branch of the Engineering Society places its hopes on the State Duma, which is presently occupied with agrarian reform and other draft legislation for the reorganization of Russian life.

The Tersk Branch of the Engineering Society protests the refusal of the Council of Ministers to realize the wishes of the people's representatives and deems it necessary to confer executive power on new ministers who enjoy the confidence of the State Duma.

95. Resolution of National Engineers' Union
April 1906

Taking into account: (a) that a fundamental reform of the state system (for which the entire country has fought for a whole year) cannot be achieved by the State Duma that has assembled, (b) that the State Duma, given its composition and competence, cannot be called a truly popular representative organ; and (c) that the attainment of political freedom and realization of labor and agrarian reform can be the business only of a constituent assembly, which embodies all the fullness of constituent, legislative, judicial and executive power—the union insists upon the basic demands of its political platform: (1) convocation of a constituent assembly on the basis of a universal, equal, direct and secret electoral law; and, as a precondition for the preceding: (2) immediate political and religious amnesty; (3) elimination of martial law and emergency security measures; (4) establishment of freedom of assembly, union, strikes, and real freedom of press and speech.

E. URBAN SOCIETY
Manufacturers, Merchants, Townsmen

The accelerated pace of urbanization and industrialization in post-reform Russia had a profound impact upon urban society—its size, structure, power and group cohesion. The increase in urban population, though offset by rapid growth in the countryside, was nontheless enormous: despite legal, economic and public health barriers, large numbers poured each year into the city in search of food or fortune. Growth also brought complexity, with blurred distinctions between some old juridical groups, sharper differentiation among specific occupational categories, and the emergence of entirely new social strata. And all these changes unfolded against a background of intense politicization, which had a particularly profound effect upon the more compact, more literate urban society. Hence social change in urban Russia was accompanied by rising self-consciousness and organizational cohesiveness of various groups—first among elites, later amidst the revolutionary turmoil of 1905–07, among the lower urban groups as well.

The following documents provide some insight into the complex, diverse world of the city—elite and artisan, conservative and radical, that rose to stand against bureaucracy and each other in the heat of revolution. The commercial-industrial elite, once avowedly apolitical, became progressively involved in state industrializing politics and by the end of the century had already acquired considerable political experience and formal organization. But it was the revolution of 1905 that propelled the *haute bourgeoisie* to participate in politics and become self-consciously independent in order to defend themselves and their property against rampaging workers, spineless bureaucrats, plundering peasants, and unsympathetic nobles (docs. 96–99). It is important, too, to note that even as the commercial elites attempted to mobilize on a national level, they found the task

difficult, not only because of their relatively small size (the factor traditionally emphasized), but also because of the profound internal differences—economic, cultural, and regional (doc. 100). Still more complex were the lower urban strata that once comprised the "towns-people" [*meshchanstvo*], now a diverse group of small merchants, business employees and artisans. Politically, the petty townspeople proved astonishingly protean, capable of liberationist (doc. 101) and black-hundredist sentiment (docs. 102–4). Perhaps least accessible in documentation are the petty shopkeepers and traders, above all because these independent businessmen rarely coalesced into local, much less national, organizations to articulate their collective inter-ests. But this large, unformed mass of petty townsmen tended to be conservative, not only because of putative monarchist and schismatic sentiments, but also because of their vulnerability to the physical de-struction of crowds and armies and because they had to combat organizing efforts by their own employees—clerks, assistants, appren-tices and the like (docs. 105–6). The artisan population, that inter-stitial group somewhere between (or overlapping with) petty shop-keepers and factory workers, had by no means disappeared from the city—even a metropolis like Moscow had a large artisan popula-tion. At the upper end of this group were the masters, whose atti-tudes were probably best expressed in the program of the artisan in-terest-group "party" formed in the wake of the October Manifesto (docs. 108–9); yet polarized against them were their apprentices and journeymen whose liberationist sentiments found easy expression in the general effort to organize, not just mobilize, society in the revolution of 1905–7 (docs. 108–9). More liberationist and broadly cast were the semi-professional white-collar employees of businesses—accountants, clerical personnel and the like—who served in larger firms and, at least when acting within formal organizations, tended to support the liberal professions with whom they most easily identi-fied (docs. 110–12). To add to the complexity of it all, it is essen-tial to remember the close nexus between town and country, to note that many artisans were semi-rural, and to pay heed to their demand that reform must not merely help the peasant, but address their needs too (docs. 113–14).

96. *Memorandum of Moscow Stock*
Market Committee to S. Iu. Witte
[Chairman of the Council of Ministers]
January 1906

The fact that the question of reconstituting the State Council is under examination, and that a correct proportion of representation of the essential pillars of the country's material and spiritual life is so important—all this emboldens the Moscow Stock-Market Committee to present Your Excellency its views on the representation of trade and commerce. These opinions pertain to the tentative number of members to be selected by industry and commerce as well as the very procedure for their selection.

With respect to the number of people elected from commerce and industry, it must be pointed out that the number proposed (twelve) is absolutely inappropriate, considering the number of representatives from the zemstvo (at least fifty) and nobility (at least eighteen). Agriculture, industry and commerce constitute the foundations of the material life of the state. The faith (represented by electors from the Holy Synod) and science (represented by delegates from the Academy of Sciences and universities) constitute the foundations of spiritual and cultural life of the country; these are equally precious to everyone, and all members of the future State Council will be equally interested in them. Hence the appointment of such members in a smaller proportion, compared with the representatives of the material interests of the country, does not appear to contradict the adopted system.

Representation from the zemstvo and nobility (the latter is the sole estate which enjoys this new high privilege) may be regarded as either the representation of agriculture and landowners, or as the representation of local organs of self-government. In both cases, industry and commerce cannot, unfortunately, count on a proper, dispassionate attitude on the part of representatives from the zemstvo and nobility. According to established notions (which are absolutely unfounded, but which nevertheless cannot be ignored, especially when the supreme legislative organ of the country is being established), the interests of agriculture are deemed antithetical to those

of trade and industry. The successful development of the latter, unfortunately, is attributed to the decline and lack of prosperity in our agriculture. Hence, among the representatives of agriculture and landholding, trade and industry risks encountering an attitude that is not only unsympathetic or biased, but positively hostile.

In its capacity as organs of local self-administration, the zemstvo regards trade and industry as alien elements, as a source of great taxes to satisfy the needs and demands of other classes in the population. The zemstvo does nothing for trade and industry, not even to satisfy its smallest needs. All that must be borne in mind, given the fifty votes of the zemstvo and the eighteen of the nobility—a total of sixty-eight—compared to the twelve of trade and industry.

The insufficiency of a total of 12 members (six for industry, six for commerce) is also evident from the following consideration. Representation of industry and trade in the State Council derives from the need for the highest legislative body to have an element that knows the conditions of the various industrial branches in Russia as well as conditions in different territorial regions. Given the great number of industrial branches and the immense breadth of our state, it is simply impossible for six representatives to satisfy this need: it is impossible to find people who would personally combine the knowledge of conditions in numerous branches and, simultaneously, would know the industrial requirements of the Far East, Siberia, Central Asia, central Russia and the Caucasus. For the future conscious work of the State Council, however, knowledge of local conditions and life should possess great significance for very many questions.

Moreover, it is impossible to disregard the following consideration. State Council members from industry and trade should be people who, in their own life and experience, have participated in these areas of activity. It is therefore necessary to enable them, after their election to the State Council, to continue their work and not sunder their ties with their local area and life. As a result, one should expect rather frequent absences of such people from St. Petersburg. Under these conditions, the presence of a full set of six representatives from industry and six from commerce at sessions of the State Council will be far from frequent.

All the above considerations show the need to increase the number of representatives from industry and trade in the State Council.

Regarding the electoral system, it is impossible, above all, to ignore the extreme danger of conferring such elections on an all-Russian congress of representatives from consultative associations in trade and industry. Given the vast size of our state and the extreme diversity of activity of various regions, one cannot assume that those representatives coming to the congress could know representatives from other regions sufficiently well to hold conscious elections. Apart from the accidental character of such elections, one cannot disregard the possibility that the representatives of the main industrial and commercial regions will fail altogether to be included among those elected as representatives.

The election of members to the State Council should be conferred on local consultative institutions in trade and industry, both for the above considerations and for the reason that in the State Council it is precisely knowledge and comparison of local conditions and needs that will be of primary significance in determining how useful the proposed state institutions are for the country. In terms of homogeneity in type of activity and the similarity in local conditions and interests, Russia could be divided into regions; and congresses of consultative institutions for trade and industry, or conferences of stock-market committees and manufacturing councils could be convoked in these regions to elect one representative each from industry and trade (depending on their knowledge) from each region. A definition of regions that takes into account the character of activity and similarity of local conditions and interests might establish twelve regions (per an attached schema [omitted here]). Each region should send one member each from industry and from commerce to the State Council. The regions of Moscow and St. Petersburg, given their special significance, scope and diversity, should have more representatives.

According to the planned number of State Council members, it would be correct to designate no less than thirty people from industry and trade. And their election should be conducted by regions so that each has the chance to explain local needs and peculiarities to the State Council.

97. Telegram from Mining
Company Congress to S. Iu. Witte
(Chairman of the Council of Ministers)
16 February 1906

For the second year now, the mining industry in south Russia has experienced acute difficulty in supplying the market with its production, especially with mineral fuel and metals. No radical measures have been taken to assure proper organization in railway deliveries. The Council of the Congress has continually sent reports to the central government about this lamentable state of rail transport and has pointed out all the calamitous consequences that this entails for so important a sphere of the national economy. At present, an enormous shortage of railway cars and locomotives has developed throughout the entire rail network; in addition, the majority of available locomotives have broken down and are unfit for service. Nevertheless, all the Russian locomotive factories have fewer orders for the construction of cars and locomotives than last year. And this occurs at the very time when, given the enormous demands of the railway network for rolling stock, one would expect just the opposite—i.e., that these plants would be mobilized for intensive operation. At a meeting of the representatives of railway car and locomotive factories in St. Petersburg on 6–7 February, it was revealed that the locomotive plants together could easily produce 36,000 cars this year, but that they have orders for the production of only 7,500 cars. Last year, locomotive plants produced 1,250 locomotives under the most adverse conditions; this year, however, they have orders to produce only 650 locomotives. The repair and overhaul of locomotives which have been given to plants cannot be completed before 1907 (when they will be modified to handle this work). The shortage of locomotives and railway cars has caused not only the extractive industries, but all branches of industry to suffer, and the resulting economic losses are incomparably greater than those expenditures that the government would make for the order of cars and locomotives. Such outlays would be completely productive and pay for themselves by stimulating trade and industry.

In a personal interview, Your Excellency deigned to reply that

you do not find it possible to expend state monies without [the consent of] the State Duma. While fully cognizant of the importance of this motive, the Council of the Congress nevertheless must voice its fear that delays in the construction of the cars and locomotives will injure all branches of industry and the railways themselves. Russian markets are experiencing an acute need for primary products like fuel, metal, salt, and grain, which—despite large reserves—cannot be delivered to the market.

In view of the above, the Council of the Congress most respectfully asks Your Excellency to have the Council of Ministers consider the question of placing orders for railway cars and locomotives for the entire year at the plants' full productive capacity. Then it would be possible, at least by autumn, to ensure the rail delivery of the above primary products.

98. Petition from Kolomna Factory Managers to the Chairman of the Duma 7 June 1906

We, the undersigned, hold the authority of directors at the Fedor Shcherbakov & Sons Manufacturing Co., which owns 2,624 dessiatines of arable land and forest near the villages of Aleshkov, Tarbushev, Rechitsy, Stoian'ev and Khakhlev (Kolomna District, Moscow Province). We are in full agreement with the compulsory alienation of whatever part of this property is needed by the peasants of these villages (on terms to be set by the State Duma and sanctioned by law). At the same time, we permit ourselves to ask you, as a representative of the State Duma (an institution which enjoys unquestioned moral prestige in the eyes of the population) to address an appropriate explanation to the peasant communities in the above villages. It should explain what manner of action (from the perspective of state interests) is desired from the peasant population regarding private land allotments until the agrarian question has been conclusively resolved in a legal manner.

The point is that, after more than forty years of peaceful coexistence with the peasants of the villages listed above, in December of last year the Rechitsy community began, without authorization, to

take timber from company woods. Since then, despite the fact that the factory has taken no hostile actions against the illegal timbering, the peasants have caused ceaseless difficulties, even threatening to seize the fields that the company had planted. But this land incontestably belongs to the factory (on the basis of deeds), has been surveyed in the presence of the peasants, and put in the company's name. Seeing no end to the peasants' encroachments and wishing first to use all peaceful means to protect the company's proprietary rights until the land question has been resolved in a legal manner, we permit ourselves to address the above request, through your person, to the State Duma.

99. Charter of the Society of Manufacturers
June 1906

GOAL OF ESTABLISHING THE SOCIETY, ITS RIGHTS AND OBLIGATIONS

1. A society called "Society of Manufacturers" is established for [the following purposes]: study, development and defense of the interests of industry; study and improvement of labor conditions; and study of the conditions and development of product marketing.

2. The Society exercises all the rights of a juridical entity, i.e., the right to acquire, mortgage, accept immovable property as collateral, form capital, conclude any kind of contract, defend its interests in court, enter into contract with other societies, etc.

3. In addition, the Society has the right: (a) to take measures, through amicable agreement or arbitration, to eliminate misunderstandings that arise with respect to terms negotiated between employers and employees; (b) to establish arbitration offices; (c) to prepare standard wages and other labor conditions for various industrial branches and to promote their implementation; (d) to petition the government for the promulgation of new laws or the modification of existing ones that pertain to industry in general or to particular industrial branches; (e) to select from its midst representatives for government and public bodies as well as arbitration offices; to select experts to give advice on the proposals of governmental, public or judicial bodies; (f) to establish a treasury appropriate to the goals of the Society; (g) to distribute assistance and provide support to

members in the event of strikes or for any other reason; (h) to estab-
lish and organize libraries, general and professional schools, courses,
public lectures, meetings, lectures (with and without charges for ad-
mission) on its own authority; (i) to establish and open filials and
branches of the society; (j) to arrange congresses and to organize
exhibitions and competitions; (k) to publish newspapers and bro-
chures; (1) to open bureaux to locate work and laborers; (m) to
open consultative bureaux to give advice on all questions pertinent
to a given branch of industry and to provide legal counsel for its
members; (n) to make it possible to acquire basic necessities and
producer goods on favorable terms.

4. The Society has the right to impose upon its members fines,
penalties and other payments and to demand a security deposit (in
the form of bills of exchange or monetary sums) to ensure imple-
mentation of obligations that have been assumed.

[Approved 5 September 1906 by the St. Petersburg City Commis-
sion on Public Societies.]

100. Declaration of 26 Moscow Companies
to the Trade and Industrial Congress
26 January 1906

While fully sympathetic with the basic idea of the need to create an
organization to represent commerce and industry in Russia, the
undersigned are nevertheless obliged to take a completely negative
position toward the draft proposal to create a union of commercial
and industrial enterprises of the Russian Empire. We find that im-
plementation of this proposal will not benefit but will inflict clear
harm on the proper organization of this cause.

The draft for a union of industrial and commercial enterprises of
the Russian Empire that has been presented for discussion at the
congress proposes to establish an excessively cumbersome and com-
plex apparatus. In many respects, its character is quite similar to the
numerous unions that were formed after 17 October 1905.

It proposes to divide commercial and industrial enterprises of the
Russian Empire into five groups and each group into sections. The
sections, which range from two to sixteen per group, make a total of

twenty-nine sections, and these in turn will doubtless be subdivided into smaller sub-sections. Examination and discussion of each question in a subsection will only be possible by convoking national congresses of subsections; to resolve a question in a section and group, it would be necessary to convoke a whole series of national congresses of subsections and sections for their unification into groups.

The Union is to be headed by a council and executive committee. The council would consist of a chairman, three deputy chairmen, and the chairmen of the sectional committees. The executive committee is to consist of the chairman of the council, three deputies and eight delegates from the Union's council. The council, executive committee and section committees are permanently located in St. Petersburg; since the council includes nonresidents of Petersburg, it can assemble only by convoking each time a congress from all corners of Russia.

These institutions are given not only executive functions, but also extremely broad powers. Thus the council, according to paragraph 28, is given the right of independently submitting petitions and appeals; the executive committee is given representation in governmental and public organizations and autonomous activity to develop local organizations on industry, trade and even labor. In essence, organizations are being created with power not the least inferior to that of ministries. Just how far such an organization corresponds to the interests of trade and industry will be clear if one considers, on the one hand, the expanse of our fatherland and diversity of conditions in various regions and, on the other hand, the complexity and cumbersomeness of this organization's mechanism. . . .

It is hardly necessary to demonstrate that, under such an organization, things will in practice come to be resolved not even by sectional committees or the Union's council, but chiefly by the executive committee, whose establishment will in essence decide the fate of Russian trade and industry.

All Russia should be divided into regions, based upon similarity of conditions and character of activity. Taking into account local conditions and peculiarities, there are thirteen such regions: (1) the northern or St. Petersburg region; (2) the central or Moscow region, including the provinces of Moscow, Vladimir, Tver, Iaroslavl, Kostroma; (3) the Volga region, including the entire course of the Volga from Rybinsk to Astrakhan; (4) the Khar'kov region; (5) the Kiev

region; (6) the Baltic region; (7) the Polish or Warsaw region; (8) the Black-Sea region; (9) the Ural region; (10) the Caucasus region; (11) the Central Asian region; (12) Eastern Siberia, including the Amur region; (13) Western Siberia, including the steppe area.

In all these regions, chambers of trade and industry should be established, uniting all the interests of trade and industry in a particular region. They should be given the right to make representations in defense of that region's interests. To examine questions that affect the interests of all Russian industry and trade, representatives of the [regional] chambers of trade and industry should be convoked. To convoke these congresses and to implement their resolutions, a bureau of congresses (with exclusively executive functions) should be created.

101. Resolution of Vologda City Council to the State Duma 28 April 1906

The Vologda City Council nourishes the firm conviction that the people's representatives will not abandon their work for a tormented, tearful and bleeding Russia until they have put an end to the shameful remnants of the previous political regime and until they have prepared the conditions for the convocation of a truly popular representative body.

To do that, the State Duma is obliged: (1) above all, to demand immediately a complete amnesty for all citizens (without any exceptions) who have suffered for their political and religious convictions and behavior; (2) to establish a parliamentary investigation of the criminal activities of the government against popular freedom; (3) to secure the elementary rights of man and citizen, i.e., freedom of speech, press, conscience, and also assembly, unions, strikes and inviolability of person and home; (4) to abolish immediately capital punishment and extraordinary courts, and everywhere abrogate martial law and emergency security measures; (5) to take, without delay, the first steps toward a just resolution of the peasant and workers' question; (6) to proclaim the necessity of convoking soon a constituent assembly based on universal, equal, direct and secret

franchise; (7) to choose a provisional ministry from the parliamentary majority until the constituent assembly can be convoked.

The Vologda City Council sees no alternative to the realization of these measures. Only by following this path can the State Duma fulfill its duty honorably before the fatherland and find enthusiastic, active support among the broad masses of the population. The Vologda City Council sends a greeting to the first representatives of the people and wishes them success in solving the tasks placed before the country. Long live political freedom! Long live universal, direct, equal and secret franchise! Long live the constituent assembly!

102. Telegram from Saratov Townsmen to the Synod 15 November 1905

We protest the delirious activity against the [general] turmoil, which has been created by the anarchy in Petersburg itself. The government announced on 17 October that no law will come to pass without the Duma, but on 3 November it issued a decree on proclamations, with the demand that the government implement [this] in several days. This is anarchy. Issue an order to assemble tomorrow in churches and to organize the election of 10 persons; [this] parish council is to assume administrative [and] police power in the parishes. Only the parishes can save Rus' [archaism for old Russia]. Only the Church, liberated from bondage [to the state], will unify Rus'. Only an organized people can stop the anarchy from above and from below.

[Signed:] An assembly of Saratov parishioners.

103. Telegram from Moscow Shopkeepers to Nicholas II April 1906

Batiushka, our Tsar! We read your precious words to the deputies to be concerned about the peasants, but the first speech in the Duma, by [the Kadet, Ivan] Petrunkevich, proposed to release from prison

all the conspirators, destroyers of the Russian Tsardom. We simple peasant shopkeepers think that Your Tsarist heart must grieve that the wrong people were elected to come to You from your loyal people. Take heart, our Batiushka, and trust in Your loyal peasantry. We all cannot live without You, Autocratic and Unlimited Tsar; we do not want any kind of constitution. The Tsardom is Yours; we are Yours; we believe You, not them.

[Signed:] From a group of peasant shopkeepers, Okhotinskii Riad, in Moscow.

104. Telegram from Kishinev City Council to S. Iu. Witte 25 January 1906

The group of undersigned members of the Kishinev City Council, fulfilling the wish of thousands of citizens and voters, appeal to Your Excellency with the following request.

The question has been raised in many cities of western Russia about the need to give Jews the right for the separate election of their own representatives to the State Duma, thereby isolating them from participation in joint elections with the Russian population. This need derives from a host of practical difficulties which amidst the preparation of the draft proposal for elections to the State Duma only now became acutely evident—after the preparatory work for the elections. Not to mention the fact that the general principle (applied to other nationalities) gives them the right to elect their representatives to the State Duma separately, it is above all more vital to note the special conditions in which the Jews find themselves; the difference between the Jewish and Christian populations would unduly increase tensions in the election campaign, making both sides still more irreconcilable. At the same time, it would deprive Russian inhabitants in the city the right to have their own representatives in the Duma. In addition, the Jews, a most mobile element, which changes its residence frequently, would so complicate and slow verification of their rights that electoral districts will be exhausted by the overwhelming work and by recognition of its futility, because there will undoubtedly be many who have themselves illegally placed on the

voting lists. But this will provoke protests, complications and long delays in convoking the State Duma. Giving Jews the right to elect several members of the Duma separately (which could easily be effected by an assembly of Jewish electors in one of the cities), would simultaneously simplify matters and resolve this electoral task in all the cities of Western Russia, thereby precluding unavoidable conflicts and animosities from both sides.

[Signed by the mayor and 19 members of the city council.]

105. *Proclamation of Petersburg Shopclerks May 1906*

Comrade Shopclerks, Butchers and Vegetable Salesmen on Vasil'ev Island!

We firmly resolve, beginning with Whitsunday (21 May), to put an end to all violations of Sunday and holiday vacations for our corporation [*korporatsiia*]: beginning 21 May, none of us is to conduct further business on Sundays or holidays. We will neither do business ourselves nor permit others to violate our holiday rest. We have forced people to observe the holiday not only in the markets but also on the streets. Henceforth not a single butcher or vegetable store, not even the most insignificant stand, is to do business on Sunday or holidays, because every violation of holiday rest, even by the most insignificant trade, threatens the security of holiday vacations for the entire corporation.

Comrades! Almost all of you signed our resolution not to go to work on Sundays or holidays, effective 21 May. Remember, your honor demands that you carry out your sacred promise! If any of your comrades did not sign our decision, he should join us in the name of our general solidarity as shopclerks. The duty of each is to carry out our resolution—with all his energy, without retreating, no matter what the consequences, no matter what the personal sacrifices.

Comrades! If any of you do not feel personally strong enough to resist the will of the storekeeper, then just ask your comrades to come and to remove you from your work the first time. The next time it will be easier for you yourself to resist the proprietor's efforts

to violate our holiday. After May 21st, we will regard as a traitor any shopclerk at a butcher's shop or vegetable store on Vasil'ev Island who does not observe the holiday rest.

The proprietors had better avoid opening their shops on May 21st. The most decisive measures will be taken against those who do business in their meat or vegetable shops.

Those Petersburg butchers and vegetable clerks who already enjoy full holiday rest should help us on Vasil'ev Island to extend full holiday rest to the entire meat and vegetable business on Vasil'ev Island. We summon our comrades who sell meat and vegetables throughout Petersburg to come the Sundays after May 21st to Vasil'ev Island in order to help us. It is important to force proprietors not to engage in trade two or three consecutive holidays, and then the final establishment of our holiday rest will be achieved.

Comrades! We are making a unified effort to obtain holiday rest for those who sell meat and vegetables on Vasil'ev Island. All Petersburg will follow the example of Vasil'ev Island. And then full Sunday and holiday rest will be established for all meat and vegetable vendors.

[Signed:] A Group of Shopclerks, Butchers, and Vegetable Salesmen on Vasil'ev Island.

Long live full holiday and Sunday rest!

106. Appeal to Shopclerks in Pskov
May 1906

Comrade Shopclerks!

We, the shopclerks of Pskov, lag considerably behind our comrades in other towns in our development. And our backwardness and lack of unity lies like a heavy burden upon us. We work virtually from dawn to dusk; we are treated shabbily by our employers; and for all of our hellish work and for all the employers' harassment, we receive only a pittance as wages. We must organize ourselves into a union, into a close-knit, friendly family. Once united, we will represent a force that will give us the opportunity to attain a better share.

Comrades! Do not delay, respond to our appeal! Let our cry reach your hearing and not remain a voice crying in the wilderness. Com-

rades, before you is a broad, smooth, and bright road to a better future. So don't delay, organize yourselves into a professional union.

[Signed:] A group of shopclerks.

107. Program of the Artisan Party
8 February 1906

ESSENCE OF THE PARTY

The centuries-old stagnation in the development of Russian political forms has evoked total disorder in the sphere of political, social and economic questions, threatening thereby the very existence of Russia. The manifesto of 17 October, together with the law of 6 August, confers the basic elements of a legal order, involving the peoples and entire society in state construction. It is essential that all who oppose stagnation and revolution unite in active work to create a strong, authoritative power with the assistance of the people; it alone can lead the country out of social chaos, after attaining Russia's unity, internal peace, and external security; and it alone can promote handicrafts and industry—the main source of popular prosperity.

PROGRAM OF THE ARTISAN PARTY

1. On state rule: constitutional monarchy in accordance with the manifesto of 17 October as an immutable principle, so that no law may take effect without the approval of the State Duma.

2. On borderland and national questions: unity and indivisibility of Russia.

3. On the State Duma: immediate (at its first session) conferral of the Duma's right to legislative initiative and final authority, with inclusion of this right in the Fundamental Laws of the Empire, and also the right to supervise the executive authority and the right to confirm the entire state budget.

4. On franchise and civil rights: right of universal suffrage, except for those without a fixed residence, and explanation of the rights granted by the manifesto of 17 October through special laws.

5. On the agrarian question and peasant resettlement: free transfer of communal lands to household ownership; an increase in the

land territory at the expense of unoccupied state lands (with the goal of expanding petty, single household and cooperative farms through land credits from the institution of the Peasant Bank); assistance for colonization and resettlement.

6. On the labor question: obligatory insurance of workers and artisans at state expense; the workday in artisans' shops must not exceed ten hours; assistance to develop artisan production.

7. On the financial and economic question: development of direct taxation based on income; protective tariff; patronage of artisan trades; easier credit for artisans (including peasants); amelioration of the business tax on artisans.

8. On education: it is necessary to teach the youth in a lively and heartfelt way, to arouse their love for the fatherland, the Tsar, other people, and to develop a feeling of national pride. Rural schools should provide information about agriculture, handicrafts and small-scale artisan business. Free, obligatory and universal education of children and the establishment of artisan technical-practical schools and museums at the expense of the state [are likewise needed].

9. On religion: the Orthodox Church [should be established] on the electoral principle of Church Councils.

10. On justice: establishment of an elected artisan court from proprietors and apprentices; preservation of artisan self-rule and guilds.

11. On military affairs: complete reorganization of the army and navy.

108. Proclamation of the Union of Plumbers' Apprentices January 1906

Comrade Plumbers!

Your condition is unbearably onerous. Your wages, compared to the inflation in prices, are so insignificant that every worker is doomed to slow death by starvation. But sometimes you also have to support a family—young children, aged parents, and sometimes your unemployed brother or sister. You work in stifling, disgustingly filthy shops, in stinking manholes, underground and in water, out in the

frost (where your feet even freeze in your boots)—wherever there are dirty, harmful places, where your weak strength is quickly drained and you are overcome by every kind of disease, which quickly carries you to a premature death. But even this meager crust of bread that you earn through such onerous, bloody toil is not secure: the slightest caprice of the proprietor or foreman—and you workers are mercilessly thrown into the street, into famine, into the cold, in penury. . . . [sic] There is nothing to be said about insults of every kind that you workers silently endure from mad, drunken and ignorant proprietors. After all, they regard you, defenseless and disunified, worse than any proprietor looks upon the livestock that bring him a profit. All year round they take care of their dogs and give them food and drink. But they do not do the same for you, comrades. When they need to drink your blood, then they butter you up; when they're fat because of your work, they treat you insolently and throw you out at the first opportunity. Comrades, you are forced to endure all this—oppressed by extreme want and miserable life—because of discord and disunity. But there is a way out of this terrible condition. Though powerless as individuals, you can make yourself into a great power by joining together in a union of plumber-workers. This union sets as its goal the organization and defense of the proletariat in order to form a unified family of workers, aimed at one and the same goal: the pursuit, for each Russian worker, of the rights of man and citizen, and a striving for final victory of living human labor over a soulless capitalism. Hurry, comrades, respond to our fervent appeal, and come forth in fraternal unity as victors in the struggle for a brighter future. Victory is ours!

109. Proclamation of the Bakers' Union
March 1906

Comrades! Bakers of rolls, candy, pretzels, bread loaves, and white bread! You know that our condition is outrageous, that we are the proletariat of the proletariat! Where else do people work eighteen to twenty hours a day? Nowhere; only we do. Where else are holidays unknown? Nowhere; only among us. We know neither Easter, nor Christmas, nor New Year's Day.

Where else do people sleep just three to four hours a day? Where do people sleep in crowded, filthy housing? Where do they sleep in shifts, with no time for the cots even to cool off? Here, among us bakers.

Petersburg society does not know that, in the basement under the floor of beautiful pastry shops and attractive bread stores, truly penal labor is going on—and who is it that is working there? We are dispersed among numerous small enterprises in Petersburg and deprived of any interaction. Now we have formed a union and organized it to struggle for our human existence and to develop among us comradely unity, mutual assistance and solidarity.

Now they have banned our meetings, and it is difficult for us to come together. Therefore, we members of the board announce that the union does exist and that, despite the oppression, it has expanded its activity. The auditing commission found our financial and other affairs fully in order, and all the false rumors disseminated by black-hundredists denigrating the union are patently false. They exploit them to get our meetings banned.

Comrades! You know what a terrible and slavish life is ours. Our only strength lies in unity. Those who have not yet signed up with the union, do so now! Spread the news of our union among all our comrades. All should join the common cause. There should not remain a single bakery or pastry-shop where workers have not yet joined our union.

The union has office hours daily from 2 to 5 and from 8 to 9:30 in the evening. Kazak Street, No. 9 (Apt. 25).

Governing Board of the Union.

110. Proclamation of the Petersburg Union of Office-Workers January 1906

Comrade Office-Workers!

The number of unemployed office-workers increases with each passing day. To ignore their needs would contradict the goals of our union. We must assist them in finding work. Therefore, we appeal to you and request that you inform the "Commission for the Unem-

ployed of the Union of Office-Workers and Bookkeepers" and as early as possible:

1. About any anticipated or existing vacancies, with detailed job descriptions.

2. About any temporary work—bookkeeping, accounting, copying (calligraphy and typing), translations from all languages, etc.

Comrades! By assisting, you can render a valuable service to our needy comrades, something each of us understands.

We request that you send your recommendations, etc. to the following address: Commission for the Unemployed of the Union of Office-Workers and Bookkeepers, 23 Zagorodnyi Prospekt, Apt. 1.

111. Proclamation of the Moscow Union of Office-Workers January 1906

The immediate economic goals toward which our Union strives are the following:

1. Complete rest on [recognized] holidays.

2. An eight-hour workday.

3. State insurance of commercial-industrial employees in the event of illness, disability and death.

4. Hereafter and until the introduction of state insurance, the Union will organize a fund for mutual aid in event of illness, disability and death. This fund can afterwards be merged with the state insurance fund.

5. For all employees (both sexes) in commercial-industrial enterprises, warehouses and offices: introduction of salary books, indicating position, amount of salary and times for payment, and also the working hours and times set for lunch.

6. The right of employees to receive salary in the event of prolonged illness.

7. Establishment of a permanent commission from an equal number of people elected from the employees and proprietors to settle misunderstandings between the two parties.

8. Obligatory, annual vacation for one month at full pay.

9. Hereafter (until introduction of state insurance) require the

proprietors, whenever an aged employee retires or dies, to issue a payment equal to one month's pay for each year of employment.

10. When an employee is discharged, he is to receive one month's warning and support for three months.

11. Organization of a corporation of office-workers and book-keepers after the model of the lawyers' corporation. This demand is provoked by the existence of the Commercial Statute (articles 18, 19ff.), which make the bookkeepers responsible, along with the proprietors, for the conduct of the business. To impose this responsibility upon bookkeepers, who are dependent upon the proprietors, is exceedingly unfair. Until the bookkeepers become members of an independent corporation, this article will hang like a Damocles' sword over their heads. Recognizing the full significance of this demand, the initiators have therefore founded a special union of office-workers and bookkeepers and have not joined the existing union of commercial-industrial employees. We completely share the idea that each branch of industry has, apart from demands common to all branches, its own specialized demands, which can never be taken into consideration, in sufficient degree, in a general mixed [organization] ([see] A. Bebel, *Professional Unions*, p. 31).

112. Telegram from 51 Moscow Bank and Commercial Employees to Chairman of the Duma June 1906

We ask that you inform the State Duma of our solidarity with its resolutions, that we are ready to support it and to join the demands of all Russia: "Down with the death penalty" and "Down with the present ministers." [Signed by 51 bank and commercial employees.]

113. Petition from Townsmen in Zhizdra (Kaluga Province) to the Duma June 1906

After following the activity of the Duma through the newspapers, we townsmen of Zhizdra have become profoundly depressed, for up to

now the Duma has not even thought of us: it has not uttered a single word about the estate of townspeople, which is composed of many millions. What unfortunate people we are! It is as though we were not part of the Russian Empire. From the very start of the sessions and thereafter, the Duma has been occupied exclusively with the living conditions of peasants—and for that matter Jews. True, it is necessary to be concerned about peasants; that question has long since been critical and in need of attention. But even if one is concerned about this question, there is no need to forget others. After all, the townspeople numerically comprise the second largest estate in the empire. Deign to look at our condition. Quite apart from the poll-tax and every other kind of obligation, who serves Russia through the military duty more than peasants and townspeople? One has to ask why we townspeople unquestioningly bear all the state and other obligations, and what guarantees our material condition? Trade in Rus' [archaic term for Russia] has almost entirely fallen into the hands of the Jews; we are not permitted to engage in agriculture, though it must be noted that almost every town has townspeople's plots rented to outsiders. What kind of order is that? Part of the city's land rightfully belongs to us townspeople; hence we should use it gratis; but that is not the way it is. If we should take it into our heads to work our own land, we have to lease it at auction—at market prices and on the same terms as any other buyer.

Nor is the condition of townspeople dwelling in villages and hamlets any better. Each townsman's condition depends upon the landowners; here the townsman is a slave to his master; the price for the plot depends completely upon the caprice of the owner—he takes as much as he likes. The townsman is always bowing and scraping before him, and must forever pay respect to the master who rents him land; if he does not "snap to attention" the way the owner expects, he is lost. God help him if he should actually cause the owner the slightest unpleasantness: you can rest assured, townsman, that a great misfortune awaits you—he'll not only double, but triple the price of the land. And it sometimes happens that the owner pronounces a death sentence, ordering that the townsman's hut be hauled off the land and the plot completely cleared. But just where is he supposed to move it? The only thing the townsman has left now is the air! Indeed, in the event you live on your own household plot and earn only enough to buy bread (you have nothing else), you

cannot even set up a household with the most basic necessities, such as a cow. Right away every peasant will harass you about this cow: "You're pasturing this cow on our land, it likes to butt, and has battered all our cows." How much does the cow cost in the summer? You have to pay the peasant commune three rubles for a "yeller" [as shepherd]; don't forget, or else (even if you will [later] pay the peasant community and shepherd), they won't make it part of the herd. Living like this, the townsman (if he engages in trade) at the same time must "choose" the right to engage in trade—that is, he must pay supplementary sums to the state, must pay the zemstvo from each ruble of profit, and then must pay the urban community of his [home] town, or [it will say:] "you, townsman of such-and-such a town, having the right to use the air and water all across mother Russia, have not paid your dues—so you'll get no passport [from us]." Although the townsman pays far larger dues each year to the zemstvo than does the peasant, he does not have the right to educate his children for free in the village where he resides, but must first pay the community what it demands for tuition. A townsman should not become overjoyed if his trade goes the least bit well: in this case the zemstvo will assess such an arbitrary tax that he'll barely be able to move and groan, but at the same time he knows that there is no way to appeal against the zemstvo, that he must pay whatever it demands. Oh, poor townsman! Anyone who can nibble at you will do it! Without taking into comparison those who live well in Rus', let us see who lives better—the peasant or the townsman. The peasant in our district pays 10 rubles in taxes and, if the harvest is good, he is a happy person: he has his own bread and firewood, fodder for his livestock, and lives (as they say) "in his own cocoon"—that is, he has his own land. Take the average townsman—he pays 150 rubles in monetary dues alone, but in the end the only thing that's left is the air he breathes. That is how the townsman lives who does some trading. But how does the poor townsman live!?!? . . . [sic]

Finding ourselves in such a position, we most zealously ask the Duma to discuss all that has been said in this declaration and to satisfy the following [needs]: (1) A townsman who lives in villages and hamlets should be registered in this rural township and given (on the same level as peasants) the right to vote in the election of peasant officials. (2) Eliminate all forms of dependence on the city government in the district. (3) Allot household plots (as property) in those

villages and hamlets where they live and own houses, with the right to alienate land at local prices (regardless of the owner). (4) In the event that state, crown, imperial cabinet, monastery and church lands are transferred to the peasantry, allot a part of these lands to the townsmen who live in villages and hamlets.

[Signed by nineteen townsmen.]

114. Collective Townsmen's Petition to the Duma May 1906

To the Chairman of the State Duma, a copy of a resolution by townspeople, soldiers' sons and others in the poll-tax estates.

An assembly of landless, city estates—numbering 1,362 individual representatives—has resolved to inform the State Duma, through your person as its chairman, of the following.

We, the undersigned—landless and for the most part dispossessed urban residents—protest against the transfer of land to peasants alone. We protest because land, its mineral resources and waters—by good conscience and common sense—are the property of the state and should therefore be considered the property of all citizens of the Russian Empire. Therefore, individual social estates have no right to possess land on the basis of private property. All the citizens of the Russian state are now equal, and to show preference for one segment of the citizenry over others is an act of coercion, which the Duma is not authorized to commit. We residents of cities (whom someone, for some reason, called "townsmen" [meshchane], soldiers' sons and other poll-tax estates) essentially constitute part of that same body of rural peasants, for our forefathers, grandfathers and fathers—in greater or lesser degrees—expanded the borders of our country with their own blood, contributed to its might, delivered quitrent and paid taxes without enjoying any profit from their service and sacrifices. These sacrifices do not include even the fact that their children (i.e., we) have been fully discarded and forgotten by the government, whereas the peasant, at least in part, is being taken care of. It was not our will that we were not attached to the land and consequently could not cultivate it, but this does not mean that we

were unsuitable for such work. Among peasant farmers, we rarely have encountered a model proprietor and honest worker, whereas fellow townsmen who bought plots of land on hard-earned money to form independent households have built up model farms. One can see the same thing [when] a townsman rents city land. We repeat, Russian land was acquired by the blood of Russians and should be given out in equal measure for use by the entire Russian people and all Russian subjects. Therefore, we demand a law that henceforth all land (with its mineral and water resources) not be the property of any part of the citizenry, but belong to the entire people who comprise the state. The Russian state should not give, sell or transfer public land to anyone. The accumulation of land in the hands of a few, above the labor norm, should be avoided; one and all should be encouraged to regard each plot of land not as private property, but as belonging to the entire people, the entire estate. The compulsory alienation of the land of squires, private owners and peasants holding more than the labor norm should be achieved at state expense; every acre of land should be assessed a rent sufficient to cover the costs of alienation of excess [private land] for the needs of the state and people. We demand, in addition, a law on the land fund, which should include state, crown, imperial cabinet, monastery, church, city, rural and private lands. We demand that henceforth all the land of the Russian Empire belong to all, be indivisible, and be the inalienable property of all citizens of the Russian Empire. Let those who cultivate the soil know—those who own gardens and homes, mines and fisheries—that they are residents and users, but not owners of the people's land or its mineral and water resources. Moveable and immoveable property of each citizen should be considered personal property and sacred; no one will dare to violate it so long as the renter does his duty before the people. But in this case, a special court for this (and acting under threat of special appointment and material accountability) [should] weigh all the circumstances so as not to ruin the property of the owner. This court should report on all this to the elected representatives of the people.

Everywhere one hears how the peasants say that the "Land is the Lord's," and by all rights should be ours, should be given to the Lord's people. But the peasants forget that townspeople are no less created by the law and after the image of the Lord, and therefore they have the right to the Lord's plenty!

If the peasants are given land as property, then we are right to demand that they give us its mineral and water resources, the land beneath our houses, the materials for construction and everyday repairs. Only under these conditions would we be made equal to the peasants.

Besides this, we demand that the Jewish people, as a restless and harmful people, unquestionably be expelled from the borders of the Russian state (together with Christianized Jews). Only then will there be complete peace and tranquillity.

[Signed by twelve authorized representatives from six cities: Odessa, Simferopol, Feodosii, Nikolaev, Kherson, and Sevastopol.]

F. PEASANTRY

When the flames of revolution reached the village in 1905, they could hardly have found more combustible material. Even if the peasants' economic condition was objectively less dire and more complex than traditionally thought, the peasants—and most observers—nonetheless *believed* the village to be hopelessly impoverished. This consensus was based on the belief that the peasant had received too little land in 1861, paid too many taxes, and lacked the means to sustain the rapid population growth of the late nineteenth century. By 1902, after the explosion of peasant unrest in Poltava and Khar'kov, it was clear that peasants were no longer willing to tolerate the perceived impoverishment; in 1905, they joined in violent disorders all across the land, held in check only by brute military force. Nonetheless, the Tsar and top government officials continued to regard the peasant as essentially conservative and monarchist and to ascribe the whole phenomenon of mass unrest in the village to outside revolutionary agitation and misunderstandings.

As the flood of peasant petitions and collective resolutions make abundantly clear, however, the once silent majority was by no means so socially conservative as high officials liked to think. In such collective statements, variously adopted to impress the public, Duma and Tsar, the peasants cried out for land, land, land; tedious to the extreme, such petitions (like that in doc. 115) focused narrowly on the land issue, demanding that the authorities, Tsar or Duma (it mattered little) provide them with additional land. Significantly, rarely did the peasants trouble themselves to discuss the terms of land transfer—whether and how the original owner was to receive compensation—but focused instead upon proving their right or need to the land. The volume of such demands was immensely higher than in the 1860s, when the peasantry passively resisted and waited for the benefactor Tsar to set things aright; in 1905, peasant communities turned supplication into demand, pressed authorities to take immediate action, and when that still failed to produce results, simply evicted, plundered and seized.

If most peasant resolutions focus on the all-important land question, some did broaden their vision of village needs and rights. Thus, a number of peasant declarations were laundry lists of desires; those from Tambov and Samara (docs. 116–17) include such requests as salaries for clergy (to spare themselves the expense!), public schools, and amnesty for all those arrested or sentenced for revolutionary activity. But not all were so uniformly liberationist; a resolution from Stavropol, while demanding social justice for themselves, expressed undisguised antipathy toward minorities, especially Jews (doc. 118). Of particular import is the fact that, by the summer of 1906, many peasants had abandoned their traditional "naive monarchism," especially in the wake of the ministerial declaration to the Duma in mid-May that categorically rejected radical land reform—compulsory expropriation with compensation. As a result, large numbers of peasants dispatched resolutions, letters and telegrams to the Duma urging it to stand firm, to insist upon a just solution to the land question. At the same time, anti-bureaucratic sentiments plainly permeated peasant thinking, and the experience of increased official tutelage, especially after the land captains reform of 1889, had dramatically increased peasant agitation (docs. 119–22). One final, important dynamic bears emphasis: villagers close to large cities felt the impact of political talk and party propaganda. Thus, whereas most peasants accepted the legitimacy of the Duma and in vain expected it to legalize their seizure of gentry land, the radical resolutions of two peasant communities near St. Petersburg (doc. 123)—presumably more exposed to radical propaganda—flatly repudiated the Duma and demanded a constituent assembly.

115. Resolution by Peasants in Byl'tsino (Vladimir Province) 27 February 1906

We, the undersigned peasants of the hamlet Byl'tsino (Oltushevskaia Township, Viazniki District, Vladimir Province), assembled today with one head from each household, discussed our needs, and came to the conclusion that our main need is a lack of land, since each male soul now has less than two dessiatines of land of all types—i.e.,

arable, wood and pastureland. This amount of land makes it impossible to run our peasant economy, for (in spite of all our efforts) we never have enough grain for ourselves, not to mention for our livestock (which are essential to our economy), or enough woods for our needs. As a result, our economic condition has deteriorated and we are forced to resort to outside employment. In addition to these needs, we have suffered much from private landowners, whose land almost completely surrounds our hamlet. Hence we cannot let our livestock out of the courtyards or else it would trespass on their land (for which we are forced to pay large fines, since we simply cannot prevent the livestock from doing this).

To eliminate this land shortage and to improve our material condition, we find that the only solution is to increase our land allotment to a minimum of 5 dessiatines per male soul, or to return to us the land that we utilized before the transition to redemption [at the time of emancipation]. Moreover, the increase must include all kinds of land—arable land, woods and pasture. To increase our land, private holdings should be purchased at a fair price (not at whatever price [the landowners] set), since the latter—taking advantage of the need for land—will set too high a price for the land. We transmit this declaration to our authorized representative in the name of our township, and ask that he give this to our elector at the provincial congress, and that [he] in turn submit this to the provincial deputy at the State Duma, before which we submit the present petition.

116. Letter from Peasants in Nizhnii Shibriag (Tambov Province) to the Duma May 1906

We, the undersigned peasants of the village Nizhnii Shibriag (Verkhne-Shibrianskii Township, Borisoglebskii District, Tambov Province), discussed among ourselves the activities of the State Duma and government. We saw that the State Duma firmly upholds our demands for land, freedom and amnesty, which we need right now. But these state demands have not, up to now, been satisfied by the government. We think that the government does not want to do anything useful for us. We address this to you as representatives of the people and

ask that you stand firmly behind our demands. For our part, we promise you our support if this become necessary.

117. Resolution by Peasants in Romashkino (Samara Province) 15 June 1906

We, the undersigned peasants from the village of Romashkino (Romashkino Township, Buzulukskii District, Samara Province), consisting of 420 heads of households, held a village assembly today in the presence of our village elder, Stepanishchev, with 298 heads of households present. We came to the following conclusions [about] our material condition:

1. We should have land and freedom: as a person cannot live without air and water, so too is it impossible for us to live without land.

2. In addition, all monastery, church, crown and private land should be confiscated. The last should be alienated to form a reserve land fund for the entire toiling class.

3. Grant a complete amnesty to all political [prisoners].

4. Abolish capital punishment and establish a legal court.

5. Furthermore, abolish all indirect taxes and replace these with an income tax.

6. All our village authorities should receive a salary, not from the peasant community, but from the state treasury.

7. Abolish township courts and replace them with peace arbitrators.

8. Universal public education and complete access to all educational institutions for our children to study at state expense.

9. We demand the implementation of all freedoms proclaimed in the manifesto of 17 October 1905.

10. We find ourselves in a hopeless situation! It is impossible for us to move without trespassing on other people's land! By exploiting our lack of rights and our helplessness, the squires oppress us by squeezing out impossible prices, and out of caprice they [sometimes] do not lease the land for any amount of money. We are doomed to starve to death!

We entrust this instruction for delivery to our authorized representative, Maksim Afanas'ev Chursin, and sign our names in confirmation of that.

[Thirty-four literate peasants sign for themselves; another two hundred and sixty, because of their illiteracy, had their names listed by a scribe.]

118. Resolution by Peasants in Nogutsk (Stavropol Province) 29 June 1906

We, the undersigned state peasants of the village of Nogutsk (Nogutsk Township, Aleksandrov District, Stavropol Province), composed of 900 heads of households with a right to vote in the village assembly, attended an assembly (840 people were present). It was convoked by the township elder Iosif Kolesnikov, who (per article 66 of the General Statute on the Peasantry) replaced the village elder, where we heard:

Two months have already passed since the State Duma was convoked, but it is not clear that it has resolved a single question. But restoration of tranquillity in the country depends upon [proper] resolution of [one] question: immediate allotment of land to peasants who lack sufficient land or have no land at all. From the newspapers received in our village, it is clear that, although the Duma placed this question on the agenda, it did not come to a final resolution of the matter and is instead preoccupied with other matters—for example, amnesty, national autonomy and other things unnecessary for the Russian state and conducive not to tranquillity, but to still more lawlessness and murder, which up to now the revolutionaries have not ceased to perpetrate. From the same newspapers, it is clear that some members run the Duma alone, and that the peasants do not have a say; however, only the peasants can say what is needed for the country and what can restore tranquillity. One must assume that they do not let the peasants talk, and if one of them does speak up, then they immediately ridicule him and afterwards the rest of them keep quiet. The only people who make speeches in the Duma are

those know how to speak eloquently by using foreign words. As a result of the foregoing, we consulted among ourselves and have unanimously resolved: present this resolution to the chairman of the State Duma and ask him to propose at a session of the Duma the following questions, the resolution of which will lead to the restoration of tranquillity in the country.

1. There should be no amnesty of political criminals in view of the fact that up to now the murders have not ceased.

2. Do not give rights of autonomy to anyone, because this will lead to new sacrifices on the part of the peasants.

3. Under no circumstances give equal rights to the Jews, since these people seek to gain power over us; they wish to destroy the existing state system in Russia and to arrange things so that Jews will govern Russia in place of God's anointed.

4. The death sentence should be imposed only by a court decision.

5. Martial law and emergency security measures should be retained until the country is pacified.

6. The State Council should be retained (as more acquainted with the laws and capable of correcting the mistakes of the State Duma).

7. It is immediately necessary to begin reviewing the question of the alienation of land and forests of the state, crown, imperial cabinet, monastery, church and noble squires. The land is then to be allotted to peasants who have too little or no land and forests.

8. The community of Nogutsk petitions to exclude from the State Duma all non-Russians and persons of Jewish nationality who have converted from Judaism to our faith; exclude, too, all people who have been punished either through a court verdict or administrative order, since the Russian state is supported by the peasants, who have spilt their blood to achieve its power on the condition that the Slavic population holds superiority.

9. Abolish the state sale of alcoholic drinks, or draft a law to have the treasury pay the communities the amount derived from private traders. These monies would enable the communities to construct schools and churches, which the peasants need (as was done prior to the establishment of the state [liquor] monopoly).

10. Set a state salary for the parish clergy, with the stipulation that they assess no fees for performing religious rites.

11. Establish universal, free education.

12. Establish a pedigree system for livestock and horses.

13. Order that sessions of the State Duma be held only on regular workdays, not on holidays, as the Duma has designated.

14. Ask the Sovereign Emperor to abolish the positions of veterinarians and paramedics as well as excise tax officials, since the expenditures to support them form a heavy burden on the unpropertied classes of the population. At the same time, these people do not bring any substantial benefit to the state.

15. Publish a law that the capital endowment of churches be used for their upkeep and for the construction of new churches. Their income and expenditure should be controlled by bookkeepers elected by each community.

16. Make the zemstvo responsible for all the post offices, since the expenditure for their upkeep is a heavy burden for the community.

17. Prepare a law that the insurance assessment from each community (for private and public structures) go to the communities, not the state, and that the communities assume responsibility for buildings that burn down.

18. Both military and civil authorities should be composed of Orthodox Russian men—not foreigners, or non-Orthodox people, or people of Jewish origin who converted to Christianity, or Poles.

19. People found guilty of stealing livestock or other property should be hired out by the state; those who suffered losses from their actions should receive compensation from the state.

20. Publish a law on the equality of all citizens.

We express the conviction that our petition will not be a voice crying in the wilderness.

[Signed by 41 literate peasants; the names of another 599 illiterate peasants are listed.]

119. Resolution by Peasants in Berezov Township (Poltava Province) 14 May 1906

Comrade representatives! We send you our sincere greeting and wish you success in the struggle for the people's cause!

Do not forget, comrades, that we simply no longer have the strength to live in extreme material and spiritual poverty.

Remember, it was from the hands of the people that you received the right to arrange for our well-being. Your chief obligation now is to give freedom to those who have battled for the people's cause.

Every moment that you are in rich palaces [in St. Petersburg], keep in mind our half-collapsing peasant huts and the [prison] "quarters" where tens of thousands of the best people are now suffering.

Remember that our entire lives are spent tilling someone else's land; our toil, our bloody labor goes to benefit the rich. Without our own land it is impossible for us to live. Our taxes exceed our ability to pay.

Remember as well that we need enlightenment so that any of us can be a conscious defender of the interests of our homeland.

Remember, the laboring force which provides our fatherland with soldiers and grain is counting upon you.

God help you, comrades!

120. Resolution by Peasants in Zhel'tsovo (Vladimir Province) 2 June 1906

We, the undersigned peasants of the village of Zhel'tsovo (Chekovskii Township, Vladimir District, Vladimir Province), assembled today in a village assembly with . . . [sic] heads of households, in the presence of our village elder Semen Iakovlev Kalinin. We discussed our onerous, rightless condition and how to overcome this.

Forty-five years have elapsed since we were given "Freedom," but our life has changed little for the better; it is still in almost the same condition as it was during the black, shameful days of serfdom.

In legal terms, we left the wild [state] of enslavement to squires and fell into bondage to state officials. Every cockade or shiny button has become our superior. They all try to extirpate in us any manifestation of free thought or independent activity in general, and to reduce us to the level of animals with no rights whatsoever. And how bitter, how onerous is our life in terms of our economic condi-

tion! All the best land that surrounds our home village, into which our fathers and grandfathers poured their sweat and blood (indeed, where we now do the same), went to the squire. We were given the land that was sandy, stony, and at a significant distance from the village; with this land we are supposed not only to feed our families, but to buy our shoes and clothes, to pay the poll tax and other assessments (direct and indirect) that our solicitous government has imposed upon us. To this it should be added that we do not even have free access to these pathetic strips of land, since the squire owns land not only around the village but inside it as well. Hence the only way to reach or drive livestock to our allotments is to go through the property of the squire. Thus the lack of sufficient land and the lack of free access to our fields forces us year after year—from the very moment "Freedom" was proclaimed—to lease the squire's land at a very high price. In the course of this protracted period, we have paid the present landowner several times more than the price he paid for the land. Such a dependent status, with no rights whatsoever, has reduced us to poverty and ruin. We have often assembled, discussed and tried to think of a way to improve our bitter living conditions. For decades we have endured, believed, and hoped that there at the top—in St. Petersburg—they are concerned about us, that soon the joyous day will dawn when this great injustice will be eliminated and the land, as God's creation, will belong only to those who work with their own labor. All these parasites, who grabbed the land and commercialized this highest gift of the Lord, will stop getting fat on someone else's work. For it is said: he who does not work shall not eat!! But after 13 May, when the ministerial declaration [repudiating radical land reform in favor of the peasants] was announced, our faith and hope have been totally lost. We understood who is our friend and who is our enemy. At the present time our sole hope rests upon you, who have been chosen by the people. We thirstily took in every word which has come from the halls of Tauride Palace [seat of the Duma] and attentively listened to them. Stand firm! Not one step backwards! Work to get us our land and rights; do not give up without these. We do not want to live any more like this. Remember, in a critical moment, all of peasant Russia will support you. As soon as possible try to regulate the prices on the leasing of land and to abolish all intertwining of land plots [between squires and peasants] and other limitations (for example, on grazing).

121. Resolution by Peasants in Nizhnoe Sharskoe (Viatka Province) 12 June 1906

We, the undersigned peasants, gathered this day at an assembly in the hamlet of Nizhnoe Sharskoe in the presence of the village elder and, after talking things over, have decided to petition the people's representatives in the State Duma about our vital needs.

Reduced by a bureaucratic official order to the most dire state of poverty and violation of all divine and human rights, we openly and directly proclaim to all of Russia that, under the existing unjust orders, we peasants do not live but vegetate—being deprived each day of basic necessities. That is because all our insignificant revenues go entirely to pay (and sometimes do not even cover) direct and indirect taxes, which rest like a dead weight upon the population. In addition, we have experienced no less a burden and oppression from people who hold power—from the land captain to the lowest-ranking youth in a police uniform, they all arbitrarily lock us up in bug-infested jails. The police and gendarmerie burst in upon the peaceful population in the middle of the night and conduct a real pogrom, not a search for illegal literature.

For failing to pay our taxes, the land captain orders the township authorities to sell our grain and last head of stock, and leaves us and our families to starve to death. Besides these criminal actions of the government, we experience an acute need for land and firewood. We also encounter intolerable oppression on the part of the Votkin factory administration: it assesses a large fee for pasturing our livestock and for a plot of woodlands (for example, from 8 to 15 rubles for one dessiatine), and increased the fee for wood this year by two or three-fold. All this is extremely burdensome for us.

We hope that you, defenders of the people's interests, will not decline to defend—in the face of powerful officials and capitalists—our demands listed below. We demand:

1. That emergency security measures be lifted immediately in view of the fact that, under emergency security rules, it is impossible for us to hold any kind of meetings about the peasants' needs.

2. That the Duma be a legislative institution and that the people's

representatives to the Duma be elected on the basis of universal, direct, equal and secret franchise; and that the ministers and other officials be responsible [to the Duma].

3. The institution of land captains, as harmful for the people, should be immediately abolished; the police should be elected and responsible before the people.

4. Mandatory education at general state expense.

5. The transfer of all land to the communal ownership of the entire people.

6. Abolition of indirect taxes and their replacement by a progressive income tax—i.e., those who receive more [income] should pay a higher percentage.

7. Abolition of capital punishment and freeing [of all prisoners] through an amnesty.

122. Resolution by Peasants in Seltinsk Township (Viatka Province) 24 June 1906

We, the undersigned peasants (from the hamlets of Umetgurt, Mad'-iarov, Budzimshir and Bol'shaia Nyria of the Umetgurt Village Community, Seltinsk Township, Malmyzh' District), gathered in a village assembly on 24 June 1906 with a total of 147 household heads in the presence of our village elder, Il'ia Morozov. After discussing current events, we resolved to request the State Duma as soon as possible to demand the following from the government:

1. Free all those innocent people being held in prisons.

2. Replace the present ministers with [new ones] chosen from the State Duma, who should be responsible to the people.

3. Abolish the State Council.

4. Make all social estates equal in rights.

5. Transfer all noble, crown, monastery and other [private] lands to the entire working people.

6. Introduce universal, mandatory elementary education in the country; in addition, make access to secondary and higher education open and tuition-free for all.

7. Abolish the office of land captain and replace it with someone elected by the people.

8. Eliminate the emergency security measures in our province and, in general, such extraordinary measures are not to be taken in this country.

9. Abolish the shameful death penalty.

10. Replace the onerous indirect taxes with a progressive income tax.

11. Do not prosecute the brewing of koumiss [fermented mare's milk],' since it is brewed not for the sake of drunkenness, but for preserving our health in difficult moments of peasant life (because government liquor is too expensive and not always available).

12. Ask the Sovereign Emperor to pay heed to the pleas and petitions of the entire Russian people and to liberate it from the yoke and arbitrariness of the officials who surround it.

123. *Resolution by Peasants in Systroetsk District (St. Petersburg Province) 19 February 1906*

We, rural inhabitants in Systroetsk and Raivol'sk, gathered at a township meeting on 19 February 1906 to choose electors and discussed the question of elections to the State Duma. Taking into account: (1) that the State Duma is not a true representative body (since this body violates our absolutely legitimate demand—the convocation of a constituent assembly on the basis of universal, direct, equal and secret suffrage); (2) that the government executes, arrests and exiles to hard labor our best comrades (and hence there can be no doubt that a true representative body will not avoid the same fate); and (3) that the Duma convoked in this way will be primarily black-hundredist and serve as a new instrument to oppress peasants and workers, we resolve:

1. To refuse categorically to participate in the elections.

2. To explain to all our comrades the truth about the State Duma.

3. To fight to the end for our demand to have a constituent assembly.

G. INDUSTRIAL WORKERS

From the first expressions of collective action in the 1860s, the Russian working class developed into a leading revolutionary force by the turn of the century. Even against the background of 1905, when virtually every group in society organized to define and defend its interests, the workers still constituted a key element in the struggle against autocracy. Their radicalism attained its apogee after the October Manifesto, in the heading "Days of Freedom" that ended in barricades and repression by the year's end. Although the labor movement thereafter lost some of its momentum, the workers nevertheless remained acutely disaffected, especially in the hard-core urban working-class areas, where they tended to repudiate the Duma's legitimacy and to support more radical political currents (doc. 124).

But the workers, like other groups, were at once highly diverse and still groping towards autonomous forms of social (not just political) organization. The workers' interest and zeal in unionization (docs. 125–26) was extraordinary; even the unemployed sought to organize and mobilize their forces (doc. 127). But for contemporary observers, most impressive of all was the set of aggressive political and social demands presented in their public proclamations and strike resolutions. If some provincial workers tended to be more conservative (for example, accept the legitimacy of the Duma, as in doc. 128), most still demonstrated the radical spirit that at once encouraged revolutionaries and alienated more moderate segments of society (docs. 129–34).

124. Resolution of Workers in Miuzskii Park (Moscow) March 1906

The State Duma, on the basis of the law of 6 August [1905], does not answer the demands and needs of the Russian people and is nothing more than a mockery. The election law gives advantage to the rich over the poor, to squires over peasants, to factory-owners over workers. The election law was created in order to convoke not the true representatives of the people, but only those who are obedient to the government and those who are allied with it. The State Duma is necessary to the government to obtain money; this Duma is nothing else except a ridiculous charade of popular representation. The Russian people is still more than ever enslaved. In view of all this, we refuse to participate in any way in this electoral comedy. We demand that a national constituent assembly be convoked on the basis of a universal, equal, direct and secret franchise. In particular, we demand that all the workers and white-collar personnel of city enterprises who were arrested be released immediately and that all those who have been dismissed be accepted again into service.

125. Proclamation of Workers in Leather-Processing Shop (St. Petersburg) April 1906

To Comrades in the Leather-working Shop!
 Comrade workers!
 The circle of workers in the leather-working shop have decided that to live any longer in our condition—that of enserfed slaves—is impossible. We must organize; we must defend our own needs and those of our fathers and brothers. We must free ourselves from the yoke of shop proprietors and protect ourselves from unemployment. Our circle also hopes, by means of peaceful agreement with the owners, to establish a ten-hour day in all the workshops of the city of St. Petersburg.

Comrades: in order for our union to develop and become organized more quickly (and as soon as possible to begin yielding real benefit to all the comrades of our guild), we urge you to unite, to organize, and thereby to improve our position.

Know well, comrades, that strength lies in unity, and the improvement of our condition depends upon us ourselves.

We summon you, comrades: think and respond to our appeal— "unite!"

126. Charter of the Metalworkers' Union (St. Petersburg) April 1906

PURPOSE OF THE SOCIETY AND ITS MEANS OF ACTION

1. The society of workers under the name "Union of Metalworkers" has the goal of clarifying [the workers'] economic interests, improving the work conditions of [Union] members, and assisting in their intellectual and moral development.

2. To attain the above goal, the society: (a) seeks means (through negotiations and third-party arbitration) to eliminate misunderstandings that arise over agreements between firms and members of the society; (b) clarifies the amount of wages and other labor conditions in the sphere of this profession; (c) distributes assistance to its members in the event of illness, unemployment, travel etc. [Note: the procedure for rendering assistance is determined by a special instruction, which has been confirmed by a general assembly]; (d) opens a bureau to provide legal assistance and an information office for those seeking jobs; (e) establishes a dormitory for the unemployed and [newly] arriving members of the community; (f) organizes lectures, talks, evenings and excursions; establishes libraries, reading rooms and other institutions contributing to the intellectual and moral development of its members; (g) arranges general meetings of the society's members, of individual groups, and also public meetings to attract new members; (h) organizes medical assistance; (i) acquires moveable and immoveable property, rents apartments, and concludes all kinds of contracts; (j) defends its interests at court through its authorized representatives; (k) enters into relations with various indi-

viduals and institutions with respect to the affairs of its members; (1) opens, to the degree necessary, branches which have no special administration but whose activities will be determined by a special instruction, confirmed by a general assembly.

127. Proclamation of Unemployed in St. Petersburg to the City Council 12 April 1906

As a consequence of the terrible unemployment, most of the workers' families are now left without a crust of bread. The workers do not wish to support themselves by charity or handouts. To escape the present situation, we demand work for ourselves. Proprietors refuse to give us work, saying that they have no orders. Meanwhile, the city—which could give us work—sends its orders [to firms] abroad. We deem this use of public funds by city officials to be unacceptable. Public funds should go for public needs. And our need is for work. Therefore, we demand that the city council immediately arrange public work in Petersburg for all those who need it.

We do not demand charity, but our rights, and we will not be content with any kind of handouts.

The public work that we demand should begin immediately. All the unemployed of St. Petersburg should be accepted for this work. Each should receive an adequate wage.

We have been authorized to insist that our demands be fulfilled. The masses who send us will not agree to accept anything less.

If you do not fulfill our demands, then we will communicate this to the unemployed and you will have to talk not with us, but the entire mass of unemployed.

128. Telegram from Workers in Undol' (Vladimir Province) to the Duma 24 May 1906

The workers of the Bazhanov factory in the village of Undol' (in Vladimir district), numbering more than 2,000 people, warmly greet

you representatives of the Russian people and bless you in the difficult struggle with the enemies, who stubbornly defend arbitrariness, violence and illegality in [our] tormented country. We salute the banner for giving land and freedom, for abolishing the death penalty, and for improving the material condition of the working masses. It is a banner which you proudly took to the Tauride Palace. Fight the enemies for this sacred banner right to the very end and demand total amnesty for those who have fought for freedom. But if their hand is ready to tear the banner from you, give this holy thing to the people. We are behind you and will not spare our life for the benefit of our fatherland.

129. Resolution from Reval [Riga] Workers to Labor Deputies in the Duma 7 June 1906

To the Workers' Caucus

We, workers in the plant "Motor" [Dvigatel'], having assembled on 7 June 1906 as a group with more than 1,000 workers, greet you for your bold address to the entire working class of Russia. We protest the black-hundredist agitation of revolutionaries, who alleged that the liberation movement was fomented by isolated agitators, and assert that it is caused by our desperate and oppressed condition. We demand, comrades, the following:

1. Judicial prosecution of administrators who have committed violence against the people.

2. Complete amnesty for those who have suffered for political, agrarian and religious causes.

3. Immediate abolition of capital punishment.

4. Abolition of martial law and emergency security measures.

5. Convocation of a national constituent assembly on the basis of universal, equal, direct and secret franchise without regard to sex, religion and nationality.

6. A unicameral parliament.

7. Introduction of local self-government on broad, democratic principles.

8. Responsibility of officials before the laws (in the same manner as all citizens).

9. Freedom of speech, press, unions, assemblies, strikes and religion.

10. Universal, obligatory education until the age of 16.

11. An eight-hour working day.

12. State insurance of workers against illness, old age, and unemployment.

13. Immediate introduction of local peasant committees to resolve the agrarian question.

14. Abolition of permanent troops and their replacement by a permanent militia.

15. Retirement of the present ministers and the appointment of a new responsible ministry by the Duma, since this is one of the conditions that will contribute to the convocation of a constituent assembly.

Comrades, stand up for our demands! If conflicts with the government ensue from these [demands], know that we—who have been steeled in battles over the preceding months—are ready again, together with the entire Russian proletariat, to stand up in defense of our demands.

130. Instruction from Railway Workers in Eniseisk (Siberia) to Duma Deputy 4 June 1906

Instruction to a member of the State Duma from Eniseisk Province, Nikolai Fedorovich Nikolaevskii, which was unanimously accepted by a meeting of two to two-and-a-half thousand people on 4 June 1906 at the recommendation of an orator from the Krasnoiarsk Committee of the Russian Social-Democratic Workers' Party:

The criminal policies of the government have brought the country to a terrible catastrophe. The peasants are ruined, and a merciless famine reigns in the village; factories and plants have closed in the cities, with tens of thousands of workers thrown into the street.

Everywhere there is unemployment and death from famine. The fighters for the people's freedom and well-being languish in prisons

and in exile. Almost all of Russia is fettered by the chains of martial law and emergency security measures. Unbounded opportunities are opened for the arbitrariness and impunity of officials.

What is the way out of this situation? Where is salvation? The State Duma has attempted to take a peaceful path and, through peaceful work, to heal the open wounds of the people. But the government, relying upon force and power, has already closed off this peaceful path for the State Duma. The worker and peasant deputies in the Duma have understood the utter impossibility of peaceful work and are now beginning to address the people itself with their appeals.

The only powerful force is the people—only they can conquer the common foe in an open battle.

Only by relying upon force and a popular victory can the Duma become a real authority in the state.

Nikolai Fedorovich! After appearing in the Duma, together with its best part strive toward the following:

(1) Throughout the country, popular sovereignty should replace bureaucratic authority (by establishing soviets of worker deputies, peasant committees and unions again).

(2) Real, stalwart fighters for freedom—relying upon the people— should tear away authority from the government.

(3) Once this authority is attained, they should immediately decree: complete freedom of speech, press, assembly, conscience, unions and strikes; an eight-hour workday throughout the country. Having obtained land for the peasants, convoke a national constituent assembly on the basis of a universal, equal, direct and secret franchise to establish new laws and a free order in the country.

This is the sole path to a bright future. We, the railway workers of Krasnoiarsk, summon and direct you to follow this path, together with the workers' deputies and with our comrade workers in the State Duma.

131. Proclamation by Workers
in Dmitrievka (Taganrog)
June 1906

We, citizen workers of the suburb Dmitrievka (in Taganrog okrug), having gathered in a meeting of five thousand persons, declare that

the State Duma cannot accomplish anything. We demand the convocation of real representatives with constituent functions, elected through universal, equal, direct and secret elections. We demand the resignation of the old ministers and the election of new ministers from members of the Duma. We are firmly convinced that only a constituent assembly will free the people from arbitrariness, abolish capital punishment, grant amnesty to those under arrest, and give the peasants land and freedom. We declare that we will support the Duma in demanding the convocation of a constituent assembly. The struggle of deputies for this demand is our struggle, too. With all our heart, we protest against the Belostok pogrom and all those who perpetrate violence and disorder. These pogroms have made a dirty mark upon the entire Russian people, which has had nothing to do with them.

132. Instruction from Ekaterinoslav Metalworkers to Duma Deputy April 1906

1. Introduction of legal protection of labor in the state.
2. Immediate introduction, through legislation, of an eight-hour working day (with preservation of current wages).
3. Abolition of obligatory decrees for overtime work.
4. Establishment of local mediation offices for the employment of workers in all branches of production, with the participation of representatives from worker organizations in its administration.
5. Amnesty for all political [prisoners] and abolition of capital punishment.
6. Unlimited freedom of conscience, speech, press, assembly, strike and union.
7. Establishment of reconciliation offices with an equal number of representatives from labor and capital to normalize all relations of employment and final wage settlements and to settle disputes and disagreements that arise between the workers and employers.
8. Abolition of the practice of hiring labor through contractors.
9. Abolition of fines and suspensions.
10. State insurance for illness, accidents, and professionally-related disease; the costs for this are to be paid by the firms.

11. State insurance for old age and disability.

12. Development of labor protection for women and children and the establishment of special control over production that is known to be harmful to the [workers'] health.

13. Introduction of universal, free and obligatory education in elementary schools, with the transfer of administration of school affairs to organs of local self-government. Organized assistance to those pupils in need.

14. Introduction of schools on Sundays for adult workers.

15. Establishment of criminal responsibility for the violation of laws on labor protection by both workers and firms.

133. Strike Demands of Moscow Textile Workers 25 May 1906

1. A nine-hour workday, with a break for lunch from 12 to 1:30 and with [another] half-hour for evening tea.

2. Increase by 30 percent the wages of those who receive 6.50 to 10 rubles; 20 percent for those who receive 10 to 15 rubles; 10 percent for those who receive 15 to 20 rubles; 5 percent for those who receive more than 20 rubles.

3. Money for provisions should be paid monthly.

4. Replace the existing cots in the sleeping quarters with iron beds and mattresses.

5. Complete abolition of overtime work.

6. Abolition of searches; free entrance to the factory courtyard for kinsmen and friends.

7. Polite treatment of workers by foremen and their assistants.

8. Payment of full wages for the holiday of 1 May.

9. Immediate discharge of the [plant] engineer.

10. A worker must not be discharged without the consent of the workers.

11. Those elected by the workers to negotiate with the factory administration are not to be discharged.

134. Strike Demands of Kirillov
Textile Workers (Moscow)
22 June 1906

1. Nine-hour workday for workers on the day shift.

2. Abolition of overtime work except in those cases where, for technical reasons, it proves necessary.

3. Abolition of searches; polite treatment by people in management positions.

4. Increase in [monthly] wages: 30 percent for those earning less than fifteen rubles; 25 percent for those earning fifteen to eighteen rubles; 15 percent for those earning eighteen to twenty rubles; 10 percent for those earning twenty to thirty rubles.

5. Insurance for workers in disability and old age.

6. Issue workers a housing subsidy of three rubles each month.

7. Workers who transfer to other divisions are not to have their wages cut.

8. Election of permanent deputies (one per branch), who should investigate all misunderstandings that arise between workers and management. Without the consent of the above [deputies], workers are neither to be hired nor fired; nor are wage rates to be altered. Election of deputies should be held without any restrictions, without consideration of their age or the amount of time that they have worked in the plant.

9. Payment in full for the period of inactivity in December (7th to 18th). In addition, compensate workers who suffered losses from premature summons by the factory management [to appear] by 14 April. (As a result of this, the workers had to live until 24 April by pawning and selling their personal effects).

10. A prohibition for workers to perform work that does not form part of their duties.

11. Provide the workers each with the means to visit a bathhouse every day.

12. Establishment of a three-day rest period (with a cessation of work on Thursday) during the holidays of Christmas and Shrovetide.

13. Because of rude treatment by the foreman Nikolai Fedorov Popentsov, we demand that he be removed as foreman and discharged from the factory.

14. Full pay for inactivity during the present strike.

H. MINORITIES
AND WOMEN

Like the rest of Russian society, religious and national minorities hastened to press their demands upon a tottering autocracy. Thus the Old Believers, who enjoyed some improvement in their status but still suffered from a variety of diabilities, raised their expectations ever higher—and in 1905, demanded not only freedom from repression but full civil rights, including the right to proselytize. When the Emperor proclaimed the principle of religious tolerance on 17 April 1905, Old Believers demanded that the new regulations be systematically implemented (doc. 135). Similarly, ethnic and national groups like the Jews, who had pleaded for greater rights, now organized independent organizations and supported sympathetic candidates in the Duma elections (docs. 136–37).

The revolution also brought an intensive growth of feminist activism, especially in wake of the October Manifesto and convocation of the first Duma. Exclusion of women from the Duma provoked strong discontent, including appeals to the Duma itself to demand political enfranchisement for women (doc. 138); nonetheless, the Duma—like the Catherinean Legislative Commission—was to remain without the representation of women. Although the women's movement divided into moderate and radical fringes, some of which were partly incorporated within existing parties, there was also an independent attempt to form a women's party. Given the structure of Duma elections and disenfranchisement of women, it had little real impact, but its formal program does offer an interesting statement of aspirations among the more liberal, perhaps radical, wing of the women's movement in 1905 (doc. 139). In the factory, too, gender and class provided the basis for attempts to organize women by occupation, giving a specifically female perspective to broader working-class demands (doc. 140).

135. Address of National Congress of
Old Believers to Nicholas II
21 February 1906

Great Sovereign!

Your most gracious decree of 17 April [1905] regarding reinforcement of the principle of religious toleration was truly "a great deed of peace and love," and for us Old Believers, from time immemorial devoted to the throne and fatherland, an act of inexpressible mercy.

For two and one-half centuries we lived in the dark shadows of religious oppression, deprivation, and civic alienation—without the right to pray and confess as our conscience dictates (according to the rites of the ancient Russian Church, which our fathers and forefathers have taught us). At times these dark shadows turned into pitch-black night, and the awesome specter of hard punishment and persecution relentlessly followed us everywhere—in our homes, in our chapels.

We bore this trial without complaint: we were inspired by prayer "for all men, for the Tsar, and for all those who are in power" (in accordance with the commandment of the Apostles), and grew stronger in our conviction that the day will come when our heavy hearts will experience relief.

This day has arrived—a clear, utterly blissful day, for it fell on the first day of our Savior's resurrection, with the first sound of the Easter welcome. The darkness of night disappeared, and the majestic light of religious freedom, of spiritual regeneration shone over the Russian land: "Verily, Christ has arisen!"

With tears of joy and emotion, at a solemn Easter service, we prayed to the Arisen on that Easter night for health and success for You, Sovereign.

And now, through the grace of the Almighty God and Your Sovereign authority, we have seen the light of religious freedom and have received our inalienable possession—the right of citizenship.

The voice of our heart and internal duty orders us to bow down before Your face, to pour out the feelings of infinite gratitude that inspires us. But we do not know or see a means to do this.

Command, Great Sovereign, that our elected representatives ap-

pear before you, so that our living word prove to you what we are not in a position [to prove] through these weak written words.

We pray, Sire, that He protect You and Your family for many, many years, and that the Almighty Creator help You to govern your tsardom.

136. Proclamation by Union for Legal Equality for Russian Jews February 1906

Brother Jews, use your right and participate in the elections to the State Duma!

The proximity of elections to the State Duma is forcing people who share the same ideas to unite into political parties and unions. We stand on the side of only those parties that represent the equality of all without differentiation according to nationality, the equality of all citizens before the law, the complete realization of political freedoms and a right of universal franchise. However, in such an important moment (when the acquisition of civil and political rights for us Jews is of greater importance than all other questions), we believe that above all we should unite into one whole in order to give all our votes to those future representatives in the State Duma who will swear to you to advance the question of Jewish equality before all else and to defend it in the Duma on our behalf.

137. Resolutions of the Third Congress of the Union for Jewish Equality February 1906

1. On the question of relationship to State Duma elections

The Congress, having heard the report of delegates from local branches of the union from various ends of Russia, confirms that the election campaign which has begun at the local level is proceeding under the most onerous, intolerable conditions of political life. Martial law, extraordinary and intensified security, countless searches, ar-

rests and exiles, the unheard-of brutality of pogroms that have already occurred (as well as pogroms which still threaten Jews), the reactionary elements that have been inspired by the government—all this, independent of the great shortcomings of the very electoral law, prevents the elections from proceeding properly and blocks a full manifestation of popular will. Terrorized by general and specialized persecution, the Jewish population participates in the electoral campaign without the conviction that it will be able to send a corresponding number of freely chosen representatives to the State Duma, and [operates] under the onerous awareness that the Duma itself will not correspond to the demands of a true, popularly chosen parliament.

Nevertheless, the Congress recognizes its national obligation—in defense of Russian Jews—to take the most active role in the electoral campaign for the following reasons.

The unprecedented arbitrariness in Russia (now more terrible than ever), the condition of Russian Jewry, its maturing demand for political protest and active defense of its trampled rights—here are the sources of that oppositionist energy, which has expressed itself in the form of a consistent political struggle within the framework of representative institutions that are extremely unsatisfactory and in need of radical reconstruction.

The participation of all other national groups, as well as reactionary parties, in the electoral campaign obliges Jews to stand up for their civil and national interests, to be concerned that they not be left defenseless in a future assembly of popular representatives and, at the same time, to strengthen the contingent of progressive elements in the State Duma.

At the same time, the Congress recognizes that Jews should not limit their participation to all the steps in the electoral campaign and preelection agitation, but should—through their elected representatives—participate in the State Duma. There they are to defend both the general constitutional principles as well as their own civil, political and national rights. This appears necessary not only in view of the fact that the Congress recognizes the participation of Jewish representatives as useful, even in a Duma convoked by irregular procedures, but also because it is impossible to separate the question of elections from participation in the Duma on purely constitutional grounds.

2. On the question of relationship to the existing political parties

The Congress deems it possible, in view of the goals of the electoral campaign, to enter into a coalition with those political groups whose program and activity are directed—in the sphere of the Jewish question—toward realizing a democratic order on the basis of universal, equal, direct and secret electoral right and the guarantee of all forms of freedom. In the event it is impossible to have coalition candidates, the members of the Union will vote for the more progressive of the competing parties.

3. On the question of forming a national Jewish group in the Duma

The Congress deems it necessary that future Jewish delegates to the Duma, despite all the differences in the party programs, be firmly conscious of their national unity whenever all questions pertaining in some measure to the rights of the Jewish people are under discussion; and that they unite for collective discussion and all possible collaborative efforts to achieve equality for Jews in Russia. At the same time, the Congress recognizes as unacceptable for Jews to enter non-Jewish national groups.

4. On the question of an electoral campaign

In cities which constitute autonomous electoral districts, candidates as Duma delegates are nominated by the city electoral committee of the Union of Equality [for Jews] and confirmed finally by a general assembly of all Jewish electors of a given city. If this is not possible, then [these are nominated by] an assembly of electors from various electoral districts of a given city.

5. On the question of demands, which the Union should present to candidates it has supported to the State Duma

A. They are to be guided in their work in the State Duma by the program and resolutions of the Union of Equality of Jews.

B. They are to insist on a resolution of the Jewish question unfailingly in the spirit of the basic statutes of the constitution and the elementary general human liberties.

C. A non-Jewish candidate supported by the Jews should also be expected to uphold in the Duma, beyond point 2, the civil, political and national rights of Jews.

138. Petition of Russian Women
to the State Duma
February 1906

On the great day of the opening of the State Duma, a day which all of Russia has awaited with intense impatience, when the first representatives of the Russian people gather, it will not include a single woman or a single representative directly chosen by women.

By the state acts of 6 August 1905, 17 October 1905 and 11 December 1905, half of Russia's population is deprived of the right of franchise as a duty common to all citizens; they have been deemed legally incompetent and relegated to the category of adolescents and creatures without any rights.

The Russian Women's Mutual Philanthropic Society, which, in the course of its ten years in existence, has indefatigably served the interests of women, and [which has been] supported by the sympathy of the undersigned, deems itself duty-bound, in the name of justice, in the name of the defense of the human dignity of women, to place before the Duma the question of the political equality of women in Russia.

The Russian woman partipates alongside men—in all spheres of work and endeavors in the cause of the development and growth of the motherland; in peasant agricultural work; in factory and industrial work; in the sphere of science, literature and art; in state, public and private institutions; and in the high service as doctor and teacher— and bears the great responsibility for the upbringing of future citizens.

Along with men, she pays taxes and assessments, and stands responsible before the law on an equal basis with all citizens. As an equal in the payment of taxes, as someone who works on the same basis as men, as one responsible in an equal degree before the law, a woman—in all fairness—should have the right to defend her interests through participation in a legislative assembly, whose decisions also directly affect her fate no less than that of men.

Almost all the Russian political parties that have appeared recently have come to this just conclusion and have incorporated in their programs a demand for a franchise law without distinction on the basis of sex.

We, Russian women, appeal to the deputies of these parties and to all those representatives of Russia in the State Duma.

Deputies of the Russian land! You have been summoned to a great creative work for the benefit of our motherland. Be just and dispassionate to the declaration of women, who demand equality of rights. Respond in concurrence with the numerous voices of those who are firmly persuaded of the rightness of their demands and who, among the number of reforms to renew Russia, include the regeneration of life for women by granting them equal rights to participate in service to the motherland.

139. Program of the Women's Progressive Party 30 January 1906

Women are the most rightless, dispossessed part of the population. They find themselves in subordination to men and in complete dependence upon their will. They are deprived of their human personality and enslaved by the existing laws and their economic dependence on the ruling sex. Because of their subordination, economic dependence and lack of rights, women cannot develop all their spiritual abilities and render active assistance to the perfection of mankind (in spiritual and physical respects) and improvement of the social order. Because lack of political rights is one of the main causes of the enslavement of women, the Women's Progressive Party makes its immediate goal the attainment of complete political equality of women with men.

The Women's Progressive Party regards it as necessary to struggle with all the shortcomings of contemporary life and to realize general human ideals: truth, equality, fraternity, freedom, justice and humanitarianism. It holds that realization of these ideals is only possible through a peaceful, evolutionary path. To achieve these goals, it deems the following necessary:

1. All citizens of the Russian Empire, without distinction of sex, confession or nationality, are to be equal before the law. Any differences based on social estate [*soslovie*] and all limitations on personal and property rights should be eliminated.

2. All citizens should be granted freedom of conscience and confession, freedom of speech (oral, written and printed), inviolability of person and home, and freedom of assembly, strike, petition, movement (through abolition of passports), and business. No one may be subjected to persecution and punishment except through judicial autority and on the basis of law.

3. At the present time, a constitutional-democratic monarchy is the most appropriate form of government for Russia. A popular representative assembly should be elected by all citizens who have attained the age of 21 years, without distinction of sex, nationality and confession, on the basis of an equal, direct and secret vote. All citizens are to be accorded a passive electoral right. The popular assembly is to prepare a constitution, to wield the right of legislative initiative, to hold ultimate authority for the promulgation of laws, to exercise broad control over executive authority, to have the right to confirm the state budget, and to exercise control over it. The ministers are to be responsible to the popular assembly.

4. All the peoples inhabiting Russia are to be united in the name of general human ideals. All the peoples of Russia are to enjoy complete freedom in the use of their language in the press, court, school, and various public institutions. Russian is recognized as the state language.

5. The broad development of local self-government [should be achieved] over the entire expanse of the Russian state on the same principals as those of the popular assembly. Self-governing units for the better realization of their goals can form themselves into unions. Satisfaction of all local needs is in the jurisdiction of self-administrative organs. They have the power to tax themselves. Central authorities are only to oversee the activity of local self-government organs and to take them to court in the event they violate the law.

6. The court should be free from any kind of external pressure and is to be guided solely by the law. Justice should be immediate, prompt, merciful, and the same for all citizens. The court should be composed of women (in the capacity of judges, lawyers and jurors). They are to have the right to occupy all judicial positions. Capital punishment is to be abolished. Legal custody, suspended sentences, and parole are to be introduced. Women are to participate in the review of existing laws, both criminal and civil.

Civil marriage is to be established in family law and made obliga-

tory for all. Religious sanctification should be left to the free will of each. Parents hold equal authority over the children. Wives are equal to their husbands in all respects, have the right to one-half of family savings, and in a legal manner should be made economically independent of their husbands if they cannot have their own income because of family circumstances. The procedure for divorce is to be simplified and made easier. A broad defense of children, especially illegitimate children, should be established through legislation. Laws should be promulgated to prohibit the establishment and maintenance of every kind of house of prostitution, "homes of tolerance" and commerce in female bodies, and to establish severe punishment of middlemen, souteneurs, and other people who derive material profit from trade in women or who contribute to their seduction into prostitution. Medical and police supervision of prostitution and prohibition of marriage by military men are to be abolished. Punishment for appearing drunk in public places, more severe punishment for crimes and misdemeanors committed under the influence of alcohol, and limitation (and, in time, a total ban) on the production and sale of spirits are to be promulgated.

7. Indirect taxes are abolished. So far as possible, a progressive income tax and progressive inheritance tax are to be introduced.

In the economic sphere, one should strive to abolish the unequal distribution of wealth and to [introduce] a more just compensation for labor. Each adult capable of working should earn his own means of existence; no one should live off the exploitation of others' labor. Industrial enterprises should be established primarily on collective artisan [artel'] principles or, at least, the workers should have the right to a certain percent of the profit. Legislative defense should exist for all forms of hired labor (including house servants). Inspection that is independent of entrepreneurs and that includes participation by elected representatives of the workers should oversee the enforcement of laws concerning the protection of labor. Inspection by women should be established, especially in those industrial enterprises where female labor is employed, but it should also be admitted to other establishments as well. An eight-hour working day should also be introduced. It may be increased or reduced, depending upon the nature of industry: in harmful industries, the working day should be reduced to the minimum feasible level, while in industries that are not harmful it can be increased, but only with the con-

sent of the workers and by no more than two hours [per day]. The workday should include a two-hour break for lunch and rest. Night work is permissible only for those kinds of production where it is [technically] unavoidable. Night work should not exceed six hours. Overtime work is prohibited. Use of child labor of either sex is prohibited for those of school age (under 16); adolescents between 16 and 18 are not to work more than six hours a day. Women are to be freed of work for four weeks before and six weeks after giving birth and are to receive their wages in full during this period. Childcare for infants and small children is to be established in all enterprises where women work or serve. Women who are still nursing infants are to be freed [from work] for one-half hour every three hours. To supervise women working in factors, female supervisors are to be appointed in lieu of male supervisors. Compensation for labor by both sexes is to be made equal, and equality is also to be established in their work relationships.

State insurance is to be established for all (without exception) for old age, illness and disability. Arbitration courts are to be established to resolve misunderstandings between workers and employers. Payment in kind is to be prohibited.

8. Peasant landholding is to be expanded through various means: transfer to peasant ownership or use of state, church and privately owned lands on terms that will be worked out by the popular assembly (according to local conditions) and that will facilitate the transfer of a sufficient quantity to the people so that they can cultivate [the land] by their own family and without using hired labor. Colonization [to Siberia] must be improved. Women have equal right to the use of land. Peasant women should have a land allotment equal to that of peasant men. Preservation of communal ownership or the transition to private household allotments should be left to the judgment of the peasants themselves. A broad development of agricultural cooperatives, unions and other organizations (with the goal of improving the material condition of small landowners) is needed. A rural inspectorate is needed wherever hired labor is used. It is necessary to have a broad development of model farms, experimental fields, and other institutions that can assist in improving agriculture.

9. Representatives of central authorities are only to exercise control over education. They are not to violate freedom of moral de-

velopment and education. The moral and educational aspects of the schools and other educational institutions are to be in the hands of local self-government organs; moreover, final authority over these matters belongs to people employed in moral development and education. Along with public and state schools, private schools that have been founded by private persons or organizations may also exist. Such schools are under the control of authorities but have freedom in their organization of moral and educational development. Women should have the right to hold all positions in schools. Education of both sexes is to be identical. There is to be equal, free, obligatory, universal and professional education for all children of both sexes until the age of 16 years. Free education in secondary and higher institutions of learning is desirable. Institutions of higher education are to have full autonomy. There is to be joint education of both sexes in all forms of schools, but separate schools for them are permissible. There are to be reforms in instruction in order to unite all schools (elementary, secondary and higher) so as to facilitate the transfer of children from one school to the next. Schools should give attention to the intellectual development of pupils; to the improvement in their moral level; to the ennoblement of their souls through a strengthening of their will; to the development of a sense of justice, respect for women, sensitivity to beauty, love and a devotion to general human ideals; and to physical development. There is to be a broad concern for professional, agricultural and extracurricular education.

10. There is to be a broad concern for public health with the aim of improving the sanitary conditions of life for the urban, rural and factory populations. Rational removal of human waste and refuse from populated areas, good water supplies, healthy and inexpensive housing for workers (and in general for all the unpropertied classes), and other useful institutions (e.g., playgrounds for children, public laundries, bathhouses, etc.) are to be established. There is also to be sanitation supervision over housing, food products and other items of consumption, every kind of hired labor (including house servants, industrial and commercial institutions, schools, etc); in addition, women are to be involved in supervision on the same terms as men. Criminal liability is to be established for violation of laws on the protection of labor and, in general, laws and binding decrees on the protection of public health. Medical assistance

is to be free. But the main effort is to be directed toward sanitary measures, which, by protecting the health of the populace and preventing illness, should reduce medical assistance to a minimum.

11. Militarism must be abolished and, instead of armies, a militia should be established. For defense against external foes, it is necessary to conclude arbitration agreements with all the neighboring countries that surround Russia, and to strive to develop peaceful unions between various groups of the Russian population with various foreign states. It is necessary to repudiate the policy of aggression and to direct efforts toward the peaceful development of the country.

140. Proclamation of Women Workers January 1906

Comrade Women Workers!

Your condition as women workers is intolerably onerous. . . . [sic] Your wages, compared with inflation, are so insignificant that every female worker is doomed to slow starvation, yet sometimes she has to support her family—young children, aged parents, and occasionally an unemployed husband or brother. . . . [sic] You work in stuffy, disgustingly filthy shops, where your weak strength is quickly exhausted and you are made vulnerable to every kind of disease, which quickly brings you to a premature death. But even the meager crust of bread that you earn by such hard work is not secure. [At] the slightest caprice of the supervisor or any other superior, the woman is mercilessly thrown out into the street—to cold, famine, poverty. . . . [sic] There is no need to speak of every kind of insult which you women workers must submissively tolerate on the part of the factory administration—after all, they regard you [as] defenseless, disunited people and treat you worse than any proprietor treats livestock that yields a profit.

But there is a way out of this intolerable situation. Helpless alone, you can form an enormous power by joining together in a Union of Women Workers! This Union makes its goal that of organizing and defending the female proletariat in order to form a single working family, pursuing one and the same goal: the pursuit

of the rights of man and citizen for each worker and the striving for a final victory of living human labor over a dead, soulless capitalism.

Hurry, comrades, respond to our fervent appeal, and in fraternal [*sic*] unity emerge victorious in the struggle for a brighter future.

Victory is ours!

Central Committee of the Union of Women Workers.

SOURCES

1. *Sbornik Imperatorskogo russkogo istoricheskogo obshchestva* [here-after *SIRIO*], 141 vols. (St. Petersburg, 1867–1916), 4: 224–37.
2. *SIRIO*, 4: 271–77.
3. *SIRIO*, 4: 265–71.
4. *SIRIO*, 93: 240–42.
5. *SIRIO*, 147: 138–40.
6. *SIRIO*, 123: 220.
7. *SIRIO*, 43: 42–62.
8. *SIRIO*, 93: 252–53.
9. Tsentral'nyi gosudarstvennyi istoricheskii arkhiv SSSR [hereafter TsGIA SSSR], f. 796 (Synod), op. 55, g. 1774, d. 96, ll.1–2.
10. *Dokumenty i materialy po istorii Moskovskogo Universiteta. Vtoraia polovina XVIII v.*, 3 (Moscow, 1963): 127.
11. *SIRIO*, 43: 371–73.
12. *SIRIO*, 43: 215–17.
13. *SIRIO*, 95: 119–34.
14. *SIRIO*, 93: 163–75.
15. *SIRIO*, 123: 90.
16. *SIRIO*, 123: 144–45.
17. *SIRIO*, 123: 162–63.
18. *SIRIO*, 123: 323–25.
19. *SIRIO*, 115: 197.
20. *SIRIO*, 123: 119–22.
21. *Pugachevshchina*, 1 (Moscow-Leningrad, 1926): 200–201.
22. Ibid., 1: 216–17.
23. *SIRIO*, 115: 260–64.
24. *SIRIO*, 115: 286–88.
25. *SIRIO*, 115: 107–8.
26. *SIRIO*, 115: 311–12.
27. *Regesty i nadpisi: Svod materialov dlia istorii evreev v Rossii*, 3 (St. Petersburg, 1913): 160.
28. M. F. Shugurov, "Istoriia evreev v Rossii," *Russkii arkhiv*, 1894, no. 2: 157–58.
29. TsGIA SSSR, f. 796, op. 49, g. 1768, d. 260, ll. 1–2.
30. "Adres tverskogo dvorianskogo obshchestva," *Pravdivyi*, 1862, no. 1 (23 March): 3.

31. TsGIA SSSR, f. 1282, op. 2, d. 1092, ll. 140–41 ob.
32. TsGIA SSSR, f. 1282, op. 2, d. 1092, ll. 23–25 ob.
33. TsGIA SSSR, f. 1282, op. 2, d. 1096, ll. 65–70.
34. TsGIA SSSR, f. 1282, op. 2, d. 1095, ll. 16–18 ob.
35. D. Shumakher, "Ob izmenenii shtatov po Khoziaistvennomu Departamentu," in TsGIA SSSR, f. 1287, op. 46, d. 1981, ll. 8–15.
36. TsGIA SSSR, f. 1412, op. 75, d. 222, l. 3–3 ob.
37. "Adres grazhdanskikh chinovnikov," *Kolokol*, 1861, no. 114 (Dec. 1): 949.
38. "Ot grazhdanskikh chinovnikov (v redaktsiiu *Kolokola*)," *Kolokol*, 1862, no. 131 (May 1): 1088–89.
39. "[Retsenziia]: D. K. Schedo-Ferroti, *Études sur l'avenir de la Russie*," *Russkii invalid*, 1862, nos. 175–77.
40. A. U. "Donskoi polk po sformulirovanii i na sluzhbe," *Donskie voiskovye vedomosti*, 1860, no. 35 (Sept. 6): 167–70.
41. TsGIA SSSR, f. 804, op. 1, r. 1, d. 60, ll. 2–15.
42. TsGIA SSSR, f. 804, op. 1, r. 3, d. 13, ll. 146–47 ob.
43. TsGIA SSSR, f. 804, op. 1, r. 1, d. 49, ll. 25–26 ob.
44. "Ustav obshchestva psikhiaterov," *Russkii invalid*, 1862, no. 10 (Jan. 17): 2.
45. I. Neskrov, "Tovarishchestvo russkikh tekhnikov," *Narodnoe bogatstvo*, 1863, no. 76 (Apr. 10): 303–4.
46. "Ob uchrezhdenii vspomogatel'noi meditsinskoi kassy," *Meditsinskii vestnik*, 1861, no. 1: 1–3.
47. Floriks, "Zametka o pravakh narodnykh uchiteliakh po novomu proekty obshche-obrazovatel'nykh uchebnykh zavedenii," *Uchitel'*, 1863, no. 6 (March): 335–42.
48. "Adres moskovskikh studentov," *Kolokol*, 1862, no. 121 (Feb. 1): 1009–10.
49. Opinion on urban reform, filed by the city commission in Gorokhovets (Vladimir Province), in TsGIA SSSR, f. 1287, op. 37, d. 2148, ll. 181–91.
50. TsGIA SSSR, f. 1287, op. 37, d. 2146, ll. 28–30 ("Mnenie ot deputata tsekhovogo obshchestva Efima Kotova").
51. "Mnenie sukonnykh fabrikantov o tarife na sherstianye izdeliia," *Aktsioner*, 1862, no. 23 (June 9): 177–78.
52. "Ustav obshchestva dlia sodeistviia protsvetaniia otechestvennoi promyshlennosti," *Russkii invalid*, 1862, no. 5 (Jan. 9): 2.
53. "Russkoe kupecheskoe obshchestvo dlia vzaimnogo vspomozheniia," *Russkii invalid*, 1862, no. 8 (Jan. 12): 1.
54. "Svod zamechanii na izdannyi v 1860 g. 'Proekt pravil dlia fabrik i zavodov v S.-Peterburge i uezde,'" *Trudy Komissii uchrezhdennoi*

dlia peresmotra ustavov fabrichnykh i remeslennykh, 2 (St. Petersburg, 1863), appendix 15, pp. 275–92.

55. [Portnoi] F. Domanskii, "Slovo o remesle," *Russkii remeslennik,* 1862, no. 12: 22–24.

56. "Soderzhanie rabochikh v sele Pavlove," *Russkii remeslennik,* 1863, no. 5: 24.

57. TsGIA SSSR, f. 1291, op. 52, g. 1862, d. 27, ll. 12–13 ob.

58. TsGIA SSSR, f. 1291, op. 52, g. 1863, d. 72, ll. 6–7.

59. TsGIA SSSR, f. 1291, op. 52, g. 1861, d. 38, ll. 168–71 ob.

60. *Krest'ianskoe dvizhenie v Rossii v 1861–1869 gg. Sbornik dokumentov* (Moscow, 1964), pp. 123–24.

61. TsGIA SSSR, f. 219, op. 1, d. 6518, ll. 1–3.

62. *Rabochee dvizhenie v Rossii v XIX v.,* vol. 2, pt. 1 (Moscow, 1950): 108–9.

63. Ibid., pp. 181–83.

64. *Polozhenie rabochikh Urala vo vtoroi polovine XIX v.-nachalo XX v. Sbornik dokumentov* (Moscow-Leningrad, 1964), pp. 577–78.

65. "Ograblenie tserkvi i liudei (kopiia s proshenii)," *Obshchee veche (pribavlenie k Kolokolu),* 1862, no. 1 (June 15): 3–4.

66. "Adres ot Bobruiskogo evreiskogo obshchestva," *Sovremennyi listok,* 1863, no. 19 (May 12): 198.

67. "Otvet *Siona,* organa russkikh evreev, redaktoru *Dnia,*" *Den',* 1862, no. 33 (May 20): 5–8.

68. "Ob"iavlenie ob izdanii literaturnogo zhurnala, *Zhenskii vestnik,*" *Zhenskii vestnik,* 1866, no. 1 (advertisement).

69. "Postanovleniia s"ezda predvoditelei dvorianstva v Moskve," *Pravo,* 1906, no. 4 (Jan. 29): 330–33.

70. "Ekaterinoslavskoe dvorianstvo. Vsepoddanneishii adres," *Novoe vremia,* 1906, no. 10769 (March 8).

71. "Polozheniia vyrabotannye s"ezdom Kruzhka dvorian 22–25 aprelia 1906 g.," *Kruzhok dvorian vernykh prisiage. Otchet s"ezda 22–25 aprelia 1906 g. s prilozheniem* (Moscow, 1906): 1–4.

72. A. A. Belozerov, "Opyt istorii Nizhegorodskikh gorodksikh professional'nykh soiuzov," *Rabochee i profsoiuznoe dvizhenie v Nizhegorodskom krae 1869–1917 gg.,* ed. V. G. Illarionov (Nizhnii Novgorod, 1923), p. 99.

73. *Revoliutsiia 1905–1907 gg. v Prikam'e. Dokumenty i materialy* (Molotov, 1955), p. 148.

74. TsGIA SSSR, f. 796, op. 187, g. 1906, d. 6608, l. 26–26 ob.

75. "Tsirkuliar Departamenta Zemleustroistva," *Birzhevye vedomosti,* 1906, no. 9160 (Jan. 8): 3.

76. Police copy of handwritten hectograph reprinted in K. V. Bazilevich,

Ocherki po istorii profsoiuznogo dvizheniia rabotnikov sviazi 1905–6 gg. (Moscow, 1925), pril., pp. 65–69.

77. Ibid., pp. 79–80.

78. "Otkrytoe pis'mo k chlenam Pervoi Rossiiskoi Gosudarstvennoi Dumy," *Nasha zhizn'*, 1906, no. 433 (Apr. 30): 3.

79. TsGIA SSSR, f. 1278, op. 1 (44), 1 sozyv, d. 236, ll. 106–7.

80. *Golos truda*, 1906, no. 4 (June 24): 2.

81. "Zaiavlenie ofitserov Vtorogo Pekhotskogo Sibirskogo Chitinskogo Polka," *Pravo*, 1906, no. 6 (Feb. 11): 525–26.

82. *Vtoroi period revoliutsii 1906–1907 gg. Ianvar'–aprel' 1906 g.*, pt. 1, bk. 1 (Moscow, 1957), pp. 318–19 (doc. 204).

83. *Khrestomatiia po istorii rodnogo kraia* (Volgograd, 1970), pp. 142–43.

84. "Obrashchenie," *Birzhevye vedomosti*, 1906, no. 9166 (Jan. 16).

85. *Otzyvy eparkhial'nykh arkhiereev po voprosu o tserkovnoi reforme,* pt. 3 (St. Petersburg, 1906): 344–57.

86. TsGIA SSSR, f. 796, op. 187, g. 1906, d. 6574, ll. 3–4.

87. "Soiuz tserkovnogo obnovleniia," *Tserkovno-obshchestvennaia zhizn'*, 1906, no. 5 (Jan. 20): 185–86.

88. TsGIA SSSR, f. 796, op. 187, g. 1906, d. 6809, l. 16.

89. *Revolutsionnoe dvizhenie v Orlovskoi gubernii v period pervoi russkoi revoliutsii 1905–1907 gg.* (Orel, 1957), pp. 112–13.

90. "Obrashchenie k zemstvam," *Kliaz'ma*, 1906, no. 19 (Jan. 21), special supplement.

91. "V Pirogovskom Obshchestve," *Rech'*, 1906, no. 3 (Feb. 25): 3.

92. "Rezoliutsii obshchego sobraniia Peterburgskikh prisiazhnykh poverennykh," *Pravo*, 1906, no. 6 (Feb. 11): 529.

93. TsGIA SSSR, f. 1278, op 1 (114), g. 1906, d. 236, l. 73.

94. TsGIA SSSR, f. 1278, op. 1 (114), g. 1906, d. 287, l. 123–123 ob.

95. "Vserossiiskii s"ezd Soiuza Inzhenerov. Rezoliutsii," *Nasha zhizn'*, 1906, no. 428 (Apr. 25): 4.

96. "Zapiska Moskovskogo birzhevogo komiteta S. Iu. Vitte," *Torgovo-promyshlennaia gazeta*, 1906, no. 16 (Jan. 20).

97. *Trudy XXX s"ezda gornopromyshlennikov Iuga Rossii*, 2 (Khar'kov, 1906), pt. 2, no. 2: 24–25.

98. TsGIA SSSR, f. 1278, op. 1 (114), g. 1906, d. 291, l. 109–109 ob.

99. TsGIA SSSR, f. 150, op. 1, d. 3, l. 147.

100. "Zaiavlenie 26 moskovskikh firm v torgovo-promyshlennyi s"ezd," *Novoe vremia*, 1906, no. 10716 (Jan. 13).

101. TsGIA SSSR, f. 1278, op. 1 (114), g. 1906, d. 244, l. 86–86 ob.

102. TsGIA SSSR, f. 796, op. 186, g. 1905, d. 894, l. 38.

103. *Russkoe znamia*, 1906, no. 116 (May 8): 3.

104. *Novoe vremia*, 1906, no. 10729 (Jan. 26).

105. K. Pnin, "Iz istorii profsoiuznogo dvizheniia torgovykh sluzhashchikh v Peterburge," *Materialy po istorii profsoiuznogo dvizheniia v Rossii*, 3 (Moscow, 1925): 289.

106. *Revoliutsionnoe dvizhenie v Pskovskoi gubernii v 1905–7 gg.* (Pskov, 1956): 145.

107. "Programma Remeslennoi Partii," *Nasha zhizn'*, 1906, no. 368 (Feb. 11): 3.

108. "Soiuz podmaster'ev vodoprovodchikov. Vozzvanie," *Professional'-nyi soiuz*, 1906, no. 8 (Jan. 29): 6–7.

109. "Soiuz bulochnikov, konditerov i baranochnikov. Vozzvanie," ibid., no. 13 (March 19): 12.

110. "Ot soiuza kontorshchikov i bukhgalterov," *Kontorshchik*, 1906, no. 2 (Jan. 26): 14.

111. "Moskovskii soiuz kontorshchikov i bukhgalterov," ibid., no. 4 (Feb. 9): 12.

112. TsGIA SSSR, f. 1278, op. 1, g. 1906, d. 236, l. 51.

113. TsGIA SSSR, f. 1278, op. 1, g. 1907, d. 785, ll. 61–64.

114. TsGIA SSSR, f. 1278, op. 1, g. 1906, d. 244, ll. 138–39 ob.

115. TsGIA SSSR, f. 1278, op. 1, g. 1906, d. 287, ll. 33–34.

116. TsGIA SSSR, f. 1278, op. 1, g. 1906, d. 238, l. 1–1 ob.

117. TsGIA SSSR, f. 1278, op. 1, g. 1906, d. 237, ll. 206–8.

118. TsGIA SSSR, f. 1278, op. 1, g. 1906, d. 237, ll. 9–14.

119. TsGIA SSSR, f. 1278, op. 1, g. 1906, d. 288, l. 89.

120. TsGIA SSSR, f. 1278, op. 1, g. 1906, d. 237, ll. 108–9.

121. TsGIA SSSR, f. 1278, op. 1, g. 1906, d. 238, ll. 27–28.

122. TsGIA SSSR, f. 1278, op. 1, g. 1906, d. 238, l. 29–29 ob.

123. *Nasha zhizn'*, 1906, no. 376 (Feb. 22): 4.

124. *Pravo*, 1906, no. 10 (12 March): 938.

125. "K tovarishcham kozhennogo tsekha," *Rabochee slovo*, 1906, no. 4 (April 6): 3.

126. F. A. Bulkin, ed., *Na zare profsoiuznogo dvizheniia* (Moscow-Leningrad, 1924), pp. 481–85.

127. *Rech'*, 1906, no. 46 (Apr. 12): 4.

128. *Kliaz'ma*, 1906, no. 130 (26 May): 3.

129. *Golos truda*, 1906, no. 2 (June 22): 1–2.

130. Ibid., p. 2.

131. Ibid., no. 3 (June 23): 2.

132. "Nakaz chlenu Gosudarstvennoi Dumy," *Rabochee slovo*, 1906, no. 21 (Apr. 29): 2.

133. *Moskovskie tekstil'shchiki v gody pervoi revoliutsii (1905–7 gg.)* (Moscow, 1929), p. 190.

134. Ibid., p. 195.
135. "Vserossiiskii s"ezd staroobriadtsev," *Kliaz'ma*, 1906, no. 51 (Feb. 25): 3.
136. "Soiuz dlia dostizheniia ravnopraviia Evreev v Rossii. Vozzvanie," *Rech'*, 1906, no. 3 (Feb. 25): 4.
137. "Rezoliutsii III delegatskogo s"ezda Soiuza ravnopraviia Evreev," *Pravo*, 1906, no. 8 (Feb. 26): 708–10.
138. "Petitsiia russkikh zhenshchin v Gosudarstvennuiu Dumu," ibid., 707–8.
139. "Programma Zhenskoi Progressivnoi Partii," *Zhenskii vestnik*, 1906, no. 1 (Jan.): 26–29.
140. "[Vozzvanie k rabotnitsam]," *Rabochaia gazeta*, 1906, no. 5 (Jan. 24): 2.

BIBLIOGRAPHY

Part One THE CATHERINEAN ERA

GENERAL: Ia. Abramov, "Soslovnye nuzhdy, zhelaniia i stremleniia v epokhu Ekaterinskuiu komissiiu," *Severnyi vestnik*, 1886, nos. 4, 6–8; V. N. Bochkarev, "Kul'turnye zaprosy russkogo obshchestva nachala tsarstvovaniia Ekateriny II po materialam Zakonodatel'noi komissii 1767 g.," *Russkaia starina*, 1915, nos. 1–5; Paul Dukes, *The Makings of Russian Absolutism, 1613–1801* (New York, 1982); A. V. Florovskii, *Sostav Zakonodatel'noi Komissii 1767–1774 gg.* (Odessa, 1915); Isabel de Madariaga, *Russia in the Age of Catherine the Great* (New Haven, 1981); Marc Raeff, *Imperial Russia, 1682–1825* (New York, 1970).

A. NOBILITY: W. R. Augustine, "The Economic Attitudes and Opinions Expressed by the Russian Nobility in the Great Commission of 1767" (Ph.D. diss., Columbia University, 1969); M. Confino, *Domaines et seigneurs en Russie vers la fin du XVIIIe siécle* (Paris, 1963); Paul Dukes, *Catherine the Great and the Russian Nobility. A Study Based on the Materials of the Legislative Commission* (Cambridge, 1967); R. L. Givens, "Supplication and Reform in the Instructions of the Nobility," *Canadian-American Slavic Studies*, 11 (1977): 483–502; R. L. Jones, *The Emancipation of the Russian Nobility* (Princeton, 1974); Marc Raeff, *Origins of the Russian Intelligentsia; the Eighteenth-Century Nobility* (New York, 1966).

B. BUREAUCRACY AND ARMY: J. L. H. Keep, *Soldiers of the Tsar* (Oxford, 1985); W. M. Pintner and D. Rowney, eds., *Russian Officialdom. The Bureaucratization of Russian Society from the Seventeenth to the Twentieth Century* (Chapel Hill, 1980); S. M. Troitskii, *Russkii absolutizm i dvorianstvo v XVIII v.* (Moscow, 1974).

C. THE ORTHODOX CLERGY: E. Bryner, *Der geistliche Stand in Rußland im 18. Jahrhundert* (Göttingen, 1982); G. L. Freeze, *The Russian Levites: Parish Clergy in the Eighteenth Century* (Cambridge, 1977); I. M. Pokrovskii, *Ekaterinskaia komissiia o sostavlenii Novogo Ulozheniia i tserkovnye voprosy v nei* (Kazan, 1910); I. M. Prilezhaev, "Nakaz i punkty deputatu ot Sv. Sinoda v Ekaterinskuiu komissiiu o sochinenii proekta Novogo Ulozheniia," *Khristianskoe chtenie*, 1876, II: 223–65.

D. PROFESSIONS AND EDUCATED ELITES: John Alexander, *Bubonic Plague*

in Catherinean Russia. Public Health in Early Modern Russia (Baltimore, 1980); M. M. Shtrange, *Demokraticheskaia intelligentsiia Rossii XVIII v.* (Moscow, 1965).

E. URBAN SOCIETY: Francois-Xavier Coquin, *La Grande Commission Legislative, 1767–68. Les cahiers de doléances urbains (Province de Moscou)* (Paris, 1972); idem, "Un document d'histoire sociale: le cahier de doléances de la ville de Moscou (printemps 1767)," *Révue d'historique*, 1971, no. 1; W. Daniel, "The Merchants' View of the Social Order in Russia as Revealed in the Town *Nakazy* from Moskovskaia Guberniia to Catherine's Legislative Commission," *Canadian-American Slavic Studies*, 11 (1977): 503–22; Manfred Hildermeier, *Bürgertum und Stadt in Rußland, 1760–1860. Rechtliche Lage und soziale Struktur* (Cologne, 1986); J. M. Hittle, *The Service City. State and Townsmen in Russia, 1600–1800* (Cambridge, 1979); Bernd Knabe, *Die Struktur des russischen Posadgemeindes und das Katalog der Beschwerden und Forderungen der Kaufmannschaft, 1762-1767* ("Forschungen zur Osteuropäischen Geschichte," vol. 22) (Berlin, 1975); I. M. Pokrovskaia, "Nakazy ot gorodov Sibiri v Ulozhennuiu Komissiiu 1767 g. kak istoricheskii istochnik," *Arkheograficheskii ezhegodnik za 1961 god* (Moscow 1962), pp. 82–98; L. S. Rafienko, "Otvety sibirskikh gorodov na ankety Komissi o komertsii kak istocheskii istochnik," *Arkheografiia i istochnikovedenie Sibiri* (Novosibirsk, 1975); K. V. Sivkov, "Nakaz zhitelei Moskvy deputatu komissii 1767 g. i zakonodatel'naia deiatel'nost' imp. Ekateriny II v 60–80 godakh XVIII v.," *Uchenye zapiski Mosk. Gos. Ped. Instituta im. V. I. Lenina*, 60 (1949): 193–222; S. Voznesenskii, "Gorodskie deputatskie nakazy v Ekaterinskuiu Komissiiu 1767 g.," *Zhurnal Ministerstva narodnogo prosveshcheniia*, 1909, no. 11: 89–119, no. 12: 241–84.

F. PEASANTRY: M. T. Beliavskii, "Nakazy sibirskikh krest'ian v Ulozhennuiu komissiiu 1767 g.," *Arkheografiia i istochnikovedenie Sibiri* (Novosibirsk, 1975); idem, "Nakazy Orenburgskikh odnodvortsev 1767 g.," *Vestnik Moskovskogo Gos. Universiteta*, Seriia: Istoriia, 1982, no. 6: 69–79; S. A. Omel'chenko and M. T. Beliavskii, "Nakazy Tobol'skogo kraia v Ulozhennuiu komissiiu 1767 g.," *Sibirskoe istochnikovedenie i arkheografiia* (Novosibirsk, 1980): 185–207; V. Bogoliubov, "Ekonomicheskii byt krest'ian severnogo kraia po krest'ianskim nakazam v Ekaterininskuiu zakonodatel'nuiu komissiiu 1767 g.," *Uchenye zapiski Imperatorskogo Kazanskogo Universiteta*, 80 (1913): nos. 1–4 (sep. pagination: 1–120); E. G. Gorokhova, "Nakazy krest'ian russkogo severa v Ulozhennuiu komissiiu 1767–1768 gg. kak istoricheskii istochnik" (Kand. diss., Moscow, 1982); P. V. Ivanov, "Sotsial'no-politicheskie nastroeniia i predstavleniia

gosudarstvennykh krest'ian i rabotnykh liudei v Rossii 40–60-kh godov XVIII v.," *Uchenye zapiski Kurskogo Gos. Ped. Instituta,* 78 (1970): 125–213; A. A. Kondrashenko, "Krest'iane Priural'ia po nakazam v komissiiu 1767 g.," *Uchenye zapiski Kurganskogo Gos. Ped. Instituta,* 5 (1963): 85–106; F. I. Lappo, "Nakazy odnodvortsov kak istoricheskii istochnik," *Istoricheskie zapiski,* 35 (1950): 232–64; M. F. Prokhorov, "Pomeshchich'i krest'iane Moskovskoi gubernii v tret'ei chetverti XVIII v." (Kand. diss., Moscow, 1975); D. S. Raskin, "Ispol'zovanie zakonodatel'nykh aktov v krest'ianskikh chelobitnykh serediny XVIII v.," *Istoriia SSSR,* 1979, no. 4: 179–92; N. L. Rubinshtein, "Krest'ianskoe dvizhenie v Rossii vo vtoroi polovine XVIII v.," *Voprosy istorii,* 1956, no. 11: 34–51; V. Semevskii, *Krest'iane v tsarstvovanie Ekateriny II,* 2 vols. (St. Petersburg, 1901–02).

G. INDUSTRIAL WORKERS: V. N. Bernadskii, "Dvizhenie pripisnykh krest'-ian v 50–70-kh godakh XVIII v.," *Voprosy istorii,* 1953, no. 8: 41–56; idem, "Ocherki po istorii klassovoi bor'by Rossii v tret'ei chetverti XVIII v.," *Uchenye zapiski Gos. Ped. Instituta im. Gertsena,* 229 (1962): 42–65; M. N. Martynov, "Nakazy pripisnykh krest'ian kak istoricheskii istochnik," *Arkheograficheskii ezhegodnik za 1963 god* (Moscow, 1964): 141–57; *Materialy po istorii volnenii na krepostnykh manufakturakh v XVIII v.* (Moscow, 1937); A. S. Orlov, *Volneniia na Urale v seredine XVIII v.* (Moscow, 1979); R. Portal, "Manufactures et classes sociales en Russie au XVIII siécle," *Révue historique,* 1949, no. 3; 1950, no. 1.

H. MINORITIES AND WOMEN: D. Atkinson, ed., *Women in Russia* (Stanford, 1980); R. O. Crummey, *The Old Believers and the World of Antichrist* (Madison, 1970); M. Hildermeier, "Die jüdische Frage im Zarenreich," *Jahrbücher für Geschichte Osteuropas,* 32 (1984): 321–57; J. Klier, *Russia Gathers Her Jews. The Origins of the Jewish Question in Russia, 1772–1825* (DeKalb, 1986); A. Kappeler, *Rußlands erste Nationalitäten. Das Zarenreich und die Völker vom 16. bis 19. Jahrhundert* (Cologne, 1982); C. S. Nash, "The Education of Women in Russia, 1762–1796" (Ph.D. diss., New York University, 1978); R. Pipes, "Catherine II and the Jews," *Soviet Jewish Affairs,* 5 (1975): 3–20.

Part Two THE ERA OF GREAT REFORMS:
SOCIETY IN THE 1860s

GENERAL: I. Dzhanshiev, *Epokha velikh reform* (6th ed.; Moscow, 1896); G. Schramm, ed., *Handbuch der Geschichte Rußlands,* 3 (Stuttgart, 1983): 5–201; Hugh Seton-Watson, *The Russian Empire, 1801–*

1917 (Oxford, 1967); *Velikaia reforma* (*19 fevralia 1861–1911*), 6 vols. (Moscow, 1911).

A. NOBILITY: Terence Emmons, *The Russian Landed Gentry and the Peasant Emancipation of 1861* (Cambridge, 1968); Daniel Field, *The End of Serfdom* (Cambridge, 1976); A. P. Korelin, *Dvorianstvo v poreformennoi Rossii 1861–1904 gg.* (Moscow, 1979); I. P. Popov, "Tverskoe vystuplenie 1862 g. i ego mesto v sobytiiakh revoliutsionnoi situatsii," *Revoliutsionnaia situatsiia v Rossii v 1859–61 gg.*, 6 (Moscow, 1974): 257–77.

B. BUREAUCRACY AND ARMY: D. Beyrau, *Studien zu Militär und Gesellschaft Rußlands im 18. und 19. Jahrhunderts* (Cologne, 1984); V. A. Diakov, "Proekt 106 ofitserov," *Revoliutsionnaia situatsiia v Rossii 1859–61 gg.*, 1 (Moscow, 1960): 224–37; V. E. Fil'gus, "Karta revoliutsionnogo dvizheniia v russkoi armii v 1861–63 gg.," *Revoliutsionnaia situatsiia v Rossii v 1859–61 gg.*, 1 (Moscow, 1960): 238–45; J. L. H. Keep, *Soldiers of the Tsar* (Oxford, 1985); W. B. Lincoln, *In the Vanguard of Reform: Russia's Enlightened Bureaucrats, 1825–1861* (DeKalb, 1982); R. H. McNeal, *Tsar and Cossack, 1855–1914* (London, 1984); Hans-Joachim Torke, "Das russiche Beamtentum in der ersten Hälfte des 19. Jh.," *Forschungen zur Osteuropäischen Geschichte*, 13 (1967): 7–345; E. Wirtschafter, "A Social History of the Lower Ranks in the Russian Army, 1796–1855" (Ph.D. diss., Columbia University, 1983); P. A. Zaionchkovskii, *Pravitel'stvennyi apparat samoderzhavnoi Rossii XIX v.* (Moscow, 1978).

C. THE ORTHODOX CLERGY: I. S. Belliustin, *Description of the Clergy in Rural Russia* (Ithaca, 1985); G. L. Freeze, *The Parish Clergy in Nineteenth-Century Russia: Crisis, Reform, Counter-Reform* (Princeton, 1983); J. Oswalt, *Kirchliche Gemeinde und Bauernreform* (Göttingen, 1975).

D. PROFESSIONS AND EDUCATED ELITES: H. D. Balzer, "Educating Engineers: Economics, Politics and Technical Training in Tsarist Russia" (Ph.D. diss., University of Pennsylvania, 1980); Daniel Brower, *Training the Nihilists* (Ithaca, 1975); J. Brown, "The Professionalization of Russian Psychiatry, 1857–1911" (Ph.D. diss., University of Pennsylvania, 1981); N. G. Filippov, "Nauchno-tekhnicheskie obshchestva dorevoliutsionnoi Rossii," *Voprosy istorii*, 1985, no. 3: 31–45; Nancy Frieden, *Russian Physicians in an Era of Reform and Revolution, 1856–1905* (Princeton, 1981); Dietrich Geyer, "Zwischen Bildungsbürgertum und Intelligenzija: Staatsdienst und akademische Professionalisierung im vorrevolutionären Rußland," in Werner Conze and Jürgen Kocha, eds., *Bildungsbürgertum im 19. Jahrhundert* (Stuttgart, 1985), pp. 207–30; A. Gleason, *Young*

Russia: The Genesis of Russian Radicalism in the 1860s (New York, 1980); Thomas J. Hegarty, "The Student Movement in Russian Universities, 1855–61" (Ph.D. diss., Harvard University, 1965); V. R. Leikina-Svirskaia, "Formirovanie raznochinskoi intelligentsii v Rossii v 40-kh godakh XIXv.," *Istoriia SSSR,* 1958, no. 1: 83–104; idem., *Intelligentsiia v Rossii vo vtoroi polovine XIX v.* (Moscow, 1971); R. S. Wortman, *The Development of Russian Legal Consciousness* (Chicago, 1976).

E. URBAN SOCIETY: D. Brower, "Urbanization and Autocracy: Russian Urban Development in the First Half of the Nineteenth Century," *Russian Review,* 42 (1983): 377–402; Manfred Hildermeier, *Bürgertum und Stadt in Rußland, 1760–1870. Rechtliche Lage und soziale Struktur* (Cologne, 1986); L. T. Hutton, "The Reform of Government in Russia, 1860–1870" (Ph.D. diss., University of Illinois, 1972); V. Ia. Laverychev, *Krupnaia burzhuaziia v poreformennoi Rossii 1861–1900* (Moscow, 1974); Thomas Owens, *Capitalism and Politics in Russia* (Cambridge, 1981); Alfred Rieber, *Merchants and Entrepreneurs in Imperial Russia* (Chapel Hill, 1982); J. A. Ruckmann, *Moscow's Business Elite: Social and Cultural Portrait of Two Generations, 1840–1905* (DeKalb, 1984); P. G. Ryndziunskii, *Gorodskoe grazhdanstvo doreformennoi Rossii* (Moscow, 1958).

F. PEASANTRY: T. Emmons, "The Peasants and Emancipation," in W. Vucinich, ed., *The Peasant in Nineteenth-Century Russia* (Stanford, 1968); V. A. Fedorov, "Lozungi krest'ianskoi bor'by v 1861–63 gg.," *Revoliutsionnaia situatsiia v Rossii v 1859–61 gg.,* 3 (Moscow, 1963), pp. 237–58; Daniel Field, *Rebels in the Name of the Tsar* (Boston, 1976); V. I. Krutikov, "Krest'ianskoe dvizhenie v Tul'skoi gubernii v 1858–63 gg.," *Ezhegodnik po agrarnoi istorii Vostochnoi Evropy. 1963 god* (Vilnius, 1964), pp. 709–15; V. I. Krutikov, "O kharaktere krest'ianskikh vystuplenii v period razlozheniia feodal'no-krepostnicheskoi sistemy i pervoi revoliutsionnoi situatsii v Rossii," *Ezhegodnik po agrarnoi istorii Vostochnoi Evropy. 1964 god* (Kishinev, 1966), pp. 593–602; N. N. Leshchenko, "Krest'ianskaia reforma 1861 g. v Khar'kovskoi gubernii," ibid., pp. 603–14; B. G. Litvak, "Dvizhenie pomeshchich'ikh krest'ian v Velikorusskikh guberniiakh v 1855–1863 gg. (statisticheskie itogi anketnogo obsledovaniia mestnykh arkhivov)," ibid., pp. 558–71.

G. INDUSTRIAL WORKERS: T. Esper, "The Condition of the Serf Workers in Russia's Metallurgical Industry, 1800–1861," *Journal of Modern History,* 50 (1978): 660–79; T. M. Iagodin, " 'Rabochii vopros v russkoi legal'noi demokraticheskoi presse 60-kh gg. XIX v.," *Trudy Istoriko-arkhivnogo Instituta,* 9 (1957): 113–37; G. V. Rimlinger,

"Autocracy and the Factory Order in Early Russian Industrialization," *Journal of Economic History*, 20 (1960): 67–92; V. A. Sobolev, "Rabochee dvizhenie 60–70-kh gg. v Viatskoi gubernii," *Uchenye zapiski Gor'kovskogo Gos. Ped. Instituta*, 97 (1971): 111–20; Ch. G. Volodarskaia, "Klassovaia bor'ba possessionnykh fabrichnykh obrabatyvaiushchei promyshlennosti v 1800–60 godakh," *Uchenye zapiski Leningradskogo Gos. Ped. Instituta im. Gertsena*, 131 (1957): 149–236; R. E. Zelnik, *Labor and Society in Tsarist Russia. The Factory Workers of St. Petersburg, 1855–70.* (Stanford, 1971); idem, "An Early Case of Labor Protest in St. Petersburg: The Aleksandrovsk Machine Works in 1860," *Slavic Review*, 24 (1965): 507–20.

H. MINORITIES AND WOMEN: A. S. Beliaeff, "The Rise of the Old Orthodox Mechants of Moscow, 1771–1784" (Ph.D. diss., Syracuse University, 1975); Barbara Engels, *Mothers and Daughters: Women of the Intelligentsia in Nineteenth-Century Russia* (Cambridge, 1983); J. Frankel, *Prophecy and Politics: Socialism, Nationalism and Russian Jews 1862–1917* (New York, 1981); J. D. Klier, "The Jewish Question in the Reform Era Press, 1855–1865," *Russian Review*, 39 (1980): 301–319; Richard Stites, *The Women's Liberation Movement in Russia* (Princeton, 1978); G. A. Tishkin, *Zhenskii vopros v 50–60-e gody XIX v.* (Leningrad, 1983); S. L. Zipperstein, "Jewish Enlightenment in Odessa: Cultural Characteristics, 1794–1871," *Jewish Social Studies*, 44 (1982): 19–36.

Part Three SOCIETY IN REVOLUTION, 1905–1906

GENERAL: B. V. Anan'ich et al., *Krizis samoderzhaviia v Rossii 1895–1917 gg.* (Leningrad, 1984); T. Emmons, *The Formation of Political Parties and the First National Elections in Russia* (Cambridge, 1983); S. Harcave, *First Blood: the Russian Revolution of 1905* (London, 1969); G. Schramm, ed., *Handbuch der russischen Geschichte*, 3 (Stuttgart, 1983): 203–384; T. Shanin, *The Roots of Otherness: Russia's Turn of the Century* 2 vols. (New Haven, 1986).

A. NOBILITY: Gary Hamburg, *The Politics of the Russian Nobility, 1881–1905* (New Brunswick, 1984); T. S. Hause, "State and Gentry in Russia, 1861–1917" (Ph.D. diss., Stanford University, 1973); A. P. Korelin, *Dvorianstvo v poreformennoi Rossii, 1861–1904* (Moscow, 1979); Roberta T. Manning, *Crisis of the Old Order in Russia* (Princeton, 1982); G. W. Simmonds, "The Congress of Representatives of the Nobles' Associations, 1906–1916: A Case Study of Russian Conservatism" (Ph.D. diss., Columbia University, 1964); Iu. B. Solov'ev, *Samoderzhavie i dvorianstvo v 1905–1907 gg.* (Leningrad, 1981).

B. BUREAUCRACY AND ARMY: John Bushnell, *Mutiny and Repression. Russian Soldiers in the Revolution of 1905–1906* (Bloomington, 1985); W. J. Fuller, *Civil-Military Conflict in Imperial Russia, 1881–1914* (Princeton, 1985); A. Lewin, "Russian Bureaucratic Opinion in the Wake of the 1905 Revolution," *Jahrbücher für Geschichte Osteuropas,* 11 (1963): 1–12; D. C. B. Lieven, "Russian Senior Officials under Nicholas II," ibid., 32 (1984): 190–223; W. P. Pintner and D. Rowney, eds., *Russian Officialdom; the Bureaucratization of Russian Society from the Seventeenth to the Twentieth Century* (Chapel Hill, 1980); P. A. Zaionchkovskii, "Soslovnyi sostav ofitserskogo korpusa na rubezhe XIX–XX vekov," *Istoriia SSSR,* 1973, no. 1: 148–54.

C. THE ORTHODOX CLERGY: J. S. Curtiss, *Church and State in Russia, 1900–1917* (New York, 1940); J. H. M. Geekie, "Church and Politics in Russia, 1900–1917: A Study of Political Behavior of the Russian Orthodox Church in the Reign of Nicholas II" (Ph.D. diss., East Anglia, 1976); P. E. Immekus, *Die russisch-orthodoxe Kirche zu Beginn des XX. Jahrhunderts nach den Gutachten der Diözesanbischöfe* (Würzburg, 1978).

D. PROFESSIONS AND EDUCATED ELITES: A. K. Erman, *Intelligentsiia v pervoi russkoi revoliutsii* (Moscow, 1966); N. G. Filippov, "S"ezdy, sozvannye russkim tekhnicheskim obshchestvom v 1870–1904 gg.," *Trudy istoriko-arkhivnogo instituta,* 19 (1965): 207–72; J. F. Hutchinson, "Society, Corporation or Union? Russian Physicians and the Struggle for Professional Unity, 1890–1917," *Jahrbücher für Geschichte Osteuropas,* 30 (1982): 37–53; A. E. Ivanov, "Demokraticheskoe studenchestvo v revoliutsii 1905–1907 gg.," *Istoricheskie zapiski,* 107 (1982): 171–225; K. Jarausch, ed., *The Transformation of Higher Learning, 1860–1930* (Stuttgart, 1983); V. R. Leikina-Svirskaia, *Russkaia intelligentsiia v 1900–1917 gg.* (Moscow, 1978); *Revoliutsionnoe dvizhenie demokraticheskoi intelligentsii v period imperializma* (Moscow, 1984); Jonathan B. Sanders, "The Union of Unions: Political, Economic, Civil and Human Rights Organizations in the 1905 Russian Revolution" (Ph.D. diss., Columbia University, 1985); S. J. Seregny, "Professional and Political Activism: The Russian Teachers' Movement, 1864–1908" (Ph.D. diss., University of Michigan, 1982); Manfred Späth, *Fach- und Standesvereinigungen russischer Ingenieure 1900–1914* ("Forschungen zur osteuropäischen Geschichte, vol. 35) (Berlin, 1984).

E. URBAN SOCIETY: Joseph Bradley, *Muzhik and Muscovite: Urbanization in Late Imperial Russia* (Berkeley, 1985); C. A. Goldberg, "The Association of Industry and Trade, 1906–1917" (Ph.D. diss., University of Michigan, 1974); N. A. Ivanova and V. V. Shchegolaev, "Torgovye sluzhashchie v revoliutsii 1905–07 gg.," *Istoricheskie*

zapiski, 101 (1978): 160–216; M. Joffe, "The Cotton Manufacturers in the Central Industrial Region 1880s–1914: Merchants, Economics and Politics" (Ph.D. diss., University of Pennsylvania, 1981); A. J. Rieber, *Merchants and Entrepreneuers in Imperial Russia* (Chapel Hill, 1982); S. E. Sef, *Burzhuaziia v 1905 g.* (Moscow, 1926).

F. PEASANTRY: O. G. Bukhovets, "K metodike izucheniia 'prigovornogo' dvizheniia i ego roli v bor'be krest'ianstva v 1905–07 godakh (po materialam Samarskoi gubernii)," *Istoriia SSSR,* 1979, no. 3: 96–112; V. I. Chuprov, "Prigorovy i prosheniia Komi krest'ian kak istochnik po izucheniiu ikh ekonomicheskikh trebovanii nakanune i v gody revoliutsii 1905–07 gg.," *Severni arkheograficheskii sbornik,* 4 (Syktyvkar, 1977): 124–29; V. V. Kucher, "Krest'ianskie soiuzy v Sibiri v 1905–1907 gg.," *Izvestiia Sibirskogo otdeleniia AN SSSR,* 1980, no. 1: 70–76; A. I. Nil've, "K metodike izucheniia prigorov i nakazov krest'ian, poslannykh vo II. Gosudarstvennuiu Dumu," *Arkheograficheskii ezhegodnik za 1970 god* (Moscow, 1971), pp. 174–80; idem, "Prigovory i nakazy krest'ian vo II. Gosudarstvennuiu Dumu," *Istoriia SSSR,* 1975, no. 5: 99–110; M. Perrie, "The Russian Peasant Movement of 1905–1907," *Past and Present,* 57 (1972); V. I. Popov, "Krest'ianskoe dvizhenie v Riazanskoi gubernii v revoliutsii 1905–07 gg.," *Istoricheskie zapiski,* 49 (1954): 136–64; B. A. Trekhbratov, "O statisticheskom izuchenii prigovorov kres'tian v I. Gosudarstvennuiu Dumu," *Istochnikovedenie otechestvennoi istorii. Sbornik statei* (Moscow, 1982), pp. 131–44.

G. INDUSTRIAL WORKERS: Victoria E. Bonnell, *Roots of Rebellion. Workers Politics and Organization in St. Petersburg and Moscow, 1900–1914* (Berkeley, 1983); Heather Hogan, "Industrial Rationalization and the Roots of Labor Militance in the St. Petersburg Metalworking Industry, 1901–14," *Russian Review,* 42 (1983): 163–90; idem, "Labor and Management in Conflict: The St. Petersburg Metalworking Industry, 1900–1914" (Ph.D. diss., University of Michigan, 1981); Laura Engelstein, *Moscow, 1905: Working-Class Organization and Political Conflict* (Stanford, 1982).

H. MINORITIES AND WOMEN: A. L. Bobroff, "Working Women, Bonding Patterns and the Politics of Daily Life: Russia at the End of the Old Regime" (Ph.D. diss., University of Michigan, 1982); L. H. Edmondson, *Feminism in Russia, 1900–1917* (London, 1984); Rose Glickman, *Russian Factory Women: Workplace and Society, 1880–1914* (Berkeley, 1984); V. V. Grishin, "Dvizhenie za politicheskoe ravnopravie zhenshchin v gody pervoi russkoi revoliutsii," *Vestnik Moskovskogo Gos. Universiteta,* Seriia: istoriia, 1982, no. 2: 33–42; H.-D. Löwe, *Anti-Semitismus and reaktionäre Utopie* (Hamburg, 1978); Hans Rogger, *Jewish Policies and Right-Wing Politics in Imperial Russia* (London, 1985).

INDEX